Art as Contemplative Practice

Art as Contemplative Practice

Expressive Pathways to the Self

Michael A. Franklin

Foreword by
Christopher Key Chapple

Published by
STATE UNIVERSITY OF NEW YORK PRESS, ALBANY

© 2017 Michael A. Franklin

All rights reserved

Printed in the United States of America

For information, contact
State University of New York Press, Albany, NY
www.sunypress.edu

Production, Laurie D. Searl
Marketing, Michael Campochiaro

Library of Congress Cataloging-in-Publication Data

Names: Franklin, Michael A., 1956– author. | Chapple, Christopher Key, 1954–
 writer of foreword.
Title: Art as contemplative practice : expressive pathways to the self /
 Michael A. Franklin ; foreword by Christopher Key Chapple.
Description: Albany : State University of New York Press, 2017. | Includes
 bibliographical references and index.
Identifiers: LCCN 2016031434 (print) | LCCN 2016032158 (ebook) | ISBN
 9781438464336 (hardcover : alk. paper) | ISBN 9781438464329 (pbk. : alk. paper) |
 ISBN 9781438464343 (ebook)
Subjects: LCSH: Mysticism and art. | Contemplation. | Art—Problems, exercises, etc.
Classification: LCC N72.M85 F73 2017 (print) | LCC N72.M85 (ebook) | DDC
 701/.17—dc23
LC record available at https://lccn.loc.gov/2016031434

10 9 8 7 6 5 4 3 2 1

One never knows when and where the teacher will emerge:
For my students who continuously reveal this lesson to me...

Contents

Figures, Tables, and Rubrics

Figures

Tables

Rubrics

Foreword

there are a lot of
rules here BUT + ideas
about
what
MUST "

Creativity (requires) a moment of stillness through which inspiration might be gleaned. We can set the conditions but creativity defies coercion. What factors can make all the ingredients align? From what depth does art arise?

Art (requires) rhythm, perspective, vision, craft, and bravery. Art (must) arise from a place of deep honesty, from a place both known and unknown to the artist and to the recipient of the experience. Art as cookery can be smelled and tasted. Art in the form of crockery can be handled and stroked. Art in the form of sculpture or painting or film can be viewed. Art in the form of prose or poetry can be read silently or enunciated through the spoken word. Good art represents an agreed-upon version of cultural reality, recognizable to all. Great art pulls on the heartstrings, revealing hidden truths through honest, mindfully crafted work.

Can art heal? Can art bring laughter, good cheer, wholeness, wisdom? Therapeutic aspects of art have long been known. The good, the true, and the beautiful, spoken of by Socrates in ancient Greece, hold the key to human fulfillment and happiness.

This book approaches the artistic experience from a place of personal pain and resiliency due to a cancer diagnosis. Facing mortality, a human being automatically finds herself or himself thrust into a cascade of questions. What caused this to happen? How will others treat me? Do I have the strength and resilience needed to survive? Other, bigger questions also arise. Has my life been worthwhile? Will I leave a legacy? Can my daily routines bring solace? What more can be done? What more can I do?

Michael Franklin boldly brings his reader into a place of shared confidences, expressing sadness not in a maudlin way, but with enthusiasm and grace. He invites the reader into feeling the frailty of the body and the finality of facing a future with no progeny. The parental urge wells up from within the depths of the human body and psyche. Franklin, stymied by biology, takes

the need to express genetic identity and transforms it into the creation of artworks using materials such as charcoal and clay and fire to make ceramic objects and drawings that evoke a sense of family and his desire to care for others. And most importantly, Franklin leads the reader into an exploration of the delicate relationship between subject and object that can ultimately lead to the dissolution of both through meditation. By holding firm to a vision of connection to higher-order realities, by explaining the specific practices that lead to transcendence, and by boldly committing himself to a place of deep honesty, Franklin makes space for self-understanding and compassion.

Indian philosophy finds a home in this book. Theories of vibration (*spanda*) and mood (*rasa*), the "theophanic gaze" (*darśan*) and imagination, mantra and "flow" abound in these pages, explaining in everyday language the moments of beauty engendered through states of meditation. Franklin gives form and flesh to the spiritual impulse. He helps the reader interpret the art of such luminaries as Kandinsky and Mondrian, as well as his own clay rendered response to the alteration of his own body, in a manner that brings the viewer not to a place of alarm but to a place of being alert and engaged.

Some of the Sanskrit interpretive categories elucidated by Professor Franklin include *rasa, darśana, guṇa, aṅga, prāṇa, mantra,* and *śakti*. Abhinavagupta's eight flavors (*rasa*) describe the range of human emotions from hilarity to anger to love to transcendent peace. The theophanic gaze or *darśana,* can be universally applied as the focused optimal manner in which to regard the world, to revere images of beauty and of the divine, and one another. Three *guṇas* organize one's relationship to above, middle, and below; in the *Bhagavad Gītā* Krishna teaches Arjuna how to obtain equanimity by regarding all phenomena as suffused with different ratios of these three fundamental strands. The eight limbs or *aṅgas* of Yoga guide one from ethics and comportment to awareness of body and breath, inwardness, concentration, meditation, and moments of freedom. The breath of life or *prāṇa* suffuses all experience, allowing the senses and the mind to engage the world, and allowing the world to touch and affect and effect each individual's reality. Mantra provides a spoken, chanted, and heard thread to higher, deeper experience. Finally, all the world operates through power or *śakti,* the matrix of all manifestation, the everyday material inseparable from the garment cloaking the universal body.

Franklin provides pathways to link the material and the spiritual through art. He highlights the importance of "metaphoric narration," the capacity to find meaning within one's life by entering into the vision of another medium or another person's creation of beauty or by not rejecting the lessons to be learned in the darkness of shadow. His catalogue of media provides refreshing insight into the many linked expressive forms, including the fluid and the dry,

the pliable and the solid, two-dimensional paintings and three-dimensional sculptures, the still image and the moving image, installation and performance. All carry, in his words, "implicit healing metaphors."

At the end of the book Franklin innovates recipes and instructions on how to convey depth of meaning through specific creative exercises. These include keeping a sensory diary, perhaps such as traveling with a sketchbook; exploring the various Buddha families famous in the beloved *mandala* practice lauded by Carl Jung; creating a "split screen *tonglen*," wherein one visualizes the pain of another and sees it reflected in one's own pain; and the practice of dying, delicately and sensitively presented as a means to move from attachment to freedom, writ small and writ large.

Michael Franklin has created a space for readers to engage in a process of stillness, reflection, and artistic encounter. This book holds deep personal interest for me on many levels. Pottery serves as an important creative outlet for Franklin. Similarly, ceramics were one of my great passions in high school and college, where I took an undeclared minor in throwing and glazing pots. Therapy through the arts came into my life while hosting music therapy events at Moksha Bookshop of Yoga Anand Ashram in Amityville, New York, where I managed a community education center. The workshops helped heal difficult wounds experienced in my twenties, and sold me on the restorative power of the arts. Upon arrival at Loyola Marymount University this interest became part of my professional life, as I reviewed our Clinical Art Therapy program, oversaw its name change to Marital and Family Therapy, helped hire its faculty, and served as adjudicator for many thesis projects. The late Helen Landgarten, the program founder, and her successors have been cherished colleagues for many years.

We built the nation's first Master of Arts in Yoga Studies at Loyola Marymount University, inspired in part by the success of our Art Therapy program. The LMU Yoga Studies program conducted a six week residency at Covenant House in New York City in 2015 and teaches ongoing yoga classes at Lynwood Women's Detention Center, bringing this important healing modality to underserved communities. Michael Franklin shares this concern for bringing resiliency strategies to those who face personal and societal challenges, having worked with angry teenagers and other difficult populations. And, finally, Franklin delves into contemplative practices that have engaged my thought and practice for more than four decades, providing evidence for the efficacy of these modalities. For all these reasons and congruencies, it has truly been an honor to read and introduce this important work.

The reader will be edified by the wisdom contained in these pages and perhaps inspired to pick up a pencil to write a poem or create an abstract or

even literal form or design to give voice to the feelings welling up from within. Art in its myriad forms holds the power to heal. Michael Franklin invites us to explore that power.

Christopher Key Chapple
Doshi Professor of Indic and Comparative Theology
Director, Master of Arts in Yoga Studies
Loyola Marymount University

Author's Note

Concerning Sanskrit, which is a language that deserves accurate pronunciation, the universally accepted Roman transliteration schema with diacritical marks is used throughout this book, with the more commonly used English spellings shown alongside when relevant. Certain terms, especially those that have been adopted by the English language, have had spaces, dashes, or the plural "s" added to the transliteration to make them more accessible to a general audience. As with so many ideas presented in this book, further learning requires additional study and the assistance of a knowledgeable, adept teacher to help guide your practice.

Even if working with a seasoned teacher knowledgeable about spiritual practices, the student can open too quickly without the accompanying resources to integrate the experience. The eruption of unanticipated states of awareness can be difficult to self-regulate.

Additionally, it is the nature of art to loosen defenses and reveal personal material at an accelerated rate. When this happens, manifested unconscious imagery can feel unexpectedly provocative, resulting in a confrontational encounter with ignored intimate subjects. Be gentle with yourself and consider this moment as an opportunity to become mindfully curious about personal imbalances expressed through this unanticipated arrival. If confusion persists, think about seeking the services of a seasoned art therapist with transpersonal training.

Lastly, rather than write a book about art that briefly describes many contemplative traditions, I have chosen instead to focus on yoga, meditation, and imaginal approaches. Certainly there is more to say about the topics discussed in each chapter. What is presented within these pages only scratches the surface of these remarkable traditions. The only way I know to access this content is through a practitioner-researcher narrative that moves between first and third person voice. Stylistically, these voices shape the tone of the book.

Acknowledgments

First, I wish to thank my acquisitions editor at SUNY Press, the late Nancy Ellegate, and her steadfast assistant Jessica Kirschner for believing in this book. Laurie Searl, senior production editor, marketing support, Michael Campochiaro, and copyeditor Alan V. Hewat skillfully shepherded this project through its final phases of polished completion—thanks for your patience and support. I would like to also acknowledge Jennifer Phelps and Jan Freya for their editorial assistance. Both offered insightful guidance on various technicalities while I was writing this book.

Select colleagues, whom I respect and admire, read either sections or the entire manuscript, offering helpful critical feedback. Although keenly interested in Sanskrit, I am not a scholar. Therefore, guidance presenting the nuances of this vital spiritual language was important. Professor Sreedevi Bringi, colleague and friend, proposed incisive grammatical and conceptual advice related to terms and Hindu-yoga-tantric philosophy, which are her areas of scholarly expertise. Together with her gifted graduate student James Peacock, their invaluable assistance helped me to further catalyze my ideas on these timeless subjects. Cynthia Drake read the entire manuscript, generously reviewing each section. Her literary acumen and Buddhist practice background helped to judiciously hone earlier drafts. Douglas Blandy, longtime colleague, also read the full manuscript, assuming an aerial perspective of validation and support. Jo McBride, who always brings a loving critique to my work, showed me yet again how to unpack my content-laden sentences. She consistently reminded me that "sentences are carriers of energy" and to simplify terms in order to clear the bandwidth for the reader. Josie Abbenante provided wise and helpful advice on sections related to imaginal traditions. Laurie Wilson, art therapist and art historian, insightfully blends the wisdom of both disciplines. While consumed in the fast-moving current of her own book project, she generously reviewed and critiqued chapter 3. Special thanks to Lola Clark, who at the tail end of this intensive project, offered her steadfast organizational help review-

ing the final galleys. Much of the art that appears throughout the book was created by workshop attendees. I would like to thank the many artist friends who gave me permission to show their work. Lastly, my colleagues at Naropa University and in art therapy, who genuinely understand art as contemplative practice, have kept me moored to the foundations of my beliefs. Upon arriving at Naropa in 1997, I immediately realized how fortunate I was to work in an institution filled with so many like-minded staff, faculty, and students who live the shared beliefs explored in this book.

Efforts like this project do not happen without the encouragement of mentors. I have been most fortunate throughout my career to bank support from many guides, especially Richard Loveless, MC Richards, Elinor Ulman, Shaun McNiff, Rabbi Zalman Schacter-Shalomi, and the Sisters of Saint Francis at the College of Saint Teresa. Each in their own way encouraged the trajectory of my ideas that have become this book. Finally, this entire project would not be possible without having met my root teacher, Swami Chidvilasananda. Her radiance brings the Siddha path to life.

Introduction

Quite by accident, during a routine doctor's visit, I was diagnosed with prostate cancer at the age of forty-seven. During the next year as I researched treatments and prepared for surgery, I went through a version of hell, took the trustworthy friends of art and meditation with me, and had a surprisingly meaningful time. Between a disciplined meditation practice and a lifelong art practice, I was able to observe my thoughts before they became alarmist fiction. From the first moments of diagnosis, self-talk such as, "Am I going to die?" or "What irreparable damage will my body suffer?" was ready to plague me. Rather than indulge these impulsive thoughts, I observed them and, when needed, invited them to take form through art so I could see what all of the fuss was about. Simply, meditation offered a way to become the witness of my mind while art literally showed me the content of my mind. Together, both practices revealed the synergistic union that has inspired this book.

Cancer confirmed what I already knew—that art is a contemplative practice of gently and intentionally maintaining moment-to-moment awareness while tangibly manifesting thoughts. Visual art fine-tunes our capacity to mindfully observe whatever emerges. As the subtle textures of silence, stillness, and action emerge in the work, contemplative curiosity deepens. Subtler still, art offers a way to prayerfully love back the gift of life, including our suffering. We cannot live in our bodies and avoid physical and emotional distress. However, we can create our way out of our anguish by answering back with the transformative technologies of art and meditation. As one learns to sit with and create out of any state of mind, meaning in suffering is revealed. Both practices have been the contemplative oxygen of my life.

Catastrophic illnesses such as cancer reaffirm the blessing of life. We are most alive, it seems to me, when mindfully and artistically observant of the events that comprise our lives. In a strange way, art and meditation prepared me for the cascading realities of cancer. Thus, there is an important backstory

to tell. The epicenter of this prequel occurred during forty seconds that saved my life.

When my father died, I was fifteen and he was forty-seven. When I turned forty-seven, I went to the doctor for a routine physical inspired by my father's early death. Everything checked out well except for my PSA blood test, which measures the amount of a protein found in the prostate gland. Alarmed, the doctor did not hold back his frank concern. I told him that I felt great, that perhaps this could be a false positive. He agreed and suggested we retest.

Surprisingly, the results of the second PSA screening were perfect. His previous alarm softened as he told me that I was fine and did not need to return to his office for another year or two. This was great news, yet something in me hesitated. Somewhat stunned by this unexpected thought, I asked the doctor if I could take a minute to inwardly focus my attention and listen to this unanticipated hesitation. He agreed and sat quietly while I closed my eyes.

As I settled my mind, from some felt unknown shadowy place inside, I heard faint whispers telling me to check further. I opened my eyes and suggested that we indeed do additional testing. With a tone of gentle disagreement, he advised me yet again that I was fine. I told him that I was an artist and a meditator and that when I do not listen to these intuitive messages I get clobbered. "Please investigate further," I asked. He acquiesced and scheduled another appointment.

The next step was to biopsy the prostate gland, which is a very uncomfortable procedure. Like aiming at a small walnut-size dartboard, he skillfully removed several minute core samples from different regions of the gland. For the next several days I patiently waited for the results. The call finally came from the office telling me that I indeed had prostate cancer. My previous intuition was confirmed. If I had not taken these forty seconds to inwardly listen, it is likely that I would not be here writing this book. More importantly, it was art and contemplative practices like meditation that fine-tuned my intuitive awareness to listen, hear, and honor intangible interior processes.

Ultimately, I did have surgery to remove the prostate gland. After the operation and the pathology report came back, I was told all was fine, that the cancer was contained within the capsule of the gland. However, six months later after another routine test, a spot showed up on my left lung. Alarmed, the pulmonary doctor suspected that the previous cancer had metastasized. I went back to the hospital for a lung biopsy and was told that I would either wake up with a quarter coin-sized piece of my lung missing, or three-fourths of my lung removed. Yet again, uncertainty arrived and all I could do was practice my way through this latest episode. Fortunately it was not cancer.

It was a benign nodule of abnormal tissue large enough to get the doctor's attention.

From diagnosis to surgery and for the next six years I made numerous clay pots, paintings, drawings, and videos about my cancer experience. Much of the work revealed unanticipated imagery. Although I am well practiced at skillfully observing art processes and products, the art I did during this time tricked and surprised me. What emerged was astonishingly accurate to my circumstances, yet unknown to me at the time of creating the work. I was constantly taken by surprise, often weeks or months later, by the revealed truth held in the imagery. For example, during consultations with physicians I would hear complex, detailed information. At first, what I heard was beyond my comprehension. It all blended together rather than existing as retrievable information. Yet, the images I created exposed unconscious insight, such as the series on x-ray drawings and root vegetables.

Not knowing why, I kept making x-ray drawings of onions, carrots, and parsnips. In hindsight, I simply wanted to see inside of myself. X-ray perspective is a visual method used by children to simultaneously show inside and

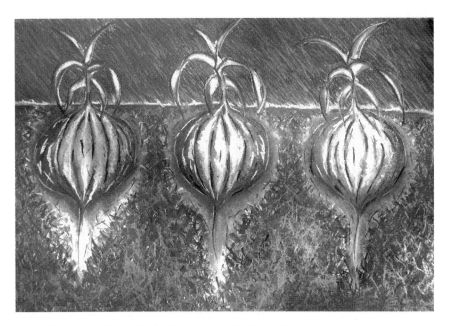

Figure I.1. *Three Bulbs (X-ray drawing)*. Original artwork by the author.

Figure I.2. *What I Look Like Inside*. Original artwork by the author.

outside space. As a strategy, it cut away façade so that I could literally see within myself. At first, using this method was an unconscious choice. Some intuitive insight, unknown to me at the time, selected this manner of working. Eventually I understood why.

Although I could not see the actual tumor, art showed me the progression of my psyche trying to grasp my cancerous circumstances. Finally, it occurred to me why I was drawing so many root vegetables. The prostate gland is located in the region of the *mūlādhāra cakra* (muladhara chakra) area. Known as the root/base *cakra* located at the base of the spine, the *mūlādhāra* is the subtle energy center of earthly survival instincts and the seat of the *kuṇḍalinī-śakti* (kundalini-shakti).[1] This region also holds energetic connections to reproduction and therefore family too. I do not have children, which has been a source of sadness for me. Metaphorically, my body was grieving a loss. I also wanted to see inside of myself. The only way I know to image my inner life is through art. Over time, unconscious imagery became clarified, guiding me toward greater awareness.

In addition to using art as a contemplative practice in my personal life, particularly during challenging events, I have worked with people across the

developmental spectrum steeped in personal tragedy. Since beginning my art therapy training in 1979, I have witnessed how the creative process allows access to suffering while supporting the discovery of resiliency. I am also an educator who has held three academic appointments, two of which integrated studio art and art education with art therapy. For several reasons, the integration of educational and therapeutic approaches to art makes sense. Whether in a classroom setting or receiving therapeutic services, art can gently loosen defenses and surface unanticipated, yet necessary poignant emotional material. The human psyche has a way of manifesting truthful content in dreams and artwork, something that art teachers, artists, and counselors understand. The arrival of unanticipated psychologically laden material can take us by surprise. During these moments, choices often feel out of reach. People want to create art, but are afraid. Experience has taught me that part of the fear resides in not knowing about art materials and processes. Still others like the idea of art but are mystified by the resources needed to turn out creative work. When people say they can't draw it is a good bet they are also saying they know little to nothing about materials and processes. Competent teaching is essential when providing a positive encounter with art and contemplative practices.

Similarly, I have participated in many hatha yoga classes where teachers knew little about human anatomy, healthy joint alignment, or how to work with existing injuries. They would invite people into complex poses without the knowledge to make necessary corrections. As a result, people would get hurt. Since competent teaching is essential to designing your own contemplative practice program, I have included a tutorial section with exercises and assessment rubrics toward the end of the book. Additionally, contemplative work results in refined outcomes under the guidance of a well-trained teacher. When beginning, and even if a seasoned enthusiast, it is important to seek out a trained yoga or meditation instructor to help guide your practice.

I developed many of these methods while teaching at Bowling Green State University in Ohio and at Naropa University, where I currently train graduate-level counselors and art therapists. Included in this education is an integrated curriculum combining the contemplative practice of mindfulness meditation with therapeutic applications of art and community-based models of social engagement. This unique learning environment invites students and faculty to bravely develop skills for living with composed presence.

At Bowling Green State University, I directed an undergraduate art therapy program within a large, thriving art school. I was repeatedly asked by the MFA students to be on their committees due to my comfort and ease with their visual content. While many colleagues approached graduate

student work from a formalist view where the compositional imagery was to be defended, I conversely responded from a collaborative position that privileged image, process, product, and artist equally. For me critiques were less about clever defense of the art and more about observational listening to image.

Art can be a hard slog. When in the studio, I always ask my students and myself, "What am I/are you trying to do or accomplish and am I/are you achieving it?" Forming personal truth into candid compositions requires honest self-examination. Wassily (Vasily) Kandinsky (1911/1977) believed in the importance of art emerging from responsiveness to inner spiritual need. Receptivity to these subtle quakes of interior truth is a hallmark of imaginative work.

Art as contemplative practice begins with the inner necessity to be authentically ourselves and to let our work emerge from the ordinary sanity that we are. Chögyam Trungpa Rinpoche (2005), the founder of Naropa University, taught that we are all brilliantly sane with an ordinary core nature of basic goodness. Like a subterranean spring, art accesses authentic expression of our ordinary sanity and what is intrinsically true for us. This is the case for one simple reason: art is a full spectrum awareness or *sādhanā* (sadhana) practice, akin to meditation and yoga. Art slows us down and wakes us up from degrees of amoral slumber. This contemplative result is accomplished by connecting our receptive and expressive channels to the vast continuum of life. The arts provide access to the majesty of landscapes, cultural trends, historical patterns, and opposing internal emotional realities.

When experience is made into art, the simultaneity of dualistic perception is unified into compositional form. Warm and cool colors, foreground and background, or rough and smooth textures eventually cohere into a final, united arrangement of lines, shapes, and colors. Duality is held within a non-dual product thus allowing a view of the many within the one. Such encounters cultivate deeper curiosity for the ordinary and the sacred.

My contemplative practice life has taught me that if I keep backing up and observantly peeling away the layers of awareness and identity, I end up with a view of a not so solid self. Instead, I arrive at a subtle refined inner destination where the filter of I/me softens and void-like awareness opens up. One of many rings in a developmental trajectory of meditative states, there is vast space within us beyond concepts and categories.

As an artist collaborating with personal images I wish to create visual forms to hold contemplative content. I want to offer the same opportunity to others, yet people are often intimidated by art. The feeling of incompetence is immediate—I can't draw a straight line, or at best, I can only make stick

figures. They usually feel that art should convincingly look like something. Like a Xeroxed copy, art is supposed to reproduce what is seen. Sadly, this outlook is sternly ingrained within the adult Western psyche. Shifting this attitude takes time. In fact, this is a perfect example of art supporting contemplative practice. Immediate thoughts of "I can't draw" arise for observation rather than judgment. So we begin with what shows up and befriend the solidity of the perceived inadequacy. Understanding that "art" is not a copy of something but instead a response to an experience that deserves to be explored and expressed takes time.

Aside from the art object, such as a painting or any humanly made items that comprise material culture, or encounters with the beauty of the natural world, art is something that happens to us. For example, when watching a film we can be taken to unanticipated places of intensified emotional experience. Like a medicinal potion, images enter us sparking empathy for the events unfolding before us. We know ourselves differently at the end of the film than before it started, an indication that art has happened to us. If carefully observing, the same results occur when leaving an art museum, a student exhibit, or a national park. Heightened felt experiences that teach us to see, feel, and know ourselves differently are a civilizing outcome of art.

Another view is to consider art as a synthesis of Creation, manifesting through us as a reflection of spirit made visible. Is art a copy or approximation of nature or another limb of nature manifesting herself? Art is a process of something extraordinary coming through us. Therefore, although I use the common term *art* throughout this text, what I really mean is that art is an **EVENT**. Many factors are rolled together into this happening we call art. Culture, ancestry, memory, emotion, familial history, craftspersonship, and more constellate this eventful experience.

Two goals are satisfied in this book. One is to review how art has served as contemplative practice at different times and in different places and cultures. Understanding art's enlightening and humanizing function in spiritual/contemplative life is essential to this discussion. The second originates from a belief that studying the phenomenology of embodied experience through art and meditation awakens awareness. In essence, contemplative practices are legitimate forms of interior research. Self as subject, when explored within the context of the artist/practitioner/researcher, yields disciplined standards that honor authentic artistic intentions. However, there are traps along the way to confront. Inevitable, vain, self-indulgent artistic impulses are best served when met with curiosity. Once when working with a teenager, I told him that he could create anything he wanted in the studio. "Anything?" he asked. "Yes, of course," I responded. He then took a very large sheet of butcher paper and

wrote FUCK YOU in large letters. Trying to shock and test me, my simple response was, "Is this the best you can do? What do you really mean? Show it . . . Tell it . . . Find other ways to say what is behind this FUCK YOU," I suggested. "And let me know if you need any help." He took the bait and proceeded to dig deeper and deeper and find what was waiting for him. Rather than putting effort into shocking others, and me, he began discovering the layers of his legitimate anger.

As this story and the story about my cancer diagnosis illustrate, attunement to inner events cultivated from a contemplative lens facilitates access to life-saving insight. To do art from this intentional perspective slowly reveals who we are beyond rigid views of personality and identity. Like the yogi casting awareness inward to observe the unfolding textures of inner life, the artist, too, objectifies and subjectifies the strata of conscious experience. We make art to stir aesthetic awareness of ourselves, each other, and our collective potential. Moving beyond limited views of a separate, solid self toward conditions for self-transcendence is a birthright for every person. At our optimal potential, we are unlimited awareness contemplating itself.

Written from the perspective of the practitioner-researcher, this book is intentionally created for a wide-ranging audience of artists, art students, art teachers, art therapists, meditation or contemplative practitioners and teachers, clergy, and psychotherapists. Essentially, these chapters are meant to be a supportive companion for awakening the contemplative artist within.

While it deals with an expansive subject, several core tenets cycle through each chapter. The points outlined below name and chart the coordinates of these guiding principles:

1. Embodied consciousness emanating from the subtle, nondual core of being, known as the Self, quakes and throbs the yearning *spanda*[2] impulse to manifest.

2. Art is a means for answering Creation back with creation.

3. Art, as an awareness practice, cultivates open, unrestrained alertness to inner sensation, emotion, and states of mind. It widens the mindful gap-space between stimulus and response, impulse and action. Essentially, wherever one intentionally aims awareness, information is waiting to be discovered.

4. Art manifests and blends inner imaginal culture with outer social, material culture. Additionally, art makes available interiorized experience for outer reflection.

5. Resulting symbolic narratives become conversation partners as well as collaborative allies in an I-Thou relationship of expressive exchange (Buber, 1923/1970).

6. These materialized images for the practitioner-researcher exist as visual language for self and audience consumption.

7. Through art, audience and artist can oscillate between form and formlessness, solidity and dissolution, idea and object, culture and self, and intention, attention and manifestation.

When viewed through these lenses, art facilitates thinking, sensing, feeling, nonjudgmental noticing, praying, worshiping, and learning about self and other.

Part I addresses important foundations of art as contemplative practice. Starting with chapter 1, transcendent and immanent views of creation are examined including the core relationships between art, imaginal wisdom, and yoga including *kuṇḍalinī-śakti* and the *spanda* impulse. Chapter 2 reviews the foundational terminology and pertinent constituent parts of art as contemplative practice. Chapter 3 offers focused snapshots of early-twentieth-century European and American modernism and various known artists working with contemplative intentions. Chapter 4 explores the textures of *rasa*[3] theory and the theophanic gaze of *darśan* (darshan)[4] experiences. Chapter 5 examines the practice of imagination, including the wisdom gleaned from imaginal traditions.

Part II specifically looks at the subjects of art as yoga and art as meditation. Each reviewed area is followed by a discussion on art-based connections to that subject. Chapter 6 broadly looks at various yoga traditions and terminology that relates directly to art as a contemplative practice. Chapter 7 takes up art as meditation including the similarities between mindfulness and concentrative approaches to meditation. Chapter 8 involves an examination of karma, karma yoga, and the role of the socially engaged artist working in the twenty-first century. Chapter 9 concludes with a personal epilogue about expressive pathways to the Self. If interested, it is fine to skip to chapter 9 at this point and read about the artwork created during my cancer experience.

Part III closes the book with various exercises and rubrics to help establish an art-based contemplative practice. Teachers will also find helpful rubrics in this section.

In order to begin, I have outlined suggestive definitions of art below. While difficult to nail down, the following preliminary list casts a wide net around the idea of art practice:

Table I.1. Ways of Thinking about Art

Art is a means to see, to question, to know, to feel, to be, to communicate, to pray, to worship, to love, to respond, to learn, to listen, to be silent, to be absorbed, to appreciate, to lose and find oneself. Below are further explanations on the what, how, and why of art.

Art emerges from the nondual *spanda* moment as consciousness seeking form and expression	Art is a way to reflect and contemplate
	Art gives feeling/emotion tangible form
	Art is symbolic communication that surfaces splits in the psyche
Art is creation responding to creation	Art is a response to something
Art is ritual	Art is absorption in action and in the stillness of silence
Art is a practice of inquiry	
Art stimulates perception and the senses	Art is silence made visible
Art is a whole brain, whole body event	Art is the sacred made visible
Art is inner communication—making the hidden seen	Art is inner imaginal freedom made visible
Art is making visible the phenomenology of inner experience	Art is creative use of physical materials
	Art is the act of making special
Art is communication between people and cultures	Art is a political act
	Art is civil societies made visible
Art is cultural diversity made visible	Art is a way to protest (personally and spiritually)
Art manifests self as subject	
Art is experience made visible	Art inspires risk taking—to fail and rebuild
Art is image and imagination made visible	Art facilitates creating our way out of our suffering
Art is physical space made visible	Art facilitates connections with I-Thou relationships
Art is life-force made visible	
Art is choice and action made visible	Art is the fragmentation and unification of body, speech, and mind
Art manifests material and imaginal culture	
Art is something that happens to us	Art is a practice of sitting with the Divine, joining with the Divine, and serving the Divine
Art invites failure and learning from failures	

Simplified Sanskrit Pronunciation Guide

Sanskrit employs very specific mouth positions to pronounce specific lettered sounds. A complete description of these phonemes is beyond the scope of this book, but is readily available on the Internet (see Roman transliteration schema for Devanagari script/Sanskrit/Hindi languages). A simplified pronunciation guide follows:

a	short vowel, as in c*u*t
ā	long vowel, as in f*a*ther
i	short vowel, as in b*i*ll
ī	long vowel, as in p*ie*ce
u	short vowel, as in s*ui*t
ū	long vowel, as in m*oo*d
ṛ	vowel, as in mer*ri*ly
c	palatal consonant, as in *ch*at
ṭ, ṭh, ḍ, ḍh, ṇ	cerebral consonants—tip of the tongue is curled back at the roof of the mouth, producing harder sounds. As in ha**t**, **d**og
t, th, d, dh, n	dental consonants—tip of the tongue touches the back of the teeth, producing softer sounds. As in '**th**us,' **th**irsty
ś	palatal sibilant, as in *sh*ip—tip of tongue is flat on the palate, producing a flatter sound
ṣ	cerebral sibilant, as in *sh*oot—tip of the tongue is curled back, producing a fuller sound

Additionally, -h after a consonant letter adds aspiration (breathy sound) to the consonant sound.

Abbreviated Glossary of Sanskrit Terms

Roman Transliteration	Commonly Spelled	Definition/Description
Ākāśa	Akasha	Sky/ether/endless space
Bodhicitta	Bodhichitta	Buddhist term for our "true nature"/ pure clear awareness
Brahmacarya	Brahmacharya	Chastity/living with ethical restraint
Cakra	Chakra	"Wheel"/center of subtle energetic power along the spine
Cakṣu	Chakshu	Eyes/sight/vision
Cit	Chit	Pure consciousness
Darśan	Darshan	Act of sacred "seeing"; linking to the sacred dimension
Doṣa	Dosha	*Āyurvedic* constitution principle; 3 *doṣas* are linked to 3 basic human temperaments
Īśvara-praṇidhāna	Ishvara-pranidhana	Surrendering to the inner Divine Presence or to one's chosen deity principle
Kāñcuka	Kanchuka	A covering/veil, as in the 5 *kañcukas* of *māyā* (5 aspects of limitation or contraction of consciousness in Tantra)

Roman Transliteration	Commonly Spelled	Definition/Description
Kuṇḍalinī-śakti	Kundalini shakti	Embodied subtle energy/creative power (*śakti*), metaphorically coiled like a pot (*kuṇḍa*), or snake, at the base of the spine
Mātṛkā	Matrika	Mother archetype principle embodied in all letter-sounds
Mātṛkā Śakti	Matrika Shakti	Embodied energy/power of Divine Mother archetypal embedded in every Sanskrit letter-sound
Mātṛkācakra	Matrikachakra	Wheel of the Mother/totality of embodied Divine Mother energetics in all Sanskrit letter-sounds together—linked to source principles of reality/existence
Mokṣa	Moksha	Liberation/self-realization
Paramaśiva	Paramashiva	Transcendental aspect of Divine Reality (as the Divine Masculine)
Parāśakti	Parashakti	Transcendental aspect of Divine Reality (as the Divine Feminine)
Paśyantī	Pashyanti	"Seeing"/nondual level of sacred speech experienced as inner revelation/insight
Paśyantī-vāk	Pashyanti-vak	Inner revelation phase of sacred speech (*vāk*)
Prakāśa	Prakasha	Self-illumined source (Divine Source as self-effulgent/shining)
Prakṛti	Prakrti	Manifesting power of Source Consciousness *Puruṣa*/sacred power, forces and manifestations of Mother Nature
Pṛthvī	Prithvi	Earth/archetypal Mother Earth principle

Roman Transliteration	Commonly Spelled	Definition/Description
Puruṣa	Purusha	Pure Awareness/Witness/Consciousness Source in the *Sāṅkhya* wisdom tradition
Śabda	Shabda	Sacred word-sound/essential basis of the cosmology of Divine Reality through Word-Sound
Sadāśiva	Sadashiva	"Stillness always"/Consciousness as eternally present/stillness; the most subtle aspect of *Śiva*
Sādhanā	Sadhana	Meaning to accomplish and go straight to the goal. Sincere engagement with contemplative practices like chanting, prayer, service, and art for transforming attachment and pursuing spiritual goals of transcendence
Śak	Shak (etymological root)	To be able/to have power/root verb of *"śakti"*
Śakti	Shakti	Embodied power/divine feminine power to manifest consciousness in all existence
Śaktipāta	Shaktipat	The awakening descent of Grace and resulting realization of inner Divinity; often received through transmission from a guru, but not necessarily
Śānta	Shanta	Quality of peace/artistic sensibility depicting a peaceful nature
Santoṣa	Santosha	Contentment, joy
Sat-cit-ānanda	Sat-chit-ananda	Existence-Consciousness-Bliss/Vedantic attributes of embodied Consciousness or *saguṇa Brahman*

Roman Transliteration	Commonly Spelled	Definition/Description
Satsaṅga	Satsanga	Spiritual gathering/group. Literally, a "gathering of the seekers of truth"
Śauca	Shaucha	Cleanliness/quality of inner and outer cleanliness in yoga
Śiva	Shiva	Tantric Supreme male deity/Consciousness/Source Spirit
Spanda	Spanda	The primordial vibrational throb of all creation. A 'seeming movement,' the 'vibrational impulse' of Lord Siva's engagement in the play of the Divine, in the Kashmir Shaivism Tantra tradition.
Spanda śakti	Spanda shakti	Feminine divine power of "seeming movement" or vibrational movement of Consciousness/*Śiva*
Sparśa	Sparsha	Touch/sense of touch
Śṛṅgāra	Shringara	Sentiment of love/eroticism as an artistic quality or *rasa*
Sṛṣṭi	Shrishti	Creation (one of 5 Divine acts of *Śiva*)
Śuddha	Shuddha	Pure
Vimarśa	Vimarsha	Self-reflective awareness principle in Kashmir Shaivism tradition. As in "Illuminating Source" and its "power of Self-Reflection" *(prakāśa-vimarśa)*

PART I

FOUNDATIONS, HISTORY,
AND IMAGINAL AWARENESS

1

Art as Contemplative Practice

Beginnings

Practice traditions such as *vipassana* meditation stress the importance of upright physical posture. This core foundation enables practitioners to feel alert in their bodies while nonjudgmentally observing sensations, thoughts, and emotions. Similarly, this chapter defines a posture of foundational information referred to throughout this book. Establishing a base of pertinent ideas supports our investigation into how art functions as contemplative practice. Beginning with transcendent and immanent views of creation, the chapter then turns to the core relationships between art, imaginal wisdom, and yoga including *kuṇḍalinī-śakti* and the *spanda* impulse. Integrated throughout, are personal reflections that catalyzed my predisposition toward this material. Many of these subjects are further developed later in the book.

Ascent, Descent, and Imaginal Space

As a child, growing up in Miami, Florida, I would often go fishing. While trolling on Biscayne Bay, schools of dolphins would appear. Like shiny metallic sewing needles, they would stitch the sea by diving deep, disappearing for a while, eventually surfacing to breathe and then dive again. Watching in amazement, I would wonder about the vast seen tabletop of the water contrasted with the dark, invisible world below. Later I came to realize that the dolphins were plunging and reappearing similar to the way visual symbols behave, from unconscious to preconscious to conscious awareness. Recalling now how the dolphins sutured the sea continues to reinforce this germane teaching.

Visual symbols are the transportation between unconscious inner realms and awareness. They provide graphic embodiment for unknown felt material to manifest as relatable content. Symbols help to rebalance psychological

forces by materializing discrepancies within the psyche. For example, craving riches in day-to-day life, yet dreaming at night about nonmaterial spiritual adventures, conveys the point. When received and embraced, symbols serve as compensatory messengers to help break patterns and recalibrate personal values (Harding, 1961).

Transcendent subject matter addressed throughout this book is difficult to write about. Finding accurate language for experientially existent, yet indescribable transpersonal phenomena presents a dilemma. In order to tease apart the subtleties of these semantic challenges I am using the following term(s):

1. The intangibility of ether or formless phenomena (ascend, expand, and dissolve).

2. The tangibility of form-based, material phenomena (descend, condense, and embody).

3. The in-between, bidirectional realm of imaginal phenomena linking form and formlessness (image-sight).

Ether and the Emerging Formless

I use the term *ether/formless phenomena* to represent expansive potential space. Ether is related to the word *ethereal* and here is prepositionally described as around, over, under, between, beyond, or even within the subtle interstices of solid forms. This emptiness is not object, item, or event until we think it so. Essentially, void space is the subtlety of boundless freedom emerging from fertile emptiness. And from this emptiness, thoughts or handmade objects surface for expression. Many creation stories across cultures and throughout time, like the Genesis passage, refer to a great void of dark, formless fertility. These stories consistently teach that whatever arises from the abundance of emptiness contains both the origin and trajectory of nothingness becoming something. Boundless, yet with direction, consider how formlessness/emptiness and form/object are freely joined together within any creative process. Think of a blank canvas, lump of clay, or roll of film. And back up even farther to consider all of the previous interconnected, known, and unknown events that produced the physicality of each material. The entirety of any creative process implies a co-arising, interdependent, genesis of perceived and hidden conditions.

Contemplative traditions such as Buddhism teach that sensation or phenomenon is not a single, independent arising event. Rather, all phenomena are codependent as they surface (Rabten, 1999). Although human perception might tell us otherwise, the subtleties within any creative process are inter-

connected, emerging from five interiorized aggregates or *skandhas,* which are: form, feeling, discernment, influential cognitive elements, and the essence of consciousness (Rabten, 1999; Trungpa, 2005). All five, which will be discussed in chapter 2, make any moment internally known to us with either clarity or confusion. Since we are able to perceive past, present, and future possibilities, we become well practiced at solidifying illusions and believing in them, especially when it comes to imagining the future. It is within this subject of fertile potential that words such as God or *Puruṣa* (Purusha) appear in theological vocabularies referring to an all-pervasive eternal Consciousness.

Each unborn moment is an ever-present space of surfacing possibility. Artists know this territory well. Standing before any art material presents a multitude of possibilities. Rather than open to this opportunity, people new to art often crave certainty or predictability like the banality found in paint by number kits or coloring books. Yet opening to the ambiguity of now, as so eloquently presented by a blank canvas, raw piece of clay, or random moment to be photographed, is where ethereal potential is waiting.

As embodied consciousness, or embodied infinity, we are literally creation knowingly contemplating itself, and art becomes the embodiment of that quintessence. To create as an artist is to join with this fundamental universal pulse beating as the heart and soul of our planet. Each time we enter into the creative process of manifestation, we bring something new into the world that has never existed before, nor will ever exist again in that exact same form regardless of our capacity to make accurate reproductions. The magnificent generosity of creation observed in art, biology, physics, chemistry, astronomy, and metaphysics is stunning and spans the ages as geological, biological, ecological, cultural, and spiritual fact. This list of signposts only approximates the vast reaches of creation in its countless seen and unseen manifestations.

When Mount St. Helens in Washington State exploded in 1980, total annihilation spread across the landscape. The devastation was immense, leveling entire forests for miles. Between this destruction and the interdependent, co-arising renewal of then and now, the same land is greening and alive as it was before the eruption. Destruction and renewal exist side by side in nature and in art. Painters scrape away pigment as they get closer to their intention. Sculptors chisel away rock and editors cut film in order to discern their way toward clarity. I always feel that I have to be willing to lose something I am working on in order to break free of habitual patterns and find what is waiting for me.

Art is an awareness practice filled with numerous avenues for discovery, be it moving toward emotional or physical pain, joy or celebration, or accessing the creative friction of erosive forces. As a practice, art trains us to

see the unique in the familiar and to respond to CREATION with creation. Like prayer, through art we link with our embodied vastness by artistically responding and joining with this inner creator. Within this fundamental connection provided by art materials and processes, we no longer have to feel separate from creator and creation, which is a core reason for so much spiritual anxiety in modern life. To feel separate from the Divine causes many to feel the existential grief associated with a limited, alone, solid sense of self.

By Divine I do not mean a physical, external, anthropomorphized sky God. Rather, humans embody divinely immanent, quintessential conscious awareness and through art they can explore the endless fundamental possibilities of creation. The great pronouncement from the *Upaniṣads*[1] (Upanishads), '*tat tvam asi*,' which means "That art thou," orients us toward the budding potential of our innermost, transcendent Self (Feuerstein, 2003, p. 258). Thus, art is an expressive pathway to That which is pure and vast within us. Carl G. Jung (1998) considered the Indian notion of the Self a foreign concept for the Eurocentric worldview. However, Jung acknowledges that the Self is an embodied spiritual "Source" that is not different from God as the unlimited intelligence of universal essence. Contemplating this Source begins to shift perspective from I-ness towards absorption in the vastness of the Self, which is the goal of many spiritual traditions. Eventually, suggests Jung, practitioners realize that they are not only contained in this Divinity, they are of this same transcendent Divinity.

Solidity, Form, and Descent

Ascent—to rise, climb, merge, and dissolve into the Divine—is a theme in many spiritual traditions. Descent—to fall, drop or plunge—is an equally powerful theme often associated with negative connotations. We fall from Grace or drop into the underworld during a crisis. Within monotheistic institutions there is dualistic split between good and bad, heaven and hell. From this divided view, a positive/negative dialectic emerges producing either-or relationships. The question is, How do we listen to and mend these splits?

The beauty of a dark waiting underworld beneath rocks or within caves summons us closer to obscure spaces. Yet we tend to favor habitual security by going inside as night falls, avoiding the lush veiled subtlety of darkness. What is counter to habit is good for the development of intuition; perhaps the most important ally in artistic work. There are moments when it is time to step off of the edge of safety, plunge into darker unknown spaces, and take healthy risks. One way I learn about these leaps of faith is to enter unfamiliar landscapes with intense curiosity.

When possible, I seek out caves like at Lewis and Clark Caverns State Park in Montana and experience these fantastic dimly lit places. One enters into the cavernous darkness with respect, knowing that the ground, walls, and canopy consist of delicate rock formations patiently sculpted over millennia. The temperature quickly drops, light fades, and one soon realizes that tactile knowing is an indispensable way of receiving information. Gently feeling into the darkness and tenderly touching the cool stone surfaces reveal the contoured language of rock and time. The face feels moisture while the ears hear the expanding, viscous silence. Though foreign to usual perception, this "down there" darkness, too, is home.

Figuratively speaking, spelunking is a skill for the contemplative artist. To journey into emotional spaces where it is silent, dark, perhaps even hellish, can reveal ripe opportunity. Like many dialectic relationships, the freedom to ascend and descend does not imply contradictions of either-or, positive-negative undertones. If willing, we can go toward counterintuitive, prohibited subjects and mend the splits of dualistic thinking, while participating in the discovery of personal wholeness.

The exploration of formlessness promises revelation. In alchemy, the empty space of ether is the *prima materia,* or the original material from which all forms and ideas emerge. From the emptiness, a soon-to-arrive unborn moment emerges bringing the assurance of manifestation.

Art teaches us to fall in love with the physical world including what is easy to see as well as what repels us. Dead flowers are as interesting to look at as a living bouquet. Mindfully perceiving with full sensory awareness deepens participation in any life event.

When I worked inpatient psychiatric care with hospitalized teens, they often announced their boredom. "How can you be bored?" I responded to them. "If you are bored it is because you are boring." Yet they had a point as many were deprived of any sort of arts education. So I would teach them how to see through paper towel tubes, photograph with homemade pinhole cameras, and investigate their surroundings with magnifying glasses. We found ways to experiment and build small dreams such as drum sets and life-sized guitars out of cardboard and thrown-away ice cream store barrels. Over time, boredom moved into remission. The teens became emotionally and aesthetically engaged and excited about their sensory capacity to receive the world, feel their feelings, and step into the emptiness of blank canvases and cardboard remnants in order to create their stories. Most encouraging, they repeatedly requested new, more complex assignments. They were alive and they knew it, learning that persistence always yields results when attempting to manifest unseen ideas.

Image-Site/In-Sight: Imaginal Dialogues Within Liminal Space

During my life, I have lived in several warm climates in Asia and the United States. When it was unbearably hot, I always appreciated an oscillating fan to circulate the stale humid air. Although I could not see the subtle wind currents, I still felt the cooling breeze across my face and body. Sometimes small particles of dust would join the swirling air and make the faint wind patterns visible. Imagination often feels like this to me as streams of breezy images circulate throughout the day, beckoning my attention. Remarkably, these inner events coalesce and arrive as spontaneous, noteworthy visitors. Consider how a random door SLAMMING shut or the faint scent of a summer rose bush suddenly becomes a catalyzing moment setting images in motion.

Like cooling background weather patterns, the imagination imagines itself imagining. As a faculty, like an indispensable appendage, it freely crosses liminal borders between waking life, dream life, and other states of consciousness. Boundaries soften between time, space, and memory as images anneal into living narratives. All we have to do is pay attention to the flow of images moving throughout the bandwidth of the psyche. When we orient attention in this way, introspective revelation takes shape, especially when plowed into art materials and processes. In this way art deepens imaginal intelligence and the instinctive truth of images (Hillman, 1999).

SUFI TRADITIONS AND IMAGINAL WISDOM

Within Sufi traditions, prayer pairs with imaginal methods for entering numinous mystery. Religion, at its core, is the experience of holy, transcendental transformation. It is in this context that I use the word *numinous*.

Henry Corbin's (1958/1969) work on the philosopher-mystic Ibn al-Arabi addresses the importance of imagination as an appendage-like faculty used in contemplative life. In his study of al-Arabi, William Chittick (1989) noted that intellectual traditions embraced by the West resulted in a split from other faculties of inquiry practiced in the East.

Reason can only take seekers so far until they need other forms of transport into mystical and spiritual realms. Corbin (1958/1969) observed how imagination is often misunderstood as fantasy. He noted a lack of validation for "an intermediate level between empirically verifiable reality and unreality" (p. 181) or fantasy. Between the rational realm of empiricism and the impulsive, unchecked territory of fantasy resides the indispensable capability of the

imaginal. Here the practitioner can develop the "supersensory sensibility" (p. 182), whereby the Divine can arrive through images and be communed with and served. Corbin sees this perspective as opposite to the often embraced position of "*creatio ex nihilo*" (p. 182), which means God creating everything from nothing. Such a position, Corbin felt, degrades the notion of creation as theophany, or the appearance of the Divine through imagined images. Within this view, prayer becomes theophanic imagination accessing the Divine (p. 182). The God to whom such a prayer is directed creates the experience of that God through the construction of imaginal revelation.

Neither wholly rational nor reckless fantasy, imagination is closely linked to intuition, insight, and therefore to empathy. Images arrive as visiting entities to be listened to, felt, and followed. Through imaginal mindfulness, a personally devised term, we greet our guests by nonjudgmentally observing their moment-to-moment arrival and evolving narratives. To carefully observe them, feel within their presence, and imagine into their unique manifestation, teaches plurality. Also taught is to do no harm. If the senses were carefully trained to see and adore all that is around and in us as forms of magnificence—then why would we perpetrate self or other harm? When we do not see the dignified, systemic, and sentient majesty of images, animals, ecosystems, and cultures, we slip into objectified permission to injure these others. Art as contemplative practice can reverse this tragic tendency by feeling into what is other, listening to this plural pulse of other, and making meaningful contact with these inner diversities.

Images, metaphors, and symbols then offer revelatory insight into relational and personal truth. Listening to images, following them, and collaborating with them is a key goal of contemplative art processes. The deep well of the imagination is the vehicle for entering what at first seems illogical. For example, consider the heart, which is a precious inward destination found in many contemplative traditions. This central embodied space has its own metaphoric language. Opening, entering, and setting a place within the heart for worship are all imaginal practices. We literally pour our heart out and into this process. While this likely makes sense, it is also illogical at first. Yet, we can loosen formulaic resistance and thoughtfully pierce these chambers of possibility. Below are two examples of loosening defenses through embodied art practices in order to access the passport of imagination. Freeing vital life force through vigorous movement, coordinated with breath and mark making, quiets the conceptual mind. Access to interior domains such as the heart is made easier with exercises that privilege the innate intelligence of the body to think and feel inward. For additional examples, see Appendix B.

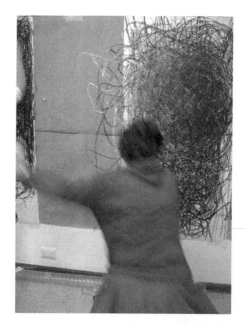

Figure 1.1. Person doing active drawing (1). Photograph by the author.

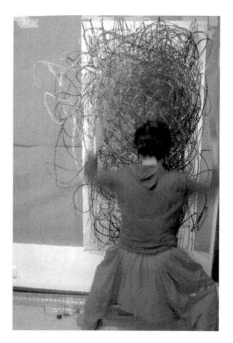

Figure 1.2. Person doing active drawing (2). Photograph by the author.

Art as Yoga and Contemplative Practice

In 2013, the Arthur M. Sackler Gallery, which is part of the Smithsonian complex of museums, hosted an ambitious show entitled *Yoga: The Art of Transformation*. The curator, Debra Diamond, assembled a team of scholars to research and present the iconographical, historical, and transnational lineages of yoga. From ancient texts and manuscripts to recent popular culture examples, the gallery showcased the manifold legacies of yoga, East and West. This extraordinary show exemplified the urge to make yoga visible by illustrating how ineffable content was materialized over the millennia for spiritual instruction (Diamond, 2013).

Art as an awareness practice silently aligns body, mind, and imagination with the present moment. Likewise, yoga is a practice of aligning the spiritual domains of body, mind, and behavior with Now in the service of transcending suffering. To accomplish this intention, yoga prescribes time-tested methods for cultivating skillful conduct, moral ideals, and a disciplined relationship with thoughts and actions. In order to learn and relearn the orientation of present-focused awareness, yoga illuminates our finite experience of personified awareness with an expansive, revelatory view of the infinite consciousness that we are.

The distinguished art historian Ananda Coomaraswamy (1934) considered yoga and art as the integral union of dexterity, attention, concentration, and absorption that literally takes form in the practice of aesthetic acts. Artists working from this perspective combined contemplative, yogic presence with the notion of visiting realms where angelic deities live. The goal was to see what needed to be reproduced so that others could participate in these revelatory experiences. Conversely, reducing art exclusively to banal perception and superficial responses limits contemplative sensitivity (Mookerjee & Khanna, 1977).

In his introduction to *The Mirror of Gesture* (Nandikeśvara, 1917), Coomaraswamy (1917) observed:

> The arts are not for our instruction, but for our delight, and this delight is something more than pleasure, it is the God-like ecstasy of liberation from the restless activity of the mind and the senses, which are the veils of all reality, transparent only when we are at peace with ourselves. From the love of many things we are led to the experience of Union. (p. 9)

Coomaraswamy elegantly sums up how art can quiet the mind and dissolve veils that fog contemplative perception. This yogic view of art connects us to the nondual unifying consciousness that splits and repeatedly divides into the infinite forms of the physical world. The magnificence of the natural

environment exposes seemingly unending patterns that reveal how the one becomes many.

By turning awareness inward through practices such as meditation and yoga, the phenomenology of consciousness is steadily revealed. This mounting contemplative knowledge guides inner transformation of unchecked urges like libido and instinctual desires. Early psychoanalytic thinkers, with their interest in impulsive urges and unconscious motivation were on the right track. Although certainly interested in the depths of the psyche, early Freudians did not probe deeply enough beyond their limited view of the ego and the analytic unconscious. During the late nineteenth and early twentieth century, Jung fortunately arrived at the doorsteps of these subtle regions of the psyche. Through heuristic research into his personal process of struggle, he descended deep into the interior imaginal world of the psyche. It was here, in the basement of his active imagination, that he could fall apart and rebuild from the wellspring of healing images that came to him (Jung, 2009). For Jung, and for us too, the arrival of inner images stimulates fundamental questions. What is their origin? From where do they come? And how can traditions such as yoga help us to surface answers?

As a young boy I caught glimpses of these questions the first time I saw Russian matryoshka dolls. Seeing these nesting dolls, one emerging from the other, I began to grasp that one reality could coexist as multiple, hidden realities, from the obvious to the subtle. The same concept was confirmed when a little older. As mentioned earlier, I spent a good deal of time at the beach staring at the ocean. The perpetual moving surface of waves and currents revealed an obvious view of the upper layers of the sea. But underneath the water's façade was a world I could barely grasp and only imagine. At around the same age, my haircuts took me to the neighborhood barbershop. While sitting in the chair I delighted in how the mirrors were positioned in such a way that they reflected infinite permutations of me looking at myself. Time became visual as I observed reflected spatial versions of an unlimited self. With the nesting dolls, my visits to the ocean and to the barbershop, it was clear to me as a boy that there were worlds I could intuit, but could not fully see. While somewhat cliché, these were important lessons.

Kuṇḍalinī-śakti, the Primordial *Spanda* Impulse, and the *Ātman-Brahman* Relationship

Later in life, I became steeped in a yoga tradition and lineage. There, I learned about the subtle ever-present *Kuṇḍalinī-śakti,* or primordial creative force. She emerges as the ultimate manifesting life pulse. She has a dynamic aspect, which is *spanda,* the essence and vibratory throb of creation (Singh, 1992). At the

Figure 1.3. *Spanda Impulse.* Original artwork by the author.

most fundamental level, art and the creative process are expressive manifestations of the nondual *spanda* pulse that is the *kuṇḍalinī-śakti*. Moreover, *spanda* is the primary, supremely intelligent force manifesting in the world of objects, perceived as cascading dualities, ripe for artistic investigation. The artist inquires into these diverse subjects by working through manifest forms back toward their subtle origins, a point implicit in Coomaraswamy's view of art as yoga. From the subtle to the manifest and the manifest back toward the subtle, art makes spiritual life visible.

Art as yoga and contemplative practice aims to align with the universal creative *spanda* force. The principles of creation become forms of supplication for venerating divinity and consequently arriving at states of contentment and serenity (Knight, 1987). *Enthios,* Greek for "the God within" (Ayto, 1990,

p. 203), is the etymological root of enthusiasm. Passion for creative and imaginative work supports inner and outer discovery of the many textures of *enthios*. To find our way, Mihaly Csikszentmihalyi (1997) emphasized that happiness is found through direct absorption with engaging experiences. Immersion in the moment will lead to focused attention whereby time stops, concentration increases, and action merges with awareness (Cooper, 1998).

Within this view of art and *enthios,* including purposeful engagement with materials, processes, and images, collaboration with the *spanda* pulse is inevitable. Art makes contemplative domains of *spanda* spatially and visibly accessible. Materials and processes help us to see space (and time), enter space, add space, subtract space, edit space, mix space, fill space, empty space, layer space, and infuse time with space.

Creating art and viewing creations made by others refines faculties of observing, examining, perceiving, scrutinizing, watching, and inspecting. Noticing with fine-tuned, panoramic awareness allows us to see the many textures of NOW and translate this awareness into artworks. Included in this translation process is awareness of the subtle *Ātman-Brahman* reality behind any manifestation.

Within Hindu-yoga traditions, *Brahman* is the name for the uncreated, unmanifest universal consciousness holding the unfolding cosmos. Described often as existing behind the behind, within the within, and hidden beyond the hidden ALL that is or eternally will ever be. *Brahman* is the ultimate source consciousness of the universe. *Ātman*, or the Self, is *Brahman* interiorized within the human heart and mind, as the individual Self-expression of the Universal Brahman. William Mahony (1998a) notes, "The World-Soul is identical to the sublime essence of the inner Self residing within all beings" (p. 165). Yoga is practicing our way to incremental degrees of reunification with this hidden, embodied divine relationship with the *Ātman*/Self.

The "mind in its conventional state is sedimented with various impurities," which obscure perception of this fundamental understanding of pure consciousness (Chapple, 1984, p. xiii). Sadly, the result is recycled pain. We continue to spin on the wheel of suffering until right understanding is established. As we will see in the upcoming chapters, combining art with yoga and meditation refines our knowledge of these repeated patterns. With the help of archetypal forces like the *śakti* (shakti) and her many manifestations such as qualities of the Goddess *Sarasvatī* (Saraswati)[2], we can literally create our way through and beyond patterns of anguish.

Creation and the Divine Mother

Śakti is synonymous with Devi or Goddess. She is that eternal and universal presence that manifests the entirety of creation. The heart of tantric practices,

she is the focus of ritual and worship. The etymological root *śak* (shak) means "to be capable of" (Muktananda, 1979, p. 20). This capacity refers to that aspect of consciousness that is active. This dynamic presence is the ultimate cause and change within the entire known and imagined universe. *Śakti* therefore is the ultimate muse for the artist to commune with during creative work. As Devi, she is transcendent; her ultimate, vast power includes her capacity to create, maintain, destroy, and absorb the cosmos (Khanna, 1979). She is also immanent and therefore alive in all beings (Pintchman, 2001). As the supreme Divine Mother, she has the power to manifest every conceivable possibility.

Blissful and wrathful, *Śakti,* as an amalgamation of her various forms, manifests and reabsorbs all things at all times, in all places. She has three main powers/*śakti*s that are important to recognize for artistic and contemplative work—*icchā* (will), *jñāna* (knowledge), and *kriyā* (action). While *Śiva* (Shiva) represents the vastness of the creators' reach, the blended combination of these three powers emancipates *Śakti's* energies to become the full "existence of created Being" (Jee,[3] 1988, p. 26). Additional material on this subject can be found in the section titled "Kashmir Shaivism and Art."

When the word *Śakti* is capitalized, it signifies the singular, ultimate Divine Feminine. In this form, she has no beginning or ending point. To worship her is to revere creation itself, offering adoration to the supreme creative principle. Divine Will, or *icchā Śakti,* coalesces in the creative act in order to feel, research, and manifest. It is through the motivation of will (not desire) that we initiate action. When intention is brought to this process, alignment with action becomes a willful act, even when working spontaneously. The intention to relax control and work in unstructured ways is still an act of will that can be mindfully witnessed.

Jñāna can be considered as emanating layers of manifest and latent intelligence and artwork is where this knowledge can materialize for contemplative investigation. We see ideas made visible in art through the expression of acquired skills and created work. The universal power behind all layers of this process is *Śakti's* complete freedom or *svātantrya,* which is the foundation of all creation. It is through *Śakti's svātantrya* that we can imagine anything, anytime, anywhere. As our free will, it is her autonomy inside of us come alive.

And then we act. *Kriyā* or power of action is the dynamic manifestation of will and knowledge and likely the most obvious expression of *Śakti* in art. Creative work is something we do to innovate, invent, and produce. Removing all pronouns like *we* and *I,* and sensing for a moment the subtle forces behind all gestures of our expressive work, we begin to see why the divine feminine force of *Śakti* is worshipped for the freedom she inspires.

One form of *Śakti* relevant for this discussion is *Sarasvatī,* the Goddess of wisdom, sacred speech, and the arts. She is a specific manifestation of

Figure 1.4. *Home for Sarasvatī*. Original artwork by the author.

the Divine Goddess, serving as the archetypal patron of wisdom communication, gracious thoughts, the arts, and fluidity of the creative spirit. *Sarasvatī's* name, which means "she who flows towards the Self," connects her to all that pours forth (Mahony, 1998a, p. 38). To invoke the muse of the *spanda* pulse and flow of imaginal processes through speech and imagination is to invite *Sarasvatī* to emerge as a guide on the journey of harnessing and unblocking the creative current.

2

Art as Contemplative Practice

Foundations

The word as, in art AS contemplative practice, denotes comparison and connecting emphasis between the words on either side of its placeholder. Simile also uses as to connect metaphoric relationships. Importantly, metaphor means seeing the similar in the dissimilar and in the context of this chapter, it is helpful to emphasize the connective, emblematic foundations of art AS contemplative practice. Subjects addressed are art as: consciousness, material culture, contemplation, beginner's mind, the art studio as sanctuary, and meditation. Many of these subjects are given cursory attention below while later on in subsequent chapters they are addressed in greater detail. I begin with art as the expression of consciousness since creative acts reveal the unfolding subjectivity of sentience and the self-referential, cascading textures of awareness.

Art as Consciousness Expressed

All art forms, including music, dance, poetry, and visual art, uniquely signify, express, and articulate human feeling. Susanne Langer (1951, 1953) noted that through the arts we subjectify objective information and objectify subjective personal experience. We create because we deeply feel and wish to artistically express the full range of human emotion.

Sentience, which relates to sensation, refers to the perception of subjective experience, including feeling. Through art, we give these feelings room to breathe in external art forms such as film and painting. Additionally, since consciousness is intimately connected to the subjects of yoga and art, it can be considered from at least three perspectives: depth psychology (conscious, preconscious, unconscious, collective unconscious, unity consciousness), the interiorized processes of discerning felt sentient states of awareness, and the

17

Indian context of the witnessing function of pure consciousness including the subjects of universal *Puruṣa* and the categories of the *Tattvas*.

The word *consciousness* consists of two Latin roots: *con* (together or with) and *scire* (to know). Together, both roots imply first-person subjective knowing through the reflective act of joining or being with. The study of consciousness focuses on engrossed, interconnected, felt properties of states of awareness. Direct sensory observation of these states can be further massaged by the processes of aesthetic encounter and responsive engagement, which are both indigenous to all art experiences. Consciousness studies have grappled with these wide-ranging topics when it comes to methods for studying introspective data (Weisberg, 2011).

Consciousness, taking form through art, implicitly invites knowing through activity/manifesting and reflecting/observing (Cane, 1951). When studying consciousness, questions emerge, such as, how are mental constructs similar to the concepts and objects they represent? Researchers note that concepts are "mental representations" like components of thought. Within this view, "concepts are to thoughts as words are to sentences" (Gennaro, 2007, p. 1). In terms of art, this quality of awareness implies that visual content is to thoughts as images are to graphic narratives.

Certainly, all of the arts could be explored in this book as ways to express awakened consciousness. In terms of music, Hindu Brahmins chant the Vedas.[1] Trappist monks sing their scriptures as a form of choral prayer. Sacred harp singing of visual shape notes is another form of group scriptural choral prayer. And then there is the Muezzin's call to prayer in Islam or the Cantor's chanting of the Jewish liturgy. Music and sound, cross-culturally, are intimately woven into prayer, worship, and daily practice.

Dance and movement, too, are part of this conversation. The Sufi Dervishes rhythmically turn their bodies to enter their Sema ceremony. In this movement prayer, awareness is altered in order to foster non-ordinary states of consciousness and join with the Divine. First acknowledging the physical realm they then spin and move toward spiritual dissolve of the ego, next merging with and into the Divine, followed by journeying back to the physical realm of action and service. In fact, the large hats worn by the Sufis represent a tomb for the ego.

Sacred geometry and architecture is still another subject ripe for investigation within the subject of consciousness and contemplative arts. When the Swiss-French architect Le Corbusier went to Turkey, he was deeply moved by the elementary, yet formal purity of the mosques in Istanbul. In these holy buildings, the square, cube, and sphere were gracefully used to communicate spaces that visually unified devotional faith (Kortan, 1991).

When personally visiting Turkey and entering the majestic *Hagia Sophia,* I could not help but wonder what it was like for people of this time to enter this magnificent structure. Most buildings of this era were earthen and small, while this soaring interior surely inspired architectural permission to believe in God. Throughout history, the arts have served as symbolic speech for the input and output of the senses, devotional expression, and inspired worship.

Art as Representation of Body, Speech, and Mind: Talent, Discipline, and Practice

When we engage with a person or an art-object, meticulous inner awareness of this "other" is essential. Therefore, we begin by becoming disciplined students of inward experiential observation. Promoting internal attention to "others" starts with mindful reflection on our own body, speech, and mind activity, which serve as the three initiating doors of all action (Sivaraksa, 2005). In addition to reflective observation, attentive discipline becomes refined as we intentionally concentrate on these three gateways of awareness.

From the mind, according to Sivaraksa, actions are expressed by way of the body or speech. It is through body, speech, and mind that we emotionally leak, ethically transgress, or rise above base impulses. Importantly, traditions like Buddhism and Yoga have methodically developed practices that integrate alertness to these areas (Wegela, 2009). Art too, as an awareness practice, helps orient us toward the qualities and textures of these three domains. Since the arts are considered communicative methods for working with human emotion, they offer a direct strategy for expressing and processing the content of body, speech, and mind narratives.

Body

Often taken for granted, yet serving as our most reliable feedback system, the body serves us in countless ways. It is through the body that we make contact with others, serve others, practice devotion, and manifest artworks. Tending to the body is its own lifelong practice. If we are listening, the body is feeding us information about inner systems and basic health.

We all have a body type, favored ways of dressing, and a health history. We embody the ethnic heritage passed down to us by our ancestors including their generational values. Through the gift of the body we hold and push a paintbrush, sense the world, feel reactions, and artistically respond. Creative work orients us deeply within the body. Or, art can show us how we become

dissociated from the body during moments of emotional detachment. What is disassociated can be reassociated through artwork by reengaging with fragmented story lines and piecing them together within imaginative compositions. Either way, if we are paying attention, art makes the actions of the body visible and relatable.

Speech

Pioneering art therapist Margaret Naumburg (1987) referred to art as symbolic speech. She felt that "objectified pictorialization" helped to make the unconscious conscious by softening the constraints of censorship so easily employed in habitual verbal speech (p. 2). Our words can harm or heal and so can our pictures or films. Like food, images enter us and immediately begin to work on the human nervous system. Artists bear significant responsibility as they put work out into the world. Anticipating how artworks speak to others is essential. So often this is not the case since people are primarily involved in their personal process which in and of itself is not wrong. But if the work is to be shown to others, then consideration of its effects becomes an ethical responsibility of the artist.

Mind

The art process externalizes the movements of the mind, immediately reflecting content back to us. We can literally see our thoughts emerge and take shape. This expressive process not only reproduces our current state of mind through the symbolic speech of art, it also reveals interconnected relationships. Central to Buddhist teaching is the notion of "dependent arising" which means the thought I am thinking right now is codependent with many known and unknown connections to other thoughts and experiences. Therefore, all phenomena are dependent on cause-effect connections (Rabten, 1999). Every mark made while drawing, whether we are aware of it or not, shows the relational influences of dependent arising. Learning to see aspects of the process in the product trains awareness of this interconnection. Art then is visible mindfulness in action.

Lastly, I would like to say something about talent. Most people feel they do not have it. And when asked what it is, they often define talent in terms of what they lack, saying things like, I cannot draw a face, a person, or even a straight line. Implicit in these comments is that they cannot make art that flawlessly looks like the thing they are observing. Those who can draw immaculate realism are thought of as talented people possessing magical skills. After years of teaching, I am certain that what looks like talent is really

the result of disciplined learning about materials, processes, and the desire to artistically say something. Talent is code for practice and practice is code for disciplined rehearsal, repetition, and training. It is the same for athletes and chess players. If willing to practice, people can learn to draw, paint, or shoot film and consequently experience shades of personal ability. Rather than fret about not having talent, the real question is, do you have discipline? Certainly for some, talent is an endowed something that is indefinable. For most of us, disciplined, persistent work with body, speech, and mind narratives will always yield impressive, art-based results.

Art and Yoga as States of Consciousness Revealed

Yoga posits various states of consciousness embedded within the human psyche. Through art we can aesthetically articulate information from the waking state, the dream state, the sleep state, and even the super-conscious state of *Samādhi* (Chaudhuri, 1975).

Waking experiences relate to the gross sensory level of consciousness. This is the world we experience when wakefully alert, as when concentrating on a model in a figure drawing class. When the waking state recedes, the dream state emerges. Access to unconscious material and imaginal subject matter from this state is available through dreams and creative processes such as Jung's active imagination, which is a means of intentionally softening conceptual control in order to stimulate internal imagery to emerge (Chodorow, 1997).

Furthermore, to make the unconscious material conscious through art implies relaxing defenses so that content from the dream state can emerge into awakened awareness. Ernst Kris's view of art as a way to regress in the service of the ego is an applicable example (Knafo, 2002; Kris, 1952). By consciously relaxing control of conceptual mind and habitual patterns, manageable regressions can occur where there is access to latent material.

The sleep state is even subtler, behind the waking and dream states. This is the refined territory of undifferentiated spatial emptiness where the potential of formless expanse exists. Closely guided meditative practices geared toward accessing these subtle states reveal refined qualities of our interior dimensionality. Lastly, the superconscious textures of *Samādhi* are beyond temporal definitions. Nondual, pure witness consciousness-awareness emerges revealing limitless transcendence and interconnectedness (Chaudhuri, 1975; Feuerstein, 2001, 2003). Disciplined practice, mentored by an awakened teacher, cultivates understanding and eventual identification with the profundity of these states including the pure awareness of *Puruṣa* within us that is "free of cause and effect," existing "beyond time," and is never ending (Hartranft, 2003 p. xi).

Rare yet available, we can touch and even directly know these variant states of consciousness.

Depth Psychology

The psychoanalytic typography of the human psyche consists of the unconscious (material that is out of awareness), the preconscious (out of awareness but accessible), and conscious awareness (knowingly accessible). Often illustrated as an iceberg, what is seen above the waterline is knowable. Below the waterline, where the bulk of the ice exists, there is much that is beyond our wakeful understanding. Jungian views further expand the notion of the unconscious by articulating a fascinating collective element in addition to the personal unconscious. Within this model of the psyche are shadowed elements, potent complexes, and archetypal forms expressing universal qualities within an individual's personality. For Jung and Berry, psyche is image and working with and through images can develop greater conscious awareness (Berry, 1982, p. 73; Jung, 1961/1989).

Overall, a significant goal of the depth psychologies, which includes Jungian and Freudian perspectives, is to make the unconscious conscious by bringing disowned traits of the personality into awareness and willingly applying these insights toward livable changes. This process is significantly aided by dreams and artwork. Nocturnal stories emanating from deep sleep offer a way to observe the workings of the psyche's unconscious. Dreams have a tendency to send up compensatory, yet veiled symbolic messages about an out-of-balance lifestyle (Harding, 1961). Artworks like those created by the early Surrealists intentionally try to create from unconscious inspiration. Aside from their content, visual symbols and images are the fundamental language of the psyche's unconscious material.

Discerning Felt Qualities within States of Awareness

From a Eurocentric perspective, consciousness is understood from a monophasic point of view, particularly the waking state. Other states, such as sleep and drug and alcohol use, are also part of the Western monophasic worldview. Sadly, our culture often uses illicit substances to numb rather than awaken.

Accessing polyphasic, or multiple states of consciousness beyond consensus reality is common in other cultures. We know about these various examples of consciousness through anthropological studies of aboriginal wisdom traditions (Walsh & Shapiro, 2006). Meditation, dance, vision quests, fasting, and totem/deity personification are gateway practices for expansion of consciousness. It is no accident that indigenous art from Africa influenced early European modernists to break from the academy in order to bend and

twist consensus reality in their artwork. Cubism shattered the one-pointed, straight-on gaze between artist and subject. Multiple perspectives on a flat surface could be shown at once as a way to redefine previous views held in the art world of that time.

Whichever way we consider these various perspectives, consciousness is emergent awareness that can be known through contemplative methods of exploration. To sit and suppose our thoughts and then move them into artworks is consciousness emanating from essence toward conceptualization and then taking form as a painting, song, or poem for further self-reflection. Although what we know best is the conceptual level of awareness, ideas and therefore artworks are always layered configurations of consciousness taking form.

Creating art about these phenomena engages perception, organizing, and finally cognizing concepts into tangible objects. The world appears to us because fundamentally "there is an essential identity between consciousness and the object perceived," which allows us to have a direct experience of something (Dyczkowski, 1987, p. 47). To observe and translate experiences into art is to see consciousness made physically visible. When creating or looking at an object through the filter of attention we perceive an inner reflection of the observed outer event. But who within is doing the seeing? Behind all scientific constructs of how human perception works must be the Observer of the observer.

Contemplative practices tooled for spiritual transformation, such as art and yoga, cultivate "mystical absorption" (Hewitt, 1977, p. 389) in our awakened awareness of this inner observer or witness. Various techniques for balancing mind with body, spirit, and culture reveals knowledge of this interior witness which is the elemental nature of pure awareness.

Universal Consciousness and the *Tattvas*

Originally published in 1901, Richard Bucke conceived a model of consciousness consisting of three stages. First was simple consciousness inherent in segments of the animal kingdom such as mammals. Second was conscious self-awareness, which includes language, logic, and imagination, yielding access to self-reflection of inner psychological states. Third was cosmic consciousness and here and now awareness of elevated, awakened illumination of interconnections, including understanding of disembodied immortality. This subject of cosmic consciousness, which in fragments he thought about as a boy, at age thirty-six was directly experienced. After an evening with friends reading the poetry of Wordsworth, Shelley, Keats, and particularly Whitman, while heading home he found himself deeply absorbed in the poetic imagery inspired by these authors. In a state of quiet "passive enjoyment," he had a seconds-long experience of being "wrapped around a flame colored cloud," a light that he

realized was within himself (Bucke, 1923, p. 9). Beyond words, he felt great joy and "intellectual illumination" as "Brahmic Splendor" folded into the realization of the soul's immortality (p. 10). Bucke writes that he realized more during these seconds than all previous experiences in his life combined. His account of this moment describes a classic *Śaktipāta* (Shaktipat) experience, which is the descent of Grace and resulting realization of suffused inner Divinity, often received through transmission from an awakened teacher, or in this example, it was poetry, which allowed him to enter nondual, *Samādhi* awareness.

Certainly predisposed throughout his life to lean toward mystical knowledge, what I find meaningful in Bucke's account is its direct connection to poetic illumination. In this example, an art form tenderized his psyche to move beyond limiting ego identifications by facilitating penetration into awakened knowledge of something grander. It is this topic of art as a pathway to the Self that is discussed next.

Beginning with cosmic, nondual universal consciousness the one supreme, intelligent essence, or *Puruṣa,* becomes the endless multiplicities of *Prakṛti* (Prakriti). This eternal circulating creative presence unfolds the timeless cosmos. Imagining paintings from unrealized germinating ideas to completed creations is a microcosm of this surging vital force. From this perspective, creative acts are emanations of formless, nondual consciousness rising through layers of awareness to become formed expressions.

Emerging from nondual expansive potential, the Absolute becomes many. Subtle and solid elemental qualities, known as the *tattvas,* materialize as "levels of reality" (Wallis, 2012, p. 125). Each *tattva,* or principle of "that-ness" or "such-ness," describes the bidirectional process of manifestation—from the nondual to dualistic multiplicities and from dualistic diversity back toward the Absolute, *Paramaśiva* (Paramashiva). In *Sāṅkhya* (Samkhya)[2] philosophy there are twenty-four *tattvas* and in *Shaivism* there are thirty-six (Jee, 1988).

The arts can be viewed as an amalgamation of the *tattvas.* These subtle and solid components of creation are found in the most tangible earthly elements that proceed to subtler and subtler elemental qualities until reaching the finest of *Paramaśiva* (Jee, 1988). Through the *tattvas,* or the various solid and subtle elements of an artwork, the one unifying consciousness is multiplied. Moving from the nondual moment of the *spanda* impulse, to subtle states of awareness seeking expression, to intentional efforts to manifest tangible creations through the material qualities of the *guṇas,*[3] the senses, the five rudimentary elements, and the five gross elements, an artwork is born.

A lovely illustration that helps to conceptualize the yogi's understanding of the *tattvas* can be seen in *"Three Aspects of the Absolute folio 1"* from the *Nath Charit,* a nineteenth-century manuscript illustrated with enlightening imagery. From 1803 to 1843, the court of Mahārāja Man Singh of Jodhpur supported the *Nātha* (Nath) order of yoga practitioners. Devotedly, the *Nāthas*

Table 2.1. Outlining the *Tattvas* (Categories of "That-ness")

Kashmir Shaivism, the focus of the chart below, defines thirty-six *tattvas*. Top down represents the descending, progressive order of creation. Bottom up represents the path of liberation of return to source. (Jee, 1988; Muktananda, 1979; Wallis, 2012)		
		Art-Based Connections
Absolute Nondual Reality = *Paramaśiva*		
I.		The first five *tattvas* from the *Śiva tattva* to the *Śuddha Vidyā tattva* are called the pure, absolute *tattvas*. They represent gradations of universal, ultimate reality.
1. *Śiva tattva* (transcendental light of consciousness, Being)	Eternal and mutually	
2. *Śakti tattva* (power of reflective self-awareness)	inseparable realities	
II.		Beyond and behind ego, this is the unseen creative spark preceding all conceptual ideas—the nondual, precognitive moment in artwork of complete freedom where consciousness, as awareness, imagines itself becoming.
3. *Sadākhya* or *Sadāśiva* (Sadashiva) *tattva* (*icchā śakti*—power of will)	The three purely ideal states of manifestation	
4. *Īśvara*[1] (Ishvara) *tattva* (*jñāna śakti*—power of knowing)		
5. *Śuddha* (Shuddha) *Vidyā* or *Sad Vidyā tattva* (*kriyā śakti*—power of action)		
III.		The six *tattvas* from *Māyā* up to *Niyati* are called the pure-impure, cloaking, and psychical *tattvas*. Mixing into the creative process is the subtle presence of various freedoms and limits within the illusions of desire, time, and causality. Inner vision in the creative process: this is where awareness as emerging insight surfaces.
6. *Māyā* (illusion within individuality)	The differentiating power. 6–11 are the six *kāñcukas* (kanchukas) or limiting powers of *Māyā* or illusion.	
7. *Kalā* (limited authorship or agency found in creativity)		
8. *Vidyā* (limitations of knowledge)		
9. *Rāga* (limitations of desire, craving, attachment)		
10. *Kāla* (limitations of temporal time)		
11. *Niyati* (limitations of causality, space, form)		

1. Manifested inner divine awareness, Divine Presence/Inner Ruler.

continued on next page

Table 2.1. Continued.

IV.		
12. **Puruṣa** (individual consciousness, ego and subjectivity)	The subjective manifestation. The limited individual soul with its fivefold limitations.	
V.		
13. **Prakṛti** (power of manifestation and all forms of Nature)	The objective manifestation with the three *guṇas*: *sattva, rajas,* and *tamas* and its constituents.	The physicality and properties of material culture, and all of nature, which can be experimented with through art materials and processes.
VI.		
14. **Buddhi** (intelligence, intellect)	The three psychic faculties.	The aiming of "I-ness" in the creative process: manifesting and sensing one's way into the work with materials, processes, and products. Where art becomes ownership and doership.
15. **Ahaṅkāra** (Ahamkara) (I—maker, ego and objectivity)		
16. **Manas** (mind, attention, and sense processing)		
VII.		
17. **Śrotra** (organ for hearing)	The power of hearing.	The five senses of perception. Engaging the senses in the creative process including awareness of sensory pathways both inward and outward as gateways for knowing and inspiration.
18. **Tvac** (organ for touch)	The power of feeling by touch.	
19. **Cakṣu** (Chakshu, organ for seeing)	The power of seeing.	
20. **Rasana** (organ for tasting)	The power of tasting.	
21. **Ghrāṇa** (organ for smell)	The power of smelling.	

would engage in transformational practices to merge the physical body with the shimmering luminosity of the Absolute. Although imagery of the nondual Supreme is usually not represented in art, below we see a golden atmosphere

VIII.		
22. *Vāk* (speech)	The power of speaking.	The five organs of action. Art as language and communication. The sensuality of full body engagement in the creative process—making space, time, culture, and emotional liveliness visible. Taking in and releasing creative output.
23. *Pāṇi* (hand)	The power of grasping or handling.	
24. *Pāda* (foot)	The power of locomotion.	
25. *Pāyu* (excretion)	The power of excretion.	
26. *Upastha* (creative)	The power of procreation and sexual enjoyment.	
IX.		
27. *Śabda* (Shabda) *Tanmātra*	Sound	The five rudimentary elements. Encountering and working with materials and processes through qualities like sound and tactile engagement. Odors emerging from paint, the feel of the materials are experienced here.
28. *Sparśa* (Sparsha) *Tanmātra*	Touch	
29. *Rūpa Tanmātra*	Form, color-appearance	
30. *Rasa Tanmātra*	Flavor, taste	
31. *Gandha Tanmātra*	Odor, smell	
X.		
32. *Ākāśa* (Akasha)	Ethereality-space	The five gross elements. Collaborating with the five elements through materials and processes. For example, clay pots materialize space by working with wet earth; when dry and placed in fire, clay emerges hardened like stone, elegantly telling a story of transformation.
33. *Vāyu*	Aeriality-wind	
34. *Agni* or *Tejas*	Fire	
35. *Āpa* (Ap) or *Jala*	Liquidity-water.	
36. *Pṛthvī* (Prithvi)	Earth-solidity.	

representing this all-pervasive reality. In the second panel, a yogi hovers in this golden ambiance. And in the third frame, the yogi sits on a sparse, physical landscape as if to at once reveal connection to the subtle and manifest realms (Diamond, 2013).

Seeing this actual triptych displayed in a museum, especially the first panel, reminded me of the artistic experiments of reducing form into essence

Figure 2.1. *Three Aspects of the Absolute.* Page 1 from a manuscript of the Nath Charit, 1823, by Bulaki. India. Opaque watercolor, gold, and tin alloy on paper. Permission granted from the Mehrangarh Museum Trust.

pioneered in the work of Kandinsky, Malevich, af Klint, and others to be discussed in chapter 3.

Art as Material Worship

The ancients of the planet found the building materials they needed from the environment. Berries and select plants were used for dyes. Pigments were ground from colored sands, rocks, and minerals. Trees became fuel, wood for homes, weapons, tools, and ritual objects such as masks. Rocks were formed into enduring circles found in places like Avebury and Stonehenge in the United Kingdom. Clay became functional objects like pots as well as totem amulets. Earthen materials were alive and therefore so were the many results of their application.

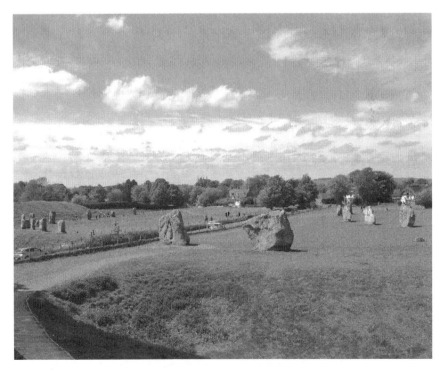

Figure 2.2. Avebury, UK. Photograph by the author.

Equator-based sun cultures are surrounded by exotic flowers and animals. Their natural landscape beckons collaboration with nature's palette. Approximating these lush colors and forms from the immediate environment stimulates the senses to respond back to the abundance that surrounds and sustains.

Presently, the ecology movement awakened awareness of interconnections between all living systems on our planet. There is a complex chain of relationships permeating the numerous biological systems that support the miracle of life. Paying attention to these systems, how they intersect, support, undo, and unite each other can be easily lost in a culture steeped in consumerism.

Therefore, the ecological movement has taught that all phenomena is connected or co-arising, not only within sophisticated ecosystems, but also within the chain of manufactured and consumed objects. There was a time not long ago when the connection to resources and daily consumption of those resources was more easily observed. Much of what was needed was gathered from the environment, tooled, and used. Although this is a simplified account, before the Industrial Revolution connections to resources and their many uses were not as complicated as today. And, this view cuts both ways. Materials were often used that were highly polluting, such as processes to mine gold. The results of such practices were devastating to the environment. However, when connections were simple, participation in the wisdom of ecological thanksgiving was perceptible and familiar. Meat eaters saw into the eyes of the animal they were about to slaughter. To subsist with values like this reminds us that Divinity is systemic and always nearby in the other.

Likewise, art materials are part of *prakṛti's*[4] great chain of interconnection and created products are *prakṛti* as well. Therefore, material culture originates from the vast totality of nature's potential. It follows, then, that the dimensionality of *prakṛti* can be uniquely researched through art media and processes of manifestation.

Additionally, each material contains its own extensive language around process and possibility. Learning the grammar and vocabulary of clay, charcoal, film, or bronze takes time. Literally like becoming fluent in a foreign language, materials represent the complex speech of *prakṛti*. Collaborative engagement with the communicative possibilities of art materials supports intuitive understanding of this language.

Most people intimidated by art simply do not know or understand the nature of materials. Decades of experience as an art educator and art therapist have shown me that I am obligated to teach the basics of each material. Before creating content, it helps to know how the materials work. The first goal is to become conversational rather than fluent with art media. Learning fundamental phrases unique to each material can mitigate their unfamiliar, intimidating nature. Once the basics are learned, becoming fluent is always an ideal option.

For this and other reasons, I prefer clay. While I have heard people say over and over that they can't draw, I have never heard anyone say they cannot clay. Below are two examples of the eloquence of clay and how it can materialize unfathomable possibilities, from palatial homes to mending the deepest grief.

Outside of Villa del Leyva in Colombia, South America, is a house made out of 100 percent clay. Also known as the Terracotta House, all of the clay materials used to build the house came directly from the property. Built by architect Octavio Mendoza, this enormous clay house is perhaps the largest piece of pottery in the world.

The second example recalls a time when I was a college student studying with M. C. Richards. At the time of our meeting, her book *The Crossing Point* (1973) had recently been published. She repeatedly referred to this primary metaphor in her teaching since it eloquently held the wisdom of opposites between above and below, light and dark. In soil, she would tell us, is a place of crossing where above a certain microscopic point plants reach for the light. Below this subtle point, plants set down roots that grow into moist darkness.

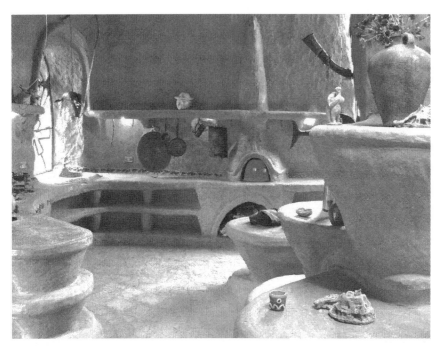

Figure 2.3. Interior—Terracotta House, Villa del Leyva, Columbia. Photograph by the author.

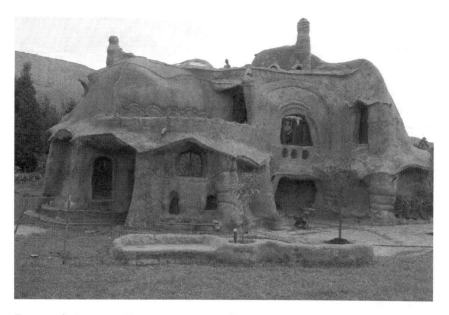

Figure 2.4. Exterior—Terracotta House, Villa del Leyva, Columbia. Photograph by the author.

So it goes for us, too. Our feet touch the earth while our crowns point upward. We have unconscious shadow material to address and well-lit goals to pursue. In order to be whole, we need to grow in both directions.

Concerning art materials, M. C. taught that clay was alive with limits of resistance. She told us that we were not forming pots only; we were also forming ourselves. Clay can be pulled or stretched only so far before collapsing. To know that edge just before the clay crumples teaches us to know when to rest, stop, or reverse strategy in life. It is the point where opposition lives and where we come to know the paradox of willingness and holding back.

Over and over, clay has taught me important lessons. For example, when my mother died, I tried to be as involved as possible with her dying process and eventual death. She had delivered me into this world—I wanted to help birth her out of her tired body. Like a long labor, her release was an arduous process.

The call from the hospital came very early in the morning, alerting me that her breathing patterns had shifted, signaling that her final exhale was near. I quickly dressed, arriving at the hospital ten minutes after she had passed, thankful that the cold had not yet set in. As I stroked her hair, she still felt the same, warm and sweet. She was gone from her body, the soul released.

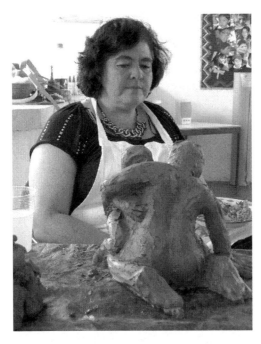

Figure 2.5. Clay workshop, Villa del Leyva, Columbia. Photograph by the author.

A few days later, at the funeral, the director of the chapel called me aside to view the body in order to confirm that it was her in the coffin. In the Jewish tradition, we do not view the body before the burial. Yet, there was a chapel policy to confirm that it was indeed her. Together we stepped into the next room, which was empty except for the casket. Seeing the lifeless image of my mother before me was not easy. She was nicely dressed and her hair tolerably combed, yet she also looked like an artificial version of herself. I felt cautious as I approached, knowing that I wanted to kiss her cheek one last time. And yet I heard a strong inner voice advise me not to make contact. I disobeyed this assertive intuition and leaned in to kiss her one last time. As soon as I did, the icy chill of her skin assaulted my earlier memory in her hospital room. Then, she still felt warm and familiar. In this moment of my final goodbye, the two sensations of warmth and chill, life and loss, collided. I literally needed to spit out the coldness that intruded. A few months later, I was conducting a workshop and had an unexpected experience. To me, clay has always felt like cold skin. All of a sudden, while working, I was transported back to the scene of my mother in her coffin. I heard the same voice that previously told me not to kiss my mother's cheek now tell me to kiss the clay.

I did. This time I was prepared and ready to feel the chill against my lips. Yet without realizing it, the warmth of my hands had slowly heated up the cold clay. As has happened so many times before, the clay with its innate wisdom helped me to find resolution. The warmed clay body allowed me to transform my intrusive memory of cold skin into a new, reclaimed positive memory.

Art materials teach different kinds of listening skills such as tactile sensitivity, sensory attunement, systemic awareness, and how forming them transforms us. Art, as contemplative practice, is intimately tied to engagement with materials. Simply, it is easier to know myself when my actions are shown back to me from the responding materials (Erikson, 1979).

Material culture provides an innovative way to think about media, processes, and objects. Broadly defined, material culture refers to "any and all human-constructed or human-mediated objects, forms, or expressions, manifested consciously or unconsciously through culturally acquired behaviors" (Bolin & Blandy, 2003, p. 249). Humanly created items are evidence of manifested consciousness and therefore inspire curiosity to understand the time and place from which the work originated.

Art as Contemplation

Etymologically, *to contemplate* means to observe with reverent attention in the sacred environment of a temple (Ayto, 1990). Earlier definitions were concerned with the observation of omens realized while gazing with attentive awareness. Additionally, the Latin roots *con-templum* refer to observational practices used to reveal realities within a revered two- or three-dimensional space. The result of this form of vision is true insight or the capacity to see "things as they really are" which is the meaning of *contemplari* (Mahony, 1998b, p. 57).

Combining the root meanings of concentrated awareness within the sanctified environment of a temple raises several questions. First, where is the actual location of this temple and what sort of vision is needed to access contemplative space? Is the temple within the innermost transcendental nondual Self? Or does it refer to an actual holy site like a place of spiritual pilgrimage? Or, could it be that this "temple" is a seamless spectrum where immanent personal and transcendental realities are revealed through introspective revelation? Finally, how do we train ourselves through contemplative practices to participate in inner life and outer surroundings with focused attention, regardless of whether we are in an architectural temple, nature, a studio, or a noisy urban setting? Essentially, contemplative experiences can emerge anytime, anywhere, such as during a silent meditation retreat, a crisis, or while doing civically engaged work. Overall, the sanctuary of contemplative insight can be found by slowing down, honing attention, and remaining present without judgment.

Since the words *temple* and *contemplate* have similar origins, attentive perception can invite the sacred to emerge as direct experience to be observed and pondered. The practitioner absorbs such an experience, and conversely, the practitioner is absorbed by what is being contemplated. The conduit for this exchange is image.

According to James Hillman (1978) and imaginal psychology (Marlan, 2012), image is not the retinal event of perceiving an object. Seeing a lawnmower is different from the *image* of a lawnmower. Image is the implicit narrative that lives within the object that is perceived or experienced. It consists of "mood, context, and scene," which together constitute the imaginal narrative to explore through art (p. 159). The freedom to imagine is referred to by Patricia Berry (1982) as the complete democracy implicit within the image. Engaging freely with the simultaneous mood, context, and scene contained within an image unfurls its expressive sovereignty. Images are emissaries calling to us. In the spirit of true collaboration, a dialogue unfolds between artist, image, and the materials. To contemplate, then, refers to direct, fully engaged absorption of meaningful, imaginal experiences. It is the opposite of mindless wandering. All stages of an art process can invite sacred pilgrimage into absorbed states of mind from first-person, second-person, and third-person inquiry to extreme states of mind such as those broken open by a crisis or mental illness.

Artistic work invites careful observation of internal phenomena while focusing on external subject matter (landscape) and processes (use of materials). The artist, as well as the viewers of artworks who intentionally hold a curious, reverent orientation, can access deep aesthetic experiences that awaken numinous revelation.

The word *aesthetic* is used here to refer to the joyful contentment of clear perception emerging from deep appreciation for what is, as it is. When approached with admiration, the entire spectrum of life reveals appreciation for **as is** truth. Life elegantly and defiantly creates and devours itself. Some beauty reveals shadowed, unpleasant reality. Decomposing life in its ordinary process of dissolve candidly reflects cycles of living and dying. Ugliness can hide in beauty too. Many examples of impressive architecture are valued as masterpieces, yet they were built by slave labor. Cruelty is mixed into the mortar that holds these celebrated bricks in place.

In order to develop clear observational awareness, we cultivate perceptual discipline for meeting and appreciating encounters with each unfolding moment of creation. Aesthetic experiences have unusual power to awaken awareness, especially when it comes to the senses. A rare sunset, the birth of a baby, or transparent sections of a solid marble sculpture can transport us into sensory awe and humility.

Impressionist painters approached their work like this with mindful, sensorial attention. With penetrating observation, they swiftly rendered the

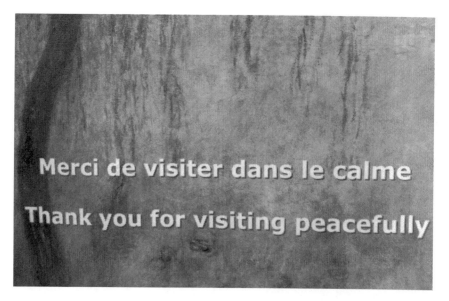

Figure 2.6. Sign outside Monet installation, *Musée de l'Orangerie*: "Thank you for visiting peacefully." Photograph by the author.

fleeting subtleties of light-bathed surfaces, filling their canvases with transitory moments of weather and luminosity. These quick, precise, responsive brushstrokes required mindfulness of the moment. Specifically, they minimized wandering attention, and intently focused on surfaces of passing light. Monet spent the last two decades of his life at his home in Giverny. There he painted and repainted his lovely gardens, including the lily pad pond. Eventually, he left the sky out of his work and concentrated on water and how it holds reflection. Not unlike how mind receives thought, water receiving mirrored trees and flowers gently reaffirms the astute contemplative silence of surface and reflection.

As one exits the Musée de l'Orengerie gallery in Paris that features his water lily paintings, there is a sign that reads, "Thank you for visiting peacefully." The gallery where these massive paintings are showcased is unusually silent for a public space. Visitors innately recognize the invitation to feel calm and soothed as they are transported into a contemplative state of silence and beauty, which is what Monet intended.

The Art Studio as Sanctuary

Entering a holy shrine such as a temple, mosque, or church can feel like walking into the holy body of the Divine. These intentional environments are

designed to invite awe and silence. Marked by threshold space, the intensity of access is heightened by crossing over and into. For this reason, we are encouraged to bring an offering or make a donation as a way to give something up in order to make room for waiting blessings. Once inside, we join with the various interior objects and symbols that beckon us to participate in ritual and practice. Leaving is also part of the experience as we internally cement what was received. Once outside, the modern world intrudes. It is easy to leak our prayerful state as our stillness is replaced with phone calls and car traffic. Holding and nurturing what was received is part of the practice.

What happens, then, when we enter the studio and how do we intentionally design these work spaces? Understandably, in schools and community settings, studios are educational environments, not places for worship. However, all interior environments are most welcoming when thoughtfully designed. The entrance, layout, sensory elements like sound and light, storage, work area, and wall space for showing work are all important. The physicality of the studio exudes the invitation to create. This means messes are expected, mistakes are anticipated, and the textures between silence and sound become familiar auditory landscape.

The studio at Naropa University serves students and community members. In order to outline simple intentions for respectfully attending, I wrote up a short document called "*Studio Dharma*":

Figure 2.7. Naropa Community Art Studio. Photograph by the author.

Table 2.2. Studio *Dharma*

STUDIO *DHARMA*
1. Treat the art materials the way you would treat good food—taste with curiosity, consume with awareness, and try not to waste. Take what is needed and return for more.
2. When walking into the studio consider that you are walking into a sanctuary to practice relationship with process, product, self, and other.
3. Engage/respond to others and their work with curiosity—practice skillful visual and verbal speech.
4. Own projections when looking and talking about artwork.
5. When finished, clean up and leave the space in a way that welcomes the next visitors.

The studio is a place of invitation, refuge for some, and creative work. Like a laboratory for experimentation, visitors are encouraged to push the edges of their curiosity. Exploring thoughts, wishes, and dreams through art concretizes vanishing ideas.

Art as Healing and Beginner's Mind Practice

Archeologists reconstruct the content of ancient civilizations through excavated artifacts. Each found object offers an opportunity to reconstruct what was culturally true for this buried civilization. Humans make objects that easily outlive their own temporary physical forms. These objects are imbedded with intentions that—to this day—live within the ancient object. When these artifacts or *art-facts*, are found, they inspire teams of researchers to decipher their purpose and meaning. Although these dormant objects seem lifeless, they call together members of the scientific community to study their significance. How can a still, silent, lifeless ancient object stir so much interest? Part of this question can be answered by considering that the imagery is alive with a particular form of imbedded narrative memory. As material evidence of culture, the object tangibly conveys information that stimulates scientific curiosity. Patiently waiting, information is revealed to those who listen with the mind of a beginner, considering points of view intrinsic to the ancient object or art-fact.

Beginner's mind, or original mind in Zen, is called *shoshin*. This quality of mind is an unbounded, attainable mentality. From this orientation, we freely approach new opportunity without agenda or self-imposed limitations. And,

this is easier to say than to do since the mind is difficult to define. Daniel Siegel (2010), an accomplished neuroscientist and meditation practitioner, worked with a team of colleagues to come up with an agreeable definition of mind. The results boiled down to mind as "an embodied and relational process that regulates the flow of energy and information" (p. 25). Mindsight, according to Siegel, is a triadic set of lenses called "triception" focusing on "openness, objectivity, and observation." Together, this coordinated tripod of mind results in beginner's clarity of inner observation (p. xxi).

The aim of original mind is to receive and participate in life events with openness, objectivity, and observant focus. Meeting each unfurling moment with fresh eyes rather than self-conscious arrogance or defeatist beliefs supports triadic clarity. Accomplishing this state is difficult. Sigmund Freud and his daughter Anna Freud (1937/1978) noticed that to associate freely to an experiential event meant that the urge to criticize had to relax. Derivatives of dreams or fantasies were best served if not judged or resisted. Toward this end, ego is trained to loosen up and quiet itself in order to refrain "from criticizing the associations" (p. 12). Relatedly, the mind of the beginner playfully opens to receive and engage.

According to Shunryu Suzuki (1999), dropping thoughts of attainment, attachment, and critical self-obsession paves a way toward a compassionate, unfettered mind. The goal is to be receptive to what is freshly emerging. Seeing the familiar for the first time requires resetting habitual patterns. One way to disrupt habit is to turn the phrase "beginner's mind" into other derivatives such as "the mindfulness of the beginner," or "minding what is beginning," or "beginner's mindfulness."

My longest running daily experience of beginner's mind is with my dog, Lily. The interspecies communication that occurs between us is an ongoing, mysterious daily koan. Mostly, she sends me silent signals in dog and I try my best to receive her messages. As she makes contact and I engage back, I quietly wonder about our relational exchange. Every day there are moments when my heart warms as I spend time with her and her version of sentience loves me back. I puzzle over the simplicity of it all and strive to drop the riddles of my researcher mind and just be with her version of embodied presence. It is during these moments that I enter the place of beginner as she teaches me about her way of being in the world.

In the nanoseconds between sleep and waking, just before eyes open, there is no conceptual traffic. Once up, the lists for the day rush in and fill the space of this open emptiness. In his essay "Sip My Ocean," Mark Epstein (2004) spoke to this point by lining up relationships between psychoanalysis, Buddhism, meditation, and art. The point of connection is "bare attention" also referred to as "naked attention" (p. 31). This quality of noticing is defined

Figure 2.8. Lily. Photograph by the author.

as a clear, discerning, aware mind receptively open to what is occurring during the ever-shifting moments of perceiving. The meditator, like the artist and psychoanalyst/therapist, strives for open awareness of what is manifesting in the moment.

Between thought and action are gap spaces to be noticed. One way to develop attention to thoughtful pausing is through meditation. Illustrated best by the subtle areas between the front end of inhaling, the moment before exhaling, and the pause just before inhaling again are subtle, silent, and surprisingly spacious gaps. Placing awareness in these openings expands the sensation of inner space, thus widening the terrain between thought and action.

Curiously, when waiting for trains in London's Tube, a recorded woman's voice comes over the loudspeaker at every station and asks everyone to MIND THE GAP (between platform and train). The first time I heard this I thought to myself, throughout the entire Tube system, people are receiving regular meditation instruction! There is always space between thought and action, figure and ground, inhale and exhale. Bare attention is gap space and therefore empty

potential space void of agenda. Out of this emptiness springs opportunity, as with my silent moments with Lily. Receptively opening to what is emerging by discouraging opinionated judgments is the goal.

Beginner's mind is needed when plagued by perceptions of failure. Disappointment challenges our emotional stability. We live in a success-driven culture where ownership of property and material goods defines our worth. The sad truth is that attachments to amassing wealth and stockpiling possessions rarely fill the hollowness of personal emptiness. Beginner's mind trains us to keep intrinsically focused. When working with hospitalized teenagers in psychiatric facilities, I observed the benefits of helping them to see their capacity for altruistic behavior. When they realized their ability to do good deeds in the world, the future held believable opportunity for relational success. This was always the subtext to my interventions—to realize personal capacities for compassionate action.

During my first art therapy job in 1981, I worked in a special education school for kids with behavior problems. New to the position, I made it a practice to observe the kids when they first arrived each morning. Many were brought to school by their grandparents. The exchanges between them were tender and loving, yet once the school day began, the behavior problems appeared. From my observations I created an intergenerational project where I took the students to a nursing home, paired them with an elder, and had them interview each other week after week. The simple goal was to make contact, remain curious about their aging partner, and show that they cared. I was teaching photography so I integrated this into the interview process. The students would photograph the residents, print the images in our darkroom, and return the next week with pictures to offer as gifts. Many of these kids viewed their futures in bleak terms. The best I could do was help to wake up their capacities for altruism, repeatedly anchor their sensations of compassion, and help foster their intrinsic belief in a believable future. The results were stunning, as these students had tangible samples of who they could be beyond their believed limitations. Additional details related to this story are addressed in chapter 8.

In terms of art and healing, the creative process usually unfolds in silence, and it is in silence that we hear ourselves sending and receiving messages. Art materials and corresponding processes are the silent therapeutic mirror, for example, reflecting moments of artistic disintegration and integration. Sustained attention within the silence of tempestuous inner events, when moved into longer-term art projects, supports an enduring capacity to become self-assured while alone with conflict (Allen, 1992). Listening at this level to the intimate microbursts of information is the beginning of personal healing. In such cases we learn to care for the splendor of silence by preserving its sustaining eloquence through the art process.

Materials, and how they slow us down in order to relish silence, insist that we wait for the initiated process to cycle through. This alone provides a healing result as artists learn to embrace the content of any process. Animation or video requires repetitively working with programs in the service of manifesting subject matter. The progression of clay work moves from wet and malleable to bone dry to fired solidity to hardened independent product. This process cannot be rushed. And if it is, consequences such as explosions in the kiln remind us to mindfully sequence through the inherent temporal processes of the material.

Art as Practice

Practice can be absorbed engagement, reflective observation, or mindful rehearsal. We thoughtfully aim our awareness, inwardly or outwardly, toward a purpose and then do something about it. By identifying and directing our will, we initiate effort to put something into practice. There is intention, drive, and commitment behind the pursuit, which makes the process and results replete with meaningful outcomes. It is no accident that phrases like "practice makes perfect" or "practice what you preach" or "walk your talk" or "we are judged by what we do, not by what we say" are so popular in daily parlance. As with contemplation, we skillfully prepare by setting an intention before initiating action. For example, an intentional goal for contemplative practice is remembering to remember, without judgment, to gently hold open moment-to-moment awareness. Furthermore, awareness practices such as art and meditation invite the metaphoric perspectives of aerial, panoramic, and focused awareness in order to cultivate wakeful absorption within self-reflection (Speeth, 1982).

While we receive the world through the senses, we can also become distracted by overstimulating seductive sensory diversions. We therefore need practice-based strategies such as art combined with yoga and meditation to redirect awareness. Together, these practices aim to attune channels of expression with mindful reflection. In fact, expression without its counterbalance of mindfulness creates uneven knowing and perceiving, especially in the arts. Maintaining equilibrium between activity and receptivity (Cane, 1951), or doing with reflecting (Rubin, 1984), nurtures an inner environment of contemplative homeostasis. Over the years I have attended many workshops where expression was the goal, yet self-observation was not encouraged.

Dispassionately turning our attention inward, toward its source, is a key component of practice. Dispassion does not mean cold detachment, but instead freedom from bias. Such a posture ultimately achieves an anchored relationship with an inner life of contemplative engagement. Today's world

presents many distracting seductions to go faster and produce more. Diagnostic categories like Attention Deficit Hyperactivity Disorder abound in our culture. We have to wonder why so many modern illnesses are directly related to the environments that we build for ourselves to live in, learn in, and work in. Consequently, not only do we make ourselves sick, we also create industries to treat our self-inflicted ailments. Whole economies of drug-based interventions thrive in order to treat impulsive behavior, distractible concentration, and wandering attention. It is worth noting that before defaulting to medication as the first line of intervention, why not try combined practices such as art and meditation with mild doses of medication? The goal is to introduce the least intrusive, yet most effective medically sound intervention. Blending both attunes and synchronizes mindful engagement with expressive urges, along with the mildest chemical intervention.

Art as Spirituality

While actively immersed in the creative process I often feel that I am performing solitary, spiritual acts of worship. Yet spiritual and contemplative life, like artistic life, is hard work. Commitment to transformation demands discipline, devotion, and skillful action. The pilgrimage of art as contemplative practice is at once inward and outward, socially engaged and private. When to make the private public is an ongoing discernment practice in spiritual and artistic life.

Spirit can mean many things, such as the ethereal soul or the core of character. When exuding carefree pleasure, we might feel full of spirit. Or perhaps something like spirit grips us from within, demanding to be expressed. In this situation, we might feel moved to act from this inner force. Renunciation of material goods is yet another way to manifest a spiritual orientation. In all of these examples, there is a quality of seeking.

Spirituality is about searching for an authentic relationship with what feels sacred. It is deeply experiential, even experimental as people identify their own methods for gathering and practicing this information. Searching for a connection with the sacred often begins by working through the physicality of the body, relationship, and place. What is precious in life is known to us through connections with others. The unique living scenery found in nature connects to systemic relations. Qualities of place inspire meaningful encounters with natural and human made spaces.

Pain is another entryway into spiritual life. Our bodies get sick and break when overburdened. Life comes through us and leaves us. When people speak about their spiritual beliefs, yearnings, or sadness, they often refer to the

body and its parts. They might say, "When my first baby was born my heart opened," or, "When my marriage ended my heart broke," or, "I have felt really down, but then something in me woke up," or, "Seeing is believing," or, "I fell apart and had to put the pieces of myself back together." Spirituality can be about the body speaking from the felt sense of suffering while pointing toward opportunities of resiliency.

When feelings of fragility visit, we cannot help but call out for transcendent inspiration. The word *spirit* originates from the Latin *spiritus,* which relates to the breath. Inspiration, the literal drawing in of breath, is the gift of life breathing us into an inspired existence. Inhaling and exhaling automatically regulate our life force by taking and releasing oxygen, the fuel of spirit.

If spirituality is the search for the sacred in our lives, then art's visual language becomes a method for materializing and dialoguing with revered subject matter. Although this venerated material can exist beyond definition, the creation of evocative imagery aids in forming the formless. As we will see in later chapters, visual shapes, lines, colors, and corresponding content become silent conversation partners in the process of unfolding meaning. Perceiving and distilling what is sacred into artworks eventually reveals the private structural forms of our spirituality. According to Rudolf Arnheim (1966, 1981), art facilitates thinking and perceiving with the senses by translating these experiences into tangible structures. Our symbolic imagery inquires into these perceptible structures by visually articulating authentic substitutes for real, yet ineffable subjects.

In 1911, Kandinsky (1911/1977) wrote *Concerning the Spiritual in Art.* In this influential treatise, he implored artists to create from the authenticity of inner need. Relatedly, Ellen Dissanayake (1992) argues that aesthetic behavior is a timeless, expressed need or urge to make objects of special significance. Between Kandinsky's point to express spiritual necessity and Dissanayake's recognition of the enduring urge to make objects distinctively special, the body-mind-spirit organism discovers its sacred nature.

A theme related to art and spirituality is the subject of light. Modern physics continues to study biophotons, or light impulses emitted by all living cells. With the right tools, at the subtlest biological levels we can study ever-present light. For many observational and intuitive reasons, spiritual traditions reference light for its representation of sensory nuance and contemplative subtlety. Finding language for light holds clues for why it is so often associated with spiritual life. We use synonyms such as radiance, illumination, glow, luminosity, and weightlessness. Light, and the lack of it, implies divinity or hellish circumstances. The lighted world shows luminosity by bathing surfaces with shadow and light and revealing shifts in time. When carefully observed, light provides ongoing lessons in what feels and reads like visual theology. The work

of the Impressionists, Steiner, and Kandinsky all referenced connections to the artist's palette for painting light. Throughout time, cultural traditions have closely observed light, noticing its weightless, ever-shifting presence. Qualities of darkness, illumination, and reflection become the perfect metaphors for grasping solidity and subtlety, enlightenment and ignorance. As physics, art, and contemplative practices continue to influence each other, light will remain a primary tool for referencing divinity and consciousness.

Art as Meditation

As many as ten million practitioners of meditation were estimated in the United States in 2006 (Walsh & Shapiro, 2006). Both authors defined meditation as "a family of self-regulation practices that focus on training attention and awareness in order to bring mental processes under greater voluntary control and thereby foster general mental well-being and development and/or specific capacities such as calm, clarity, and concentration" (p. 229). Edmond Jacobsen founded "progressive muscle relaxation" techniques (Feuerstein, 2003, p. 343). Herbert Benson (1975) was interested in stress and the physiological ramifications of what he referred to as a "hidden epidemic" of hypertension (p. 18). During the course of his research he observed considerable physiological changes in meditators. His findings were opposite to arousal states usually experienced when stressed or overcome by the fight-flight response. Benson and his colleagues called this phenomenon the *relaxation response* (Benson, Beary, & Carol, 1974).

Meditation cultivates two main qualities of mind: *Vipassana* and *Samatha* (Henepola, 1999; Smith, 1999). *Vipassana* means the inward vision of "penetrative seeing" or "insight" (Batchelor, 1999, p. 136). *Samatha* means calm abiding, open presence, "concentration or tranquility" (Henepola, 1999, p. 151). Remaining present to what arises including the randomness of thoughts and emotions, begins to develop clear, nonattached observation. This is important for one main reason—if we are affixed to our various stories, then these personal narratives will have a powerful influence on our lives.

Nonattachment to mind narratives helps us let go of recycled ruminations so common in everyday thought. Ultimately we learn that recurring thought patterns are negotiable through the practice of meditation. We also learn not to reject sources of discomfort and instead to observantly move toward our irritants. The remedy is not to deflect, suppress, or resist, but to release resistance, titrate receptiveness to the struggle, and not abandon oneself. Through meditation and art, we learn how to observe the rising and falling of thoughts rather than contracting around them. Art exercises geared toward

Figure 2.9. Carefully observing spontaneous mark making—fostering insight and concentration. Workshop, SASANA, Bogota Colombia. Photograph by the author.

simple, rhythmic mark making, coordinated with the breath, combine insight with concentration. See exercise 2. *Recording Prāṇa: Doing, Undoing, Non-doing.*

Each fresh moment is the ideal teacher. The newness of here-and-now encounters offers an alternative to resistance, avoidance, or giving into thoughtless impulses. Rather than freeze with denial or avoidance when displeasures arise, we can intentionally choose another approach to what is unfolding (Chodron, 1997). Meditation offers an alternative path of relationship to our thoughts and sensations by revealing a spacious experience of the ever-moving, thinking mind.

Contemplative practices such as art combined with meditation offer exciting possibilities, especially when managing solidified states of ego that constitute self-identity. The five *skandhas* or aggregates in Buddhism aid in understanding conditioned phenomena that form our sense of self and self-talk. Taken together, the five *skandhas* constitute both our conditioning and our humanity. Chögyam Trungpa Rinpoche (2005) referred to them as five simultaneous bundled qualities that form ego. They are the collective, simultaneous, ever-moving building blocks of selfhood. The first is *rūpa* or form, which is the object or inner event that we first perceive before meaning is made. This

is the solidity of material phenomena that initiates perception and construction of selfhood and ego. The second is *vedana* or sensation and feeling. Essentially, this is how we occupy ourselves (Trungpa, 1976). Sense impressions eventually coalesce as perceived thoughts and feelings like pleasure and pain. Number three is *saṁjñā* (samjna) or perception and projection. This is where perceived parts become a whole configuration or gestalt. Not only are experiences perceived, they are also interpreted with meaning. *Saṁjñā* is putting the parts of perception together. Fourth is *saṃskāra* (samskara), which is an impression/perception imprint derived from action. Closely related to *saṃskāra, vāsanās* are formed when *saṃskāras* are repeated and become internalized, habitual patterns. From a yoga perspective, such *saṃskāras* and *vāsanās* result in energetic blockages within the subtle body. They are often explained as psychological grooves worn into the vinyl record–like recordings of the soul or subtle body—like soul plaque, these ruminations replay stuck thought-behavior patterns. We repeat what we have not mastered. The fifth *skandha, vijñāna,* is the faculty of higher wisdom. Here, instinctual processes are measured/deepened with intellectual filtration. The five *skandhas* provide observational methods for noticing stages of artistic work. They concisely offer a blueprint for inner witnessing during the many phases of the creative process.

Table 2.3. The Five *Skandhas* Chart and Art

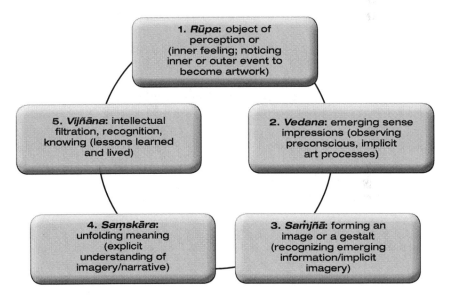

Meditation is an indispensable discipline geared toward tracking and managing states and qualities of mind. For many, the habitual, unconscious patterns of cognition occur with little awareness. The slippery slope of untamed human emotion gone astray is aptly described in this passage from the *Bhagavad Gītā*:[5]

> For a *person* dwelling on the objects of the senses, an attachment to them is born; from attachment, desire is born; from desire, anger is born; from anger arises delusion; from delusion, loss of memory; from loss of the memory, destruction of discrimination; from destruction of discrimination one is lost. (Kripananda, 1989, p. 30)

This loss of awareness, created by attachments to desires, is one critical reason contemplative discipline and practice, combined with art, is important. The cascading feeling of losing discrimination could be tracked in reverse. From the state of disorientation and the use of art to externalize these experiences, we could arrive back at the start of the slippery slope pattern. Meditation, like art, slows impulses down to a thoughtful simmer, creating a gap between impulse and action. The more we practice, the more this gap space is lengthened and widened, allowing us to act with awareness rather than from impetuous blindness.

Consider the following two points of view. First, Western approaches to art can emphasize the vanity of egotism, unchecked narcissism, and competitiveness. Art students trained in the West are familiar with self as subject matter. And taken to an extreme, neurotic, vain artistic tendencies indulged to a saturated point reveal repeated self-indulgent patterns rather than fresh discovery.

Second, focusing on "is-ness" rather than "me-ness" provides a different orientation. Is-ness implies attention to what is, as it is emerging, rather than focusing on Me as the controlling agent. Instead of self as subject matter including self as doer, the intention is to drop the focus of me or I. Awareness of what is emerging is different from controlling emergent phenomena. Trungpa (1996) suggests that within this orientation, there is no separation between art materials and artist. Both move together as one. The result is a sensation of doing without doing. While this sounds simple enough, cultivating this ability is not easy. Meditation is a ripe slowing, mono-tasking technology available to reorient attention from me-ness to is-ness and oneness with action. Three main, often coinciding orientations are helpful to consider. They are the role of the unattached observer, beginner's mind intentional focus of attention, and pliable release of contracted grasping to thoughts or ideas. Consider that intentional observation of thoughts, at times, can and will lead to negative

ruminations. No problem. With an attitude of inner friendship, the goal is to avoid the urge to judge, and instead flexibly loosen the grip around the judgment by placing space around that particular thought. Materials such as clay beautifully model this quality of pliable flexibility. Mindfully using and observing the suppleness of clay can help train the mind to do the same, that is, to bend, flex, and release. Art and meditation are autotelic practices—they are inherently rewarding and worth doing for their own sake.

Lastly, contemplative artists from different parts of the world pursue meditative principles in their work. For example, Zen calligraphers minimize conceptual mind while making marks on paper from meditative states. The learned ease of their effortless effort results in work emanating from inner states of emptiness. In this case, emptiness means less conceptual mind, judgment free open attention, and absorption in the moment.

Historically, Zen painters strove for "a thrifty brush" and fewer lines in order to convey the unpretentious precision of simplicity (D. T. Suzuki, 1959, p. 22). These methods drew people inward toward the subtlety of minimalism while searching outwardly for the same. This transcendental detachment became known as *wabi*, a style focusing on absence and paucity as independence from worldly materialism. From this posture of mindful disentanglement, one is likely to be out of step with current events. Yet, inwardly, self-acceptance arises from the elegance of a simplistic lifestyle. D. T. Suzuki (1959) likens the cultural phenomena of *wabi* to the example of Thoreau, who created out of the minimalism of his self-imposed, contemplative existence (p. 23).

Wabi, when coupled with *sabi*, is a joining of truthfulness with historical genuineness. *Sabi*, which means "loneliness or solitude," is present in the worn and tattered histories of things (D. T. Suzuki, 1959, p. 24). Imperfection eventually becomes perfection as the veracity of what is chiseled by the temporal art material of time adorns the surfaces of objects, including human skin. Suzuki explains that asymmetry, the capacity to be alone, simplicity, and "the One remaining as one in the Many" are core values of Japanese culture and art (D. T. Suzuki, 1959, p. 28).

Art as Leverage for Unblocking Obstacles

Yoga traditions posit that subtle bodies are simultaneously present in addition to the physical body. This dynamic force can become blocked and restrict participation in life. Even though this is a stretch for some, considering this possibility can begin to explain several mysteries. For example, many believe there is a soul that exits the body at the time of death. This animating consciousness that enlivens the body migrates elsewhere as we complete our last breath.

The *Granthis*

Yoga calls these psychic obstacles or energetic blockages *granthis,* meaning "knots" (Chidvilasananda, 1997). These limiting strictures, of which there are three main forms, contract vitality and fervor for life. *Brahma granthi* is located in the root *cakra* (*mūlādhāra*) of the subtle body at the base of the spine. *Brahma* is the creator's creative power and if constricted, the life force of *Śakti* within becomes stifled, as if there is not enough bandwidth to expand within the subtle body. Negativity around limitations of our creative forces deprives us of our full expressive capacity.

Next is *Viṣṇu granthi* (Vishnu granthi), located in the spiritual heart center or the *anāhata cakra*. Swami Chidvilasananda (1997) noted how this blockage dampens the distinguished virtues of "generosity, tenderness, harmony, sacredness, nobility, reverence, divine beauty, devotion, kindness, sweetness, magnificence, or good fortune" (p. 32). A daunting list, it is worth considering how a closed heart could attack itself. Just as arteries become clogged, the soul too accumulates blockages, especially in the physical and subtle heart area. *Viṣṇu*[6] is the archetypal sustaining power of emergent expression. That which manifests needs support to materialize. When the *Viṣṇu granthi* is blocked, the very center of the body-mind-spirit continuum becomes depressed.

The third psychic knot is the *Rudra granthi,* which is located in the *ājñā cakra* within the forehead region between the eyes (Chidvilasananda, 1997). *Rudra,*[7] a wrathful form of *Śiva,* represents dispersing forces such as dissolution. If the knot is taut and constricted, even if happy about something, there is background noise of anticipated pessimism, like, things are not right unless something is wrong. Bad news seems inevitable. Even though anticipated to eventually arrive, these thoughts have already limited life in the present. Within bounds of this *granthi,* anticipation and ambivalence rule, restricting *Śiva's* primordial alchemical forces of transformation.

Without realizing it, I was exposed to the *granthis* at a young age. Learning to tie my shoes as a child was difficult since I could not grasp the conceptual steps of looping laces into a bow. Given the awkwardness of my tiny fingers and confusion to understand the process, my work-around strategy was to forcefully pull the strings into knots. Consequently, I had to learn patience because later I had to loosen the knots from their grip. It was hard at first, and at times I asked for scissors to snip them free. In hindsight, this time in my young life began to show me the edges between lazily skipping steps and sensibly implementing creative solutions.

To this day, untying knots from tangled extension cords, jewelry chains, or shoelaces evokes a feeling of dread. I still notice the urge to bypass the situation and skip to a desired result by pulling on the ends of the tangled

extension cord. Knowing about the *granthis* helps to see ourselves as we are and to meet self-parts that need our assistance. M. C. Richards (1964), my ceramics mentor, rightly argued that we come to know who we are through our resistances.

It is here that art teaches about the content of any process. Skipping steps has become cultural habit in modern life. The desire to get to completion is strong, especially when stuck or blocked. However, the content of any creative process insists on being in that very moment of impasse and not rushing to find a way out of the *Rudra granthi*.

Technology has improved our engineering outcomes, medical imaging interventions, and design strategies. Thankfully, we can see the stress tolerance behavior of skyscrapers or bridges before they are built. Yet, for many, the ability to participate in the content of process is difficult. Manifesting ideas requires careful listening to those thoughts, testing them out, and refining the results. Process in art and contemplative practice is a technology for bringing awareness to the progression of trial and error exchanges. Mistakes are doorways to discovery, especially when unfurling the strictures of the *granthis*. These blockages anchor deeper when judged and consequently pulled tighter. Counterintuitive curiosity about writer's block, artistic blocks, heart-level negativity, or depressive attitudes is the first step. We become students of ourselves and our resistances in order to excavate our propensity to skip necessary phases of self-reflection and self-confrontation. Micro-discoveries afforded by imaginative processes keep us looped into the methods of creation, including the arrival of what seem to be immovable obstacles. If we relate to these moments as the beginning of breakthroughs, we learn to transform, open, and discover the wisdom of the *granthis*. The word *cover* is a helpful guide. Concealment is often a form of self-protection. Artistic experimentation with the *granthis* can assuage these protective veils of defensive resistance. As coverings dissipate, uncovering processes emerge. And from uncovering, the rewards of discovery materialize.

3

Snapshots of Western History and Lineage in Art as Contemplative Practice

My education in art was shaped by the university academy. In school, I learned about world art history, but mostly through a Western lens. As certain artists caught my attention for their innovative, groundbreaking efforts, they taught me how to unlearn my academic training and relearn the contemplative ideals that were beginning to bloom for me. Due to the limits of space, this chapter focuses mainly on some of these artists, as well as Western modernist trends of the late nineteenth and early twentieth centuries that reshaped science, world politics, psychology, and especially the arts. Additionally, throughout this portion of the book, I use the words *contemplative* and *spiritual* interchangeably. Deferring to Kandinsky (1911/1977) and his argument that spirituality and art serve as essential sparks to ignite inner life, it seems apropos to link both words together.

European and American Roots of Early-Twentieth-Century Modernism

The early twentieth century emerged like an axial age. For instance, Rudolf Steiner's (1964) writings on Anthroposophy, the metaphysical spirituality of the Theosophists (Preston & Humphreys, 1966), Sigmund Freud's (1900/1965) *The Interpretation of Dreams*, Kandinsky's (1911/1977) *Concerning the Spiritual in Art*, William James's (1902/2002) *The Varieties of Religious Experience*, Einstein's 1905 Theory of Relativity, Cubism's methods of simultaneity (Chipp, 1968), Swami Vivekananda's first visit to the West (Diamond, 2013; Vivekananda, 2012), and writings on the fourth dimension (Henderson,

1981; Steiner, 2001) influenced many artists and spiritual practitioners of the times.

During this fertile time of innovation, the eventual backdrop of World War I and World War II, including the Holocaust and Hiroshima-Nagasaki atomic blasts, haunted the international collective psyche. The insanity of mechanized world war incited artists to express both numbness and outrage to the vast malaise of suffering hemorrhaging across Europe, the United States, and Pacific Rim countries. Inevitably, movements such as Expressionism emerged as a visual language to show the full array of human emotion provoked by war, industrialization, and the nascent tides of globalization.

Regardless of time or place, universal patterns of despair result from the human-on-human violence found in war. During these dark periods, historical accounts of art expose the resilient, suffering sanity of artists trying to comprehend personal and cultural tragedy. Through the arts, their existential experiences were formed, expressed, and then consumed by others. The moral mandate to transcend decadence was decisively awakened and aided by these artists and authors experimenting with ways to sublimate personal and world trauma.

A historical legacy of European and American art can be linked with various spiritual traditions (Knight, 1987). Concerning spiritual life in the West, in the early twentieth century Steiner (1964) observed how color represented ensouled spirit. For him and his students, color studies provided a way for the embodied soul to glimpse itself. Steiner felt that sacred subject matter, like color, inspired the artistic urge to make spiritual practice tangibly accessible.

Western canons include many accounts of how the arts stimulate spiritual and creative forces for the contemplative artist-philosopher. Theologian Paul Tillich felt that art should be "truthful, expressive of complete moral, intellectual, and spiritual integrity" (T. M. Greene, 1964, p. 65), including conveyance of "the void" of existential despair (Tillich, 1980, p. 63). Tillich argued that modern art not be seen as propaganda, a view held by totalitarian governments, but instead as revelation. Intentional art of this sort transcends saccharine religious or political subject matter. Ersatz-based work becomes a form of "dishonest beautification" (p. 147) instead of leading to revelation, which was the purpose of art for Tillich.

According to James Knight (1987), William Blake, John Milton, Johann Wolfgang von Goethe, Sir Walter Scott, and Samuel F. B. Morse all reference spiritual connections with their creative work. Knight emphasizes Goethe's belief that all longing was in fact a yearning for God or the numinous, a sentiment also held by yoga traditions. For Knight, creative work is the imaginative conduit that actively fulfills the yearning for sacred connection, a point discussed throughout this chapter.

Early-Twentieth-Century Western Modernism

Many early-twentieth-century thinkers, artists, and architects such as Max Weber, Guillaume Apollinaire, Charles Howard Hinton, Helena P. Blavatsky, and P. D. Ouspensky were interested in a fourth dimension, particularly in terms of time, spatial infinity, and the embodied sensation of time without end (Henderson, 1986). The subject of diverse realities from the certainty of height, width, and depth to unseen astral realties was attractive to many including Steiner (2001), the Cubist artists, Marcel Duchamp (who was also interested in alchemy), and Kazimir Malevich, in particular. Early Cubism, for example, addressed the notion of multiple temporal perspectives. Beyond cubist fragmentation was a fourth dimension, which served as a gateway to higher levels of spatial consciousness beyond two- and three-dimensional surfaces. Therefore, refined perception to access this metaphysical space was needed and art was believed to be a way to approach, research, and enter this mystical domain.

Certainly, it is important not to idealize this time of artistic innovation. However, many artists working during this period inquired into spiritual subjects, especially in the wake of their newly found expressive, artistic independence. Out of the liberated freedom to pursue subjective instinct and the shadowed chaos of the times, numinous experience emerged as valid subject matter for art.

In his epic book *Concerning the Spiritual in Art*, Kandinsky (1911/1977) wrote about a spiritualized art that was antithetical to the slumber of materialism (Sadler, 1977). Core to his convictions was the belief in the freedom that comes from an authentically expressed inner need. Emotions were viewed as vibrations originating from the soul and color was a means for manifesting these vibratory expressions of this innermost spirit (Tuchman, 1986). It is here that spiritual and contemplative definitions of art meet as backdrop for the bold experimentation of early–twentieth-century modernism. Philosophers such as Georg W. F. Hegel influenced these early investigations. His ideas continue to impact contemporary artists and critics. For example, Donald Kuspit (2003) notes the legacy of Hegel's philosophy implicit in Kandinsky's ambitious work.

Hegel (1807/1966) stated, in relation to "religion in the form of art" (p. 709) and consciousness as self-aware spirit coming to know itself:

> Spirit has raised the shape in which it is object for its own consciousness into the form of consciousness itself; and spirit produces such a shape for itself. The artificer has given up the synthesizing activity, that blending of the heterogeneous forms of thought and nature. When the shape has gained the form of self-conscious activity, the artificer has become a spiritual workman. (p. 709)

Here Hegel offers a view of the secular spiritualized artist, such as Kandinsky, aligned with inner essence and expressive need. The artist in this equation becomes a spiritual worker engaged in making the hidden seen. Kuspit (2003) notes Hegel's influence on Kandinsky's work, such as the notion of spirit becoming conscious of itself through sensorial awareness uniquely available through aesthetic experimentation. Kuspit believes that Kandinsky's work was articulating artistic stages of spirituality and joining this awareness with universal essence.

Amid the emergence of this new art in Europe and the United States came an iconoclastic freedom to focus less on rational approaches so prevalent during and after the Renaissance and more on instinctive intuition as subject matter. New introspective creative methods for creating art emerged in place of academically sanctioned canons. Artists were increasingly self-liberated to investigate the felt sense of unseen reality and subjective emotionality. From these intellectual pursuits, experimental contemplative themes emerged in the studio. Unlike any time previously in Western art, these investigations supported authentic expression of inner life. Artists were not necessarily painting what they saw in the external world, but how they felt about what they were seeing, dreaming, or imagining. Embracing spontaneous intuition and research with color, form, and formlessness fostered a way of knowing that supported the perceptual search for essence—ineffable reality became a legitimate subject of artistic research.

For example, Sigmund Freud's ideas on primary process, irrational thinking could blend with rational, logical secondary process thought (Arieti, 1976). Surrealism's characteristic illogical imagery was repeatedly executed with refined, academically trained application of perspective and use of materials. The impossibility of primary process content characteristic of dreams was manifested in artworks through secondary, analytical painterly precision. This breakthrough application of the primary-secondary process dialectic emancipated and legitimized artistic approaches that continue to this day.

During the early twentieth century, many artists, like those discussed in this chapter, sympathized with emerging charismatic personalities who opened new doors of mystical perception. Theosophy unlocked religious and spiritual views, while psychoanalytic theory provided legitimacy for investigative techniques geared toward accessing the unconscious. Free association and automatic drawing, which worked well with cubist methods of rendering simultaneity, provided ongoing entry into various states of consciousness. Transcendent dimensions of human consciousness, explored through abstraction, were also scrutinized and studied (Henderson, 1981).

Controversial spokespeople emerged in the late nineteenth and early twentieth centuries with impressive intellectual, spiritual, and psychic ability. Chief among them was the controversial Mme. H. P. Blavatsky, author, guide,

and one of the primary founders of contemporary Theosophy, which means divine wisdom (Golding, 2000; Preston & Humphreys, 1966). Her legendary occult knowledge and psychic abilities influenced significant pockets of the emerging art of the times. Founded in New York in 1875, the Theosophical Society eventually articulated its purpose as:

1. To form a nucleus of the Universal Brotherhood of Humanity, without distinction of race, creed, sex, caste, or colour.

2. To encourage the study of Comparative Religion, Philosophy, and Science.

3. To investigate unexplained laws of Nature, and the powers latent in man. (as cited in Preston & Humphreys, 1966, p. xv)

Toward the end of her life, Mme. Blavatsky described the ideal Theosophical student in the following terms:

Behold the truth before you: A clean life, an open mind, a pure heart, an eager intellect, an unveiled spiritual perception, a brotherliness for all, a readiness to give and receive advice and instruction, a loyal sense of duty to the Teacher, a willing obedience to the behests of TRUTH once we have placed our confidence in and believe that Teacher to be in possession of it; a courageous endurance of personal injustice, a brave declaration of principles, a valiant defense of those who are unjustly attacked, and a constant eye to the ideal of human progression and perfection which the sacred science depicts—these are the Golden Stairs up the steps of which the learner may climb to the Temple of Divine Wisdom. (as cited in Preston & Humphreys, 1966, p. xvii)

Mme. Blavatsky's interests were tempered with her pronounced clairvoyant ability. A contentious figure branded as a charlatan by some, she claimed guidance from advanced disembodied ascended masters. She traveled to India, Ceylon, Europe, the United States, and perhaps Tibet, claiming to receive instruction from enlightened teachers while educating others about Theosophy. Her ideas influenced well-known artists working at this time such as Piet Mondrian, whose work expressed the multifaceted evolution of life, the emergence of revelation through the reconciliation of opposites, and how art and religion were pathways to transcend matter (Golding, 2000).

The Nabi group (Hebrew for prophet), mostly worked in Paris during the late nineteenth century. They, too, were influenced by the ideas of Rudolf

Steiner and the Theosophical Society. In an attempt to merge science with theology, Blavatsky and others such as Annie Besant and C. W. Leadbeater (1971) drew the curiosity of artists in the Nabi group. Led by Paul Serusier, the Nabis embraced the occult and gnostic ideas of Theosophy, and unabashedly considered the pursuit of spiritual enlightenment to be a function of art.

Leadbeater's book *Man Visible and Invisible,* first published in 1902, contained vivid illustrations of the delicate color fields, known as auras, surrounding the human body. This book offered a direct correlation between auras as thought-forms and the subtle or soul body. He codified the meaning of colors emanating from the soul body with affective states implicit within the physical body. This publication influenced the palette and visual vocabularies of his artist contemporaries like Kandinsky who were immersed in spiritual topics.

Many early–twentieth-century Western artists used fragmented forms, as in analytic and synthetic Cubism, to confront rules established by the orthodoxies of the artistic academy. They accomplished this, especially after Sigmund Freud's (1900/1965) *Interpretation of Dreams,* by insisting on the primary importance of multiple perspectives, including subjective experience. The Post-Impressionists, the Nabis, the Blaue Reiter (Blue Rider), the Expressionists, the Surrealists and eventually the Dada artists broke down prevailing, institutionalized attitudes (Chipp, 1968). In some cases, they too ended up making their own orthodoxies. This pilgrimage into self, ultimately revealed the contrasting spiritual dimensions within the dualities of the form-essence, subtle-manifest equations inherent in so many contemplative practices. As they tried to dematerialize objective forms from nature, they entered the nonobjective realm of pure expression (Sadler, 1977). By telegraphing felt awareness from subject to created object, as in portraiture or still life studies, empathy became an important part of the artist's repertoire.

In the late nineteenth and early twentieth centuries in Europe and the United States, Robert Vischer and Theodore Lipps (Jahoda, 2005), Edward Titchener (1909), Vernon Lee and C. Anstruther-Thomson (1912) took up this very subject. They investigated relationships between art, sympathy, and empathy in an intersubjective practice of *einfühlung*—or feeling into the world of another. Lipps felt that contemplation of artworks fostered a mode of "transport" into an image (Jahoda, 2005) and Lee (1912) believed this quality of transfer, or emotional projection, was related to aesthetic *einfühlung*, in this case, artistic empathy meant to perceptively feel and intentionally project within or into something outside oneself (Mallgrave & Ikonomou, 1994).

The combination of empathy and art became a practice for making compassionate contact with subjects. Cubism, which displayed fragmented facial features in multiple perspectives, I argue, also facilitated aesthetic empathy. For painters such as Braque and Picasso, Cubist vision in portraiture yielded insight

into the subtleties of the model's personality. It is my view that Picasso not only discovered Cubism from looking at indigenous art, but also during up-close, face-to-face encounters with lovers. When barely inches away from the eyes of an intimate partner, facial features contort and bend. As an unusually keen observer, it seems plausible that Picasso merged these intimate observations with his studies of indigenous art.

Western Artists of the Early Twentieth Century

Artists such as Alexander Archipenko, Constantin Brancusi, Wassily Kandinsky, Paul Klee, Franz Marc, Kazimer Malevich, Piet Mondrian, Hilma af Klint, and Paul Sérusier experimented with relationships between form, essence, and contemplative mysticism. Each uniquely became absorbed in the process of empathically abstracting the formal visual traits of their medium into tangible quintessence qualities.

Kandinsky pursued his work as an "artistic scientist" (Golding, 2000, p. 78), and from his experiments came new research methods into a kind of aesthetic cartography of ensouled abstraction. He kept refining his coordinates toward the true north of expressive need between art and music, which stoked his urge for spiritual expression. According to Kandinsky (1911/1977), there were three mystical elements that contributed to this need:

1. The personality trait to express, or externalize

2. The view that artists were obligated to express the spirit of their times and cultural surroundings

3. As servants of their art, artists serve art. (Kandinsky, 1977)

The spirit, like the body, needs exercise, and Kandinsky saw music and color as ways to get a workout. From this perspective, color used in painting references the amorphous fluidity of light, and is a means for touching into the formlessness of spirit. As an accomplished musician, Kandinsky believed that harmony and discord in music and in visual compositions were expressions of pure beauty and therefore spirit.

Using methods to transcend and concretize intangible concepts, Kandinsky, who was likely a synesthete, immersed himself in translating artistic spirituality. He pursued this goal through an intentional amalgamation of mystical religious traditions blended with authentic symbolism, love of music, and his sensorial acuity (Golding, 2000). Early in his career, he helped to form the Blue Rider Group with Franz Marc, and both artists insisted that members truthfully "express their inner selves" as a core conviction of spiritualized art (Sadler,

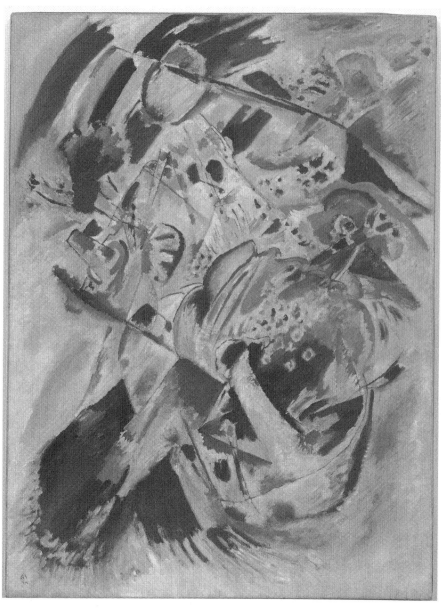

Figure 3.1. *Panel for Edwin R. Campbell No. 4.* Wassily Kandinsky (1914).

1977, p. vii). According to Robert Welsh (1987), artists such as Kandinsky and Mondrian confronted the rationalist and materialistic tone of Western culture through their work. In fact, Kandinsky pursued an "antimaterialist" agenda by considering art as a pathway to cultivate a "spiritually enlightened society" (p. 10).

Although Kandinsky is usually hailed as the first abstract artist, Hilma af Klint created notable, mystically absorbed abstract paintings in Sweden several years before him (Rachlin, 2013). While Kandinsky made deliberate compositional abstractions, af Klint approached her work from unconscious, mediumistic processes. Having reclusive tendencies, she displayed extrasensory ability from a young age. Interested in art, math, and science (particularly botany), she graduated from the Royal Swedish Academy of Fine Arts in 1887 with honors. As she and her art evolved, she became increasingly absorbed in painting qualities of invisibility (Rachlin, 2013) and duality (Fant, 1986). Additionally, with four other women in the 1890s, she formed the "Friday Group," which seriously practiced automatic writing and held carefully documented séances (Fant, 1986). Eventually, she met and cultivated a relationship with Steiner, in 1908. Following her mother's death in 1920, she traveled to Switzerland to again visit with Steiner. She embraced his technique of "painting out of color," which did away with line (Fant, 1986). Wet-on-wet strategies freed imposed boundaries of demarcation. According to Åke Fant (1986), Steiner felt those artists who tried to paint spiritual content transgressed by exactly copying nature. Af Klint had similar interests and pursued related content in her work, which precipitated a crisis, and she stopped painting for two years. Eventually, she began to paint again with a renewed interest to reconsider her approach, which included exploration of balancing male and female forces in her work.

Another significant early modernist, sculptor Constantin Brancusi reduced tangible forms to fundamental, vital essence. On one occasion he said, "I am no longer of this world, I am far from myself, I am no longer a part of my own person. I am within the essence of things themselves" (as cited in Chipp, 1968, p. 364). This remarkable statement shows precisely why art is so intimately connected to contemplative practice. Brancusi's comment reveals his sculptural pilgrimage to penetrate the transcendent essence of physical matter that exists both in and beyond form.

Many early-twentieth-century artists boldly experimented with intelligent abstractions of form. Their thoughtful research with these methods resulted in a new vision for investigating spiritual themes. Artists such as Brancusi not only used abstraction to dissect form but also as a way to transcend physical references of form, time, and space. His 1928 sculpture, *Bird in Space*, is an exemplary case in point. The solidity of bronze metal is negated by the

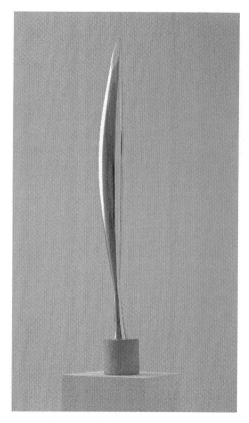

Figure 3.2. *Bird in Space.* Constantin Brancusi (1928).

highly polished smooth sensual surface. The archetypal magnificence of a bird expresses freedom to rise above and transcend the forces of gravity while still being earthbound as the base of stone and wood suggests (Burnham, 1968). This striking sculpture is emblematic of contemplative form, content, and vision. The spiritual totemic significance of the earthbound, yet weightless spirit of a stylized bird implies embodied and disembodied qualities of transcendence.

Franz Marc, who died during World War I at a young age, investigated a "spiritualized aesthetic" (Partsch, 2006, p. 24). As reported by Susanna Partsch, he was interested in the contrast between pictorial representation and emotional representation and how visual space can be a "soul shattering" place to roam and experiment (p. 12). Specifically, Marc wanted to paint the "inner spiritual side of nature" (p. 20). He found examples to aid his initial search in the works of van Gogh and Gauguin. While Marc was drawn to the world of animals,

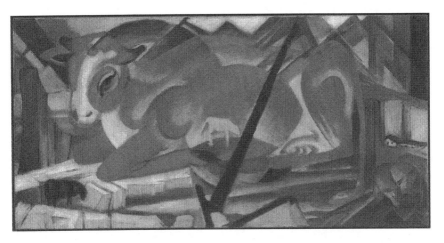

Figure 3.3. *The World Cow*. Franz Marc (1913).

he was careful not to anthropomorphize his subjects. Instead, he looked at his subject empathically and composed his work from this intersubjective place of attuned observation. The contrast between empathy and anthropomorphizing is important to clarify. Rather than project personal material onto his subject, Marc seemingly wanted to feel with and into the animals he was keenly observing.

By 1911, Piet Mondrian suspended the distinction between figure-ground relationships and "matter and non-matter" in his paintings (Golding, 2000, p. 20). Influenced by Theosophy and Hegel's philosophy, Mondrian pushed into contemplative territory by transcending opposites through abstraction. Eventually he found his way towards spiritual content through abridged compositions of the Dutch landscape. In 1917, he wrote about how religion and art, both means toward the same end, are pathways to the universal and that the new art was the older art from previous times now free of oppression. In this way, he said, "art becomes religion" (as cited in Golding, 2000, p. 28). According to Golding, Mondrian desired to depict universal and infinite themes within the finite limitations of his paintings. He saw abstract art as pure creation and chaste expression for the changing social good.

Kazimer Malevich, another pioneering modernist painter, was interested in the mystical properties of geometry. He pursued spiritual ideas of abstraction through his trepidation to embrace the human body as subject matter. He was a founding member of the Suprematism movement that believed in the ascendancy of pure artistic feeling. By pure, I mean a transcendent state arrived at through attempts to conceive formless abstraction. His work is so

profound for the time and place he was working because it demonstrates how the art process in tandem with other influences, such as P. D. Ouspensky's writing on the fourth dimension, brought him to a place of total dissolve within the "directionless space" of his paintings (Henderson, 1986, p. 221). The fourth dimension was viewed as "outside of sensory perception and . . . it reversed the dialogues as to what was real and unreal, or logical and illogical, in our perception of the three dimensional universe around us, which is in fact illusory" (Golding, 2000, p. 62). Similar to practices from contemplative traditions, we see in Malevich's work an embrace of a real, yet unseen reality to be penetrated and known through art. Within these transcendent teachings, the world is a stage play of interdependent, illusion-based impressions, or *māyā*, with an ever-present backdrop of one truth. Malevich likely knew of Eastern philosophies since he was influenced by Ouspensky, who, according to Golding (2000), had interests in the *Upaniṣads* and Theosophy.

Malevich's quintessential *Suprematist Composition: White on White* suggests dissolving into the ether of pure unrestricted space by composing the total freedom of zero within barely perceptible form. Like a rendering of emptiness within the subtleties of form, he achieved his goal by arriving at what Golding (2000) felt was Hegel's final view of evolution where "spiritual essence attains the consciousness and feeling of itself" (p. 74). Another way to view this exceptional painting is to consider that Malevich painted zero not as O, but as a square, on top of or within the spatial surrounds of infinity. Through his experiments he discovered how white atmospheres could disperse into and beyond shape toward spiritual, impermanent quintessence, or the formlessness of consciousness. Curiously, centuries earlier, the great Indian Kashmir Shaivite practitioner-scholar Abhinavagupta (950–1020 CE) used the metaphor of painting to articulate the mysteries of manifestation. The blank wall or canvas corresponded to the "purity of absolute consciousness" while the applied color performed the act of manifestation (Bäumer, 2008, p. 219). Therefore, white is a helpful tool for showing the unlimited void of supreme consciousness.

Jung (1998), in his foreword to a book on the teachings of the revered twentieth-century Indian saint Ramana Maharshi wrote, that in India, Ramana Maharshi was the "whitest spot in a white space" (p. ix), inferring his pure expansive presence. Jung's comment sums up not only Maharshi's holiness, but also serves as an indirect summary of Malevich's *Suprematist Composition: White on White*. Thus, white on white, white in white, or white behind white, painted on a canvas with four corners, implies a sense of pure atmospheric emptiness shown through the softened boundaries of a perceptible frame.

The prominence of the off-center white square, like the *bindu*[1] placed in the center of a *yantra*,[2] to be discussed later, functions like a holding place for unmanifested emptiness. The *bindu* is the archetypal, refined point of con-

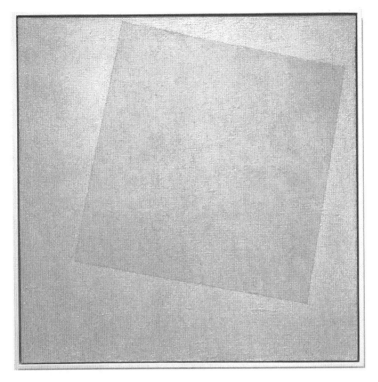

Figure 3.4. *Suprematist Composition: White on White.* Kazimir Malevich (1918).

densed essence. It is the central mark that transcends the *tattva*s (elements) and represents the most compressed vital energy of an item or entity (Mookerjee & Khanna, 1977).

It seems as if Malevich was attempting to analytically peel away the structure of "objective reality so that an underlying sheer ephemerality could be revealed," a similar point about art made by Epstein elsewhere (Epstein, 2004, p. 30). The Zen notion of form and formlessness is relevant here. Emptiness in this context can mean several things. Before conceptual thought exists the nondual moment of potential space. Emptiness is the vacuous space before something is perceived, defined, and consequently fixed in our mind. Moreover, conceptual thoughts about our observed reality are basically a constructed solidification of our point of view. Why think outside the box—or in Malevich's vocabulary, square—in order to create a new box? Instead of limiting awareness, why not unlock persistent conceptual patterns in order to embrace the openness of possibility? Things are what they are, as they are, until meaning is applied

that then fixes them within a context. Just thinking about emptiness constitutes a construction of what emptiness is, thus creating a new solidified form of the idea (Wegela, 2009). Thoughts simply arise from emptiness. The intention for the artist-researcher is to be freshly present and open to the experience of this cascading emptiness rather than fixed within conceptual conventions.

Malevich was a mystic and skilled thinker, as his Suprematist masterpieces unquestionably demonstrate. Although it might seem as though I am taking liberties, I could easily imagine him touching into void-space and witness awareness of form/solidity and formlessness/emptiness during his experimentation. Moving in and out of the posture of beginner's mind and conceptual mind seems likely as he and other artists of this time had to intentionally forget what they knew from art history and the academy in order to invent, uninvent, and then reinvent their work. Like scientists in the laboratory of the studio, they unwrapped perceptions of reality while translating those perceptions into never before seen compositions.

There were many other artists throughout the twentieth century who displayed contemplative approaches to their work. A chief moment in this history was when Marcel Duchamp's large glass piece fell and fractured while being transported. Rather than carp, his response was that it was the destiny of things and that the piece was "a lot better with breaks, a hundred times better" (as cited in Cabanne, 1967/1971, p. 75). It was as if his mind, like the piece, could shatter and begin anew as random events had their way with the work. When Jasper Johns saw it he felt it to be "very much in the present tense" rather than locating him somewhere else in place and time as a viewer (Tomkins, 1996, p. 411).

Duchamp's ready-mades such as his bicycle wheel, urinal, and coat rack bring the viewer into a present moment experience where an unexpected third something is about to happen. For example, for many art is usually a conceptual or mental act of meaning making rather than a purely visual event. The koan-like surprise of a ready-made is not unlike the psychology of a good joke or creative eureka. Both examples take two unrelated themes and recombine them into a new, unanticipated reality. In fact, the moment of encounter with a ready-made sparks our conceptual thinking to skip from initial confusion to poetic curiosity. In this way Duchamp gifted us with a mindful moment of surprise followed by an invitation to witness our thinking mind trying to make sense of the event before us.

Duchamp also liked to work on glass. This slick, transparent surface provided a break from the tradition of working with pigment on canvas since it is at once "looked at and through"(Tomkins, 1996, p. 125). Here again Duchamp changed our point of reference with the transparent quality of glass, which can infer qualities of thoughtful clear introspection or, like a dirty window,

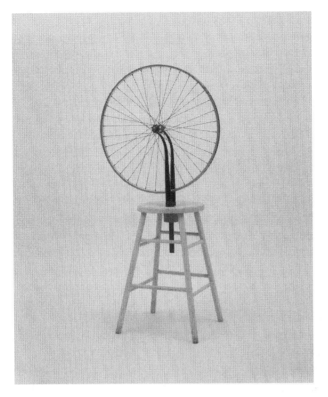

Figure 3.5. *Bicycle Wheel—3rd Version.* Marcel Duchamp (1951).

thoughts that are stained with conceptual grime. Duchamp changed the way we think about art by questioning rules, bending historical perception, and liberating the artist to compose in conceptual space.

Like many movements in twentieth-century art, abstract expressionism arrived and further peeled away historical canons and conventions. These artists were seeking out immediate, instinctual mark making. Gesture, spontaneity, even trance like states were entered in order to access intuitive processes. A felt sensation was met with a direct, unencumbered response, like a jazz player riffing on harmony and discord. Some of this work was raw and bold while other work was delicate and gutsy. Artists of this time innovatively supported fresh translations of emotion as well as responses to outer affecting events by plumbing their various candid responses on monumental canvases.

In response to the emotionally soaked art of Abstract Expressionism in the mid-twentieth century, John Cage "urged a perpetual process of artistic

discovery in daily life" (Tomkins, 1996, p. 409). His goal was to be a keen observer throughout the day and to awaken through "purposeless play," thus aligning with nature's unfolding systemic processes (Tomkins, 1996, p. 409). Random environmental sounds were simply contemplative opportunities for tasting the environment.

John Cage, Robert Motherwell, and Elizabeth Murray welcomed open-minded, meditative insights from contemplative traditions like Zen into their artistic processes. Other artists working from a mystical orientation, such as Arthur Dove, focused on nature's archetypal dynamism by striving to distill elemental forces into their paintings. With the birth of twentieth-century Modernism across the globe, artists kept returning to personal investigations of the spiritual in art.

More recently a consortium of artists, arts professionals, and philosopher-critics including Arthur Danto, Marcia Tucker, Laurie Anderson, Stephen Batchelor, Mark Epstein, and others innovatively explored connections between Buddhism and contemporary art (Bass & Jacob, 2004). They referred to their group like a *sangha* or spiritual community calling themselves "Awake: Art, Buddhism, and the Dimensions of Consciousness." As collaborators, from April 2001 to February 2003, they explored the interface between art and contemplative life by applying meditation, creativity, mindful perception, and Buddhist principles to artistic experimentation and museum work.

Contemplative approaches to contemporary art continue to expand and flourish. With the exciting work of artists such as Yves Klein, Gustav Metzger, Yoko Ono, Mary Ellen Carroll, James Turrell, Meredith Monk, and particularly Marina Abramović, the boundaries of contemplative approaches continue to be pushed and challenged. Each brings a quality of mindful experimentation with temporal processes, audience participation, and wide-ranging use of materials, including the body. Known for her sculptures, installations, and mind-body endurance performances, Marina Abramović exemplifies exploration of the confines of the ego, artistic identity, oppression, and beauty in her work (Ebony, 2009). Her performance "The Artist is Present," at once conveys the relational intimacy of silence between people with the curious voyeurism of the audience watching. Silent privacy between people becomes observable as their thoughts register a continuum of facial expressions. What was inwardly felt was made intimately public as when her past partner, Ulay, sat across from her. As she opened her eyes and saw him, a *darśan* moment materialized. Tears streaming, her head tilting, both shared a profound private and silent, public moment.

4

Tasting and Seeing the Divine

Rasa, Darśan, and Art as Worship

The personal work of art and spiritual life is to be tasted and savored. Gustatory delight along with mindful seeing become key pathways for receiving these meaningful experiences. Through sight, we can dine on the visual magnificence of the physical world, including ordinary natural landscapes, family photos, or images of deities that aid our practices. This chapter explores art as worship revealed through the culinary metaphors of *rasa* theory and the revelatory seeing of the *darśan* experience. *Rasa* is related to savoring the Divine while *darśan* references the visual theology of beholding the Divine. Together, both practices uncover insights for the contemplative artist wanting to refine sight and savor embodied spiritual awareness.

Rasa: Savoring Art's Emotional Essence

Aesthetic ties to spiritual and contemplative traditions in the West and the East have guided artisans for millennia (Coomaraswamy, 1934, 1957; Khanna, 1979). Before post-Renaissance art and the subsequent over-rational extroversion of Western attitudes, Coomaraswamy (1934) noticed how the East and West did in fact have related artistic impulses. Medieval religious mystics such as Meister Eckhart and Hildegard von Bingen practiced art as a path for discovering revelatory insight. Ancient Indian texts, such as the *Vedas* and the *Upaniṣads*, incorporated references to music and dance. Artists during these times operated as visionaries by moving subtle revelation into manifest form in order to foster the response of *rasa*.

Rasa is a significant aesthetic philosophy likely originating around 200 BCE with the work of sage *Bharata*. *Bharata's Nātyaśāstra*[1] (Natyashastra), which is a core text on *rasa* from this period, offers early accounts of the theory

with a focus on dance, music, and particularly theater (Schwartz, 2004). The great eleventh-century sage Abhinavagupta also wrote about *rasa* theory as it relates to subjects like embodied tranquility and *mokṣa* (moksha) or liberation. As described by Bäumer (2008), Abhinavagupta's intellect was cast wide and the results were stunning, spanning interests in music, poetry, perception, psychology, linguistic scrutiny, and theological mysticism. His aesthetic endeavors were gauged toward mental worship within the nondual "Lord of his heart" (p. 215). The artist for Abhinavagupta was "one who receives" from the heart-centered freedom of the inner Lord or "Divine Artist" (p. 222). To be possessed by creative urges was to channel the supreme freedom or *svātantrya* of the interiorized Divine creator. This penetrating intuition was merged into all the arts, including architecture (Schwartz, 2004). To this day, *rasa* continues to influence the contemporary arts of India. As a complete aesthetic system, the goal of *rasa* is to guide the creator and viewer to experience emotional and spiritual insight.

Rasa occurs when emotions are stimulated and appreciated beyond their usual meaning to inspire contemplative attention (Chaudhury, 1965). Within this introspective view, the egoic limited self is replaced with a poetic, imaginal perspective whereby contemplative intentions are set in motion. As Chaudhury suggests, the experience of *rasa* is like the experience of great poetry waking us up beyond our "egoistic shell to reveal the universal enlightened self within" where joy and revelation abound (p. 147). This is not just an experience of art for its own sake but of art as a form of worship—art for God's sake.

Over the millennia, aesthetics and metaphysics have been intimately connected within Indic spiritual practices. For example, the sacred geometry of *Śri Yantra* (Khanna, 1979) and maṇḍala construction (Leidy & Thurman, 1998), were integrated into practices of spiritual transformation for the artist, the audience, and the culture at large (Schwartz, 2004). *Yantras* were geometric visualizations of deities while maṇḍalas were depicted aspects of an eternal universe.

The 8 *Rasas*

The *Nātyaśāstra*, a core text on *rasa*, explains the aesthetic system of the *bhāvas* and the *rasas* (Schwartz, 2004). The *rasas* were represented by a taxonomy of emotions directly experienced by the audience. The *bhāvas* on the other hand were emotions, feelings, or psychological conditions infused into the performance that were recognized and felt by the audience (Higgins, 2007). Schwartz (2004) explained that there are eight *rasas*, each with its own corresponding color and deity (p. 15).

Table 4.1. Eight *Rasas*

Rasa	Color	Deity
śṛṅgāra (shringara—love in union and in disconnection)	Green	*Viṣṇu*
hāsya (humor, laughter, amusement)	White	*Pramatha*
karuṇā (compassion, pathos, sadness)	Dove-color	*Yama*
raudra (anger, rage, wrath, fury)	Red	*Rudra* (eventually *Śiva*)
vīra (heroism, courage)	Wheat-brown	*Mahendra*
bhayānaka (fear, terror, panic)	Black	*Kāla*
bibhatsā (distaste, recoil, aversion)	Blue	*Mahākāla*
adbhuta (amazement, surprise, marvel)	Yellow	*Brahma*

A ninth *rasa, śānta* (shanta, meaning peaceful or contentment), was added later in the eighth century. It represents the culmination of the other *rasas* since it leads to serenity and calm. Abhinavagupta compared *śānta* to *mokṣa* (liberation) as it references qualities of the Divine Self (Higgins, 2007). Citing the *Natyasastra,* Higgins (2007) stated that *rasa* emerges from what causes emotion. She suggested that "a combination of determinates" or emotional *vibhāvas,* plus consequent effects or the *anubhavas,* and the *vyabhicāri-bhāvas* or corresponding psychological states are infused into the characters within a play (p. 45). All three are core elements of any art form.

Tasting Emotions

Art as emotion is something to taste, digest, and savor as various ingredients blend together in aesthetically nourishing encounters (Chaudhury, 1965; Daumal, 1970–72/1982; Schwartz 2004). Higgins (2007) pointed out that the ingredients of art, similar to cooking, are combined into well-thought-out flavorful work.

Rasa, partly through its invocation of culinary metaphors, provides a sensorial lens for understanding the performing, visual, architectural, and literary arts of India (Schwartz, 2004). Indian cooking, so brilliantly nuanced,

is an alchemical act of blending multiple elements together in a celebration of life. As with the culinary treasures of any culture, all ingredients are carefully selected, combined, and integrated through the cooking process into a synergy of flavors. This amalgamation of stewed ingredients stimulates the visual, auditory, tactile, olfactory, and gustatory senses to receive a direct and full sensory experience. Tasting this blended essence within food is akin to an overall aesthetic experience of spiritual awakening—like touching spirit through the body. Food rouses the palate and sustains life while art nourishes the spirit and wakes up the soul.

The experience of tasting authentic emotion stimulates awareness toward a hunger or thirst for the Divine. And this is exactly the point. Rather than view oneself as limited and disconnected from spiritual urges, *rasa* convincingly uses the metaphoric complexity of food, from preparation to sustenance for life, as a method of hungering for the Creator. Additionally, the alchemy of cooking food is similar to the alchemy of artistic creation: both transform ingredients into a new experience that is life giving, even heart opening. This sustaining perspective sees food and art as a special form of offering or *prasāda* (prasad).

Food and Art as *Prasāda*

Food as *prasāda* is the essence of communion rituals, which allows individuals to take life within so that they may go on living (Campbell, 1988). Even if we are vegetarian, the ingested once-living plant or seed is still being received as a form of sacrifice. When we consume this substance, we engage in the sacrifice of a life in order to maintain our own. This form of ingesting life in order to have life stimulates an awareness of systemic connection beyond ourselves. Thus, tasting and eating is a conscious act of maintaining awareness of the web of existence.

Once cooked, tasted, chewed, and eaten, digestion further unfolds the process of the assimilated communion ritual. In an analogous way, art serves a similar purpose. As viewers take the work in and dine by visually tasting how form articulates content, they are moved to new awareness of the *rasas,* the *bhāvas,* and spiritual insight. Working from the manifest toward subtler experiences of awakened awareness is a quality of *rasa* theory.

Rasa and the Arts

Abhinavagupta viewed access to *rasa* through empathy (Higgins, 2007). For instance, knowing something about grief from personal experience allows us to enter the *rasa* of compassion. Importantly, encounters with *rasa* can be blocked.

Abhinavagupta identifies seven impediments such as a nonpersuasive drama, an overidentified viewer, or someone who is overly self-absorbed in personal emotions. Certainly to be transcended, these obstacles also tell us something about ourselves as audience participants. For some, self-indulgence becomes a distraction from empathic connection. Makers and consumers of the arts who manage these blocks can access personal wisdom through the inspired tranquility of the work (Higgins, 2007). Art in this context exists beyond mere representation by remaking rather than representing the universe.

Knowledge of the sacred was made available to those searching for direct experiences of the Divine through the arts (Daumal, 1970–72/1982). According to Schwartz (2004), Indic art practices have traditionally served as a culturally sanctioned avenue to "perform the Divine" as an act of sacred worship (p. 3). Consequently, the arts were seen as an offering in "the service of sacred understanding" (p. 9). Performance in drama, poetry, dance, and music, when enacted according to specific protocols, was literally an act of worship that brought the practitioner to the doorstep of the Divine. In this view of the arts, spirit and art become one within the imagination. Through the experience of *rasa,* the artist joins with the audience as both are transported toward an inner territory of devotional reverence (Higgins, 2007).

The metaphor of water served as a reference to the free-flowing qualities of the Divine implicit in *rasa* (Bäumer, 2008). Abhinavagupta stated that "Everything in the universe is an image of the totality that is Shiva," or the one supremely free universal consciousness (as cited in Bäumer, 2008, p. 220). The nondual fluid one becoming the illusion of many allowed the artist to delight in the joyful surprise of creativity as worship. Within this view, aesthetics became "wonder, surprise, and rumination," within the ever-interconnected web of one taste awareness (Bäumer, 2008, p. 221).

For the aesthetic traditions of India, the search for form was the search for the essence of the soul "imprisoned in the material" (Khanna, 1979, p. 132). The artist was a translator of this "universal spiritual intuition [cast] into visual terms," thereby transcending art for the sake of self-expression (Khanna, 1979, p. 132). Cultivating accurate forms to hold spiritual content provided means to penetrate Divine truth rather than serving as a badge of successful self-expression. For the traditional Indian artist, skillfully created art forms referenced the containment of symbolic, archetypal, transcendent truths. These acts of devotional creativity occurred when the "knower and known, seer and seen, meet in an act of transcending distinction" (Coomaraswamy, 1934, p. 6). Most important is that the artist aligned with the Divine inner creator, channeling the freedom/*svātantrya* emanating from the supremely free inner Self.

Darśan of the Imagination:
Adoring the Collaborative Emergent

The practice of *darśan*, which has a long history within Hindu traditions, represents a way of seeing that is more than just casual looking. *Darśan*, which means "auspicious sight," focuses attention on theophanic vision, which means attunement to the shape-shifting appearances of the Divine. This includes the revelatory experience of seeing our way toward the numinous where the separation between subject and object dissolves (Eck, 1998). It is not necessarily a direct vision, but rather an experience of heart-opening revelation. Often unexpected, *darśan* can happen in unforeseen ways. Seeing a newborn child for the first time, one's Guru, viewing a beautiful landscape, a sacred statue, or experiencing extended eye contact with an animal are all potential examples of *darśan* moments. Even digital trips to pilgrimage websites inspire the *darśan* experience (Mallapragada, 2010).

Web-based prayer sites are redefining the notion of spiritual journey. Through simple clicking on an image or website, new ways for performing pilgrimage and practicing *darśan* are happening for this "desktop deity culture" (Mallapragada, 2010, p. 111). These technologies bring us to virtual holy sites as well as representations of beloved deities. Yet prayer and worship still require imaginal and concentrative skills for accessing contemplative states whether visiting a physical temple site or screen shot of a holy shrine. Therefore, while technology provides the bandwidth for cyberspace pilgrimage, imagination is the constant variable for admittance to an inwardly animated devotional space.

Noticing divinity is an act of seeing ourselves as the sacred same. As observer and beholder, the moment becomes further venerated as inner reverence is set free to wander and connect. *Darśan* inspires an openness toward the ever-present mystical sacred surrounding us as in kaleidoscopic views of sunlight, the miracle of each breath, or the soothing textures of silence. Seeing and experiencing from this orientation becomes a reciprocal act of visually touching and being touched, holding and being held, receiving and offering back to the adored image.

If fortunate to be in the presence of a truly enlightened meditation master, a *darśan* moment can happen when observing the Guru and seeing ourselves as the same, eventual awakened potential. To behold a moment like this metabolizes the narrative of enlightenment as a real possibility. Essentially, we are not separate from what we observe during this *darśan* experience. Vibrant with spiritual meaning, images of the *darśan* encounter combined with the emotions of *rasa* sets something sacred in motion that can crack us open in the best of ways. Hillman (1978) and Diana Eck (1998) similarly note that

images resulting from encounters like this are imbedded with meaningful, simultaneous multiplicities of symbolic saturation.

Imagine entering a holy shrine. If the outer architectural features of the temple represent the cosmos, as is the case with some Hindu and Buddhist sites, then the interior is viewed as the revered center of this celestial space. Therefore, arriving at a physical temple is like symbolically entering the shrine of the heart. To the reader this can sound annoyingly cliché. By heart I do not mean the stereotypic messaging found in inspirational greeting cards. Rather, I mean the core embodied space of deep-seated devotion.

Within architectural temples found throughout India, seekers make offerings of flower garlands or food to the priest intermediary who facilitates the sacrificial transfer of the gift to the presiding symbolic deity. Once received, these offerings become blessed food, or *prasāda,* to be offered back to the pilgrim as a sanctified offering to be ingested. Taking inward the grace of the *prasāda* completes this devotional cycle.

Art is like this too. Going into a gallery or museum to see, visually taste, and feel the power of the work sets in motions forms of art-based *prasāda* and *darśan.* Encountering and viewing this graphic *prasāda* becomes a way to internalize and further metabolize the revelatory insight of meaningful artworks.

Experiences of *Darśan*

One particular story comes to mind involving an experience of *darśan* long before I even knew what it meant. In 1981, just out of my graduate art therapy training, I worked at an urban school for teenagers. The winter months often saw the weather turn, with dropping temperatures and nasty storms. On one such day, I ducked into a McDonald's to get out of a fierce ice storm. Peering through the loud, packed eating area filled with people wrapped in coats, scarves, hats and gloves, I noticed an elderly man sitting alone at a table. He carefully opened his breakfast box, set it down, closed his eyes, and began to pray a long prayer. With genuine curiosity, I watched him go inward, slowing down his pace in this frantic fast food establishment. To this day as I recall this moment, I am deeply moved by the memory of his silent prayer in this overstimulated environment. Something happened inside of me in that moment that spoke directly to the quiet sanctity of personal prayer. The juxtapositions of noise, crowds, chill, and quick food, and then this man finding stillness within the swirling mayhem of the moment was a vicarious prayer for me as well. Undoubtedly, this was a *darśan* encounter.

Thomas Coburn, author and past president of Naropa University, told me an enchanting story that also exemplifies a spontaneous *darśan* experience

(T. Coburn, personal communication, March, 6, 2009). During a trip to India and a visit to the Ganges early one morning, while others were engaged in their morning oblations, Dr. Coburn observed a woman in the near distance sit down and take a lump of clay from her bag. She then formed the amorphous material into a *Śiva Liṅga* (Lingam, a symbol of *Śiva*), and proceeded to worship this clay made holy. Once finished with her prayers, she balled the clay back up, placed it back in her bag, and went along her way. Deeply moved by what he saw, Dr. Coburn recalled this memory with affection as a noteworthy example of *darśan,* his and hers.

Similarly, encounters with art objects seen in churches or museums can stimulate unsuspected revelation. While living in India in 1992, I had a unique experience that taught me about this reverent state. During frequent visits to the home of the late–twentieth-century saint Bhagavan Nityananda, I sat before the exact chair where he received throngs of adoring devotees. As I anticipated my arrival and my walks back to the ashram where I was staying, I felt palpable silence within me. I can easily remember my tacit conversations with this deceased *Avadhūta* (saint). The more I visited, reverent affection came alive within me. Although his physical form was long gone, his tangible living image and prayer soaked chair inspired complex worship.

The same experience happens when open-minded and open-hearted pilgrims visit their church and stand before statues of Christ, Saint Francis, or the Virgin Mary. Or in traditions such as Islam, where images of the Prophet are forbidden, inner worship conjures up the experience of inwardly feeling the Divine. Although mostly discussed within Hindu traditions, *darśan* transcends "isms" and orthodoxies. When the heart opens, the reverential insight of *darśan* is set in motion. Tenderly patient, the sacred moment awaits our attuned perception of the interconnected web of life. *Darśan* is a practice of visual theology wherein the viewer is inspired from the perspective of yoga (union) and *bhakti* (devotion) (Coomaraswamy, 1957). Considering the stories mentioned above, it is clear that *darśan* can occur anytime, anywhere, even during the creative process.

Visual Theology

Darśan in art begins by becoming aware and joining with the awaiting potential within materials, processes, and resulting imagery. The exercises at the end of this book in Appendix B are intended to invite the reader into personal *darśan* encounters. When working on personal artwork, as chapter 9 also illustrates, collaborative, emergent layers endemic to *darśan, rasa,* and the arts are inevitable.

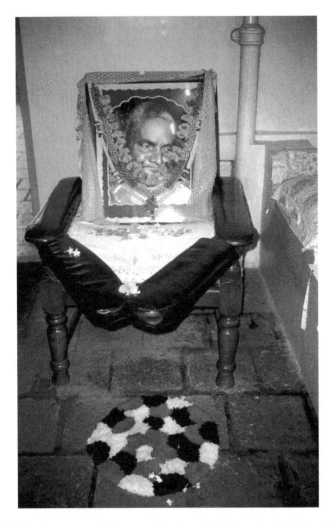

Figure 4.1. The *darśan* seat of Bhagavan Nityananda in Ganeshpuri, India. Photograph by the author.

Since the sacred is ever-present in the manifest world, all we have to do is look with a contemplative gaze—the temple is all around. When describing this quality of seeing, I am reminded of my first figure-drawing class in college. I spent hours observing the model, moving from mere looking to a penetrating view that connected my drawing tool to the curves and forms of the model's body twenty feet across the studio. Visual observation became empathic, non-verbal connection as I translated what I saw onto the page of my sketchbook.

As my charcoal touched the paper, there was an eroding separation between me, the marks I was making, and the model.

The dissolve of separation between self and other is key to the visual theology of *darśan* experiences. In India, in addition to the worship of sacred objects and images, living and deceased Saints are reverently honored. Those who have left their bodies and taken *Mahāsamādhi* (the great *Samādhi,* when a yogi leaves the body at death) have literally merged into all things and all realms. It is customary in India to sculpt a statue or *mūrti*[2] of these revered beings, thereby creating a tangible reference to their living form for respectful adoration. During certain celebrations, the *mūrti* is lovingly washed in liquids mixed with ghee, milk, honey, and other precious offerings. This practice is called *abhiṣeka,* the bathing of a holy image with auspicious liquids as a form of worship which then becomes *prasāda* (Karunamayi, 1999).

The first time I observed this practice, Brahmin priests were bathing a statue in the way described above. My Jewish upbringing had much to say about the worship of idols. From an early age, I learned about the unseen, ever-present, single God of my ancestors. To me, God was invisible, like the air that filled my lungs. Eventually, the dissonance shifted as I watched the priest bathe the *mūrti* with what was simply gentle behavior grounded in love, not unlike a parent stroking the head of an adored child. I recognized a quality of attunement similar to the ideal loving exchange and gaze between parent and caregiver described in Western attachment literature (Schore, 2003; Schore & Schore, 2008). I delighted in the care with which the priest caressed the *mūrti,* tenderly washing this bronze being. Slowly, I began to weep at the literal and symbolic love pouring over the statue. This was not about idol worship, but rather the deepest longing to express affection for the very principles that awaken the call to prayerful yearning. Bathing a *mūrti* pointed to the inherent adulation alive in the imagery of the *mūrti.* As it was washed in flowing elements representative of the *tattva* categories from *Sāṅkhya,* I too was being bathed in the *darśan,* inspired tears felt on my face—all influenced by reverence for an object, a statue, a bronze sculpture, a living image.

To me, images are our interiorized *mūrtis,* alive inside as *darśan*-invokers leading the way toward valued narratives. For some, this is a difficult thought to embrace. Paul Tillich suggests we consider that these symbols are not God but rather point us toward the Divine so that we can participate in their guiding wisdom (Harding, 1961; Kegley & Bretal, 1964). Either way, seeking and following meaningful images stimulates the very process that spawns the *spanda*-based connection of art with contemplative practice.

Imagination, as its own practice to be discussed next, is the creator alive inside as *spanda śakti* (spanda shakti) quietly calling for mutual participa-

tion from the seeker. Consider then that images are acting as the grammar of the imagination, unfolding refined awareness of the intermediate realm between intellectual perception, the world perceived by the senses, and imaginal conductivity.

Imaginal Intelligence
and Contemplative Practice

The Image, Its Function, and the Practice of Imagination

Images involuntarily emerge during sleep through dreams. Unless we are lucid dreamers, we often experience these spontaneous reveries as making an unanticipated appearance. Yet the morning residue from dreams can be profound, sometimes offering prophetic information. Surrealist artists were known for dipping deeply into the well of their dreams. They would create stirring works of irrational subjects through the logic of precise technique. Their art is convincingly rendered, yet realistically improbable.

Stories abound of contemplative innovators throughout history having farsighted, visionary dreams. For example, there is the tale about how Lord *Śiva* appeared in a dream to the ninth-century sage Vasugupta. *Śiva* told him about sacred teachings incised on a large rock, which were the *Śiva Sūtras*. Legend has it that Vasugupta found the rock and then disseminated this treasured knowledge (Muktananda, 1979).

The delight of living life is revealed through our collected daytime and nighttime imaginal experiences. Focusing awareness on these effervescent impressions sets the poetic language of symbol and metaphor in motion. The problem is that most adults ignore the inner movements of imaginal subject matter, dismissing this content as superfluous fantasy. And yet, there are many accounts of how the capacity of imagination, or imaginal intelligence, has preserved sanity. In *Man's Search for Meaning*, Viktor Frankl (1984) offered a brief passage concerning the impending death of a fellow prisoner in the concentration camp where they were both interned. He begins by saying it is a simple story, perhaps difficult to believe. The woman he referred to knew that she was going to die soon. In spite of her circumstances she told Frankl that she was thankful that destiny had taught her hard lessons. In her former life

before incarceration she thought of herself as privileged and therefore did not seriously consider the importance of spiritual accomplishments. Frankl reported that there was a chestnut tree outside of the window of the hut where she was confined. She could only see two blossoms on a single branch and pointed to it saying, "This tree here is the only friend I have in my loneliness . . . I often talk to this tree." Concerned that she might be delirious, Frankl asked if the tree replied. "Yes," she said. "It said to me, I am here—I am here—I am life, eternal life" (pg. 78). This brief passage demonstrates a poignant form of waking dream where the two living blooms provided an imaginal call and response relationship from deep within.

I include this passage from Frankl's book since it validates how all possible freedoms can be taken from a person except one—the self-determination to inwardly and privately imagine and be in conversation with stirring images. This inner real estate where free will reigns is where the "full democracy of the image" provides reliable sanctuary (Berry, 1982, p. 60).

Context, Mood, and Scene

According to James Hillman (1978), image is not the literal optical event of seeing something, such as a glass of water. Rather, it is the activated narrative that emerges as the glass of water is perceived and encountered. Image can be a hand movement, a color, a breeze wafting across the face, a memory of a glass of water, or an unexpected ambulance siren. An activated image, said Hillman, can originate as an internal, subtle encounter with a sensory experience; it does not necessarily have to be a perceptible physical object. Understanding the poetic grammar of images, which consists of context, mood, and scene, provides a helpful orientation to this mercurial topic.

Context equals the framing conditions, circumstances, or situations that comprise the core narratives present within the image. *Con* means "together/ with" and *text* means "weave." Context then represents the inherent narrative textures woven together throughout the image. Context can be observed from a metaphoric aerial or panoramic perspective as if taking in the entire field of the image. Or, zooming in to parts or passages within the image can also reveal contextual information.

Mood refers to feelings present within the image such as humor, temperament, or an overall pervading emotional tone. Mood also represents specific felt qualities of ambiance arising from within the painting or dream imagery. Disposition, attitude, or the sense that something is about to happen all imply feeling states arising from the full democracy of the image.

Scene suggests where the event is taking place, like a specific landscape, the environment in a photograph, or the site of an incident. The scene is the

simultaneous shifting and stabile qualities of environments or settings within a painting or dream. For example, within a large intentionally painted yellow canvas, buttery golden tones become the point of entry into subtle co-occurring spaces.

Most important is that dreamers and creators of art realize they are not the only part of the equation. Something else is happening beyond the perspective of "me" as doer and owner of these dreamt and painted events. Image sensitivity and sensibility is always collaborative, requiring constant attunement to this forgotten language of context, mood, and scene imbedded within the symbolic speech of imagery. The following story exemplifies this approach whether talking about a dream, drawing, or in this case, an actual outing.

During a memorable trip to Rocky Mountain National Park I decided to go horseback riding. I encountered a stable that was vividly framed by a background of sawblade-tipped mountains and foregrounded by a disheveled wooden building complete with a sunbathing potbelly pig, a caged parrot in the office, a few barking dogs, and a couple of roosters. Although the sun was shining, there was a chill in the air. All of these elements were striking parts of the scene I entered that day. It had been raining so I had to wade through ankle-deep mud and dung slurry in order to get to Ethyl, the horse I was to ride.

While walking through the revolting mixture of rain and manure toward Ethyl, I could have easily become the focus of my experiences, thereby claiming primacy from one point of view—mine. This sort of ownership, often heard in sentences beginning with "I" is only one point of analysis. And this is how most adults move through the world. That is, they insist on looking through the lens of their I-ness.

Statements such as "I had a dream last night," "I painted this picture," "I rode this horse," or "I walked through this slurry" reveal a one-sided, doership orientation. Instead, if we reverse this dominant point of reference and consider that paintings also paint us back and horses ride us too, imagination becomes a way to deconstruct habitual perception. Shifting perspective in this way toward the image of soupy slurry presents a rich, viscous sensory image alive in this moment of encounter. Then, by casting awareness toward the mountains in the background, the potbelly pig bathing in the sun, and Ethyl, it becomes clear that the context, mood, and scene of this event was revealing nuanced, observable narratives. Every one of the elements, while certainly part of "my" experience, did not belong to me; I was only part of this equation of meaningful random events. Shifting awareness from myself to these variables of sensory enchantment thrust me into a delightful imaginal space.

This chapter builds on these orienting foundations by exploring the intelligence of the imagination. To begin this discussion, consider the fiction writer, stage actor, and photojournalist.

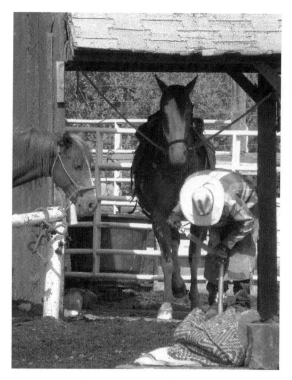

Figure 5.1. Horseback riding—Ethyl on the left. Photograph by the author.

The Fiction Writer/Stage Actor

Authors of fiction often marvel at the unique relationship they have with their characters. It is not unusual to report how the fictional personality literally writes itself into existence. In some cases, they say the character even takes over. When this happens, the author learns to get out of the way and become the scribe taking dictation from the guests emerging from the page. Images arrive as independent characters with their own traits, behaviors, and overall imaginal qualities.

It is similar for actors, since the roles they play exert surprising influence. Sometimes they have conversations with these emerging personalities as a way to embody deeper nuances of the role. Like the fiction writer, personal points of view are subordinated, especially in method acting, so that the character can purely manifest. There is a tangible, mutual quality to this seemingly illusory, yet very real relationship.

The Photojournalist

In addition to writers and actors, we can look at the role of impartial pho-tojournalists, their methods of documenting multiple perspectives, and how they arrive at unbiased truth. These observers tell stories in pictures, film, and video through an impartial, neutral camera lens.

Overall, photojournalists are trained to be dispassionate eyewitnesses fol-lowing clues, observing patterns, and circumambulating around all points of view. Blending the imaginal curiosity of the author or actor with the witness-ing integrity of the photojournalist begins to define the focus of this chapter. Specifically, how does the imagination serve as a contemplative foundation for the arts? And how do we learn to trust, hear, and follow imaginal intelligence as fertile territory for creative work?

Poesis: Visual Culture, Imaginal Culture, and Stories of Headlines and News

Poetry, from the Greek verb *poieo,* means to make, fabricate, or build (Lid-dell & Scott, 1996). Aristotle's work on poetics examined poesis and mime-sis, including tekne, which exemplifies skillful technique to manifest dormant potential. Poesis represents diverse processes of human discovery imbedded in the creation of artworks. Exploration of these artistic practices reveals inher-ent relationships between ideas, intentions, and actions. Mimesis engages the instinctual sensitivity of imitative behavior in order to discover meaning and connection. We mirror and emulate through the arts in order to reflectively discover likeness and significance (Marini, 2014).

The poetic shift from dominion over the image to serving the image is a fundamental value of art-based contemplative practice. Poesis, mimesis, and tekne instruct us to assist images by paying attention to the collabora-tive insights, sensations, and related narratives that emerge (Levine & Levine, 1999). In this way, we are talking about imaginal culture combined with mate-rial, visual culture (Blandy & Franklin, 2012). Paul Bolin and Doug Blandy (2003) examined interdisciplinary, multidisciplinary, and transdisciplinary methods related to this topic and defined material culture as:

> all human-mediated sights, sounds, smells, tastes, objects, forms, and expressions. . . . When there is purposeful human interven-tion, based on cultural activity, there is material culture. This being the case, nothing affected by human agency is overlooked as too insignificant for intensive examination, nor viewed as too small for eliciting substantive meaning. (p. 250)

Implicit in material culture is what I refer to as imaginal culture, which consists of interiorized, moving poetic narratives stimulated by the sensory input from objects (Blandy & Franklin, 2012). Imagination promotes the meaning-making languages of metaphor, idiom, and symbol essential for realizing the totality of the psyche. Consider that our inner lives are not only populated by images, but also that these images manifest the totality of our psychological consciousness.

Within the territory of the psyche, which Campbell suggests encompasses the regulating systems of body, mind, and spirit, imaginal entities become harbingers of insight (Campbell, 1988). They inspire a certain kind of listening and thinking. If we blend the sensibility of the fiction writer and actor with the witnessing precision of a photojournalist's eye, the receptivity needed for imaginal collaboration is underscored. Impartial journalists attend to all sides of a story in order to capture the waiting truth. Artists need imaginal journalistic skills in their repertoire in order to embrace the life of their poetic story lines.

When I invite my students to tell me about their artwork, they usually volunteer comments such as, "It's about this or about that," or, "I put a lot of time into it." As I wonder quietly to myself if this is the best they can do, I ask them out loud to give me the *news* rather than a one-sentence *headline* or Twitter-length statement. This comment consistently shakes loose the idea that there is more content, like hidden fortune, patiently waiting to be discovered. I implore them to not force connections but to instead collaborate with the emergent material. In time, like good journalists carefully observing and listening to their symbolic interviewees, they receive teachings from the imagery.

A student recently told a story of going to Italy with his high school choir group. The choral leader promised they would see "lots" of artwork during their tour. He suggested that when they looked at the art, they approach it as an encounter rather than quickly judging what they saw. This simple instruction changed the quality of his overall experience. He realized that information was waiting for him if he just traded judgment for collaborative contact and relationship with the news lingering within the art.

Observation and Seeing

When approaching artwork created by a child or an adult, consider suspending judgment in order to remain mindfully neutral during the initial encounter. Part of this process is to carefully describe what is seen. Known as the elements of design, or formal elements in artworks, neutral observation of the lines, forms, colors, textures, or figure/ground relationships reveals greater familiarity with implicit content. Careful observation of the formal elements leads to disciplined seeing and consequently eventual understanding of the

embedded content. Indeed, we work through the formal elements to get to content (Rhyne, 1998).

When geologists study rock formations or earthen strata, they see a story of time. Artists, too can learn to see the process in the product. The embedded clues of design relationships, when noticed, reveal patiently waiting stories within the physical structures of the work. Careful observation of the art-based geological-like elements of line, shape, and color, leads to the discovery of meaning within artworks (Rhyne, 1998).

Impartial, nonjudgmental seeing informs cooperative connections. Martin Buber's (1923/1970) teaching on I-Thou encounters further clarifies the relationship between unbiased vision and allies within images. He examined relational dialogues and word pairs of I-It (he or she), I-You, and I-Thou, noticing how existence is predicated on encounter. In I-It encounters, two participants, like subject and distant object, have the illusion of meeting and connecting. In I-Thou exchanges, relationship equals two manifestations of the Divine meeting. Buber considered the creative process in art, along with the resulting painting or sculpture, to be present in such a way that it acts on the viewer as the viewer acts upon it. Artists, who relinquish their control of ownership or dominion over their imagery, can more easily commune with the Thou-ness of those images.

Buber's (1923/1970) I-Thou encounters unmistakably connect impartial vision with opportunities for relational exchange. Seeing through an I-Thou lens, especially during art critiques, equals two manifestations of cooperative, shared presence—the artist or viewer and the imagery encountering each other. Consequently, imaginal content in art, writing, or acting presents an extended, unpolluted narrative whereby the audience vicariously experiences a two-way process with the characters or painted images taking up residence within them.

The Practice of Imagination

The Vedic Imagination

During the Vedic times of India, beginning about 3000 BCE (Chaudhuri, 1975), the visionary poets divined the mysteries of creation (Eck, 1998; Mahony, 1998a). Mahony suggests that the poetic visionary from this period joined the lineage of creators, divine and human, by channeling qualities of *ṛta*,[1] which is a rich, layered Sanskrit word. In English *ṛta* is related to ritual, harmony, and art. It means "that which has moved" to unfold and join together "universal law or cosmic order," by utilizing primordial foundations that

integrate "the divine, physical, and moral worlds" together (Mahony, 1998a, p. 3). Additional layers of *ṛta* can mean compatibility, balance, and integrity, as well as fitting together universal artistic principles including union within the entirety of creation. Those who created during this time intimately and responsibly understood how to align with the principles of *ṛta*.

As described by Mahony (1998a), wise and humbly "trembling with the inspiration of the Gods," the poet walked between the imaginal realms of the mind and heart discerning how the physical and celestial worlds fit together (p. 70). These visionary poets accessed the revelatory capacity of the imagination in order to materialize incomprehensible meaning and thus understand the moving parts of divine and natural order. Light particularly fascinated them as a means to notice how the world emergently paints itself from darkness into existence or from "nonbeing into being" (p. 71). Essentially, luminosity revealed through light was a reflection of various deities to be understood through the contemplatively honed, inner artistic eye. Visionary poets held "light in their mouths" delivered through the insight of inspired, transcendent speech (p. 73). Indeed, words become the garments of the breath and when joined with revelatory insight, the Divine and artist become collaborators in creation.

Carl G. Jung

Jung (1961/1989) believed that the imagination was an inborn necessity to honor and revere (Chodorow, 1997). He did not discover the imagination, but he did brilliantly resurrect its importance for the depth psychologies. He accomplished this through developing methods such as active imagination whereby wisdom was intentionally, yet gently invited to unfold (Jung, 1961/1989). Often described as dreaming the dream onward, or wakeful dreaming, active imagination invites progressive relaxation of controlling thoughts in order to fine-tune receptivity to inner imagery (Chodorow, 1997). As autonomous entities, images can beckon their artist-collaborator to pay attention to their guiding influence (McNiff, 1992). As harbingers of meaning, images must not only be received, but the compensatory wisdom they convey needs to be applied to daily life. For the imaginal symbol to be healing, its message must be lived out (Harding, 1961). For example, someone living a reckless lifestyle by regularly consuming drugs and alcohol hopes to change, but is not able to modify behavior. One night, this person has his dream of dreams. Within the reverie there is a tragic figure (not him) bathing in a sacred stream in order to wash off years of thick crusted dirt followed by a gentle teacher showing up to accept him into his new life as a cleansed and refreshed student. The psyche in this case is seemingly pointing out imbalances between a desire to revitalize and change, and the sad reality of a user's stained history. Upon

awakening, his first response is excitement for the dream. But then, tragically, later that day he goes to the bar and carries on as usual. The language of this dream is pointing the way toward another lifestyle. Unfortunately, the lessons are not received and applied to daily life. Graciously, on another night the psyche patiently tosses up yet another dream with similar content. Hopefully, one day there is a click of acceptance that sets the change process in motion.

When artistically created images arrive, they can offer solutions to a personal crisis. Hillman (1983) noticed that when Jung was most alone during a difficult period in his life, he turned to his images. And in his dreams, the images turned toward him. Hillman described how Jung engaged with these inner daimons, which were like visitors with divine powers. Concerning his spirit guide Philemon, Jung (1961/1989) wrote, "There are things in the psyche which I do not produce, but which produce themselves and have their own life" (p. 183). Jung went on to say that psychologically, Philemon signified "superior insight" in a form similar to the Indian notion of "guru" (p. 183). Like the Vedic poet, Jung was seemingly channeling *dhī,* which like *ṛta,*[1] has several connotations. *Dhī* is the insightful ability to see hidden meaning and sustain engagement with that primordial truth often revealed through imagination (Mahony, 1998a).

This form of refined poetic awareness can be seen as a manifestation of the *Śakti* emanating from the essence of intrinsic, unrestricted consciousness. While the term guru is usually associated with a revered teacher, it also refers to embodied, enlightened background awareness flowing through a person. Further filtered through the structures of the psyche, this inner wisdom of *Śakti* ministers to self-fragmentations through healing images, such as Jung's visits with Philemon (1961/1989, 2009). Hillman and Corbin (1958/1969) both considered the inhabitants of the imagination to be beckoning entities, referring to them as both "fictional and factual" (Hillman, 1983, p. 55). According to Hillman, for Jung this was the middle realm of "psychic reality" situated between "theological religion and clinical scientism" (p. 56). Philemon, who emerged as an inner guru and guide, arrived as a psychagogue, or primary leading image, facilitating greater understanding of unconscious processes (Jung, 1961/1989, p. 184).

Philemon is one of several guiding figures. Chodorow (1997) pointed out that Jung addressed his visitors from two directions: (1) recognizing them as an arrival of actual entities that have come to guide and teach and (2) viewing them as eruptions from the unconscious that are dealt with through methods of personification. Jung aimed to dialogue with these figures, ask them questions, and strive for integration between the conscious and unconscious realms of his layered psyche. Furthermore, his essential focus in this process was to differentiate "from these unconscious contents by personifying them" (p. 32),

thereby fostering a conscious relationship with them. Jung would write these fantasies down and ask himself what he was really doing, since it did not seem to relate to science. A strong inner voice sounding like a past patient answered, in fact argued back, that this was art (Chodorow, 1997). Peeling the layers further back, Jung concluded that this was the feminine anima soul voice within speaking. A contemplative yogic view of this voice would hear her as an emanation of *Śakti* emitting her artful wisdom.

Questions emerge such as, "Is Philemon merely an important fantasy to be observed, interviewed, and integrated through art?" or "Does Philemon arrive from a deeper stratum of the psyche's consciousness?" Whereas the unconscious can and will surface symbolic content needing attention, do figures like Philemon convey a quality of emanation from the personal unconscious or deeper strata, for example, the *Ātman*?

At one point Jung consulted with an Indian man, asking him similar questions about his inner life and relationship to his guru (Chodorow, 1997). Curiously, this man did not dismiss dream visits from his own guru, the great ancient sage Śaṅkarācārya[2] (Shankaracharya, likely born in 788 CE). For this man, these encounters were viewed as actual visits from Śaṅkarācārya rather than superficial psychological emanations. Meetings with this Indian man helped to normalize and calm Jung from thinking he had "plummeted right out of the human world" (as cited in Chodorow, 1997, p. 31).

The term *daimon,* which eventually became demon, refers back to Hellenistic times and polytheistic paganism (Hillman, 1983). During this period, daimons were considered spirit friends with wide-ranging personalities. Soul, daimon, and imagination scaffold inner life in and beyond the ego. Jung, Hillman, and, so it seems, the Vedic poets too believed that insightful emanations from the imagination were factual emissaries to honor.

Jung's (2009) illuminated manuscript *The Red Book*, also called *Liber Novus* (New Book), exemplifies art as research and contemplative practice. This prophetic work of psychological and spiritual revelation was created between 1913 and 1930 when he was evolving his core ideas on analytical depth psychology. A grand opus of sustained active imagination traversing immanent and transcendent poles, in it Jung judiciously experimented with conscious, preconscious, and unconscious movements of imagination. Like many mystics, he longed to know his own soul. Image and corresponding imaginal activity made visible through art and writing reveal Jung's capacity for cultural receptivity, introspection, and self-disclosure. Between a personal crisis, world war, and shifting political ideologies in Europe, dreams, drawings, and journaling guided Jung to observantly feel his way into and through inner-outer seismic events. Following the path toward the full bloom of his

individuation process, Jung's articulate mythopoetic imagination guided his passage.

Murray Stein (2012) suggests three primary, concentric lenses for reading the *Red Book*: Jung's personal context and biographical connections, including his break with Sigmund Freud, syncretistic literary influences, and cultural-religious connections. As a young adult, proposes Stein (2012), Jung suffered uncertainty surrounding his religious moorings. Prior and during the creation of *Liber Novus*, counterpoint collisions between science and religion were dismantling Western ideologies. Christian morality was in question, especially following Hegel's and Nietzsche's writing on eroding faith and the metaphoric death of God. As a result, reliable guiding myths were quickly receding. Shattering within and around him, Jung turned inward toward the creation of the *Liber Novus* to find his own leading mythos. He literally created his way into and through soul-shattering groundlessness toward revelatory insights so needed for our expanding modern, postmodern, and digimodern world. In fact, Jung's long-term experiments within the laboratory of *The Red Book* represent a timeless masterwork of art as a unique form of research and contemplative practice.

The Polycentric Imagination

The subtle entities, or daimons, so dynamically present in Hellenistic mythology and Jung's active imagination, are also reminiscent of the polycentric imagination of Vedic times as described by Eck (1998) and Mahony (1998a). Mahony remarked on the Vedic perspective where deities, Gods and Goddesses, were viewed as celestial artists who created the many forms of the universe. He pointed out that they first accomplished this through cognitive conception and then externally projected those conceptions into time and space, ultimately inhabiting the forms they created.

Hinduism is a religious tradition steeped in the imaginative or image-making practice of seeking the sacred (Eck, 1998). Mahony (1998a) observed that early Vedic texts view imagination as the power by which the Gods and Goddesses create. Within this viewpoint, the Divine imagination forms images of the "artful universe" (p. 4) and makes them accessible to the human imagination. In this way, outer creations became the projection of inner divinity within this highly visual and imaginal tradition.

The Divine is not imperceptible but rather visible and can be found through the "polycentric imagination" (Eck, 1998, p. 25). Throughout history, the traditional Indian artist attempted to manifest the unseen. From these revered practices emerged a visual theology whereby artists were not trying to make aesthetic statements of beauty. Instead, they were inspired from the

perspective of *yoga* (union) and *bhakti* (devotion) (Coomaraswamy, 1957). If *iconography* means "writing in pictures," then this approach to art articulates visual imagery as a form of artistic scripture (Eck, 1998, p. 12). The sentiment of these statements is relevant for contemporary artists and art students. What motivates our creative efforts? Who are we making art for? Might our artistic work provide methods for divining contemplative insight? How can art connect us to cultural trends that beg for our compassionate engagement?

Henry Corbin

Corbin (1958/1969) suggested a similar attitude held within Christian and Islamic traditions—that God, as consciousness, internally imagined the universe. Through this process, God then created the universe "from the eternal virtualities and potencies of His own being" within us (p. 182). According to Corbin, the mystic-contemplative objectively viewed the world from a triadic perspective: (1) intellectual perception; (2) sensory perception; and similar to Jung (3) the realm of the imagination, which is the intermediate territory of unique ideas emerging as images and lies between the two worlds of logic and sensory awareness. Layered between the cosmos of "pure spirit" and the phenomenal world, is the intermediate realm of "Idea Images" known to the Sufis as the space of "supersensory sensibility" where luminous "spirits are materialized and bodies spiritualized" (p. 182). These potent numinous effects shape the practitioner into the form of what has been imagined, even the Divine Godhead. Adding art to this process of imagining the divine forces of creation furthers the dialogue of the subtle taking form for aesthetic contemplative engagement. Jung and Corbin, both friends and colleagues, deeply valued their mystical relationships with images and imagination.

Active imagination, according to Corbin (1958/1969), is theophanic imagination where divine deities appear. The appearance of these symbolic messengers can be illustrated through the example of prayer directed toward the Divine. This willful act of focusing prayer on what is holy creates the Divine (epiphany) and simultaneously reveals the Divine (theophany) or Godly manifestation to the practitioner. This activity of the theophanic imagination is how the inner and outer voice of the heartfelt creative spirit communicates. It is how we can hear wisdom speaking to us. This sort of open-minded and open-hearted orientation inspires theophanic visions to appear.

It is important to clarify that this is not a description of fantasy-based themes that occupy qualities of a narcissistic or hedonistic mind. Corbin (1958/1969) saw the activity of the contemplative imagination as a theophanic organ whereby revelatory epiphanies can and will emerge. When seeking to be "alone with the Alone" (p. 6) in contemplative solitude, which is also a goal of yoga, the organ-like facility of the imagination will reveal meaningful

symbols that go beyond rational allegory toward deeper numinous mystery. The imaginal symbol extends an invitation to be replayed again and again, not unlike a musical score that is repeated in order to arouse revelatory insight. Like mantra[3] practice, the symbol is repeated in various ways. In art, the studio becomes a liturgical laboratory for imaginal collaboration and visual mantra-like practice. Dreams and images repeat for good reason as they are announcing inner, often ignored content to be considered. For this reason, many artists work on a series of themes so as to track and follow what is trying to come through.

Within the metaphoric organ of the imagination, "the spiritual takes body and the body becomes spiritual" (Ibn 'Arabi, as cited in Corbin, 1958/1969, p. 4). Like a phantom appendage directly yet subtly connected to the body, the imagination, according to Corbin, is a noetic organ that senses and perceives the numinous universe. The image therefore serves as a "body" that receives and holds the "thought and will of the soul" (p. 182). This movement from contemplation to projecting thought into form/content and then inhabiting these forms through imaginal dialogue can foster a direct experience of and with the Divine.

Imaginal Mindfulness: Pathways to the Divine

Imaginal mindfulness, a term and approach that I formulated, means non-judgmentally observing the moment-to-moment arrival and evolution of con-stellating narratives within imagery (Franklin, 2016c). As reverberations of context, mood, and scene inside the image echo throughout our awareness, mindful collaboration with the full democracy of this imaginal material follows. We listen, observe, and receive the *darśan* of these arriving others. As these visitors manifest as solidified artworks, imaginal mindfulness becomes a practice of respectful engagement. As when welcoming a houseguest, awareness is activated, judgment is suspended, and the present moment between self and other materializes as receptive acknowledgment. Numinous material made available through contemplative practices requires the faculty of imagination for relational contact with this sacred subject matter.

Karen Armstrong (1993) viewed the mystical search for God as familiar to all faiths. Like Hillman, Jung, and Corbin, Armstrong sees the subjective encounter with "the image-making part of the mind—often called the imagi-nation—rather than through the more cerebral, logical faculty" as essential to contemplative life (p. 219). Analogous to the artist who pursues numinous con-tent, the mystic, according to Armstrong, internally creates deliberate somatic and cognitive exercises that cultivate visionary access to the sacred. In essence, an intentional pursuit of what is holy and divine proceeds through imaginal

pathways to somatosensory awareness, and then to mind-training exercises such as meditation and art.

Furthermore, Armstrong (1993) pointed to contemplative traditions that went back to Greek practices known as *hesychia,* an attitude that means "tranquility" or "inner silence" (p. 220). It was believed that grasping for concepts including images and ideas could derail the mystic's search. The mind could be reined in and stilled through techniques similar to yogic methods of concentration. Stilling the mind ultimately promoted an interior "waiting silence" that transcended categories and therefore favored an apprehension of reality beyond conception (p. 220). Mystically bent practitioners, including artists from various traditions, knew that silence was the language of the Divine.

To receptively wait in silence orients us toward inspired emerging material. Like the Quakers sitting patiently waiting for inner light to emerge, contemplative artists learn to quietly wait for imaginal disclosure. From the formlessness of silence emerges form, and through the contemplation of form, the practitioner can find the pathway back to the formless. Art materials are essential to this process. For example touching, holding, and modeling clay becomes a tactile sermon. To shape clay is to be transformed by its flexible language of change (see Fig. 5.2).

Figure 5.2. Clay pot example of concentric circles. Hand-built and sawdust-fired by the author.

This clay pot, fashioned into concentric chambers, suggests a solidified, yet temporal view of the moment when a pebble is dropped into water. This was not an intentional pot. Rather, it emerged in a way similar to "call and response" singing. Collaboratively, I poked the clay and it responded. I listened, and without dominating the encounter, it reliably answered in return. Back and forth we went until we both decided it was complete.

The practice of imaginal mindfulness through art and meditation is not divided; in fact, they are braided together in the creative process. With the aid of imaginal exercises, the mind is used to still itself so that its contents can settle and manifest.

Visual *Satsaṅga*: Keeping the Company of Imaginal Truth

Satsaṅga (satsang) is Sanskrit for keeping or being in the company of the highest truth. *Saṅgha,* which means community, is related to *satsaṅga* in that groups gather to uplift and learn from each other's spiritual pursuits. Sharing the teachings deeply held within a practice tradition and supportive *saṅgha* galvanizes spiritual communities. As an artist surrounded by my work and the work of others, I have felt that our collective imagery formed a symbolic *saṅgha*. The result has been an experience of imaginal *satsaṅga*. That is, visual images are bringers of truth that create inner and outer psychological community. Once manifested, they populate our walls, studios, and critiques with meaningful stories.

A dismissive attitude toward visiting images can stifle, even exile and send them away. There is a Haitian saying, "When the anthropologists arrive, the Gods depart" (Cooper, 1998, p. 63). This adage implies several important points. First, when entering a new culture, it is best to turn off familiar, bounded values and attune to the customs, mores, and overall way of life implicit to this setting. The indigenous community members are the experts on themselves, not necessarily the visiting scientist. When the researcher's or critic's eye becomes a detached measuring tool, the sensuality of place diminishes. What is local and original becomes experientially less available, since the foreigner's lens only sees what it knows, not what is. This recipe of cultural insensitivity, stemming from class- and culture-bound values, is partly responsible for oppressive colonizing attitudes of superiority. Therefore, the imagery of imaginal culture along with the full democracy of corresponding images, which at first can experientially feel foreign, demands open-minded receptivity. I and Thou.

For many of our time, existential alienation results from a disconnection with the sacred in life (Gablik, 1991). Failures to hold a systemically aware imagination of reverent vision can lead to selfish profit-driven motives that do

great environmental and cultural harm, like doubters of global warming suffering from an anesthetized imagination. Science convincingly documents problems with the world's climate while certain politicians ignore the research acting like self-ordained experts. Conversely, if we were educated to see and respect the continuity of the web of life, why would we do harm to the environments of our bodies and our land? A concerted arts education teaches youth and adults to observe, feel, and respond with critical perception imbedded within aesthetic systems thinking. Plein air landscape painting is one way to promote reliable sensitivity to environmental conditions and processes. The more we practice seeing ecological networks, the more likely we are to honor and respect the places where we live and work and perhaps reduce existential alienation.

Botanists and gardeners regularly have familiar conversations with soil, insects, and plants. These living parts of the ecosystem communicate in their own language. Consequently, it is up to the gardener to listen. And the consequences of ignoring the collective signs can be severe, especially if feeding oneself from the family land. The ecological web of this planet thrives when humans attune to her messages. Therefore, we serve nature best when we carefully observe her silent, still, and rowdy communication.

Images are rarely static fixed events; they move and unfold. The orientation of the artist, then, is to move with what is moving within the language of image. Sticking to the image, which is the drumbeat of imaginal work, is similar to entering a physical landscape. While hiking in a fragile ecosystem above the timberline, we make sure that our feet stick to the path. Images of sight, sound, and smell come alive. Like a good steward of any landscape, we move about with respect and reverence, never leaving rubbish behind or trampling delicate Alpine flowers. We strive to become an aware traveler and observer of the unique *saṅgha* setting/scenery we are privileged to visit.

Collaborative Imaginal Work in Studio Art Critiques

Concerning studio art critiques, all too often we end up defending imagery rather than listening to it. Instructors and students tear into work with unchecked projections. People involved in this sort of critique describe the experience as having their work ripped apart, a rather graphic statement. I explain art critiques to my students in the following way:

> Before interpreting or projecting views onto another person's art, slow down and really see all of the parts of the work. This initial step is often skipped or hurried. We have no business critiquing something we have not fully seen. Since art is like life trying to come through us, we have to guide the process with the integrity

of a responsible witness. The goal is to trade disparaging attitudes for intense curiosity.

Also, this is not a view that enables an attitude of anything goes or that all efforts are accepted as badges of excellence. Rather than doing inferior work, the goal is to support the emergent content trying to come through with collaborative integrity. This becomes the meaning of craftpersonship—to cooperatively respond to the emergent images by offering our best, respectful effort so they can arrive and achieve their full presence. If we are trying to serve the image, then we will always bring steadfast determination to the collaboration.

I have experienced great success with students when approaching a critique from this perspective. There is nothing to defend, rip into, or tear apart. The Self-Assessment Rubric for Art Assignments and the Imaginal Process Skill Building Rubric become a central part of this process (see Appendix C). This evaluation tool empowers students to self-evaluate rather than have a professor serve as the grading authority. The results are stunning. The rubrics open up new ways of seeing and responding to the work. In fact, in terms of form and content, their work deepens over time and widens into conceptual, imaginal sophistication. Students learn that I do not give grades. Rather, they earn them as reflected in their self-assessment. At first glance, the symbolic speech and visual dialects of symbols, lines, shapes, and colors can be confusing. Using the Self-Assessment Rubric for Art Assignments stimulates further attunement with personal artwork.

Carl Rogers (1951), a pioneer in humanistic psychology, built his approach on a client-centered stance of holding genuine, empathic unconditional positive regard. Similarly, being image centered implies an empathic unconditional positive regard toward artworks. Essentially, this orientation displays empathic attunement to the context, mood, scene, and overall narrative content residing in the imagery. As both rubrics demonstrate, standards and authentic self-assessed efforts are essential for creating honest artworks.

Insight and Imagination

As discussed earlier, in addition to authentic approaches to art, many methods of contemplative practice consist of turning attention within. This inwardly drawn focus develops insight by fostering intimate, contemplative communion with inner life. In order to accomplish this goal, the faculty of imagination is required. Another way to understand meditation as a practice of imagination is to consider the word *insight* and its meaning in further detail.

Insight is seeing inwardly with clear perception, that which is imminently observable through processes such as meditation and art. Intuitive self-awareness arises out of this practice. Imagination is that faculty that creates, communicates, and perceives with and through images (Mahony, 1998a). Insight and intuition emerge out of communion with spontaneous and intentional images. Through deliberate meditative engagement with images, this faculty is further developed.

The following imaginary story illustrates the process of the shaman's probing insight as a way to help comprehend the subtle difference between the process of projection, personification, and theophanic vision:

> A chance meeting occurs between a Western-trained artist and an indigenous aboriginal shaman. After initial greetings are exchanged, they both decide to spend several days in silence and wander about in the backcountry. Riding on horseback, they intentionally stray from the path and enter a vast forested wilderness. Traveling deeper and deeper into the bush, the trail eventually leads to a clearing where they can see a massive ancient tree. As the path opens and the men absorb this magnificent scene, each becomes engrossed in silence and drops into a receptive state of observation.
>
> For the Western artist, anthropomorphized projection inspires contemplative dialogue. Similar to a playwright penning the words of a character in an emerging story, the tree and the artist actively engage in conversation. This subtle exchange yields inner delight as the Westerner practices this form of imaginal exchange.
>
> The process of encounter with the tree is quite different for the aboriginal man. In fact, he has already encountered a seamless system of interconnection and unity between all things from the time the sun rose that morning to this moment. For this shaman, the tree simply is alive, pulsating with its own voice, speaking directly, as sentient life does. For him, all of nature is alive and ensouled, constantly communicating. There is nothing to personify. Instead his attention focuses on deep listening to the shared consciousness that underlines and fuses all of life. Rather than placing meaning *onto*, he focuses on listening *into* a unified field of being.

Dreams, active imagination, and artwork all embody a quality of living authority. Symbols and images bring revelations by embodying the subtle *Śakti* made visible. Images are complete statements that hold their own logic, knowledge, and life force. They are passages between realms without a necessary destination. Creating art is an important part of this form of travel because it

manifests subtleties into tangible form that becomes an observable event. Since creation inherently manifests necessary destruction, the artist, too, is obliged to embrace the anarchy of failure as part of the creative process. Willingness to lose work liberates attachment to outcomes, which in turn releases the freedom of the imagination to fail and succeed.[4]

CONCERNING THE CONTEMPLATIVE IN ART AS YOGA AND MEDITATION

6

Art as Yoga

The title of part II intentionally references Kandinsky's landmark book *Concerning the Spiritual in Art* (1977). His writing has influenced generations of artists to consider art as a metaphysical path. For Kandinsky, this meant attention to the primacy of expressing inner need, including attention to the dialectic between spiritual necessity and the domination of materialism. Three categories influencing his work consisted of external *impressions* generated from nature and *improvisations* spontaneously emerging from internal, unconscious realms. Third were *compositions* which represented "talisman-like qualities" that blended the importance of feeling with deliberate motivating forces born from inner necessity (Golding, 2000, p. 88). Impressions (external imprints), improvisations (internal spontaneity), and compositions consisting of inner listening in order to authentically give feeling artistic form sets up a triadic lens for approaching the spiritual in art. Relationships between matter and spirit, a subject that infused his compositions, are expanded in this section by systematically adding the contemplative subjects of art as yoga and meditation.

Foundations

Yoga likely emerged from indigenous shamanic societies as long as five thousand years ago (Feuerstein, 2003). In general, yoga is a set of practices for "harnessing," yoking, or joining together the finite physical body with the interiorized, infinite spirit or *Puruṣa*, in order to realize our nondual, transpersonal potential (Mahony, 1998b, p. 60). Additionally, yoga consists of ethical-relational-embodied technologies cultivated over millennia, to free human potential to seek its fullest expression of enlightened self-realization (Dyczkowski, 1987; Feuerstein, 1989; Frawley, 1994; James, 2002; Yogananda, 2003).

In order to accomplish this far reaching goal, elegant transformational tools for ritual and practice evolved that cultivate spiritual discipline and the core value of *ahimsā* (ahimsa), which means to do no harm (Feuerstein, 2003). This parallel connection between spiritual self-control and yoga links it with other world wisdom traditions and their branches of mysticism that encourage transcendent practices. According to Feuerstein (2003), Jewish Kabbalah, Moslem Sufism, and Christian mysticism emphasize similarities to yoga through their transcendental search for union with the Divine.

Generally, Hindu-yoga philosophical traditions subscribe to the foundational view of a triadic pantheon where *Brahma* is Lord of creation, Lord *Viṣṇu* is the preserver of the universe, and Lord *Śiva* is the deity presiding over necessary destructive cycles. Together they represent a universal blueprint for all creative acts. Creating/manifesting, preserving/sustaining, and destroying/dissolving are implicit parts of any artistic process. On closer inspection, each deity has a complex description beyond this simplified shorthand explanation. In the worldview of Shaivism, *Śiva* has many names and roles that represent much more than this abridged description of destroyer. He is also known as *Naṭarāja*, the Lord dancing the universe into its myriad forms of creation (Coomaraswamy, 1957), and as *Mahādeva,* the eternal archetype of the enlightened primordial contemplative sitting in timeless meditation. Together with his consort *Śakti,* who embodies the animating energy of the universal feminine, they manifest the entire ALL of everything that is (Muller-Ortega, 1989). Within this system, to be discussed in more detail later, the five acts of Lord *Śiva*—emanation, dissolution, concealment, maintenance, and grace, constitute further refined, archetypal views of the creative process (Silburn, 1988; Zimmer, 1946).

Hindu traditions, especially *Vedanta,* posit a Divine nondual core Self or *Ātman* comprised of the same essence as the Supreme creative infinity of *Brahman*'s cosmos. Most important is that humans can inwardly realize this reality of the *Ātman-Brahman* relationship. Through yoga, we can excavate and join with our embodied eternal Self by peeling back layers of habitually limited, solidified ego-based identities. The term *Ātman* then references the residency of the universal *Brahman* within human beings. Pilgrimage for the contemplative artist working from this perspective could be to visualize these realms through their work. This form of artistic journey is the essence of the great statement from the *Upaniṣads*, "*Tat Tvam Asi,*" which translates as "That art thou" (Feuerstein, 2003, p. 258; James, 2002, p. 457). This core teaching of the universal One that we too are, is in fact our essential nature expressed as *sat-cit-ānanda* (sat-chit-ananda: *sat*/being-ness, *cit*/consciousness, *ānanda*/bliss) (Campbell, 1988; A. B. Greene, 1940). Art becomes a means

for physically touching, manifesting, and collaborating with our fundamental nature represented in this scriptural adage.

Degrees of this reality can be understood since individual consciousness is concurrently juxtaposed against an ever-present background of universal truth. Many well-known Western thinkers and artists have been influenced by this worldview, including Arthur Schopenhauer, Ralph Waldo Emerson, Walt Whitman, Aldous Huxley, and J. Robert Oppenheimer (Feuerstein, 2003, p. 258). All of these great minds were interested in mystical contemplation. For instance, in his essay "The Over-soul," Ralph Waldo Emerson (1934) poetically describes features of the *Ātman*/Brahman continuum: "We live in succession, in division, in parts, in particles. Meantime within man is the soul of the whole; the wise silence; the universal beauty, to which every part is equally related; the eternal One" (p. 107).

In *The Varieties of Religious Experience*, William James (2002) writing in 1902, addressed the subjects of yoga and superconscious states of *Samādhi* where "we become one with the Absolute and we become aware of our oneness" (p. 457). Referring to the ideas of Vivekananda, he wrote:

In India, training in mystical insight has been known from time immemorial under the name of yoga. Yoga means the experimental union of the individual with the divine. It is based on persevering exercise; and the diet, posture, breathing, intellectual concentration, and moral discipline vary slightly in different systems which teach it. The yogi, or disciple, who has by these means overcome the obscurations of his lower nature sufficiently, enters into the condition termed *Samadhi*, "and comes face to face with facts which no instinct or reason can ever know." (p. 436)

The ideas discussed in this chapter represent revealed truth, emerging from disciplined practices refined by adept scholars, yogis, monks, and mystics. Five thousand-year-old systems such as yoga are to be carefully considered as wellsprings of wisdom waiting for discerning seekers to scrutinize and explore. These adepts were the consummate quantitative and qualitative researchers engaged in plumbing the depths of consciousness. Their systematic investigations into the phenomenology of embodied awareness offer a paradigm for practice-based research intrinsic to the arts (Franklin, 2012).

As the chart below demonstrates, there are many ways to think about yoga because there are many traditions, histories, and gifted practitioners to study.

Table 6.1. Ways of Thinking about Yoga

What Is Yoga?	
Yoga is a set of traditions, practices, and technologies for transformational spiritual change Yoga is the cultivation and skillful application of concentration, attention, and intention Yoga teaches attunement to the subtle, energy bodies within the material body Yoga is turning awareness inward to still the mind and purify body-mind relationships Yoga is skillful management of the senses and corporeal urges Yoga teaches us how to skillfully manage our thoughts, speech, and behaviors Yoga is working with and through the body to awaken awareness Yoga studies the integration of states of consciousness Yoga teaches methods for relaxing the human nervous system and cultivating a nonattached state Yoga is the study of life-force Yoga is acting without doership Yoga cultivates effort for spiritual practice	Yoga is sifting through and accepting impermanence Yoga is ethical and moral behavior in action Yoga guides us to do no harm Yoga is detachment in action Yoga is lineage Yoga is deep inner listening Yoga is becoming a student of oneself Yoga outlines paths of practice toward and beyond ego Yoga is an aesthetic practice of skillful seeing, behaving, and doing Yoga is devotion Yoga is the embodied study of awareness practices Yoga is critical self-inquiry Yoga is the study of the subtle becoming manifest and the manifest leading back to the subtle Yoga is ritual Yoga facilitates the search for spiritual identity Yoga is listening to inner necessity Yoga is inner pilgrimage to the Divine Self

Yoga Traditions and Art as Contemplative Practice

Cosmic Creation

Georg Feuerstein (2003) has identified forty diverse types of Hindu-based yoga (p. 36). It is important to consider how yoga embraces the body, mind, academic, devotional, visual/auditory, socially engaged intentions of the practitioner. Several core branches are described by James Hewitt (1977):

> *Jñāna Yoga*: (Union by knowledge)
> *Bhakti Yoga*: (Union by love and devotion)
> *Karma Yoga*: (Union by action and service)
> *Mantra Yoga*: (Union by voice and sound)
> *Yantra Yoga*: (Union by vision and form)
> *Laya and Kuṇḍalinī Yoga*: (Union by arousal of latent psychic
> nerve-force)
> *Tantric Yoga*: (A general term for the physiological disciplines)
> *Hatha Yoga*: (Union by bodily mastery)
> *Rāja Yoga*: (Union by mental mastery) (pp. 5–6)

Cosmic creation in the Hindu tradition is eloquently shown as *Viṣṇu*, the omniscient sustainer of the universe, lying asleep on the coils of the large many-headed serpent *Ananta* who drifts on the "eternal sea of milk" whence all thoughts, shapes, and outward appearances emanate (Craven, 1976, p. 121). While *Viṣṇu* rests, he dreams the cosmos into existence by experiencing the illusory, ever changing nightmare of *māyā*. The Goddess *Lakṣmī*[1] (Lakshmi) massages the feet of her sleeping consort. A lotus emerges from *Viṣṇu*'s navel with the center of the flower as Lord *Brahma,* the God of creation (Craven, 1976, p. 121). This entire scene becomes emblematic of the manifestation of all creative conception.

As in the practice of the Sabbath, celestial creation requires rest. Parasympathetic counterbalance to action is essential for human, and apparently Godly existence. From the solitude of silence emerges the creative spark or *spanda* impulse to migrate from the subtlest flash of will to solidified manifestions. Becoming settled and quiet accesses the fertile potential of the *spanda* catalyst. Of the many accomplishments obtained through yoga, Patanjali's instruction for "relaxing all stressful effort" is at the core of practice (Feuerstein, 2003, p. 341).

Art-Based Connections

Traditionally, creating art in India was approached as a form of worship. According to Coomaraswamy (as cited in Khanna 1979, p. 135), artists underwent disciplined preparation before engaging in the creation process. Prior to sculpting a deity, the artist went to a solitary destination to engage in purification rituals such as bathing. The reason for this solitude was to quiet the mind and manage impulsive urges like unconscious intrusions. Eventually, inner equanimity was reached. The artist would then appeal to the deity to be created through concentrated mantra recitation and other practices in order to form a mental map for the creative process to be undertaken. With all of this preparation, when actually sculpting the deity, the artist could locate interiorized textures of revelation uncovered by both the invoked practices and the emerging created object.

From this description we can extract relevant principles that might aid contemporary artistic work. First, life force, both formed and unformed, can be uniquely explored through visual art. Second is the importance of intention and purpose. This is not art for art's sake but instead art for the sake of worship. The power of focus and intention are intrinsic to contemplative life including creating artwork. Third, learning to observe without judging the ebb and flow of egoic self-talk fosters mindful awareness. Adept attendance to our thoughts becomes an indispensable tool when producing work. Fourth, solitude helps to set the stage for inner listening. For this reason, I often avoid playing music in my classes and workshops. There are so many distractions in our lives. Learning to receive and hear inner dialogue is intrinsic to creative work. Rather than increase our repertoire for diversion, attention to hearing private messages is essential. Fostering this ability deepens artistic intuition, insight, and capacity to listen to inner necessity. Put another way, monotasking found in many art processes facilitates slowing down and acting with deliberate observational awareness. By employing mindfulness uniquely developed through artistic practice, we retain the stabilizing effects of awareness, which is so helpful when the world of uncertainty comes rushing toward us.

For example, within the reality of an ever-changing lethargic world economy, many of us are asked to do more with less and embrace frenzied, multitasking behavior in order to compete and survive. In some cases, people rush to red lights, nobly hold down several jobs, commute long distances, and actually work in their sleep! Understandably, they wake up exhausted and start the cycle all over again the next day. Art as contemplative practice, as this chapter maintains, offers a set of slowing technologies to reorient us toward spiritual homeostasis.

Sat-cit-ānanda, and Art

Yoga, as a transformational developmental process, cultivates realization of the interiorized transcendent Self. Incremental awareness of this unified state of consciousness, or our true nature of *sat-cit-ānanda*, is a primary goal of practice. *Sat* translates as "being," or absolute Being-ness, *Cit* (chit) as "consciousness," or fully awakened awareness, and *Ānanda* as "bliss" or fundamental instinctual joy. In *The Power of Myth*, Joseph Campbell (1988) spoke to this subject by saying:

> Now, I came to this idea of bliss because in Sanskrit, which is the great spiritual language of the world, there are three terms that represent the brink, the jumping-off place to the ocean of transcendence: *Sat, Chit, Ananda*. . . . I thought, "I don't know whether my consciousness is proper consciousness or not; I don't know whether what I know of my being is my proper being or not; but I do know where my rapture is. So let me hang on to rapture, and that will bring me both my consciousness and my being." I think it worked. (p. 120)

Campbell's advice is helpful. I will assume for most reading this book that either art or contemplative practice is where you find personal joy and delight. By pursuing these sources of elation, we find entryway into *Sat-Cit-Ānanda*.

Art-Based Connections

Art as contemplative practice embraces creative pathways for genuine self-expression of truth, awareness, and joy. With the help of symbols to articulate these ineffable subjects, core spiritual themes can be expressed and explored. By stimulating the senses, including the heart, we see more, feel more, and consequently act on the desire to communicate what we learn and know. Therefore, art offers methods for symbolically naming the unnamable aspects of pilgrimage into the qualities of being, consciousness, and bliss.

In terms of the art process *sat*, which also infers the search for personal artistic truth, can be explored from various angles. Artistic practices help us to become centered and present, a point beautifully articulated by M. C. Richards (1964) in her classic book *Centering in Pottery, Poetry, and the Person*. She poetically connects the metaphoric example of centering clay on the potter's wheel to cultivating felt centeredness. Additionally, creative work externalizes thoughts ripe for subjective and objective contemplation. By outwardly manifesting personal experience, we perceive and detect our thoughts, moods,

and behaviors. Overall, centered contemplative investigation through art invites the search for truthful imagery. Insight increases as awareness is revealed.

Art therapist Edith Kramer (1971, 1979) referred to carefully crafted artworks as formed expressions consisting of evocative power, economy of means, and inner consistency. Art has the power to evoke genuine emotion for the artist and viewer. Economy of means relates to not overdoing the work. Inner consistency conveys whether the artist is misleading him/herself or the audience. Art can be a means for exposing self-deception, including defensive unconscious attitudes. In the search for truthful imagery, a truer sense of self emerges. For example, art students who paint trendy in-vogue imagery, while professing personal profundity, might reconsider examining their artistic motives.[2] This is the meaning of inner consistency, which addresses whether the artist is being honest with him/herself or, conversely, if defenses have overtaken personal expression. In the case of the latter, the result is visual self-betrayal or mundane stereotypy. Regardless of skill level, one can still pursue inner consistency. David Henley, protégé and accomplished synthesizer of Kramer's work, noted how strongly she felt about authenticity as an artist (D. Henley, personal communication, January 22, 2011).

Cit unfolds in the art process as the artist experiences moments of wakefulness. Awareness emerges through acts of untangling, forming, and transforming multiple inspirations into refined, synthesized compositions. Distillation and refinement represent qualities of discriminating perception. Furthermore, distillation is the act of making still the multiplicity of ideas and images that populate our thoughts. Created artwork serves as a visual, virtual witness, receiving, capturing, and reflecting back the movements of an active mind. As a process, art is replete with opportunities to develop awareness of self, other, and the environment.

Ānanda or bliss can surface at any moment during the art process. It simply feels good to serve images and give inner life tangible form. The translation process from idea, to action, to manifestation, to acceptance of the product is invigorating. Unsuspected joy emerges as clear visual communication is received and understood by others. To be accurately seen by way of our personal artwork contributes to self-esteem (Franklin, 1991). Investigating the full range of human subject matter, including grief and suffering, can result in fulfilled contentment. This sense of intuitive realization and acknowledgment from others afforded by the art process can connect us to a larger, blissful view of relational connections. Lastly, art encloses, conveys, and reveals expressions of *ānanda*. Sri Aurobindo (2004) viewed beauty as *ānanda,* taking form in the physical world. Art not only stimulates the senses; it also inspires pleasure. The full spectrum of life, including decay and mortality made available through investigations within the creative process, refines sensual perception and the ordinary, beauty of *ānanda's* ever-present abundance.

Sāṅkhya, the Three Guṇas, and Art

Sāṅkhya

Sāṅkhya, an ancient Hindu wisdom tradition, provides a system for understanding ontological categories of existence and how reality is known through classifications of "being-ness" or existence (Feuerstein, 2003). As with all traditions in yoga, there are many permutations to each philosophical canon. In the case of Sāṅkhya, reality is exponentially plural. Prakṛti represents the seemingly endless forms of the natural world. Simultaneously occurring alongside prakṛti are the transcendent qualities of puruṣa,/the Self as witness consciousness/awareness.

The Three Guṇas

Prakṛti is comprised of three main dynamic forces called the guṇas, which literally means "strand." Tamas (inertia/stability) represents dormancy, static, "inert and concealing" forces (Feuerstein, 2001, p. 75; Vivekananda, 2012). When we are complacent and bored and therefore blocked, we are gripped by tamas.

Rajas (fluid/kinetic) is movement, agility, and stimulation. When we are stirred up and agitated while creating, we are influenced by rajas.

Sattva (sublime/subtle essence) represents resiliency and illumination. When we are serene and unruffled in the art process, we are governed by sattva. Additional characteristics of the guṇas in prakṛti are as follows:

Tamas: dark, static, inactive, impenetrable, and dormant embodiment. A person behaves in a sedentary way with little or no exercise. Tamas manifests out of ignorance. Tamasic behaviors or lifestyles include being passive, fearful, and overeating. Food preferences in a tamasic lifestyle would be lots of meat and meals full of heavy carbohydrates and calories. One would leave the table stuffed. Artistic work may represent stuck ideas, rigid use of materials, or bloated content.

Rajas: energy, action, movement, change, transformation, and overdoing things. Rajasic lifestyle patterns would consist of being a workaholic; listening to loud, frenetic music; and engaging in a great amount of discursive thought. Food preferences would include spicy seasonings and overdoing stimulants like coffee or caffeine beverages. Artistic styles sometimes favor fast, spontaneous, methods. Activity is essential for manifestation. And so is receptivity—both live within balance as with sattva.

Sattva: harmony, lucidity, balance, joy, thoughtfulness, wisdom, equipoise, flexible perception of events and relationships. Ultimately,

sattva is a proportioned balance of *tamas* and *rajas*. Foods chosen would be fresh vegetables, fruit, lots of water, and one would not overeat. In fact, leaving the table slightly hungry would equate with *sattvic* personality traits. Compositionally, the artist works to achieve Kramer's evocative power, economy of means, and inner consistency.

Art-Based Connections

These three, irreducible qualities of *prakṛti* can be related to artistic processes, materials, and products. Whereas seemingly infinite combinations of the three *guṇas* are possible, they represent essential aspects of the creative process. Florence Cane (1951) referred to creative work as an alternation between active and receptive rhythms. Additionally, emanation and reabsorption can be added to this fundamental blueprint of the creative process (Silburn, 1988). When searching for language to articulate creativity, *tamas, rajas,* and *sattva,* known to us through art materials, enhance our vocabulary of activity and receptivity, emanation and reabsorption.

Art Materials

It is important to mention that any one material can contain all three elements of the *guṇas*. Oil paint applied in a thick heavy fashion could have a *tamasic* quality. Thin washes of oil paint could activate *rajasic* attributes within the artist and viewer. A balance of density and buoyancy in color usage that reveals striking qualities of subtlety, could imply a *sattvic* experience.

Any work of art can travel the pathway of all three *guṇas,* uniting and therefore contributing to the creation of significant and living form (Langer, 1953). Significant form, suggested Susanne Langer, expresses human feeling through corresponding symbolic structures. Line, shape, and color can hold and communicate a felt idea. Living form results when artworks of any kind express life and vitality through visual elements that show feeling (Julliard & Van Den Heuvel, 1999). Many artists describe moments of being artistically blocked (*tamas*). Movement from this stagnant state can be massaged through *rajasic* activity such as stream of consciousness writing or spontaneous mark making.

Directly working with the three *guṇas* was palpable while creating art during my cancer experience. There were *tamasic* moments when I was assaulted by the heaviness of uncertainty. When I was agitated, *rajasic* states of mind were present, and during moments of clarity, *sattvic* qualities were present. What I was thinking and feeling naturally fused with the artwork I was creating. This mixture of emotional states with the visual elements of art is also known as isomorphism.

Arnheim's (1966) work on isomorphism and his Gestalt theory of expression addressed how there is a similarity in organization between emotional states and the outer visual structures of art that emerge from those inner states. **What we feel, so we show.** The manifestation of the three *guṇas* in the work I created provided another avenue for observing isomorphic relationships of significant and living form within myself that ranged from chaotic thoughts to sedentary sadness to moments of clear awareness.

Art materials, depending on how they are used, will manifest the properties of the *guṇas*, as in the following examples: *tamas* can be referenced through stone, steel, and other dense materials; *rajas* can be accessed with watercolor and other liquid paints, or temporal, flowing materials that move such as film or video; *sattva* can be explored through layering processes such as collage, light sculpture, and other buoyant materials. Any material can be looked at in terms of its *tamasic, rajasic,* and *sattvic* traits. Two materials, clay and charcoal, are examined from this perspective:

Table 6.2. Example of the Three *Guṇas* Inherent in the *Prakṛti* of Art Materials

Materials	Tamas *(mass)*	Rajas *(energy)*	Sattva *(essence)*
Firing clay	Has mass, bulk, and density; is physically heavy, earthy; invites exploration of thickness, weight, gravity, flatness, and solidity; fires hard; perceived as dirty to some.	Thins and mixes with water, water eventually evaporates and becomes green ware; can quickly change form; undoing is fairly easy at various stages of the process; can blow up in the kiln due to the expansion of trapped air heated up during the firing process.	Is pliable, flexible; holds and communicates space; supports layering; holds and communicates opposites; has additive and subtractive qualities; awakens insight into transformation and resistances through the resistive qualities of the clay.
Charcoal (vine and compressed)	Is burnt wood; application yields dark, dense fields of solid black; absorbs light; undoing is difficult; perceived as dirty to some; areas can quickly become murky and fingers and skin can feel grimy.	Transforms from one form of carbon to another (wood to charcoal); smudges easily, challenging to blend, light areas can quickly change and become muddy as the material is added to lighter areas.	Produces chiaroscuro effects, rendering atmosphere and degrees of light; supports blending, holds and can represent opposites through application of darks and lights; has additive and subtractive properties when using an eraser.

An understanding of the three *guṇas*, as they relate to the use of art materials and processes, helps artists realize necessary aspects of their inner state. Within this context, the transformational capacity of different media can assist the artist in both noticing and shifting states and enduring traits associated with the *guṇas*.

Discovering *Prakṛti* through Clay

When people meet each other in India, they join their hands together at heart level in prayer position and say, "*Namaskar.*" This form of greeting has deep roots. According to Shri Vivek Godbole (1993) the five fingers represent the five elements. The left side of the body is *Śakti,* the universal *Kuṇḍalinī* energy, and the right side of the body represents *Śiva.* In *namaskar,* the elements, along with the embodied divine feminine and masculine unite, transcending duality as *Śiva* and *Śakti* merge and are offered to the person being greeted. I have observed this sort of hand gesture in two other instances: when people are praying and when they are at work on the potter's wheel.

I learned respect for materials and craftspersonship from my teacher, M. C. Richards. With humble passion, she prayed on the potter's wheel, namaskaring the clay into center. She worshipped this material for its receptive flexibility and reproductive genesis. For her, pottery was a collaboration with fire—indeed, with all of the elements of *prakṛti.*

Centering clay does look like praying. Once centered, the prayer continues as the clay is gently coerced to rise like a *liṅga* (the aniconic symbolic form of *Śiva*) and open like a *yoni* or symbolic womb-like appearance of *Śakti.* The finished pot simultaneously displays the solidity of form and the emptiness of space. The contrails of a completed pot reveal the coordination of five fingers as the five elements joining *Śiva* and *Śakti* to unite, contain, and transcend duality. Since a pot is at once solid and empty, it articulates qualities of "innerness" which are suggested, "but cannot be seen" (Richards, 1964, p. 20). These unseen attributes that M. C. Richards described demonstrate Langer's qualities of vital, living form (Julliard & Van Den Heuvel, 1999).

To Form Is to Transform

Earth as clay is made of organic matter that has simmered in the ground for millennia. This earth holds whatever it is asked to receive. Ground can burn, freeze, slide, regenerate, or sink. It grows our food and holds our rubbish. Humans bury their dead in her body and spread their ashes upon her surface. It is no accident that indigenous peoples held clay in high esteem since it retells the story of transformation while simultaneously containing the five elements of water, air, earth, fire, and ether or space.

This story of transformation begins with digging for clay. Once found, this moist viscera is brought to the studio. Next, artistic intentions are collaboratively merged with the clay by squeezing and pulling forms into existence (see Fig. 6.1). After the work is completed, the water element in the clay evaporates, resulting in a brittle bone-dry state. The transformation process continues by placing the clay object into the fire, one of the most powerful elemental forces. Out of the fire, it emerges hardened like stone. The final pot is open and empty, yet solidly formed. It is also a part of us, yet separate from us.

It is important to remember that any art material has its own media-based genetic code of implicit, transformative healing metaphors. We apply paint, scrape it, layer it, thin it, and mix it. We work large and also small. Similarly, we hold interior layers of large and small emotional memories that we metaphorically blend, aggressively rend, and gently scrape away in the act of painting. When working with materials and processes, consider how the three *gunas* are experienced in combination with the healing metaphors intrinsically present within your practice.

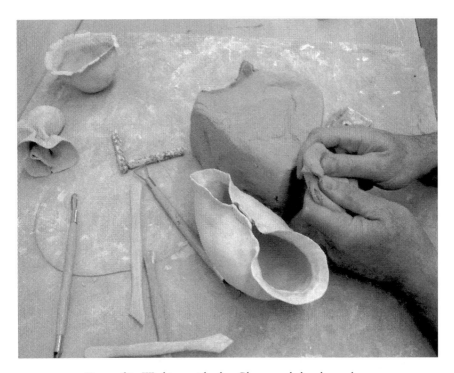

Figure 6.1. Working with clay. Photograph by the author.

Vedantic Yoga and Art

The Six Views of Oneness

Tat Tvam Asi, translated as That Art Thou, is a core expression of nonduality or *advaita.* Although the world we know through the senses and scientific instruments appears as a series of cascading realities, within and from the One come the many. Six expressions of this viewpoint emerged as distinct schools (Feuerstein, 2003, p. 260; Muktananda, 1979, pp. 3–4):

- *Sāṅkhya* School: perhaps the oldest tradition within Hinduism, sorts out the subtle and manifest categories of Spirit *(puruṣa)* and Nature *(prakṛti)* into the twenty-five *tattvas.*

- *Vaiśeṣika*[3] (Vaisheshika) School: presents a pluralistic view of reality. It has similarity to *Sāṅkhya.*

- *Nyāya* School: values logic as a practice for discovering interpenetrating realities.

- *Pūrva-Mīmāṁsā* School: expounds investigation through ritual in order to foster revelation of *dharma* or right action.

- *Yoga:* skillfully working with the management of thoughts, mind, and body in order to directly know ultimate reality.

- *Vedanta* School (*Uttara-Mīmāṁsā*): believes in the oneness unity of *Brahman* that transcends all conceptual categories.

Nondual Hindu-yoga traditions such as *Advaita Vedanta* are linked with the great sage Śaṅkarācārya (c. 788–820 CE) and profess belief in the oneness unity that transcends all conceptual categories. This unified perspective of refined awareness moves beyond all subject-object categories as the plentitude of life (Deutsch, 1969).

In addition to the *Vedanta* period, nontheistic, empirical *Sāṅkhya* is one of the other six original schools. *Sāṅkhya* is dualist and views the universe as ontological categories of existence to be codified for the purpose of contemplation so that pure awareness *(puruṣa)* can disentangle from *prakṛti* (Feuerstein, 1998; Hewitt, 1977). Both *Sāṅkhya* and *Advaita Vedanta* help to navigate the dual-nondual, solid and subtle realities of contemplative life. In fact, both free the contemplative artist to roam within these bounded-unbounded relationships of infinite form and universal formlessness.

Art-Based Connections

Art-based connections can be considered from at least two perspectives—process and product.

PROCESS

If we had the refined awareness to inwardly observe the unfolding process of emptiness becoming thought, speech, and action, we would realize that all that emanates from within emerges from a subtle conscious core. Within milliseconds, before there is awareness of the "I" thinking the thought, there is a nondual moment rising from emptiness. Before an action, before the impulse toward the action and before the realized thought, there is expansive possibility. Photography provides a helpful way to illustrate this point.

When wandering the streets with a camera among random events, we observe life around us in perpetual motion. We enter this flow of chance choreography as witness observers holding a powerful tool that can seize any moment, frame it, and fix it in time. Prior to awareness of the urge to click the shutter, there are moments of not choosing. Then a unique situation emerges. We spontaneously respond by aiming, focusing the lens, and photographing. But just before this decision is made, there is a gap of spatial emptiness within us and around us. Like the aperture of breath between an inhale and exhale, there is a fertile space of pause momentarily seen through the aperture of the lens. Implicit in the arbitrary events unfolding before us are numerous subjects to photograph, yet we choose one moment and click. Similarly, within us there is uninhabited freedom holding waiting potential. This is the nondual ephemeral moment when there is no subject, no choice, no urge; just a gap between silence, impulse, and action.

Process is an ordering of actions and relationships. In art, creative work unfolds in linear, nonlinear, spontaneous, intuitive, rational ways. Microsecond decisions are made to choose, not choose, and eventually act. The art becomes a record of options, selections, and edits. Meditation, combined with art, refines awareness of these microburst choice decisions. Opposite of self-conscious action, is acting from uncluttered wakefulness in a sort of non-doing way. Within this approach, art becomes an awareness practice revealing and noting the content of our process.

PRODUCT

The art product offers a glimpse of enlightened space by visually showing unified multiplicities. Stationary artworks such as paintings and sculptures present

integrated elements in a cohesive presentation (Julliard & Van Den Heuvel, 1999). Warm and cool colors or smooth and rough textures transcend their contrasting parts to become an interconnected whole composition. As awakened space is presented and mindfully perceived, a realization of how the many become a unified one is momentarily grasped. This is a unique reason why the arts are integral to contemplative practice. Paint, ink, and brush become extensions of mind as they transfer thought onto paper. Our hands and attention coordinate—not too conceptual and not too random. We hold the brush—not too tightly and not too loosely—to make mindfully felt marks.

Below is a painting by Florence Cane, a gifted artist and art educator working in New York City from 1916 to mid-century (Detre et al., 1983). Cane's knowledge of nondual iconography can be seen and heard in her description of this 1926 painting called "Immanence and Becoming":

> It developed from the idea of the small self in the state of becoming, and the greater self, or universal being, as in the state of Immanence, being eternally the same. The little figure is in a lotus flower, which is opened through great tenderness received from the spirit. The upper part of the painting is treated in reds and yellows and represents sunlight and the lower part night, or the moon and the darkness of night. The central triangle of light symbolizes a state of peace, and the smaller triangles to the left and right represent the terrifying force of the everyday world.

The relationship between the small ego-based self and the *Ātman*-Self of universal consciousness in this painting underscores the essence of spiritual life and spiritual work realized though creative efforts. The integration and transcendence of opposites is observed as the sun and moon, perhaps masculine and feminine principles, harmonize together. In this artwork many parts unify, revealing spiritual migration toward the One Supreme Reality.

The *Yoga Sūtras* of Patanjali and Art

A major work in classical yoga from the period of the second to fifth centuries CE that organizes the transcendental qualities of yoga is Patanjali's *Yoga Sūtras* (Chapple & Viraj, 1990; Feuerstein, 1989; Hari Dass, 1999; Hartranft, 2003). The *Yoga Sūtras* were written in four parts or *pādas*[4]: *Samādhi Pāda* (the absorbed state of attention), *Sādhanā Pāda* (spiritual practice and discipline), *Vibhūti Pāda* (the extraordinary powers of manifestation), and *Kaivalya*[5] *Pāda*

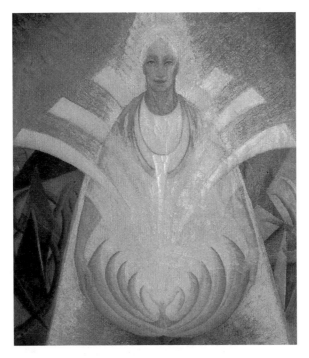

Figure 6.2. *Immanence and Becoming.* Oil painting by Florence Cane, painted in New York City in 1923, 33" × 36". Example of *Sāṅkhya*-Vedanta iconography. Gift to Naropa University by the Cane family.

(solitude, isolation and yogic emancipation) (Castillo, 1985; Chapple & Viraj, 1990).

Within this text, Patanjali combines, clarifies, and maps the liberating practices of yoga, including ethical lifestyle and the sacralizing transformation of consciousness (Castillo, 1985; Feuerstein, 1989). Cogent instruction is offered that exposes conditioned, flawed views of reality and, consequently, why we suffer. A pathway beyond this confusion is presented through the use of self-reflective methods to quiet our habitually active minds. If we could settle our thoughts toward stillness, then we would behave from this tranquility rather than from unchecked opinions or desires. Like disturbed water in a pond, the surface becomes clouded as the debris of our thoughts is stirred. Once the current of the whipped water settles, similar to our active minds, we begin to see the true nature of how mind and thoughts behave. This is the message of *Sūtra* 2, which states "control of thought waves in the mind is

yoga" (Hari Dass, 1999, p. 5). In addition to the fruits of practice or *sādhanā*, Patanjali emphasizes the return to subtilization and the goal of *Samādhi* (the yogic transcendent state of equanimity accessing higher states of consciousness).

Patanjali's Eight Limbs of Yoga

According to Christopher Chapple and Yogi Ananda Viraj (1990), yoga practices have the power to end emotional grasping by increasing "subtilization of one's focus" away from frivolous physical/sensory distractions toward acquired states of sublime awareness (p. 4). The following chart outlines the eight limbs of practice that yield these inspiring contemplative results:

Table 6.3. Patanjali's Eight Limbs of Yoga

Samādhi (unity awareness)	*Yamas* (moral discipline)	*Niyamas* (observances for inner pilgrimage)
Dhyāna (forms of meditation)	(SELF)	*Āsana* (physical postures)
Dhāraṇa (contemplative concentration)	*Pratyāhāra* (sensory discipline-inner attention/awareness)	*Prāṇāyāma* (breath work)

THE YAMAS AND NIYAMAS

The *yamas* (five restraints or abstentions) offer instruction on how to behave and live a principled moral life. The *niyamas* (five observances) cultivate a deeper relationship to the one unifying reality.

Table 6.4. The Five *Yamas*

5 Yamas *(moral discipline for self-discipline so as not to harm others)*	
Ahimsā	To not harm; to be nonviolent with our thoughts, behaviors, and actions
Satya	Truthfulness with our thoughts, behaviors, and actions
Asteya	To not steal, dispassionate orientation—not influenced by strong emotional desires
Brahmacarya	Chastity for transcendence by conserving energy, like self-restraint with frivolous sexual urges and desires
Aparigraha	Releasing the urge to grasp with materialistic greed

Table 6.5. The Five *Niyamas*

5 Niyamas *(deepening the inner pilgrimage to the Self)*	
Śauca (Shaucha)	Dispassionate physical and mental purification—right decisions with food, rest, activity/social engagement
Santoṣa (Santosha)	Being content by releasing attachments; working with craving behavior
Tapas	The heat *(tapas)* generated by commitment to austerity for stillness; reducing the flow of outgoing energy
Svādhyāya	Study of the Self—becoming an observant student of oneself, sacred texts, and practices such as mantra recitation
Īśvara-praṇidhāna (Ishvara-pranidhana)	Devotional alignment with and surrender to the Divine, to cultivate pure awareness in the service of the Divine

AHIṂSĀ AND ART

Ahiṃsā is fundamental to all yoga and all spiritual traditions. One might argue that many spiritual practices proceed from a similar nonviolent attitude to not harm. As a cardinal virtue to aspire toward, *ahiṃsā* implies protective appreciation for all forms of life. Nonviolent, ethical behavior is the practice of this truthful morality in action.

ART-BASED CONNECTIONS

Ahiṃsā, one of the five *yamas,* can be practiced through exercises that cultivate nonviolence. Art has the capacity to transform clumsy seeds of base urges into symbolic counterparts representative of the original, now transformed impulses. From this perspective, art becomes a yogic practice of excavating right action or *dharmic* behavior. This view of art as yoga is not about self-censorship of impulsive aggression. Rather, art as yoga is the willingness to understand and work skillfully with powerful impulses. From this orientation, the artist converts base desires into art for contemplative processing. The arena of art, like the body in haṭha[6] yoga, is a place to practice flexibility of mind, body, and behavior. There is a difference between fusing unconscious aggression with mark making and holding awareness of aggressive impulses while making the same marks.

One reason why harm is relentlessly perpetrated against webbed eco-systems across our planet and throughout time has to do with stunted, profit-driven, immoral perception. Sadly, we are not trained or educated to carefully observe and see. The propensity to do harm begins with failures of imagination and lack of contemplative perception. Consequently, I would

argue that ecological, systemic vision needs to be taught within all levels of our education system. Ethical seeing is intimately connected to ethical behavior. If we were awake with visual discernment and really saw the full spectrum of life, we would reduce ecological damage. Yet people often harm because they hurt. They identify with aggression because they have been traumatized. One way to tolerate such intrusions is to become like the aggressor (A. Freud, 1937/1978). Aside from identifying with the provoker, which perpetuates generational trauma, there are other pathways to consider. Beauty, as Sri Aurobindo noted, is how we locate and find the *ānanda* aspects of our moral identity.

Laura Sewall (1995) offers a model of intentional visual engagement for untangling existential isolation. Matters of relational alienation within daily existence can be connected to an absence of reverent perception. Suzi Gablik's (1991) and Sewall's (1995) suggested remedy for separation is to cultivate awakened observation where seer and seen become one and the same. Open attendance to positive and negative visual culture is the opposite of psychological numbing. Instead, we remain perceptually connected rather than numbingly severed.

ĀSANA, PRĀṆĀYĀMA, PRATYĀHĀRA, DHĀRAṆA, DHYĀNA, AND SAMĀDHI

Additional limbs are *āsana,* which addresses attention to the body and the importance of postures that promote physical and psychological health; *prāṇāyāma,* which focuses on the science of skillful breath regulation, control, and management of overall inner energy systems; *pratyāhāra,* which consists of mindfully withdrawing our sensory awareness from incoming stimuli and turning attention inward; *dhāraṇa,* relates to disciplined concentration; *dhyāna,* refers to contemplation; and *Samādhi,* infers Self-realization. The latter three help to cultivate indrawn awareness, concentration, and liberation (Ajaya, 1976; Hewitt, 1977).

ART-BASED CONNECTIONS

These core principles of yoga practice (*āsana, prāṇāyāma, pratyāhāra, dhāraṇa,* and *dhyāna)* support a contemplative working methodology in the art studio. In many ways, art is a decelerating technology for practicing the eight limbs of yoga.

ĀSANA: THE BODY AS THE ULTIMATE FEEDBACK SYSTEM

There are a wide range of considerations to ponder regarding art and the body. For example, *āsana,* with its focus on correct bodily postures, would call

attention to how we physically orient to the easel, potter's wheel, or editing table. Then there are the health and safety awareness standards of the Occupational Safety and Health Administration (OSHA) to consider. Artists work with chemicals, toxic materials, and in some cases dangerous processes such as bronze casting. Protecting the body is the *dharma* of the artist. Mindful lifting, sitting, and moving are constantly happening in the studio.

Within the context of the *Yoga Sūtras, āsana* means relaxing solidified definitions we hold about our bodies. Overall, embodied intelligence is promoted from a haṭha yoga perspective of *āsanas*. Cultivating and listening to a limber, smart body continuously informs the art process. Overall, art is an embodied, whole brain practice of physically using a range of materials and processes.

PRĀṆĀYĀMA AND CREATION: BREATH AS AN ART MATERIAL

The first thing humans do when they enter the world is inhale. Their last act before death is to exhale one final time. In between these two points is a flow of countless inhales and exhales, or small deaths. In any given lifetime, we literally experience millions of micro deaths as we breathe.

Figure 6.3. Practicing *Kuṇḍalinī* Yoga, teacher Jo McBride. Photograph by the author.

When relaxed, most adults breathe in and out approximately fourteen times per minute or roughly 840 times an hour. If a work of art takes twelve hours to complete, then like wallpaper in the background hang approximately 10,080 rounds of breath. Artworks then are repositories of life force and also numerous minute deaths.

Prāṇāyāma, or breath management, extends the contemplative manifestation of life force energy implicit in the art process. Through art materials and processes, we make vital forces visible. Awareness of breath, as the essence of inspiration, fuses this fundamental power with artistic intentions.

It is no accident that spiritual traditions focus on the breath as a vehicle for centering concentration and preparing for a graceful exit during death (Sogyal Rinpoche, 1993). As the vehicle for life force or *prāṇa*, oxygen is our most important food (Hewitt, 1977; Yogananda, 2003). In Buddhism, *prāṇa* is said to be "the vehicle of the mind" because the mind could not move without this precious life force (Sogyal Rinpoche, 1993, p. 68). Neither could a paintbrush. Breath, which is behind and within all that one does, reminds us that although the body is experienced as solid, *prāṇa* is energetically subtle. There are five primary forms of *prāṇic* energy outlined in the following chart:

Table 6.6. The Five Primary Forms of *Prāṇic* Energy

Name	Definition	Art-Based Connections
Prāṇa (inhalation)	Inbreath or breathing in vital energy into the body	Visual inhale, receiving or subjectifying sensory information for creative work (input)
Apāna (exhalation)	Expelling, releasing vital energy	Visual exhale through art, externalizing or objectifying subjective material for tangible work (output)
Vyāna (distribution)	Circulates pervading vital life force	Silent spaces between actions, space between subjectifying and objectifying—circulation of the creative process (through-put)
Samāna (assimilation)	Absorption and integration of assimilated vital life force	Metabolizing images for expressive work
Udāna (breath for speech)	Taking the breath upward for speaking	Visual speech—breathing up and into the manifestation of symbolic language

To look at the world, be it another's artwork or an engaging landscape, equals a visual inhale. Arriving at a final art product is like seeing a long, unified visual exhale take shape. Between a visual inhale and exhale is a fertile space of potential materialization where images have a quality of spirit, which originally meant "breath" (*spiritus*) and "soul." When communing with artworks, an exchange of wisdom and soul occurs by breathing life-force back and forth between the viewer and art object. Breath, as the essential animating force, is what drives the entire creative process.

Like working with clay, when engaged in contemplative practices we are taking ourselves apart and rebuilding, losing, and finding ourselves. All art materials inwardly hold their own version of this process. Through the materials and through the breath, *spanda*-inspired images emerge to be seen and known. Every object created thus has as part of its essence the *prāṇic* life force of the artist contained within.

PRATYĀHĀRA: ARTFULLY AND MINDFULLY FILTERING THE TIDES OF EXCHANGE

Prāṇāyāma significantly aids the cultivation of *pratyāhāra*. This was perhaps the most meaningful filter utilized during my cancer experience. By monitoring incoming stimuli and concentrating on witnessing my thoughts, I was less inclined to become emotionally hijacked by fictional anticipation. Withdrawing my sensory attention from derailing stimulation and turning this awareness inward resulted in a cleared pathway for focused engagement with creative work. I also leaked less emotion, which meant I had more vitality to call upon for artwork and daily chores.

Often referred to as withdrawing the senses, I prefer to think of *pratyāhāra* as managing the incoming and outgoing tides of sensory exchange. The sensual world offers tempting distractions. Yoga is learning our triggers and managing impulses with awareness. If we can reverse the tendency for attention to flow outward unchecked, then the result is a sense of inner sanctuary. Becoming acquainted with indrawn awareness builds an architecture to house silence.

DHĀRAṆA AND DHYĀNA: ATTENTION, INTENTION, AND ABSORPTION

Art often requires absorbed attention so that we may concentrate on the quiet intimacy of creative work. Collaborating with images demands attention to the exchange between visiting content and our response to these visitations. The processes, as well as the product, are ripe for contemplative investigation.

Discovering how to interiorize yoga by managing the senses deepens the internal aspects of practice. As a result of this understanding, further development unfolds through *dhāraṇa*[7] and *dhyāna*.[8] Art processes and practices

cultivate receptive awareness of the interstices between subject and object rela-
tionships. Pioneering art therapist Elinor Ulman (1975) addressed this fun-
damental binary relationship in art as the meeting ground between inner and
outer relationships. Of art she says:

> Its motive power comes from within the personality; it is a way of
> bringing order out of chaos—chaotic feelings and impulses within,
> the bewildering mass of impressions from without. It is a means
> to discover both the self and the world, and to establish a relation
> between the two. In the complete creative process, inner and outer
> realities are fused into a new entity. (p. 13)

Since so much attention seeps out through our eyes, best to develop
skillful seeing of subject/object relationships. Looking outwardly at an object
or scene can be a superficial experience. Deepening our capacity for reverent
I-Thou vision is aided by holding attention, particularly to the heart area, while
watching the world unfold before our eyes. The result is that we learn to look
inward while outwardly seeing with heartfelt connection. Similarly, while hold-
ing a paintbrush or looking at a work of art, holding bidirectional awareness
of the inner state while observing the art event strengthens witness awareness.

There are several ways to practice *dhāraṇa* in the studio. First, consider the
relationship between observation and concentration. We can observe tangible
objects and processes, such as using a paintbrush. How to hold it, change
positions, modify our grip, slant the brush, and load it with paint all refer to
attention, intention, and action. Another way to work with *dhāraṇa* techniques
and concretized images is to mindfully look at finished work or work in prog-
ress. Below is a strategy for attending to work in progress or finished projects:

1. Approach the work without judgment, like when meeting
 a stranger of interest for the first time. Allow the work to
 simply be. Observe at first without an agenda: do notice rising
 judgments, but bracket them out of your awareness for now.
 Write them down, however, place them to the side so they
 no longer distract you. If relevant, refer to these projections,
 musings, or judgments later.

2. Engage with a phenomenological description of the formal
 elements (Betensky, 1977). Consider form as representative of
 content. Without interpreting, describe the qualities of line,
 shape/form, color, texture, size/scale, symmetry, foreground/
 middle/background, or any other element related to what you
 are encountering. If there is text, then describe or paraphrase back
 to yourself what you are reading. If film, observe the language
 of edits and transitions as well as the complexities of character

development. The goal at this stage is to caringly and rigorously observe and work through the formal qualities in order to get to shades of content. Always consider cultural elements implicit in artwork, such as gender, class, ethnicity, geographical region, or economic background of the person and the times.

3. Engage imaginal contact with the work. Look at the overall work and also the simultaneous parts. Consider context-mood-scene relationships throughout the parts and whole presentation. Listen to, write down, and note the narrative within the imagery rather than judge or defend it. Refer to Appendix C and the Imaginal Skill Building Rubric.

4. Now gather your personal associations to the work. What do you see? What is it telling you? Put steps one through three together.

PATANJALI'S MAP

Art can aid this process by serving as a reflective surface to see emanations of mind from extreme, chaotic states to calming silence. We learn to see the visual vocabularies of chaos and stillness in our work, which is the focus of the *Yoga Sūtras* (Hartranft, 2003). For this reason, many practitioners find Patanjali's map so appealing. Below is a Venn diagram to further help conceptualize aspects of the *Yoga Sūtras*.

Table 6.7. Limbs of Yoga Applied to Forming/Informing/Transforming through Art

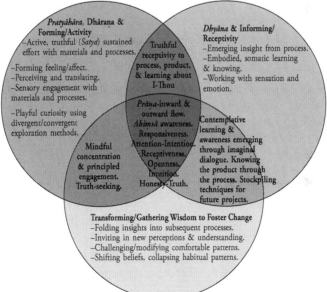

Kashmir Shaivism and Art

Kashmir Shaivism began around the ninth century in Kashmir, rendering the apotheosis of *Śiva* as the highest truth (Muller-Ortega, 1989). Kashmir Shaivism is also referred to as *Trikā,*[9] which stands for the eternal threefold topics of God, soul, and matter (Muktananda, 1979). Feuerstein (2001) refers to *Trikā* as three aspects consisting of "*Shiva* (the male pole), *Shakti* (the female pole), and *Nara* (the conditional personality seeking liberation)" (p. 265).

According to Swami Muktananda (1979), Kashmir Shaivism or *Trikā Shaivism* is divided into three broad parts: *Āgama* (tradition/revelatory scriptures), *Spanda* (systemization of the literature), and *Pratyabhijñā* (logical interpretations of the literature) (p. 2). Overall, *Trikā Shaivism* expounds the "origin of spirit and matter" along with the nature of "Ultimate Reality" including the *Spanda* impulse of creation (p. 5). The underlying premise of this far-reaching philosophy is that there is one definitive reality, *Śiva,* consisting of two aspects. The first Reality (*Prakāśa;* Prakasha), transcends the universe. The second (*Vimarśa;* Vimarsha) operates through it (p. 5). Furthermore, Kashmir Shaivism beautifully explains what other systems thoughtfully describe (Jee, 1988).

Śiva and Śakti

Different than the trinity of *Brahma, Viṣṇu,* and *Śiva* discussed earlier, this perspective of *Śiva* embodies manifestation, preservation, and necessary destructive cycles. *Śiva* is viewed as pure consciousness with inseparable *Śakti* as the manifesting power. If the entirety of Creation were to be represented by one deity or cosmic being, it would be the creator/preserver/destroyer that is *Paramaśiva* (*Śiva* as Supreme Lord) (Jee, 1988; Muller-Ortega, 1989; Zimmer, 1946). Along with his consort *Parāśakti* (Parashakti: *Śakti* as Supreme power), they begin Creation together in their form of pure light. While difficult to conceptualize, consider the essence of creation as untainted light that is the highest, quintessential presence of all quivering energies emanating as the all-encompassing freedom to manifest. *Spanda* is the primordial throb that originates within this context of *Śiva's* ecstatic Divine play. In loving unison, *Parāśakti* and *Paramaśiva* initiate a blissful *spanda* pulsation from within their transcendent reality, in the service of ultimate creation. The great silence of the *anima mundi* or "universal spirit," crescendos with a primordial tension where *Śakti* lovingly agitates this stillness into a wave configuration within the Absolute. This wave formation is the flickering of consciousness self-referring itself into "the foundation essence of all manifest reality" (Muller-Ortega, 1989, p. 120). Included in this perspective is the palette of subtle interiorized tremors, emanating from the core of consciousness within the artist, initiating the creative process.

For some, particularly Westerners, the notion of a Hindu deity as conscious essence manifesting the many from the one can border on inaccessible mythology, obtuse folklore, or even heretical doctrine. And yet there are limitations to the points of view of individual perceptual reality or consensus reality. These primary lenses for meaning making trick us into believing this is all there is. Existing as wave/particle potential, similar to *Shaivism,* nonmaterial quantum concepts from physics insist otherwise (Capra, 1975, 1996; Stone, 2012). As demonstrated by artists such as Lynden Stone (2012), accessing, researching, and contemplating quantum ideas through art is possible. Artists usually do not speak the language of the scientific academy. However, they do often feel at home loosening rationality and using artistic processes to research and contemplate indefinable subjects like those proposed here.

Śiva and *Spanda*

In order to conceptualize the primordial throb/wave of *spanda* and imagine the vastness of this subject, a name is needed along with a visual reference. Thus, *Śiva,* using his complete freedom (*svātantrya*) to create any aspect of this entire living universe, becomes synonymous with universal consciousness (Jee, 1988; Muller-Ortega, 1989; J. Singh, 1992). In this sense, *spanda* as rhythmic movement toward expansion and contraction, is the initiating origination of any creative act. With complete freedom, the cradle of conscious intelligence known as *Śiva* references its creative potential of *Śakti,* to quiver into existence through a throbbing impulse to manifest any or all possible forms. One can become aware of the continual unfolding of creation that is *spanda* by mindfully observing artistic manifestation as impulse becoming will and then merging into action.

Spanda is when "the power of consciousness is recognized to be the spontaneous expression of the absolute made manifest" as endless forms "without compromising its essential unity" (Dyczkowski, 1987, p. 79). Abhinavagupta, a great sage of the Kashmir Shaivism tradition, addressed this viewpoint with the following statement:

> Creation is to make that which shines within, externally manifest while it still preserves its original internal nature. Therefore, [the object] must be made manifest by that in relation to which it is said to be internal and which makes the internal externally manifest. (cited in Dyczkowski, 1987, p. 79)

Additionally, *Śiva* has access to infinite *spanda śakti.* In fact the "perpetual *spanda* creative pulsation" is the essential nature of God (J. Singh, 1992, p. 10).

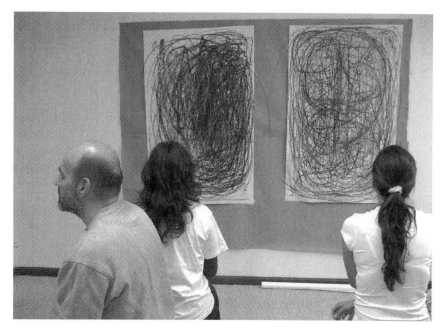

Figure 6.4. Observing the *Spanda* impulse in Artwork. Photograph by the author.

The universe is therefore a continual "opening out" of *Śakti's* ever-unfolding expansions. According to Swami Muktananda (1979), the five main *Śaktis* are:

1. Self-revelation, or *cit-śakti*.

2. Absolute bliss, or *ānanda śakti*.

3. The will to create (not desire), or *iccha-śakti*.

4. The power of knowing, or *jnāna-śakti*.

5. The power or action to assume any form, or *kriya-śakti*. (pp. 7–8)

Art-Based Connections

All five *Śakti*s relate to art-based ideas, processes, and products. Consider how art reveals, brings joy, tempers will, unfolds meaning, and manifests immanent and transcendent awareness. When considered from a contemplative perspective, human creativity is a process of mindful manifestation. Conceiving questions, surfacing problems, envisioning solutions, and then resolving the problem is all part of the creativity equation. Not only can this template be

applied to art but also to larger life lessons as well. So much of the creative process is precognitive. Self-expression emerges when unrecognized "Consciousness reposes in blissful self-awareness," revealing "the dynamic impulse toward self-expression" in art (Wallis, 2012, p. 107). Long before we make our first mark with charcoal, inner stewing is heating up with inspiration.

My own cancer diagnosis supported a meaningful journey into a tantric yoga view of creativity. Between initial denial and eventual acceptance were many hours of silent practice culminating in an embrace of my private circumstances. Creative process, particularly with the fire materials of charcoal and clay combined with meditation, became a tangible, silent place of refuge. It was here where I could minimize intrusions other than the interruptions of my own thoughts, which eventually settled down to become actual art objects. Committed participation in art and meditation facilitated processes of letting go and dissolving old thought patterns (*saṃskāras*), which eventually led me to embrace a new understanding of struggle and transformation. As an aside, repeatedly referencing my cancer experience is not meant to convey a private, context specific view of art as contemplative practice. This is only an example and is not intended to infer approaches to art that rely on illness or other forms of struggle as primary subject matter.

Reframing creation as a progression of *spanda*-like events becomes a liberating perspective. The forces of erosion that carved the Grand Canyon are also alive inside of us. If everything is in process, then everything is unfolding in such a way that if we pay close attention, we can notice threaded connections. Like the artist whose work spills forth out of joyful desire, *Śiva* with *Śakti* as supreme artists pour forth their pulsating affection for Creation as artistic creation. According to Shaivism, this entire universe is an outer reflection of Lord *Śiva*'s vast mind. Through the blissful revelation of creative will, any form can emerge from this original reflection in tandem with the *spanda* impulse.

The Five Acts of Lord *Śiva* and Creation

Pratyabhijñā is an outgrowth of Kashmir Shaivism dating back to the ninth century and the sage Utpaladeva. This school considers how the human condition of narrow understanding, stemming from solidly held beliefs, results in forgotten knowledge of our true identity or Self. In the eleventh century, Kṣemarāja[10] (Kshemaraja) wrote the *Pratyabhijñā-hṛdayam*,[11] which translates as "The Heart of Self-Recognition" (Shantananda, 2003; J. Singh, 1998). Key here is that our true Self can be recognized and known. This celebrated text and corresponding school described numerous insights into manifestation, the ontology of the *tattvas,* and self-realization. Related to manifestation are views of creation, specifically the five acts of Lord *Śiva* (Shantananda, 2003; Zimmer,

1946). They are emanation or creation (*sṛṣṭi,* sristi), maintenance (*sthiti*), dissolution or destruction (*saṁhāra*), concealment or veiling (*vilaya* or *tirobhāva*), and the dispensing of grace (*anugraha*) (Zimmer, 1946, p. 154). Through these five acts, *Śiva* carries out all creative processes that unfold the cosmos.

All five acts are actions that can simultaneously manifest in any unfold-

Table 6.8. The Five Acts of Lord *Śiva*

Five Acts of Lord *Śiva* or Five Cosmic Activities (*Pañca-kriyā*) This blueprint of creation and creative process is presented below along with how this model relates to universal qualities of the artistic processes (Shantananda, 2003; Zimmer, 1946)		
Descriptions	*Explanations*	*Art-Based Connections*
*Sṛṣṭi-*creation	Emanation, pouring forth, unfurling	The emerging nondual *spanda* moment before conceptual thought. Inspired freedom feeding waiting potential.
*Sthiti-*maintenance	Duration	Artists use temporal elements such as erosion, impermanence, metamorphosis, and preservation to explore realities of time as an art material.
*Saṁhāra-*destruction	Dissolution, reabsorbing, taking back	Often defined with negative connotations, destruction is a necessary part of any creative process. Progress depends on the fermentation or breakdown of restrictive habits. Erosion, obliteration, and eradication followed by resurrection and revitalization are implicit within imaginative practices.
Vilaya or *Tirobhāva-*concealment	Veiling truth by way of illusion—māyā	Art makes the psyche visible by consolidating layers of conscious and unconscious experience and then transporting this material into visual symbols. Hidden content is now visible and available for contemplation and creating. Art can refine perception, whittling away at illusions that veil truth. And art can also express veiled, unconscious material.
*Anugraha-*grace	Revelatory manifestation	Surprise moments of artistic revelation happen as novel discoveries are made. Creatively combining unrelated subjects removes the illusion of separateness. Deepening these aesthetic connections stimulates the blissful feeling of inter-connected relationships, including the oneness of the inner Self with permutations of the outer Divine.

ing moment. Like *Śiva*, we artists carry out the *Pañca-kriyā*[12] (Pancha-kriyas), or the Five Cosmic activities throughout our day and certainly in artwork. Embedded in any creative process, they offer a helpful model for observing the fundamental pulse of artistic work. Observing the five acts on any given day can inspire what Abhinavagupta recognized as the practitioner's capacity to realize the freedom to engage the five operations (Shantananda, 2003, p. 207). In fact, these five acts offer a slowed-down view into the subtleties of creative work. Taken together, they suggest appreciation for contemplative approaches to art. Each act could be the subject of a separate artwork helping to articulate and make connections between the subtleties of the creative process.

Art-Based Connections

The five actions of Lord *Śiva* could be observed in the art process in the following ways. A painter sets up her easel in an inspiring landscape. The distant formation of hills and trees emanates inspiration (*anugraha* or grace). This beckoning is a way to visually inhale and join with the waiting revelations present in both the landscape and the creative process about to unfold. Next, the artist is moved to respond by making those inspirations manifest. Soon thereafter, the artist begins to apply paint and engage in her craft of creation (*sṛṣṭi* or emanation). Thoughts of the details in the painting are held, translated, and maintained in perceptions both on and off the canvas (*sthiti* or maintenance). Eventually, moments occur when the artist responds to inevitable flaws that demand undoing and redoing. Thus, dissolving previous ideas and repainting different sections is intrinsically required (*saṁhāra* or dissolution). All kinds of blocks can emerge at this point that seem to paralyze the next moves needed to further the painting process. During these moments the artist is experiencing *vilaya*, or concealment, whereby progress is stalled by inaccessible, perhaps suppressed information or even self-doubt. On the other hand, if the artist embraces the notion that there is opportunity in this confusion then *anugraha*, or the dispensing of grace, is set in motion.

In addition to cycling through the art process, the five acts of Lord *Śiva* constantly cycle throughout all living processes and systems. When the Yellowstone fires ravaged the park in 1988, the entire landscape was parched. The destruction was unprecedented, charring miles of forest. Today, this same land is fecund and green as it was before the burn. As the five acts of Lord *Śiva* demonstrate, all creation embodies the constant oscillation between emanation,

manifestation, maintenance, concealment, and graceful emergence. To see creation as a process that embraces only manifestation or simple beauty is to miss the point. Attachment to one point of view negates the vision of the five acts of *Śiva*, and consequently, artistic discovery. In addition to the qualities of these five acts, it is essential to consider how the *Śakti* moves from the subtle to the manifest in images and speech.

Mātṛkā Śakti and the Origin of Images

The five acts of Lord *Śiva* together with the theory of the alphabet, *mātṛkā śakti* (matrika shakti) or *mātṛkācakra* (matrikachakra), can link the subtle processes of universal creation with visual and verbal symbols as they are formed. Deep within the shadows of human consciousness, subtle sound matrices rise to become letters, which eventually become words, which ultimately create cognitions or thoughts that contribute to perceptions of personal reality. As an art therapist and art educator, my interest in this material originates from my curiosity about the origins of speech and how words represent pictures that import symbolic meaning. Speaking and writing weave these picture-sounds called words together in a way that conveys experiential value. When I studied ceramics with M. C. Richards, she used to wonder out loud where the words were before they were spoken. This comment eloquently sums up the subject of *mātṛkā śakti* and my curiosity about the origins of verbal and visual language.

Words are the garments of the breath. Before they exist in manifest form, they emerge from subtle quintessence, specifically the five *Śaktis* of: *cit* or consciousness, *ānanda* or bliss, *icchā* or will, *jñāna* or knowledge, and *kriyā* or action. Images, too, first exist in silence, eventually coagulating into solidified or conceptual form through the five *Śaktis*. As a primary healing phenomena within the psyche, images hold a numinous potency that continues to inspire a series of questions (P. Berry, 1982; Hillman, 1978; McNiff, 1992; Watkins, 1984). From where do they emerge? How are they formed? What is the relationship between words, sounds, and images? To understand this complex subject, Kashmir Shaivism and *mātṛkā śakti* are consulted for their view of sound as the matrix of the cosmos, and therefore, all mantras verbal or visual (Feuerstein, 2001; Jee, 1988).

Swami Lakshman Jee (1988) offered clarification of the contemplative science of sound, or *mātṛkācakra*. The evolution of subtle consciousness emerging through stages into gross or manifest form is also relevant for

visual art. A spoken word or artwork reversed backward toward its origin would lead to the very genesis of *Śakti*'s untainted, pure, essential genesis state. If inquiry into the origins of sound and speech is possible, then these constructs can seemingly be applied to the emergence of image-based narratives.

Four Levels of *Vāk* within *Mātṛkā Śakti*

Swami Muktananda (1989) discussed *mātṛkā śakti* as the power matrices of sound imbedded in the alphabet. He wrote:

> From letters, a word is formed with its own meaning. From words a sentence is formed with its own meaning. That meaning carries an image. Once an image is formed, you begin to feel good or bad. . . . If you divide the letters of a particular word, those letters have no meaning in themselves. For example, take the word fool. Now, if you just say these letters—F-O-O-L—one at a time, in themselves they don't carry any meaning. But when you combine these letters and say "Fool!" it really has its own power. It has meaning and it bears fruit too. The fruit of words is either painful or pleasurable; sometimes it is sweet, sometimes bitter, sometimes sour. This is a brief explanation of *mātṛkā sakti*. (p. 385)

Important for this discussion is how Muktananda, an enlightened meditation master, infers that meaning is carried as *image*. Not only does sound migrate through levels of subtlety to manifestation, so do images. How sound and image are ultimately cognized determines right or wrong understanding or perception. Simply, the world is how we see it and say it to ourselves.

The letters DSA mean little until rearranged as SAD. Once realized, associative thoughts and images start to riff in different directions of personal meaning. Sound becoming letters and eventually speech powerfully directs our thoughts. Behind each word is a supreme power that generates conscious and unconscious mental processes. The four levels of *vāk*[13] within *mātṛkā śakti* address how the subtle, pre-sound state moves to a manifest state.

Table 6.9. *Mātṛkā Śakti*

Four Levels of *Vāk* within *Mātṛkā Śakti*		
The power and trajectory of sound matrices move through coalescing stages of formation. Emanating from subtle, internal essence consciousness to manifest speech, images, and art forms (Shantananda, 2003). Note: vāk means speech.		
Parā-vāk Descriptions: The origins of pure silence emerging from Kuṇḍalinī as Supreme speech.	Explanations: The waiting potential that originates as sound essence. The most subtle level of internal sound or nada.	Art-Based Connections: Similar to sound, images seemingly coalesce and start to emanate their emergent trajectory from this innermost subtle level of consciousness.
Paśyantī-vāk Descriptions: Sound as an image before actual thought.	Explanations: Joining together at this level is sound as a latent image eventually becoming conceptual thought.	Art-Based Connections: Before images become thoughts, they are forming latent, not yet thought content.
Madhyamā-vāk Descriptions: Intermediate sound, speech, or image.	Explanations: Sound here merges with thought and eventually speech.	Art-Based Connections: A preconscious level of artistic work where images apparently merge with thought. Changes from being out of awareness to becoming accessible.
Vaikharī-vāk Descriptions: Manifest sound, speech, or artwork.	Explanations: Spoken audible sound. The subtle is now manifest in its final, more perceptible form.	Art-Based Connections: Manifest, seen, actual created content. The product, if observed in reverse, has moved through several stages of materialization.

PARĀ-VĀK

The deepest and most subtle level is called *parā-vāk*, meaning the "supreme speech" (Shantananda, 2003, p. 235). *Parā-vāk,* which is beyond the *tattvas* (categories), is the pure presence of the Divine within, as *Śiva* in union with *Śakti,* rising out of nondual silence toward manifestation. Within each person, this realm of "soundless sound" is the origin of pure consciousness where all waiting potential exists (Feuerstein, 1998, p. 189). *Parā-vāk* subsumes all forms, all words, "all objects, all beings—everything that is to compose the created universe" (Shantananda, 2003, p. 238). Furthermore, at this level *parā-vāk*

is alive with pure potential. It is where the Supreme *Śiva* with *Śakti* literally quiver as *aham*, or "I am," which is the very pulsation of the Self within each of us (Shantananda, 2003, p. 238). The entirety of creation, with her infinite vibratory sounds, exists in the silence of this great void of genesis potential where yet to be formed images exist.

When creation manifests vibrationally as sound, *Śakti* manifests as *parā-vak*. Spoken phonemes are basically externalized, gross expressions of "phonemic energies" (Dyczkowski, 1987, p. 198). According to Dyczkowski, the perpetual fullness of latent consciousness is expressed objectively through the waiting possibilities inherent in language. The energy through which this prospective essence manifests into expressive language, or the "world of denotation" is called *mātṛkā* (matrika) (p. 198).

PAŚYANTĪ-VĀK (PASHYANTI-VAK)

From *parā-vāk*, sound and associated imagery rise to the next level called *paśyantī-vāk*, which means visionary or visible speech, located in the subtle heart region (Feuerstein, 1998; Shantananda, 2003). Here, the sounds begin to take form as letters, but all is still concealed and only accessible, at best, through crystal clear intuition. At this point consciousness is starting to divide into duality as it seeks to manifest. Similar to mitosis or cell division, the *paśyantī* (pashyanti) level references the dividing of consciousness seeking form. Both the *parā-vāk* and the *paśyantī* levels remain unconscious unless we can become adept practitioners capable of tuning into these extremely fine levels of inner experience. At this unconscious level, the visual symbol is seeking form. Harding (1961) recognized that a true symbol emerges as a transporting mechanism to bring unconscious, shadowed material to the surface in an accessible metaphoric representation.

MADHYAMĀ-VĀK

The next point of emerging sound into language is the *madhyamā-vāk* stage or intermediary level. It is located in the area of the throat. Here, unspoken words take shape as the intonation of thought; however, they are not yet articulated, like knowing what to say before saying it. At this point, the intellect (*buddhi*) begins to have the awareness of rising cognitive activity. The *madhyamā* level is similar to the preconscious realm of psychoanalysis, where information is rising, but not yet fully accessible. Or out of awareness, but reachable through art. Here, letters coalesce and form in varying orders of discursive thought; eventually, these thoughts attach to designated objects or ideas.

The *madhyamā* level is analogous to the metaphoric realm alive within a dream or work of art. This is the precognized territory where emerging symbolic

material is surfaced but still unknown. Similar to what psychoanalyst Christopher Bollas (1987) referred to in his clinical work as the "unthought known," many experiences manifest for us in art, but we can't thoughtfully put them into words yet. Poetry and visual art offer ways to metabolize the felt sense of this preverbal knowledge of the unthought known seemingly representative of the *madhyama* level (Wallis, 2012, pp. 168–169).

VAIKHARĪ-VĀK

Verbal and visual speech then surface into the *vaikharī-vāk* level, where sound, line, and color takes on a gross audible form, becoming recognized verbal speech (Muktananda, 1989; Shantananda, 2003). According to Shantananda, *vaikharī* literally means "quite solid" and is recognized as language both spoken and heard (p. 243). At this level of everyday speech, a designated name or chosen word forms a synonymous relationship with the manifested image.

Art-Based Connections

The pathway describing how images emerge from their subtle emanations to manifest form can be illustrated with the later paintings of Mark Rothko (Borchardt-Hume, 2008), and the physics of liquids. When I have been privileged to directly experience Rothko's work in various museums, I have delighted in seeing what I perceive to be an artist's rendition of the *spanda* phenomenon as well as the notion of *mātṛkā śakti*. To me, his work shimmers with the subtleties of the *parā-vāk* level, where resting potential, as the light of consciousness, is quivering. This space of emerging possibility can be likened to the physical similarities of liquids as a way to understand the trajectory of symbolic images.

Fluids can assume solid, liquid, and gaseous form. Because the molecules of liquids flow freely, like the content of the imagination, they can assume multiple appearances, from the subtleties of fog and mist to enormous, mountainous walls of glacial ice. Similarly, Rothko's work conveys the emergence of *spanda*-like essence coalescing, like the gasses of uncognized feeling rising toward manifest sensation. His work, as I experience it, relates to Kazimir Malevich's art. Both articulate how color emerges as a field of subtle shimmering light before taking on the solidity of tangible form. This contrast between form and light, subtlety and emptiness, infers the migration of an image from its vapor-like subtle origins, to its fluid meandering, and finally to resolved, yet fog-like, final compositions.

The great Indian contemplative Sri Aurobindo (2001) addressed this point when he spoke of the synthesis of matter with spirit. Through involution or descent, and evolution or ascent, a dual movement unfolds between the

material world and the world of spirit. Within Sri Aurobindo's view of reality, God is in matter and, therefore, matter is God: "Life takes hold of matter and breathes into it the numberless figures of its abundant creative force" (p. 74). The aesthetic sense becomes an additional dimension where everything that is, is within us, and consequently, we then are within all things. Sri Aurobindo's (2004) view undergirds a contemplative view of art where the finite joins with the infinite. His emphasis on the role of artistic endeavors for transpersonal development teaches to receive and express inspiration from inner being and higher planes of consciousness.

Visual echoes of these ideas, to me, can be seen in Rothko's art. His work represents a visual example of how form and formlessness symbolically represents the levels of *mātṛkā śakti* taking form.

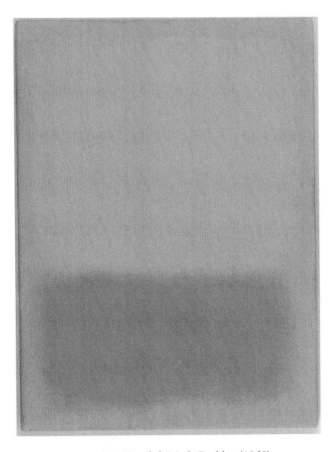

Figure 6.5. *Untitled.* Mark Rothko (1968).

Maṇḍalas and *Yantras*:
Examples of Contemplative Visual Traditions

A maṇḍala is tantamount to a sacred space or enclosure that geometrically represents the universe (Leidy & Thurman, 1998). *Yantras,* which share similar qualities with maṇḍalas, are illustrative images of a deity. Their elegant symmetrical configuration serves as a vehicle for visualization techniques and deepening prayer (Bühnemann, 2003; Khanna, 1979). Overall, maṇḍalas and *yantras* have a long history of acquired benefits received from purposefully gazing at them, praying with them, and meditating on them (Bühnemann, 2003; Leidy & Thurman, 1998, p. 18).

Maṇḍalas

Evidence suggests that during Vedic times, there was a tradition of forming a circle in which to worship (Leidy & Thurman, 1998). These were temporary formations to create a sacred space for practice. Similarly, throughout history there appears to be an urge to marry the circle form with various cultural rituals. Taking this idea even farther, Figure 6.6 is an example of a welcoming

Figure 6.6. Maṇḍala-like form using nontraditional, found materials. Spontaneously created by graduate art therapy students, Naropa University.

exercise offered to a new cohort in our graduate program. Using found objects and without instruction, small groups of students playfully took the random objects and intuitively organized them into a round structure. Upon reflection, they noticed that the challenges of being a new graduate student were soothed by intuitively creating rounded symmetry.

In their book *Maṇḍala: The Architecture of Enlightenment*, Denise Leidy and Robert Thurman (1998) explain that the Sanskrit noun maṇḍala conveys any form of circle or disc shape such as the moon. Maṇḍalas serve as "cosmograms" (p. 8) or "cosmoplans" (p. 17), whereby a certain divinity in the universe dwells within this sacred geometry. The encapsulation of sanctified space can be two or three dimensional, as found in the architectural maṇḍalas referred to as *stupas*. These rounded, complex, and often large structures were burial sites to honor a great teacher. They served as places for pilgrimage and worship, sanctified over time by adoring seekers. In ancient times, maṇḍalas inspired town planning and can also be found in alchemical traditions (Bühnemann, 2003).

Yantras

In yogic and tantric rituals, practitioners imagined and then connected their inner state to the deity enveloped by the geometrical *yantra* (Mahony, 1998b). Khanna (1979) outlined the meaning of the word *yantra*, locating its origins with the root *yam*, which infers a quality of maintaining, holding, or support for the intrinsic energy held within an object or concept (p. 11). *Yaṁ* is also the *bīja* or seed of the heart *cakra*.

When we intentionally gaze at *yantras* we are seeing the visual form of sound, specifically the sacred mantras or sonic form of a deity made visible. Therefore, mantras have a corresponding visual form or *yantra*. Repetition of revered sound while gazing at the corresponding imagery of the same deity, opens up pathways for insight and awareness. Almost like intentional synesthesia, *yantras* invite sensory cross-talk by seeing sound in its form-based deified equivalent.

Yantras are constructed out of three main principles that focus on "form, function, and power" (Khanna, 1979, p. 11). The revered area defined by the *yantra,* from the edges to the center, serves as a channel for concentrating on the body of the deity held within (Feuerstein, 1998). Just as the human form houses the soul, analogously, a *yantra* energetically holds qualities of the deity (Khanna, 1979, p. 24). The placement of the dot in the center of the *yantra,* the *bindu,* has special significance. It can represent a focal point for concentration or a depiction of transcending dualism (Khanna, 1979). The *bindu* can also represent one's innermost Self as the heart center of the practitioner.

Yantras offer access to subtle states of awareness. These mystical diagrams literally become a transformative dwelling place for both various deities and the viewer. To contemplate a *yantra* is to absorb and be absorbed by the quality of that deity (see Fig. 6.7). *Yantras* represent a visual tradition wherein the image is not a picture of the Divine but rather the abode of the Divine.

Additional meaning of the *bindu* found in the center of the *yantra* represents the original seed emerging out of the great void with exponential possibility. It can expand into all forms as it splits into the many and reabsorbs into the one. Finally, the practitioner working with *yantra* meditation internalizes the *bindu* as the intimate center of solitude and ineffable stillness.

Art-Based Connections: Maṇḍalas and *Yantras*

Jung, in part influenced by the work of Heinrich Zimmer, was fascinated by maṇḍalas as an archetypal image of the Self (Bühnemann, 2003). When inviting his patients to draw within this circular motif, he observed an organizing,

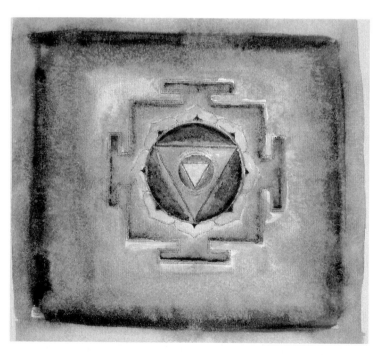

Figure 6.7. *Chinnamastā Yantra.* One of the ten *Mahāvidyās* or ten Tantric wisdom aspects of the Divine Mother. Original artwork by the author.

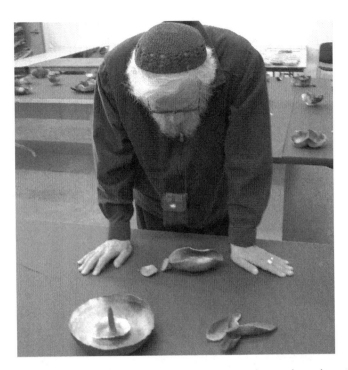

Figure 6.8. Rabbi Zalman Schachter-Shalomi visiting the studio, observing clay mandalas. Photograph by the author.

calming effect that reduced psychological confusion (Slegelis, 1987). Like an X-ray of the unconscious, it often illustrated a snapshot of psychological functioning. In fact, Jung so believed in the importance of creating mandalas as a window into inner states that he created many over the years, especially when times of strife appeared in his life (Jung, 2009).

Art therapist Joan Kellogg (2002) broadened Jung's views by systematically researching mandalas. The results of her studies culminated with her book, *Mandala: Path of Beauty*. She pioneered an elegant, all-encompassing, enigmatic system called "The Archetypal Stages of the Great Round of Mandala" (Thayer, 1994). Of her many accomplishments, the therapeutic projective instrument called the MARI® Card Test© stands out as an example of her desire to codify mandala iconography.

There is a natural effect of achieving organized wholeness by working within a circle design. Since there are no corners to retreat to, the format can invite the artist to move toward a unifying center. Drawing, sculpting,

or observing roundness in nature can offer a soothing connection to the Self archetype, which according to Jung, represents the integrative impulse of the psyche. Moreover, the circle symbol abounds cross-culturally and throughout history. The renowned Oglala Sioux shaman Black Elk (1863–1950) commented on the importance of the circular form, saying:

> You have noticed that everything an Indian does is in a circle, and that is because the Power of the World always works in circles, and everything tries to be round.
>
> In the old days all our power came to us from the sacred hoop of the nation and so long as the hoop was unbroken the people flourished. The flowering tree was the living center of the hoop, and the circle of the four quarters nourished it. The east gave peace and light, the south gave warmth, the west gave rain and the north with its cold and mighty wind gave strength and endurance. This knowledge came to us from the outer world with our religion.
>
> Everything the power of the world does is done in a circle. The sky is round and I have heard that the earth is round like a ball and so are all the stars. The wind, in its greatest power, whirls. Birds make their nests in circles, for theirs is the same religion as ours.
>
> The sun comes forth and goes down again in a circle. The moon does the same and both are round. Even the seasons form a great circle in their changing and always come back again to where they were.
>
> The life of a man is a circle from childhood to childhood, and so it is in everything where power moves. Our teepees were round like the nests of birds, and these were always set in a circle, the nation's hoop, a nest of many nests, where the Great Spirit meant for us to hatch our children. (cited in Neihardt, 1959, p. 164)

Working with clay, which can feel like tactile prayer, provides a direct connection to mandalas and *yantras*. In my experience, creating pots offers the opportunity to consider the inner and outer spaces of form and emptiness, solitude and containment. Since mandalas and *yantras* can be three-dimensional, pots become a way to maintain a tangible connection to these ancient forms and practices. Although I am not attempting to create formal iconographic versions of either, I am trying to remain connected to the fundamental principles of these visual meditations with clay's help to hold the shape of our many conversations.

Figure 6.9. Clay pot. Hand-built and sawdust-fired by the author.

No one owns the circle shape, yet appropriation of maṇḍala and *yantra* imagery from other cultures is to be handled with judicious sensitivity. When it comes to this subject, Gudrun Bühnemann (2003) warned of the importance of monitoring inaccurate, generalized comparisons across traditions. For example, trendy maṇḍala coloring books can offer soothing experiences, but they may lack contextual information that deserves additional study.

Tantra, Karma, and Sublimation in Art

Tantra and tantric scriptures break with *Brahamanic* and Hindu orthodoxy. Sometimes referred to as a left-handed path, for the times, it was highly unconventional. Substantially ritualistic, responsibly radical, and profoundly egalitarian, Tantra views the body and corresponding ceremonial ritual as experimental laboratories for transcendence (M. Cohen, 2008). The reason for this investigational embodied research is that there are vast, incalculable latent forces to be discovered within any person (Mookerjee & Khanna, 1977). Unusual for the times, women were recognized as conduits of this vital potency or "kinetic part

of consciousness," and consequently were encouraged to perform and preside over sacred initiatory rituals (Mookerjee & Khanna, 1977, p. 16; Wallis, 2012).

Tantra is concerned with unraveling polarization in all forms by combining the arts with science and ritual in the service of inclusion and transcendence. Opposites such as male and female, form and formlessness, internal and external are not mutually exclusive. Union and balance of these forces, including the embrace of feminine energies of creation, are prized as a core intention of tantric practice.

Wallis (2012), in *Tantra Illuminated*, cites a definition from the scholar Rāma Kaṇṭha, who lived around 950–1000 CE:

> A Tantra is a divinely revealed body of teachings, explaining what is necessary and what is a hindrance in the practice of the worship of the Divine; and also describing the specialized initiation and purification ceremonies that are the necessary prerequisites of Tantrik practice. These teachings are given to those qualified to pursue both the higher and lower aims of existence. (p. 27)

Within this definition, Tantra acknowledges and subordinates physical joy pursuant to teacher-guided *mokṣa* (moksha) or liberation. From this perspective, the creativity of imaginal practices such as *yantra* gazing are used to join with the qualities of a "particular deity" in order to conform personal identity with qualities of that God (Chapple, 1986, p. 75). When adept at such practices, merits of the internalized deity begin to guide dharmic behavior. Overall, the art associated with Tantra is not only representative of visual theology, it is characteristically metaphysical (Mookerjee & Khanna, 1977). Buddhist, Hindu, and Jain culture all have tantric traditions of renunciation, detachment, and asceticism as part of their creative evolution.

It is likely that Tantra practice dates back before the *Vedas*, which began around the third or fourth millennium BCE (Feuerstein, 1998). Around 3000 BC, ritual symbols of yogic postures were found in the Harappan Culture of the Indus Valley (Mookerjee & Khanna, 1977). As tantric practices evolved, they existed side by side with Vedic traditions rather than overtly in opposition to them. In fact, it seems that tantric traditions influenced Vedic thinking, especially in performing approaches to *pūjā*, or worship rituals.

Starting about 1,500 years ago in India, tantric practitioners reacted to rigid orthodoxies by choosing a nonconformist path (Feuerstein, 1998). Penetrating the deceptive fog of embodied illusion, *tantrikas*[14] committed to working with intrinsic suffering as with dying and death. Due to this worldview, suggests Feuerstein, they remained marginalized from mainstream society, especially since over time they opened their communities, regardless of caste

or gender, to any sincere seeker (Wallis, 2012). Within the community of their groups, they opposed dominant orthodox views by inverting usual classist practices. Like spiritual deconstruction, they covertly reversed norms and religious hierarchies of the times. Tantric practitioners were keen to question spiritual rules by following a nonconformist, yet sensible path that bridged spirit with the world of matter (Mookerjee & Khanna, 1977).

A tantric view of creativity and karma embraces powerful internalized forces emerging from the ground of being. For the purposes of this discussion, these vital energies can be channeled into artistic, visual equivalents, symbolic of their innermost origins. There are many elegant tantric rituals for practicing with these forces that include ceremonial uses of the arts, although the Western contemporary lexicon of these traditions would have us believe that Tantra is only about spiritualized sex. Sadly, like so many other aspects of Westernized yoga, Tantra, too, is subverted into simplified, stereotyped accounts of sexual athleticism.

The *Yoga Vāsiṣṭha*

The *Yoga Vāsiṣṭha* unfolds a dialogue between the great sage Vasiṣṭha and Prince Rāma, thereby teaching lessons on the mystery of the mind, karma, and how suffering is caused by our illusory view of the world (Venkatesananda, 1984). At its core, yoga is about being rooted in the creativity of mindful attention combined with skillful behavior. Self-effort is helpfully reframed as a creative process and art is one way to train in this yoga of creativity in action.

Using artistic metaphors such as pottery and weaving, the *Yoga Vāsiṣṭha*[15] conveys the importance of intentional actions and responsible utilization of interwoven embodied forces (Chapple, 1986, p. 73). Self-discipline, focused perception, and personal effort, all uniquely constituted in the creative process, are applicable to spiritual transformation. Art can become a way to experiment with beliefs and behaviors through symbolic forms long before becoming public behavior.

According to the *Yoga Vāsiṣṭha*, fate is illusory; there is merely a progression of unfolding events and how we participate in our choices. In his introduction to Venkatesananda's rendition of the *Yoga Vāsiṣṭha*, Christopher Key Chapple (1984) clarifies how the text focuses on the mind in terms of "what is perceived and the means of perception" including the results of thought sedimentation layered with ruminating debris. Reflexive, conditioned styles of disordered thinking cover and consequently hide the essence of pure consciousness that is the Self (p. xiii). The world exists through the screen of each individual's mind only, and our thoughts configure this reality. If this

screen is hindered by neurotic beliefs then the world appears as a painful play of suffering. As the mind becomes increasingly purified through contemplative practices, the same consciousness, rather than configure as suffering, increasingly organizes as a view of unity awareness.

Art, and the methods offered in Part III of this book, can help to clarify our thinking habits. For example, reorganizing beliefs to consider that destiny is self-determined infers that we can create our way out of our suffering through artistic processes. This view of creativity becomes a practice for dissolving "the impetus of world-creating patterns" that ignite behavioral cause-effect, stimulus-response relationships (Chapple, 1986, p. 79).

Tantric art is closely linked with ritual practices. These objects and symbols remain remarkably familiar, changing little over time. As Ajit Mookerji and Madhu Khanna (1977) point out, many are encoded with meaning like the universal cosmic egg represented by the *Śiva-liṅga*. This form is used in ritual practices to manifest realization of the cosmos. These authors address how tantric images can function as an intermediary to apprehend form and formlessness or immanent and transcendent reality. The iconography of tantric images can be grouped into four broad categories: (1) "psycho-cosmic" diagrams such as *yantras* and maṇḍalas, (2) visual-symbolic representations of the subtle body, (3) astrological calculations, and (4) "accessories used in rituals" as well as images of *āsana* (Mookerji & Khanna, 1977, p. 48).

Karma

Tantra addresses the transformative opportunities of inward-dwelling reality (Johari, 1986; Mehta, 2008). Overall, neurotic impulses are humanized and acknowledged within a tantric perspective, thereby minimizing the compulsion to shame irrational urges or ego-identified limitations. Within this framework, instinctual energy is accepted and directly folded into the practice.

Ignorance, whether intentional or unintentional, incites a cascading series of behavioral cause-effect relationships that we own as they are manifested in the world. Recognized as karma, these actions ripple out beyond oneself, initiating unseen impact around us. As our behaviors live us out loud in the world, a fingerprint of action is left behind while an opportunity to do better is ever present.

Karma is a complex, confounding topic. Scholars debate the historical origins, conceptual dimensionality, and applied theories related to the subject (O'Flaherty, 1983). Likely originating from non-*Ārya* (Aryan), tribal shamanic traditions in the Ganges valley, karma evolved into fundamental theoretical components. First is ethical causality transferred from one life to the rebirth of another. Second is how dialectic behavior that is ethically good or morally bad results in consequences spread over one or several lifetimes. Third is that

rebirth brings with it past histories from previous actions and births that influence present and future results, even after death (O'Flaherty, 1983).

Principles of karma influenced the three great religions of India. Wendy Doniger O'Flaherty (1983) noted that Hinduism, Buddhism, and Jainism have different views on the subject, especially in terms of morality and how merits influentially transfer past and present outcomes from birth to rebirth. Slippery elements of this subject can be summed up between the two poles of fate and free will. A past act can seemingly influence present circumstances, implying personal responsibility for those results. Yet, present outcomes were committed by an unknowable version of oneself from a previous life. Paradoxically, there is fault and yet, no fault.

Understanding karma reveals how personal thoughts, words, and deeds influence cause and effect results. If our perceptions are flawed, then our behaviors will likely unfold in kind (Chapple, 1986; Feuerstein, 2003; O'Flaherty, 1983). Absence of skillful discernment will result in consequential outcomes that increase suffering for ourselves and others. Since action in the world is inevitable from the moment we wake up each day, it is best to move about with awareness of stimulus-response relationships. Like a contrail engraved in the sky from a passing jet, memory traces from prior thoughts or behaviors can be acted upon, strengthened, or annulled by exercising the agency of free choice (Coward, 1983, 1985, 2002). The recorded memory, etched in some recess of the unconscious, becomes a file waiting to be activated. Once triggered, the same memory contrail behaviorally manifests in the present in similar ways to past patterns. Under the right circumstances, a repetition of thought and behavior will continue to repeat, banking a debt of guaranteed future consequences that eventually will have to be confronted. We are not necessarily the blank slate we thought we were when arriving in the world. From this perspective, human beings bring with them what they have sown in past lives and accumulated in this current life. While karmic memory traces imply that this debt is active and accumulating, free will still exists as a means to untangle these thorny webs of accrued obligations. Meditation and art are available practices for unraveling these unconscious networks of influential interconnection.

Sublimation in Art

In the Hindu *Bhagavad Gītā*,[16] Kṛṣṇa[17] (Krishna) instructed Arjuna on the basic premise that all manifestations in Nature inevitably move; additionally, action is inescapable, so one must engage with the world skillfully.

Practices such as art combined with yoga and meditation help us to observe cause-effect relationships, particularly related to instinctual psychological

drives, like aggression and desire, that interrupt inner homeostasis. We meditate to become capable of witnessing the movements of mind and behavior and we create art to see related content indicative of thoughts in action. Together, art and meditation represent resources to express, manage, and transform karmic imprints into symbolic counterparts long before spilling out onto others.

Artistic sublimation is an efficient, redemptive strategy for directly accessing and transforming powerful, usually unconscious forces (Kramer, 1971). Rather than become hijacked by spontaneously acted out impulses, art becomes a means to interrupt inevitable consequences resulting from certain actions. According to Anna Freud (1937/1978), of the many ego defense mechanisms that help to create psychological equilibrium, such as projection, repression, and reaction formation, sublimation emerges as an efficient strategy to access and transform derailing desires (Kramer, 1971, 1979).We slow ourselves down and keep one foot in the arousing content and one in the art process that contains and potentially transforms this content. This tantric perspective of art acknowledges instinctual urges, such as sexual libido, as one facet of human drives needing attention (Feuerstein, 1998). However, tantra sees this expression of drive energy as originating at deeper, subtler levels, where the *kuṇḍalinī-śakti-spanda* (kundalini-shakti-spanda) stirs and creates. Early psychoanalytic thinkers were on the right track; however, they did not probe deeply enough beyond the limited view of a personal ego and finite unconscious.

Art is one way to explore free will while practicing restraint. Promoting new choices by creating visual equivalents for complex desires results in socially productive actions (Kramer, 1971). This viewpoint is key to connecting karma with art. More to the point, the link between imagery and contemplative practice becomes evident when considering how artistic sublimation circumvents future karmic obligations.

Lastly, sublimation in art is metaphorically analogous to how the yogi balances the three embodied *dośas*[18] (doshas) of *vāta*/air, *pitta*/fire, and *kapha*/water. Corresponding to these gross level *dośas* are three additional subtle, metabolizing versions of the *dośas*. They are *prāṇa*/life force, *tejas*/radiance, and *ojas*/underlying strength (Frawley, 1994). Of particular interest for this discussion is *ojas*.

The yogi redirects, retains, and raises the *ojas* or vital life energy from fluids like semen before ejaculation. *Ojas* is also the life force extracted from food in the fire of digestion. Skillful retention of these forces raises the climax before orgasm in order to utilize life force for spiritual practice. One drop of semen, together with a woman's egg, can reproduce the cosmos as child. This same extricated, redirected force is relatedly inherent in aesthetic experience (Dyczkowski, 1987). Art stimulates the heart to open and therefore know itself as a gateway to revealed beauty. Mark Dyczkowski further explains that

when focused on an aesthetic object, senses and thoughts quiet, inner noise dissolves, and the practitioner becomes one with the object. At this moment, consciousness "turns in on itself to realize its eternal pulsing (*spanda*) nature as a divine aesthetic continuum" vibrating with universal vitality (p. 149).

Also worth noting is how the embodied practice of artistic sublimation retains an action rather than directly acting it out. Different, yet metaphorically similar to the discussion above about *ojas,* the artist redirects and holds potent interior forces and uses them for creating art. *Ahimsā* is practiced as base urges are rechanneled into artworks rather than direct harmful behaviors. As the repository of thoughts and actions, art still creates karma, yet less harm is perpetrated. In fact, society benefits from sublimated forces held in check within formed expressions (Kramer, 1971, 1979).

A conscientious practitioner avoiding frivolous irresponsible behavior redirects and uses life forces for uplifted practice. In the case of art, powerful internal vitality behind human thoughts, feelings, and behaviors can be relayed, raised, and metabolized into vital symbolic counterparts. The goal is to ennoble and harness potent urges before they become counterproductive behavior. And when done with intentional commitment, these artworks embody a continuum of culturally valuable expressions representative of compelling emotions and life forces.

7

Art as Meditation

Sigmund Freud (1900/2010) viewed dreams as a royal road to understanding the unconscious. A similar adage was voiced by Roger Walsh and Frances Vaughan (1993), who claimed that meditation was the royal road to the transpersonal (p. 47). This declaration implies that meditation, as a transformative tool, opens doors to recessed layers of the psyche while helping to unlock our vast developmental potential. Art, too, can serve as a valuable passport on this royal road journey into transpersonal, contemplative content (Franklin, 2016a).

Transpersonal psychology is concerned with spiritual paths leading toward, through, and beyond ego states and traits (Walsh & Vaughan, 1993). Practitioner researchers from this orientation, with a careful eye toward the trappings of cultural appropriation, study subjects such as nonordinary states of consciousness, contemplative life, mystical practices from indigenous wisdom traditions, and enlightenment (Boorstein, 1996; Caplan, Hartelius, & Rardin, 2003; Cortright, 1997; Franklin, 2016b; Walsh & Vaughan, 1993).

Few subjects are as elusive as the topic of enlightenment. Yet the unity awareness of self-realization is central to any discussion about the reaches of human development. With the aid of advanced teachers or gurus and disciplined practice, merging with the pure consciousness of the Self is possible. Well beyond my grasp, it would be foolish to claim direct knowledge of this humbling, far reaching attainment. But I have met several great teachers who I believe were established in this state. Their consistent message is that self-realization is available to all. Believing them, I continue to learn that art combined with meditation and service is its own *Sādhanā* (Sadhana) path capable of unfolding refined gradations of awareness that touch into this numinous content.

Transpersonal psychology is interested in the role of contemplative practices like meditation used in the arts, education, psychotherapy, and

community-based cultural work (Franklin, 2016a and c; Rappaport, 2013). These investigations study and expose the edges between emergent spiritual awakening and when those experiences become spiritually overwhelming. As a result, terms such as *spiritual emergence* and *spiritual emergency* entered into the transpersonal literature yielding thoughtful, applied clinical methodologies (Grof & Grof, 1989). It is important to consider that practices such as yoga and meditation can be overused, even abused. Consequently, unguided, reckless immersion can cause an unanticipated, psychospiritual crises, severely disorienting the eager student.

Transformative technologies like meditation open and unfold multistate experiences. Reason alone cannot penetrate the essence of these subtle layers of consciousness. Stanislav Grof and Christina Grof (1989) noticed that when deductive methods alone are used to study numinous territories, limited conclusions result. Shortsighted inquiry can lead to pathologizing revelatory experiences instead of viewing these moments as sacred events (Castillo, 1985).

Meditation: States and Traits

Meditation describes a range of practices that "self-regulate the body and mind" in such a way that it affects "mental events" through attentional/intentional focus (Cahn & Polich, 2006, p. 180). Among the many approaches to meditation are mantra recitation (Feuerstein, 2003), *yantra* gazing (Khanna, 1979), mindfulness practice (Baer, Smith, Hopkins, Krietemeyer, & Toney, 2006; Germer, Siegel, & Fulton, 2005; Kabat-Zinn, 1990; Rappaport, 2013; Siegel, 2010), and tantric yoga (Brooks et al., 1997; Feuerstein, 1998, 2001; Wallis, 2012).

Traditions and practices of meditation fall into two basic categories: mindfulness and concentrative (Cahn & Polich, 2006). With mindfulness, the practitioner maintains a quality of nonjudgmental noticing attention to unfolding inner/outer events while sustaining open, unattached awareness of the intrapersonal and interpersonal field. Examples of this approach to clear seeing include Zen and Vipassana meditation and Jon Kabat-Zinn's (1994) approach to mindfulness-based stress reduction (MBSR). These practices promote an ongoing return to awareness that is open-minded as the sensory and cognitive risings of sensation and thought emerge. The idea is to remember to remember to return to observational awareness of the emerging moment.

Concentrative approaches found in Hindu-Yoga traditions, Buddhist practices, and other religious traditions such as Judaism (A. Kaplan, 1985) and Sufism (Chittick, 1989) work with conceptual and sensory material by

intentionally focusing on a mantra, an image of the guru, a maṇḍala, or a devotional imaginal scenario. Both concentrative and mindfulness practices cultivate composure and presence by utilizing the breath as a reliable focusing agent of attention.

Types of Meditation

Meditation approaches from various traditions basically strive toward the same results: cultivation of attention, intentional nonjudgmental observation or witnessing, concentration, insight, and gap-space attunement between inhale and exhale as well as impulse and action. The qualities of wakefulness, attention, and insight can lead the practitioner to refined embodied awareness. Since thoughts can confine and also liberate inner life, it is best to skillfully work with the movements of the mind on an ongoing basis. A regular meditation practice offers a sound strategy for renegotiating relationships with thoughts and compulsions before they become behaviors.

Table 7.1. Types of Meditation

Definition of meditation: "a family of self-regulation practices that focus on training attention and awareness in order to bring mental processes under greater voluntary control and thereby foster general mental well-being and development and/or specific capacities such as calm, clarity, and concentration" (Walsh & Shapiro, 2006, pp. 228–229).
Concentrative: Approaches that employ strategies for focusing the body/mind connection, such as mantra repetition or chanting.
Mindfulness: Allowing whatever is emerging at the conceptual or sensory level to simply surface and be observed without judgment.
Art-Based Connections: Art practices can consist of intentionally focusing attention, or nonjudgmental allowance of spontaneous ideas and actions to emerge like unstructured mark making. Imaginal mindfulness is observantly accepting images as they emerge, without censorship, and collaboratively following them into series of imaginal, I/Thou artistic expressions.
States and traits of meditation: The term *state* refers to the emergence of sensory, cognitive, and self-referential awareness that is activated **while** meditating. *Trait* refers to **sustained, enduring changes** that result from meditation (Cahn & Polich, 2006).

continued on next page

Table 7.1. Continued.

State Changes (Cahn & Polich, 2006, p. 181)
Inner calm; feeling peaceful; slowing of inner mind-thought chatter; comfort with ineffable material; clear perception of focused awareness. Emerging emotions are observed rather than grasped for recycled rumination. Peaceful absorption in processes is another state found in meditation.

Enduring Traits (Cahn & Polich, 2006, p. 181)
Inner calm; ease and comfort with emergent conceptual material; increased awareness of inner/out sensory experiences; renegotiated relationship with thoughts; increased witness awareness; shift from ego-body identification to compassionate beingness.

Art-Based Connections:	
States	**Traits**
1. States infer direct experiences during the art process. Art induces inner calm by continuously teaching that ambiguity is inevitable. Artists know well the experience of not-knowing how the final work will look and the lesson that persistence yields results. 2. Much art is a monotasking practice informing intentionally focused awareness on processes, materials, and final products. 3. Visual symbols are used to access, enter, and articulate ineffable material. 4. Art stimulates and refines intentional, clear perception. 5. Art is human feeling cast into visual forms. Manifested imagery creates distance between the inner feeling and its external manifestation. 6. Art processes and materials invite focused absorption in the moment. 7. Art refines observant awareness of I/Thou collaborative relationships.	1. Traits are enduring outcomes resulting from the art process. Inner calm is repeatedly learned from acceptance of inevitable ambiguity replete throughout the art process. 2. Creativity inspires playful relationships with emergent conceptual material. 3. Rudolf Arnheim (1981) suggested that art is thinking with the senses, thus increasing inner/outer sensory awareness and acuity. 4. Latent and manifest images, as bringers of unanticipated information, support renegotiated relationships to thoughts, dreams, sensations, and emotions. 5. Art is an awareness practice that cultivates inner/outer observational acuity. 6. Art shifts the ego-body boundary to include a view of art as separate, yet connected to the maker. 7. Focused and wide-angle observation carry over into interpersonal and ethical seeing.

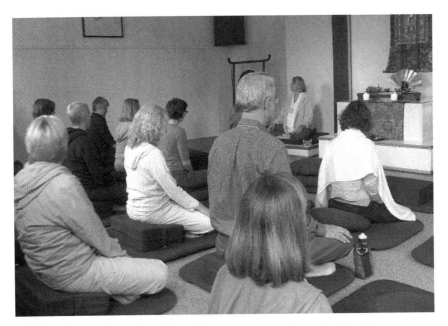

Figure 7.1. Contemplative pedagogy seminar, Naropa University. Photograph by the author.

States and Traits of Meditation

Several questions arise when comparing budding states and durable traits from meditation practice with the states and traits indicative of art practice. For example, what are the enduring traits of creative work inherent in the arts? Can art cultivate attention, concentration, insight, and increased observation or witnessing abilities? What are the similarities between art and meditation when it comes to inner state changes generated from working with various processes and materials? When meditation and art are paired, are the manifested traits truly enduring?

Whereas yoga and meditation help the practitioner to observe and still the mind, art has a knack for loosening defenses and surfacing unconscious narratives. Some may critique this position and consider art a way to indulge thoughts, which runs counterintuitive to the mind/thought-stilling efforts of meditation and yoga. Imaginal psychology, however, has demonstrated the credibility of contacting inner narratives and communing with their innate

intelligence (P. Berry, 1982; Hillman, 1978; McNiff, 1992; Watkins, 1984). Taming the wildness of the mind through meditation without excavating driving latent content behind those thoughts results in an imbalanced psychological equation. In addition to this point, it is important to acknowledge how art and meditation reduce stress by creating visual representations of our thoughts. The braided combination of the two practices, art and meditation, uniquely untangles enmeshment with shadowed, unconscious material.

Walsh and Shapiro (2006) and Davis and Hayes (2011) reviewed various approaches to meditation, the diverse effects of meditation, the various psychological and philosophical histories of meditation, and the many implications required for careful study of this contemplative practice. Based on their review of the literature, the authors observed several interesting points. For example, reduction in rumination, enhancement of empathy and compassion, and cognitive flexibility are results of meditation. Additionally, Walsh and Shapiro observed that the practice of mindfulness meditation enhances perceptual sensitivity along with creativity and the reduction of stress. Artistic process is closely linked with perceptual sensitivity, creativity, and observational skill. Meditation and art are often described as practices that refine various forms of awareness such as perceptual wakefulness.

Art-Based Connections

The practitioner of meditation becomes adept at observing rather than reacting to charged thoughts, a skill known as disidentification (Walsh & Shapiro, 2006). Just as the meditator becomes the skillful witness of the mind, the artist, similarly, does the same through careful observation of thoughts and feelings directly reflected in artwork. As previously stated, art is an externalized version of thought content fixed in the aesthetic language of symbol and design elements such as line, shape, and color. The artist observes these visual cognitions as they materialize on canvas, video, or in stone. This process extends the goals of sitting meditation by fusing nonjudgmental observation of emerging thoughts with materializing imagery representative of those thoughts. Seeing and tangibly holding thoughts fixed in physical form offers additional access to the diverse textures of awareness.

Another point of connection between art and meditation can be drawn when considering the practice of active imagination (Chodorow, 1997). Excavation of archetypal imagery provides an example of art-based entry into polyphasic states of consciousness. Active imagination and imaginal work in general become viable avenues for shifting insight and states of awareness. Practicing with cryptic imagery found in spontaneous artwork or when engaging with

maṇḍalas or *yantras* can shift consciousness from careful observation, to habitation of the imagery, to merging internalization with the I/Thou content.

Still another link between art and meditation is the cultivation of compassion and wisdom. The history of art is replete with numerous accounts of artists creating works to cultivate empathy for self and other. Käthe Kollwitz made moving art attempting to understand war, loss, and death (Kearns, 1976). Edvard Munch used the art process to explore his concerns about relationships, aging, dying, and death (Hodin, 1972). These artists were able to use their work to ask complex questions, surface shadow material, and privately wrestle with existential questions. Depth of understanding for these artists, indeed any artist, slowly unfolds from sustained aesthetic engagement with complex emotional states over time (Allen, 1992).

Flow, Materials, and Processes

Convergence between art and meditation can be found in Csikszentmihalyi's (1997) notion of flow and the autotelic personality. He defines flow as effortless engagement, whereby full attention is directed toward an activity for its own sake. This is the very meaning of the autotelic personality. *Auto* is from the Greek root for "self" and *telos* from the Greek root for "goal" (p. 117). Autotelic flow activities are sought after because they reinforce behavior worth doing for its own sake. Joy and happiness naturally emerge out of full absorption in these activities. Unlike the "exotelic" (p. 117) personality reinforced by outside goals that fulfill needs of competitive or public acknowledgment, the autotelic personality is self-fulfilled as a result of absorbed engagement.

Csikszentmihalyi's (1997) description of the autotelic personality is similar to the absorbed state of the contemplative practitioner. Flow in art and meditation provide direct rewards by cultivating introspective, reflective abilities for discovering beingness. Additionally, the autotelic personality, according to Csikszentmihalyi, is not submissive. Instead, such a person operates from a disinterested position, which means the focus is not on a particular agenda. Fulfillment arises through captivated full attention that opens toward discovery.

The state of flow also relates to beginner's mind, discussed in chapter 2. For the contemplative artist, a great deal of time is spent with an open, fresh welcoming perspective for what is emerging. This orientation is the essence of staying in the mind of the beginner, which ultimately frees energy for creative work. Csikszentmihalyi suggested that when we have clear goals, along with applicable feedback, as well as balanced challenges in combination with related abilities, attention will be systematic and invested.

This dynamic has familiar echoes with art practice and meditation practice. Both require clear goals and relevant, observational feedback that inform the process. Notably, distinct goals do not necessarily imply step-by-step, sequential objectives and outcomes. The goal could be to enhance spontaneity or to relax impulses to control. Trait skills of absorption evolve over time as the artist and meditator become practiced in their areas of focus such as painting and sculpture.

Gene Cohen (2006) noticed outcomes similar to the autotelic personality in a research study he conducted on the positive impact of the arts with aging communities. His work on creativity during the later years of life presented a holistic view of health during this often misunderstood phase of human development. For many of us, creative expression during the later adult years emerges as an attractive practice, therefore, this book is written for people in this life stage, too.

Cohen addresses several traits of art practice related to creativity and aging. These characteristics are a sense of control, the influence of the mind on the body, the importance of social engagement, and how art contributes to brain plasticity. The reason for these connections follows.

Sense of Control

The importance of a sense of control, as noted by Gene Cohen, relates to how art helps to develop increased feelings of empowerment through mastery of a chosen material and related process. Similar to the autotelic personality, if we are good at one thing, then it is likely we will bring the same intentional efforts to other endeavors.

Cohen's finding regarding the influence of the mind on the body also relates to the field of psychoneuroimmunology (PNI), which studies the influence of the mind on the immune system. Positive emotions bring a sense of control resulting in upbeat effects on the immune system. According to Cohen, feeling greater control resulting from art practice will boost the immunity, including T cells (p. 9). I mention this point since artistic content can focus on joy or anguish. Either way, what we work on in the studio effects our nervous system.

Social Engagement

Social engagement, according to Cohen, cultivates health through several avenues. A healthy body is influenced by meaningful relationships. The arts offer numerous opportunities for social contact. Cohen further noted that singing

groups, poetry groups, quilting circles, bands, acting groups, and art studio groups all help to increase social activity (p. 9–10).

Lastly, in terms of brain plasticity, the brain adapts and keeps itself vital through creative activity. Cohen explained that sustained bilateral stimulation available through artistic activity spurs the development of new dendrites. In later life, the brain savors these forms of concomitant stimulation. Like "chocolate to the brain" (p. 10), left and right hemispheres are treated to ongoing flexibility afforded by the arts.

Art and meditation set up feedback loops that offer direct pathways to enter the flow state and become absorbed in the task at hand. Both practices foster intentional absorption in the moment and, consequently, playful management of the thinking mind. Together they forge concentration, control, and attention through activities that inspire absorption. As previously mentioned, Siegel (2010) defines mind as "an embodied and relational process that regulates the flow of energy and information" (p. 25). I would add that art is an embodied, relational process that regulates the flow of energy and information. Furthermore, since art is about discovery, returning to beginner's mind maintains renewed openness to what is emerging, including uncertainty, which is a daily experience for the elder dealing with mounting losses. Cogitation on ruminating thoughts lessens as witnessed thoughts become "observed phenomena" (Cahn & Polich, 2006, p. 181). Lastly, art can direct contemplative awareness outward into social venues that foster meaningful relational connection.

Art-Based Connections

The autotelic personality and the cultivation of the flow state in art connect to my experience creating art during my cancer diagnosis. I was able to center myself and become engrossed in the process of creating while struggling. Producing is a way to coexist with the ambiguous messages of immortality. The art process slowed time down, which is a hallmark of the flow state, so that I could see each action and moment as a holy gift. Responding with deliberate decisions to materials such as clay elongated previously fleeting increments of time. The art materials captivated me with their flexibility to receive and hold my known and unknown intentions. The three *gunas* were candidly present as I moved through moments of sedentary despair to lighthearted hope peppered with distracting thoughts of avoidant wishes and fantasies. The emotional upheaval of uncertainty agitated its way into the form and content of my work. I was able to gain moments of control in the art and meditation process during this time of meandering uncertainty. In an ordinary way, I felt sane and at ease while working. As I oscillated between struggle

and hope, fragility and resiliency, mindfulness and imaginal narrative, the art process and materials held it all.

There is a saying, when someone asks for a drink of water, do not offer a firehose! As extreme thoughts and feeling emerge, there can be a tendency to contract around the rumination or drink to the point of overexposed saturation. Or, avoiding the textured messages implicit in a challenging emotion can be a form of self-abandonment. Between both extremes of avoidance and overexposure is a practice of touch and go titration. Art pulls into the moment an encounter with thoughts, moving these thoughts and feelings into actions, and then seeing them materialized. Throughout this process, we can literally touch the emerging feelings taking form and also let them go. This tangible practice of touch and go models how to do the same with thoughts. Just as art loosens defenses, releasing unexpected content into images, so too does meditation release unanticipated thoughts into awareness. Touch and go attention becomes a helpful strategy during these moments of surprise. Karen Wegela

Figure 7.2. Clay pots. Hand-built and sawdust-fired by the author.

(2009) addresses extremes of both as touch and grab or touch and really go away from the experience. Similarly, hatha yoga values the importance of flexion and extension of the muscles and joints. Flexion is grasping or tightening. Extension is the opposite of flexing, for example opening a tight fist. The body elegantly moves between flexion and extension, each balances the other, benefiting the integrity of the joints. Touch and go, flexion and extension, are tools for modifying thoughts and artistic intentions. All materials have their language of opposing syntax and grammar inherent in their aesthetic DNA. For example, watercolors pool or bleed outward. Clay contracts and expands, modeling a vocabulary of flexibility. When working with provocative subjects in art, mind and tactile engagement synchronize, providing opportunities to literally and conceptually touch and release the charge. We can also leave the work and return to it when ready. Furthermore, the content is available for receptive engagement and reflective distancing. It is necessary to step back from work in order to see it as a whole, especially when working large on an easel or wall.

Art, Silence, and Solitude

For many, silence is about restricting speech and reflectively turning awareness inward. By withdrawing from outer stimulation, connection with invisible subjective phenomena multiplies. Crossing into this unseen territory, said Alice Borchard Greene (1940), requires a temperament for progressive stillness. Combining art with meditation promotes comfort with this layered refuge territory uniquely experienced when creating art. Thus, learning to feel stillness through art and meditation anchors enduring sensations of quiet equanimity. Practitioners of yoga train mind and body to "hear the mighty silence within" (A. B. Greene, 1940, p. 172). Inner listening is cultivated by calming the body through hatha yoga, quieting the mind through meditation, and serving others with selfless intentions as in karma yoga, to be discussed in chapter 8. The artist who seeks silence can be misunderstood as living in a state of sullen withdrawal, like the mystic who prefers solitary experiences. Additionally, many who do not pursue the full lifestyle of the solo mystic are still prone to seeking, cultivating, and protecting degrees of contemplative solitude as an inoculation against the cacophony of environmental intrusions.

Silence is a cultivated taste and skill. It is certainly not for everyone, yet it is the background of contemplative life. A goal of this lifestyle is knowing

the availability of inner stillness that can accompany us when forced to plow through our active days. This perspective is not an argument against the tumult of our active lives. Rather, coexistence on the continuum between doing and reflecting, or noise and silence, is made easier when the muted end of the spectrum is practiced.

Contemporary Western culture has often misunderstood the person who seeks a solitary way of life. Anthony Storr (1988) explained that mental health in the West is often predicated on relational success. Attachment theory (A. N. Schore, 2003; J. R. Schore & A. N. Schore, 2008) and object relations theory (Hamilton, 1989), for example, focus on interpersonal bonding and the capacity for intrasubjective attunement throughout the life span. There is a paradox here that being alone as suggested by Storr is considered aberrant, whereas being relationally engaged is essential to fulfilling cultural definitions of emotional stability, success, and overall mental health.

D. W. Winnicott (1965) and John Bowlby (1980) saw a unique twist on this perspective. Both suggested that the relational exchange between seer and seen in object relations theory is essential in order to cultivate secure attachment along with the capacity to be alone. Winnicott (1965) observed a curious paradox concerning a young child's need to be alone while in the company of a distant nurturing figure. Being on our own in the presence of a caring adult some distance away sets the stage for self-discovery of felt homeostasis. According to Winnicott, without this paradoxical foundation of aloneness and connection, the experience of a true self along with a thriving penchant for solitude is stunted. This ability to maintain inner comfort while alone, yet while also in the presence of another, is a form of internal attunement similar to the artist working in solitude and then showing that work to others. Being seen and valued by viewers who realistically praise artistic efforts, as in gallery shows or classroom critiques, anchors the importance of receiving and offering judicious feedback.

Numerous historical accounts report the existence of highly productive, creative individuals who declined the relational institutions of their time such as marriage and parenthood. Instead, they embraced the solitary nurturance of the creative process and a lifestyle devoted to contemplative practices such as prayer. Storr (1988) mentioned that many forms of prayer are not petitions to a deity for a response, but instead are ways to create a poised state of equanimity within mind-body connections.

Art-Based Connections

Combining art with meditation becomes a way to practice the nuances of introversion. Creativity craves the silence of inner listening, which is how

intuitive connections are revealed. Through self-reflection, disparate subjects have space to combine, dismantle, and eventually reintegrate. Without attention to the felt environment, discoveries are compromised as precious failures are dismissed. The result is missed opportunity for creative experimentation.

Mistakes are particularly important for uncovering new insights in creative work, but they must be heard for their counterintuitive value. Errors can only become opportunities when noticed, investigated, and refined for further inquiry. This level of vulnerable processing is repeatedly practiced within the fertility of honest self-reflection.

Art is a practice of sitting in the silence of action, mindfulness, experimentation, and discovery. For these reasons, the studio environment feels like a retreat space to honor meditative introspection. Relatedly, sanctuary spaces that prized retreat for various populations have been implemented throughout history. For example, "The Retreat" was the name of a famous psychiatric institution in England founded by Samuel Tuke in 1792. Tuke had hoped that by setting up an environment that granted safe asylum for reflective solitude, healing would unfold for people suffering from significant mental illness (Storr, 1988). The human nervous system needs time and space for contemplative intervals, especially during times of crisis. The unique refuge of inner sanctuary found by retreating into the silence of the creative process and studio emphasizes the importance of safe spaces for art-based contemplative practice.

Setting up a studio deserves careful attention. Working surfaces for sitting and standing, storage for work in progress and finished pieces, display space, clean up tools, and most important, environmental permission to make a mess must be apparent. When the spatial intentions of the studio are clear, work in silence and in dialogue with others can easily happen.

The goals of retreat described by Tuke permeate the art studio setting. The public and private advancement of imaginal liberty often takes place in silence. The studio environments that I have created and also participated in, even when crowded with people, often become silent without an invitation to stop talking. It happens naturally as materials and processes invite the participants to quietly listen to their inner conversations with images. Feeling safety to explore is essential, yet this is not always easy to achieve. Art can stir emotions, manifest fears, and confront the artist with ignored personal truths. The cast of imaginal visitors that arrive alive in our artwork reveals nuanced parts of our inner diversities. We quickly learn that all points of view from the perspective of imaginal arrivals deserve to be heard. Changing geography does not cure problematic patterns. Similarly, ignoring these messages does not necessarily quiet them. Sure to return, why not hear them out and allow them to manifest in artworks?

Meditation teachers as well as art teachers frequently speak about the importance of pursuing silence by inviting students to abide in the interior-ized space of their contemplative process. Composure to move with what is moving and unfolding serves many purposes. Becoming inwardly at ease in spite of the prattle of rising thoughts or environmental intrusion softens urges to quickly produce answers and explanations. Art can be a practice of not knowing the reasons for our choices or decisions. The fertile territory of intuitive instinct develops in the creative process as inner observation and listening intensifies. Feeling the right color as the reason for choosing becomes normal. Listening to imaginal dialogue reveals wisdom and insight as messages are sent, received, and respected as legitimate sources of vital information. Consider that imaginal and emotional intelligence are valued at all stages of the art making process.

A great deal about silence and solitude can also be learned through the objects that become subjects for art. For example, the silence inherent in landscapes such as sedentary, majestic rock formations; lakes with undulating currents; fanning plants, vibrant flowers, and shallow rooted trees reveal diverse languages of place. Breezy wind, waves slapping, sky silence, animal silence, and the silence alive in a still life painting all offer lessons on how to be in synchronized perceptive harmony with objects. In fact, the practice of still life drawing and painting subdues diverse visual elements to literally rest in place. As the uniquely arranged objects become frozen choreography, followed by a rendered response, the artist absorbs and responds to the stillness of the depicted composition.

Mantra, Repetition, and Art

The word mantra is made up of two roots: *trana,* "that which protects," and *manas,* "mind" (Feuerstein, 2003, p. 297). The practice of mantra recitation protects the mind by focusing it on sacred, consciousness-transforming sounds from languages like Sanskrit or Hebrew. Mantra is also the sound form of a deity. The repeated recitation of these sacred sounds is similar to art practices of recreating a loved landscape or subject over and over.

Psychotherapists working within a cognitive-behavioral model espouse the slogan that in order to change behavior, we must change our thoughts. While certainly true, more than thought-restructuring techniques are required to alter thoughts and behaviors within the deeper recesses of the psyche. According to a yogic perspective, mantra practice smooths out this habitually patterned terrain where beliefs and their resulting behaviors originate. Whether silently

repeating or chanting a mantra out loud, the practice reliably settles thinking habits while cleansing body-mind connections.

Technically, each letter of the Sanskrit language is a seed mantra. The vibratory quality of specific sounds, as letters, configured and recited as words in the proper way, releases a potent effect upon the practitioner (Khanna, 1979). Khanna commented on how mantras are not grammatical parts of speech. Instead they are "non-discursive symbols" (p. 36) that express ineffable, transcendent, and elemental truths through sound. Often transmitted through the empowered lineage of the guru or teacher, the mantra carries within it immense power when recited with devotion by the student.

Beyond the sounds audible to the human ear is the subtlest of sounds that are uncaused and originate from the infinite vibratory origins of *spanda* (Dyczkowski, 1987; Feuerstein, 1998; J. Singh, 1992). The primordial essence sound of AUM, according to Paramahansa Yogananda (2003), is synonymous with "Hum of the Tibetans, Amin of the Moslems, and Amen of the Egyptians, Greeks, Romans, Jews, and Christians" (p. 277). Today in contemporary church and synagogue services, every time the word AMEN is recited, it harkens back to its origins of the primordial OM mantra.

A key component of mantra practice is repetition of the sound, word, or phrase. Even though specific sounds from Sanskrit are suggested, other words such as *relax,* or *ocean,* or even the name of a safe place from childhood could be tried as a mantra. By repeating this word or phrase, the sound penetrates into subtle layers of the psyche, soothing the body and mind. Aside from the sound quality of the mantra, it is this notion of repetition that is significant.

When learning music and the skills to play an instrument, the course of study involves ongoing sessions of disciplined rehearsal. The student practices day after day, exercising the proficiency needed to progress to the next stage of competence. Eventually, the teacher encourages the student to build on the skill sets gained through repetition of the notes and chords by playing the music of accomplished masters. Commitment to this form of rote process yields several results. First is the experience of accomplishment and dexterous familiarity with an instrument. The pupil also experiences the miracle of recreating the music of celebrated maestros who have inspired generations of musicians.

Art-Based Connections

Similarly, the study of art often includes phases when a student copies the works of great masters. As in music, this custom attunes the pupil to see

and learn about the process in the product, including temporal, progressive decisions reflected in the author's finished work. Stockpiling techniques aids the student artist in becoming intuitively aware of the materials and their manifesting potential.

During my cancer experience, I made eighty pots as a form of visual mantra practice. Repeating the same actions in order to create these similar, yet varied forms, had a stilling and focusing quality of auditory mantra repetition. Repetition in hand-work, breath-work, and sound-work breeds stillness, awareness, and concentration.

This form of art-based mantra practice can be observed in the work of artists such as Giorgio Morandi (Lucie-Smith, 1986) and Paul Cézanne (Plazy, 1990). Both painted and repainted many of their subjects. Morandi, often in reclusive solitude, repetitively produced still life paintings of bottles. These subtle, intimate canvases invite close inspection to see what at first might appear to be mundane motif. However, close review reveals his gentle affection for an ordinary subject matter. The color is serene and soft, invoking the intimate silence accessible through the practice of still life painting.

Cézanne, also prone to a reclusive lifestyle, replicated Mont Sainte-Victoire near Aix-en-Provence, over and over again (Plazy, 1990). His repeated

Figure 7.3. Studio, selection of eighty pots. Hand-built and sawdust-fired by the author.

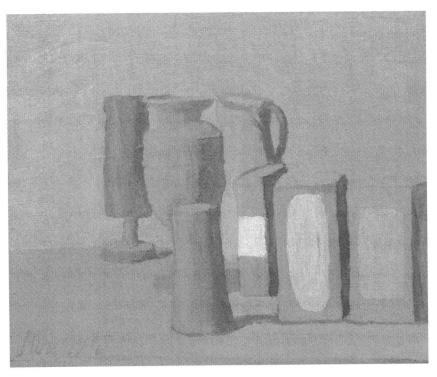

Figure 7.4. *Still Life*. Giorgio Morandi (1949).

attempts to reinterpret this scene revealed a penetrating understanding of a
new and radical analysis of form and space on a flat, two-dimensional surface.
His experiments resulted in a complete shift for the future of Western art.
Cézanne is often credited with freeing subsequent generations of artists to
continue challenging canonic rules of form, figure, and ground.

Morandi and Cézanne offer examples of how seemingly rote gestures of
repetition are like concentrative meditation practices. For some, this sort of
repetition strikes a chord of boredom, which is another opportunity to observe
the mind contracting around what at first seems monotonous. Cézanne's and
Morandi's experimentation transcended the lethargy of boredom. In my view,
art becomes contemplative practice when encounters with what at first feels
dull and bland, eventually yields appreciation for the delicacy of subtlety.

Cultivating Compassion Through *Maitrī* and *Tonglen* in Art

Maitrī

Maitrī in Sanskrit, also known as *mettā* in Pali, is an attitude and practice from Buddhist traditions. The goal is to cultivate compassionate loving-kindness toward oneself and others. Untangling the knots and webs of unworthiness accumulated over time demands gentle attention (Chodron, 1997). Although this is a laudable goal, self-deprecating beliefs often prevail. Shame, disgrace, fear, humiliation, indignity, and embarrassment are basic, debilitating human experiences that make *maitrī* at first a challenging goal and yet a necessary practice.

Maitrī does not seek to fix historical tendencies toward self-condemnation. With skillful awareness, we strive to circumvent collapse or contraction around these events, especially the propensity to label them as bad (Wegela, 2009). The practice shifts perspective and provides awareness that it is our choice whether or not to identify with a ruminating thought. With simple clarity, *maitrī* invites us to muster curiosity and notice that loving kindness for ourselves and others is a radical means for remaining empathically focused on the basic goodness of all. If true compassion is possible with regard to oneself, then it is conceivable with another, including our artwork. The images we create can immediately call up feelings of lack, disapproval, even scorn. Unchecked contempt for our efforts is another way of holding the same attitude toward ourselves. Different from healthy self-criticism, aggressive attitudes aimed at our artwork can be very revealing. Consequently, art shows us our mind in action thereby affording endless opportunities to be sensibly gentle with ourselves.

Tonglen

Tonglen is a contemplative method for receiving the suffering of others and offering back observations of hopefulness. When combined with *maitrī*, the practice expands inner altruistic attitudes for both ourselves and other beings. Tibetan for "sending" and "taking" (Chodron, 2001, p. 3), or exchanging self with other, the *tonglen* practice has four steps. First is to cultivate a welcoming attitude by briefly flashing on the openness of *bodhicitta* (bodhichitta), which means awakened heart and mind. Remembering the ever-present availability of abundant space softens us into openness. We could recall a memorable experience of seeing the vastness of the ocean, a rare and beautiful wide-open mountainous landscape, or being in the presence of one's guru who radiates unbounded compassion. Illuminating any one of these heart-opening sources seeds the experience of *bodhicitta,* which then opens inner doors of tranquil

clarity or "true compassion" (Midal, 2001, p. 129). Essentially, genuine compassion emerges out of refreshed emptiness rather than from a familiar jaded orientation. As with all practices described in this book, it is best to work with a seasoned teacher who can responsibly guide the progress of your *tonglen* experience.

The second step in *tonglen* practice is to work with the full range of emotional tones and textures that might arise from agitation related to the subject of focus. The notion is not to reject anything (Midal, 2001). Pema Chodron (2001) defined this step as "working with the textures of claustrophobia and freshness" (p. 26). The mind and breath are synchronized to breathe in that which is a source of discomfort and breathe out what is desired or sought. Inhale the challenge and exhale the related possibilities of unbounded spaciousness. Important, according to Chodron, is to use a convincing image while synchronizing the breath as a way to support a fluid conviction that nothing feels stuck.

The third stage of *tonglen* practice is to focus the imagination on yourself, a particular person in pain, or a stimulating situation of importance (Chodron, 2001). At this point, without being too conceptual, take in the general tone of their suffering and on the out-breath offer back hopefulness. If a person is feeling sadness due to the illness of a loved one, for example, on the in-breath we could silently say, "Linda is sad and worried about her mother," and on the exhale, "May Linda and her mother find the comfort and guidance they need." The synchronized phrases are then repeated on each inhale and exhale. The practice does not try to take anything away, only attune to the challenges of acceptance and release. If an obstacle emerges, then this can become the focus of the practice at this stage.

After many cycles, the intention could be expanded outward to others who similarly grieve the loss or illness of a loved one. This exemplifies stage four, which can sometimes blend with stage three. Here the practice is made universal, directed toward others. Breathing in the shared sorrow of many reminds us that it is not only our sorrow but also a common experience for others as well. Chodron encourages the practitioner to remember others when all is well for us but not for them by holding awareness of their circumstances. This is a core value of the practice. One meaning of compassion is to remember that all people suffer separately, yet often unknowingly together. Through the coordinated empathic breaths of *tonglen,* contact is made with another or many, eroding intrapersonal-interpersonal separation.

The cycle of *tonglen* is repeated in silence. Ever-present within each person, the tender territory of *bodhicitta* is enlivened when we allow the vulnerabilities of life to enter and affect our heart. This sort of humane, kindhearted receptivity naturally merges into compassion, which is a bottomless human trait.

Tonglen acknowledges the reflex to avoid, suppress, fight, or flee as possible initial tendencies. At first, avoidance is a sensible response to emotionally challenging events. However these limiting views reduce in size and eventually reverse as the practice is practiced.

Art-Based Connections

In many ways, art is like *tonglen* practice; both rely on sensitivity to image, imagination, and incoming-outgoing awareness. As with self-portraiture, through art materials and processes, we can visually take in our own pain, receive it, hold it, sift it, and silently reflect back to ourselves a sense of altruistic vision. Additionally, portraiture observes and penetrates internal states of the model. The artist translates layers of human affect revealed through careful observation of indirect cues, such as subtle facial expressions, into a final single work. The finished product distills a complex personality into an expressive visual language. Successful portraiture represents multiple aspects of the model's personality within a condensed rendering of the sitter's life. To accomplish this, the artist visually inhales seen and felt subtleties of personality and exhales integrated handmade responses of observed character traits.

For me, this process unfolded while making clay pots and charcoal drawings during my cancer episode. Through breath and image, I inhaled themes related to malignant cells, and exhaled formed aesthetic responses that were beautiful to me. Over and over again, like the repetitions of a visual mantra practice, this became a soothing way to touch into pain, release it, and acknowledge the humanity of embodied suffering experienced by other men with prostate cancer. I learned that my pain gracefully connected me to others living the reality of similar conditions.

Through this art-based approach to *tonglen* practice, I was able to cultivate deeper insight and compassionate presence for others and myself. It showed me where I held back and where I advanced forward with my circumstances. At its core, art is related to elements of attunement and empathy. When I needed to outwardly express anguish, art allowed me to silently receive these thoughts while offering back a compassionate response grounded in *maitrī* and *tonglen*. The final artwork became an empathic record of these attuned observations (see the Split Screen *Tonglen* practice in Part III).

How to Work with Disturbing Imagery

Trungpa Rinpoche and remarkable colleagues at Naropa such as Acharya Dale Asrael assert that any state of mind or any difficult situation is workable.

Since art knowingly and unknowingly loosens defenses, unexpected unconscious imagery can appear at any time. Sometimes these images shock the artist, causing unanticipated fear to emerge. McNiff (1992) thoughtfully suggested that alarming images never arrive with the intention to do harm. Although we may be startled by what emerges, working with what turns up is sensible and advisable. With curiosity, gently turning toward the powerful imagery begins the process. With this intention we reduce the tendency to avoid, suppress, fight, or flee.

Inviting this stranger to come closer, to speak, and to be in dialogue can reveal surprising information. What at first seems like destructive symbolic communication is, in fact, an abandoned self-part pushing hard to be recognized. There are many ways to work with this sort of orphaned imagery. First, since the images are made concrete through art they can be put away and visited later. Or they can be placed on the far side of the room where closeness and distance is possible. Additionally, pieces of paper can be used as cropping tools to be placed over parts of the work. Careful descriptive writing helps to maintain objective distance, yet also supports entry into the work's content. Describing the formal elements leads to knowledge of intrinsic content. Listening to and following the imagery to the next frame, and then the next frame with subsequent artworks, demonstrates that all is moving within this progressing narrative.

Images, like emotions, often get a name from us that then fixes them into a label with potent *mātṛkā śakti*. Rather than label what emerges, consider this content as moving *śakti* that needs to be loosened from its claustrophobic location. Images need their own breath and trajectory acknowledged. We can have the emotion arrive and move without casting it into unbearable meaning. Lastly, we can work with disturbing imagery through *tonglen* practice.

Practicing *tonglen* with people in an art therapy or academic class setting shifts the way I relate to work and the way students relate to their work. No matter what the setting, people notice that when disturbing art is created and the final product confronts the artist, responses of fear, resistance, and shame can emerge. Often, the unconscious projection placed into/onto the artwork can still remain unconscious or preconscious for the viewer and consequently surface harsh criticism. Like any true symbol, the meaning can remain alien to our awareness, even though the image is now concretized. Rather than explain the image or seek impromptu interpretations, artist and viewer are invited to practice *tonglen* by taking in the raw content and breathing out well-being as a way to defuse the sting. It is important to remember that *tonglen* can be a practice of titration whereby the receiving and sending is made manageable with simpler, emotionally congruent homeopathic-dosed statements. The intense power of the image is eventually softened as the artist relates to the

Table 7.2. Visual *Tonglen* Practice

Practice with challenging or benign printed imagery, for example, news about a natural disaster. If the imagery is disturbing, have cropping tools available, a way to assume closeness and distance, and a folder to carefully put the work away if titrated exposure is needed. Note that this is easier said than done. It is best to seek the guidance of a seasoned teacher.	
Stage I	Facing the imagery, flash on the openness of *bodhicitta* to create spacious perception and open connection to this very moment.
Stage II	Looking at the art or photograph, self-observe the full range of emotional tones and textures arising from the perceived claustrophobic agitation. Welcome, rather than reject, the arriving feelings. Mind and breath are now synchronized to uncramp emotional space. While observing the work, breathe in that which is a source of visual discomfort and breathe out that which is desired or sought. After several rounds, pause and write down, for a minute or two only, any responses that emerge. It is important to avoid censorship of the emergent narrative.
Stage III	Now focus the imagination on a particular part or the entire artwork. Without being too conceptual, breathe in the general tone of the disturbing felt sense, and on the out breath offer back hopefulness. Repeat several rounds. Do not try to take anything away, only attune to the challenging felt sense and corresponding imagery. If an obstacle emerges, then this hurdle can become the focus of the practice at this stage. The goal is to not feel stuck.
Stage IV	Here the practice is made universal, directed toward others. Breathing in the shared sorrow or joy of many reminds us that it is not only our sorrow or happiness, but also a common experience for others as well. Repeat several rounds.
Refining the Results Use the following steps to further relate with your artwork. **At any point in steps 1–3, engage the *tonglen* practice.**	
STEP 1.	**OPEN, BEGINNER'S MIND—FRESH VISION** Approach the work with fresh vision or beginner's mind. Monitor projections and rein them back in by putting intentional brackets around them and placing them off to the side of your encounter. Assume an orientation of neutral, impartial engagement. Strive to suspend judgment and just be present with the artwork. Still impulses to judge or interpret, monitor assumptions, and let the work exist on its own terms as it comes fully alive in your awareness. The work has presence and is to be respected.

	Remember, you are not the sole doer—you are in collaboration with the artwork, specifically the imagery—you create it and it creates you in return. You are in an I/Thou relationship, not an I/it relationship.
STEP 2.	**OBJECTIVE DESCRIPTION** Carefully/rigorously describe the artwork in as much detail as possible. Write these observations down. Notice and take responsibility for your personal bias responses. Take a careful inventory of the formal qualities of the work (line, shape, texture, balance, temporal elements). Monitor your language and avoid interpretive statements. Strive for accurate observational visual listening—careful observation of formal elements leads to closer understanding of content.
STEP 3.	**SUBJECTIVE FREE WITNESS WRITING** Based on your careful observations of the work, inwardly reflect and, without censorship, write these observations about the imagery down. Consider taking dictation from the work as "it" offers information. Write this news down. Occasionally read the writing back to yourself in order to elicit more information. Take three different color pens (red, blue, black) and underline the following in each color: (1) Words that imply emotion/feeling; (2) Words that imply movement; (3) Words that imply evaluation/judgment. Read back to yourself the red underlined words only. Then the blue, and then black. Notice the distilled narratives of feeling, movement, and judgment. Consider cultural influences, gender influences, familial, regional, class themes as well.
	Further Refinement The steps outlined above describe a method for working with art products and the results of enclosed potent imagery. Also available is to metaphorically elongate the in-breath and out-breath by actually creating corresponding artworks for each part of the cycle. In my experience, at first, it is best to work spontaneously. Follow all steps, however move from conceptual compassionate responses to visual, art-based responses. Like a long in-breath, create a spontaneous artwork of taking in potent subject matter. And also create a hopeful corresponding spontaneous artwork for the symbolic outbreath. You can practice with simple marks and lines representative of a personal visual vocabulary for each part. Once the series is complete, let's say after six rounds, hang them up on a wall, take distance, and observe the lines and shapes. If inclined, see these pieces as studies to help inform a series of additional, longer term artworks.

subject matter through a progressively attuned, *tonglen* lens. When in the teacher or therapist role, I too can silently do *tonglen* for the image produced by the client or student. Through *tonglen,* we have a practice for working with any state of mind and consequently, whatever emerges in artworks.

Karma Yoga, *Ahimsā*, and the Socially Engaged Artist

In India, from the late nineteenth century through the first few decades of the twentieth century, Mohandas Gandhi was integrating principles of *ahimsā*, to do no harm, by leading nonviolent protests against the oppressive colonial rule of the British. Around the same time, Nobel laureate Rabindranath Tagore was recognized for his refreshing use of language and originality as a poet and educator. He viewed creative freedom as a link to the pursuit of spiritual freedom (Chaudhuri, 1975). Tagore believed in the aesthetic education of the senses and how the arts taught empathy for humankind and nature (R. Singh & Rawat, 2013).

Another political activist of the same time period was Sri Aurobindo, who as a young man, eventually left activism to pursue spiritual interests after a life-changing event. His brother Barin was feverish and very sick. To his amazement, a wandering monk spontaneously cured his brother, a miraculous moment that began to shift Aurobindo's worldview (Cohen, 2008). Over his lifetime of far-reaching scholarship and practice, Aurobindo's influential work resulted in an integral view of yoga that also included a deep appreciation for creative work (Chaudhuri, 1975; Aurobindo, 2001). These three groundbreaking figures of Indian culture set seismic shifts in motion, based in karma yoga, that would forever transform the country.

Later, and related to similar social circumstances, Thich Nhat Hanh and Martin Luther King Jr. continued the practice of nonviolent, peaceful protest. In fact, Nhat Hanh's (1987) socially engaged Buddhism offers an exemplary model for reconsidering the role of the artist working in the twenty-first century (Franklin, 2010).[1] Women such as Julia Ward Howe and Jane Addams, who predate Mahatma Gandhi and Martin Luther King, championed similar ideals for social change. Consistent threads that link these

great people together are their convictions for justice, *dharmic* right action, peace-seeking motives, and compassionate acts of extreme altruism. Although not all self-identified as karma yoga practitioners, their work exemplifies many of the core principles.

Karma Yoga

Contemplative life need not be lived out in a temple or retreat setting. Instead, for the socially engaged karma yoga practitioner, commitment to connect directly with the world becomes the practice setting (Feuerstein, 2003). Between our fragile ecosystems, rampant consumerism, vulnerable animals and children, a great need exists in our own backyards for compassionate engagement with culturally diverse, impoverished communities. Altruism, renouncing attachments to outcomes, and freely offering our efforts to the Divine or to world peace, without ownership of results, begins to sketch out the parameters of karma yoga. As a complete *sādhanā* path, karma yoga includes a careful inventory of general behavior (karma), respectful action (*dharma*), ritualistic acts (*saṃskāra*), and socially engaged service (*yajña*)[2] (Michael, 2014). The goal is to discover that happiness is absorption in positive actions steeped in compassionate, selfless behavior.

Like so many contemplative paths, karma yoga unfolds along a developmental trajectory. At one end of the spectrum might be the community-minded volunteer. For many, the goal is to help, but not necessarily self-examine motivating attitudes linked to the offering. People often volunteer because it feels good and strokes self-worth. It is similar with charitable giving. While generosity is a virtuous gesture, self-serving attitudes can influence acts of philanthropy. The *Bhagavad Gītā*, which widely addresses karma yoga, suggests a broader, selfless perspective. On this side of the spectrum, rising above limiting contractions of ownership, the practitioner repeatedly self-reflects in order to transcend ego-based self-interest. Aurobindo advocates for using will to soften ego's determined grasp on action thereby supporting contemplative shifts for holding larger perspectives. Conceptual mentality becomes modified through this practice leading to the embodied supramentality of the Divine (Aurobindo, 2001). Aurobindo further notes that there is "no royal road to the divine realization," yet the goal is to make daily work the means for spiritual rebirth (p. 119). Shifting desire from craving acknowledgment for the fruits of actions, to devotedly working without attachment, frees the practitioner from the trappings of ego's desire for ownership.

For many, allocentric service to others as a path to spiritual maturity makes more sense than a solitary meditation lifestyle defined by austerity and renunciation. It is similar for the studio artist. Instead of being cloistered alone in the studio, the mission is outward to serve and work with communities. Therefore, the call to action to care and compassionately engage with society resonates as a practical path for the contemplative artist and practitioner. Sometimes referred to as the yoga of actionless action, karma yoga views every gesture as an opportunity to unselfishly be ourselves while offering ourselves (Kripananda, 1989). Like social chisel and sandpaper, this yoga whittles away and smooths the limiting doership/ownership parts of the ego. Internal shifts result as inner architecture moves from self-serving behavior to humane selfless action. As the practice deepens, the yogi/yogin's humility aligns with *dharmic* purpose in order to become a finely tuned, relational instrument of service. Promotion of thoughtful restraint in order to anticipate and monitor the need to control end results are also modified. Disciplined action, when offered with generous intentions to love and responsibly perform duties, defines daily work as a form of worship (Chidvilasananda, 1997; Michael, 2014).

Sevā, which means selfless service, helps to further define the attitude of the karma yogi. Unselfish availability to attend to others suggests willingness and readiness to assist where needed. Evaluating this need can be complicated. First, being selfless in action does not mean service as self-betrayal. For some people, extreme flexibility to help others results in self-infidelity. Exhaustion becomes an obvious result from over extending helpfulness. Our body, too, is our *sevā* and therefore needs to be served with care and devotion. Additionally, karma yoga advocates for authentic truthfulness. Sometimes, situations call for genuine acts of compassionately honed, stern responses.

All action, physical or cognitive, has some form of motivation behind it and therefore creates karma, leaving a resulting mark (Vivekananda, 2012). The calling is to work hard, but with attitudes like the *sevite,* so as to lessen the bondages of attachment to results. The following passages from the *Bhagavad Gītā* help to clarify the nuances of a karma yoga perspective.

This sacred text, which means "The Song of the Blessed One," is part of the epic *Mahābhārata.* The *Gītā* is a dialogue between Prince *Arjuna* and his charioteer Lord *Kṛṣṇa.* Faced with his *dharmic* responsibility to battle his relatives, Lord *Kṛṣṇa* instructs *Arjuna* on the many yogas. At first, *Arjuna* drops his weapons and refuses to fight. This becomes the moment for Lord *Kṛṣṇa* to teach "about life and deathlessness, duty, nonattachment, the Self, love, spiritual practice, and the inconceivable" dimensions of reality (Mitchell, 2000, p. 15). This sacred text inspired many authors including Emerson and Thoreau.

Table 8.1. Key Passages Related to Karma Yoga from the *Bhagavad Gītā*

2.47: You have a right to your actions, but never to your actions' fruits. And do not be attached to inaction.
2.48: Self-possessed, resolute, action without any thought of results, open to success or failure. This equanimity is yoga.
2.50: The wise man lets go of all results, whether good or bad, and is focused on the action alone. Yoga is skill in actions.
3.19: Without concern for results, perform the necessary action; surrendering all attachments, accomplish life's highest good.
6.2: Know that right action itself is renunciation, Arjuna; in the yoga of action, you first renounce your own selfish will.
18.2: To give up desire-bound actions is what is meant by *renouncing;* to give up the results of all actions is what the wise call *to relinquish.*

Source: Mitchell (2000)

Art-Based Connections

For whom do we really work or do artistic work? Who, actually, is our employer? Certainly, we sign contracts that need to be honored. Yet there are larger questions to ponder when it comes to our work in the world as artists. What if there was reason to untangle the need for acknowledgment and reconsider our art and work as an offering? An attitude shift such as this reshuffles the deck of artistic motivation and purpose. As artists, something is moving through us, trying to take form in the world. This process of manifestation, when combined with silent altruistic intentions to offer our artwork for the well-being of others, radically shifts our orientation.

Trungpa Rinpoche (1996) felt that art emerges from the ordinary sacredness of daily life. Materials, spaces, found objects all have inherent richness and it is up to artists to sensitively make contact with this intrinsic fertility. For him, art was an attitude of deliberate attention held while moving through any activity. Therefore, all actions could be related to artistic expression. Furthermore, genuine art can become a pursuit of nonaggression rather than showmanship. He called this nondogmatic approach and view Dharma Art (Trungpa, 1996). Aesthetic behaviors become languages of our basic goodness that artistically manifest aspects of the brilliant sanity that we are. Therefore, the art we create, as visual *dharma,* has the power to liberate blockages in us as well as others who experience it. We can discover basic goodness in ourselves by attuning to the same in the materials and processes we utilize for artwork. For example, materials are abundantly generous, trustworthy, and metaphorically behave with *dharmic* integrity. They follow their own rules, generously

collaborate, and have their own reliable nature (Erikson, 1979). The attitude of involvement with materials, processes, and final products are opportunities to set the practice of art-based karma yoga in motion.

Swami Vivekananda's (2012) writings on karma yoga address several key points to consider. All work, he suggests, originates with motives. Outgoing intentions that coalesce, as specific actions, are best served when first met with filters of self-restraint. Without self-reflection and self-control informing intentions and resistances, the results of our behavior can return to us with unyielding force. Yet context is always part of this equation as when fusing duty, honor, and morality with decision-making processes. Sometimes, what looks to others as an aberrant behavior is in fact a sensible response to insane conditions. When working in adolescent inpatient treatment settings or schools, I repeatedly heard backstory accounts of dysfunctional family histories, severe poverty, and relentless abuse. Early on in my career, this information quickly modified my judgments, realizing that if I had to endure similar circumstances I too would behave like the teens in my care. Their behavior was not necessarily about diagnosable pathology. Rather, it was often about skillful survival strategies for living in chaotic neighborhoods. My job became clear to me when I realized that the best way to work with my young clients and their pessimistic views of the future was to use art and social engagement practices to help wake them up to their innate capacities for altruism. Belief in their ability to care about others signaled to the teens that a believable, obtainable future could be waiting for them. This narrative of hopeful possibility was competing with the possibility of eventual jail sentences, neighborhood gun violence, and gang membership. Understandably, the future was viewed as an inevitably bleak, fast approaching reality.

These kids were rough, at times difficult to reason with, yet if they saw you cared, they would open the doors of relationship. Vying for status by fighting each other, even sexually abusing each other to show dominance, was commonplace for some of the boys. Yet I watched each morning as many arrived with their aging grandparents. While in the company of elders, these kids were surprisingly kind, gentle, and respectful, presenting an interesting paradox. Always willing to fight, yet consistently gentle with seniors, I started to think about art-based interventions that capitalized on their polite strengths woven together with the photography unit I was teaching.

With careful planning I took twelve students to a nursing home, paired them up with the residents, and asked them to create biographical photo essays. The teens first practiced compassionate interviewing techniques that I taught them. Once contact and preliminary relationships were established, they were instructed to respectfully take pictures of their partners. Next, the teens reversed roles, became the teachers, and showed the residents how to use the cameras. With this role reversal, the students were next interviewed and photographed.

After our long mornings, we all went back to school, developed and printed the film, and talked about what had happened. Inspired, they could not wait to return the next week to share their pictures. Offering the prints as gifts to the residents made a simple, yet profound difference for everyone involved. These young people became inwardly rewarded, beaming their kindness at each other and the nursing home community. During these moments, they became self-other nurturers offering genuine care and respect. Vivekananda's ideals concerning karma yoga mix work, love, psychology, and knowledge together into blended actions (Vivekananda, 2012 p. 109). This description of a community-based, artistically engaged project begins to define art as karma yoga.

Engaged Buddhism

Engaged Buddhism is a contemporary, applied renewal of core Buddhist teachings (Jones, 1989). The guiding principles of socially engaged Buddhism are compassion, wisdom, and loving kindness expressed in forms of practical nonviolent action (Jones, 1989; King, 2005; Kraft, 1999; Nhat Hanh, 1987; Queen, Prebish, & Keown, 2003). As well, Gautama Buddha's style of instruction offered an early version of direct teaching on the subject of suffering, and is therefore an example of socially engaged public instruction (King, 2005).

Over the millennia, including today, Buddhism has focused on compassionate inner transformation and engaged action. As the violent injustices of the twentieth century unfolded, Buddhism advanced its roots of social justice. If Buddhism did not renew itself by stepping out into these traumatic world events, some believe it would have withered, even approached extinction (King, 2005). Fortunately this was not the case. Leaders such as Thich Nhat Hanh (1987), who coined the term *Engaged Buddhism,* initiated a galvanizing movement of principled social action.

Nhat Hanh's (1987) book, *Interbeing,* offers fourteen guidelines for practicing engaged Buddhist principals. Working through art with the "seeds" of charged emotions that can hijack our composure demonstrates how in my view art practice becomes a *dharma* path revealing truth teachings. He says:

> Do not maintain anger or hatred. Learn to penetrate and transform them when they are still seeds in your consciousness. As soon as they arise, turn your attention to your breath in order to see and understand the nature of your anger and hatred and the nature of the persons who have caused your anger and hatred. (p. 18)

Nhat Hanh's guidelines relate to sublimation in art. He proposed that we penetrate and transform chaotic emotion in nascent seed (*paśyantī-vāk*) form using

the breath as the primary transformative vehicle. As soon as these impulses arise, art, combined with contemplative practices such as mindful breathing, builds a gap between anger and action. For example, as harmful speech is about to be voiced, if we pause to mindfully breathe and observantly track emerging imagery, even count to ten, space can be placed between the impulse to verbalize anger and detain it before it gets to the *vaikharī-vāk* stage. Since we can't un-ring a bell and often wish we could take our aggressive comments back, why not approach such moments with contemplative attention?

WORKING WITH THOUGHTS THROUGH ART

According to Buddhism, actions manifest through the three doors of body, speech, and mind. These are the same points of entry through which karma gets created (Sivaraksa, 2005). From this perspective, all actions begin in the mind. Since the arts express and eloquently articulate human emotion (Langer, 1951), they consequently offer a strategy for manifesting and processing the content of body/somatic, mind/cognition, and speech/affective narratives.

Buddhism and other contemplative traditions consider how toxic thoughts begin in the mind and therefore need to be transformed in the mind through related activities, like those found in the arts. Sulak Sivaraksa listed the three main poisonous thoughts to contend with: "greed, hatred, and delusion or ignorance" (p. 3). In terms of speech, verbal/visual violence can manifest in four primary ways: "divisive speech, gossip, harmful words, and slander" (p. 4). Since art is symbolic speech, it consequently offers a way to literally see this communication in visual forms before merging into destructive behaviors. While this approach to art may seem like indulging harmful thoughts, it can also become a strategy to mollify inner forces.

UPĀYA AND THE FOUR APPROACHES TO ACTION

Skillful means, or *upāya,* are needed to monitor verbal and visual thoughts that spawn karma. Under the right circumstances, we are all capable of confusion and muddled behavior. Since trouble first begins as one or a combination of the three poisons, strategies are needed to manage these cognitive impulses before they become spoken or behaviorally manifested. Transcendental actions, known as the six *pāramitās* (perfections), help to train the mind not to act violently. Sivaraksa (2005) identified them as "generosity, morality, patience, effort, meditation, and wisdom" (p. 4). Four more *pāramitās* were added from the Theravada tradition. They are "renunciation, truth, resolution, and loving-kindness (p. 4). Additionally, there are the Four *Brahmavihāras* or "Divine Abodes" also referred to as the four immeasurables. They are "loving-kindness (*metta*),

Table 8.2. Art Project Vocabulary: Poisons, *Pāramitās,* and Immeasurables

Three Poisons	Greed, hatred, delusion/ignorance
Six *Pāramitās*	Generosity, morality, patience, effort, meditation, and wisdom Additional *pāramitās*: renunciation, truth, resolution, and loving-kindness
Four Immeasurables	Loving-kindness, compassion, sympathetic joy, and equanimity

compassion (*karuna*), sympathetic joy (*mudita*), and equanimity (*upekkha*)" (p. 4).

The three poisons, *pāramitās,* and four immeasurables are worthy subjects to explore through art. Within the layer of pause afforded by art is the liminal space where we can practice aesthetically titrating the seeds of aggression and their counterpart of compassion. Modifying aggression is implicit in karma yoga practice. Chogyam Trungpa (1976) described four approaches to action:

1. Pacifying untrue situations. Gently feel out the ground, edges and center of the entire situation. Open to feeling the multiple perspectives of the situation.

2. Enriching/increasing. Working with what comes to you as it comes. Welcome it. Greet it. See it for what it is.

3. Magnetizing. Bring the parts of the situation or event together. Define and explore the parts—consider how they form a whole.

4. Destroying/extinguishing. Best to be honest with oneself. If hiding, then consider using contemplative practice to expunge or remove obstacles—destroy deceptions and begin again with authenticity. (p. 76)

These four helpful approaches to action articulate how to move toward, receive, and artistically work with unfolding events. When we meet obstacles with the skills of the *pāramitās* and four immeasurables, solidity of the situation softens and becomes workable. Creative behavior seems to thrive on problem solving. Research on creative people reveals that they not only enjoy solving problems, they actually seek them out (Winner, 1982).

Art-Based Connections: Flattening Hierarchy and Seeking Ordinary Sanity in the Community Art Studio

Within the community art studio space, most all voices and images are welcome. Other than violent speech and artwork, the studio can accommodate any state of mind. From the attendees to the emergent images and their symbolic speech, the full democracy of the space is alive with egalitarian values. The Naropa Community Art Studio, to be discussed later, offers an example of flattened hierarchy and resulting sanity that permeates the space.

The Socially and Culturally Engaged Artist

The socially engaged karma yoga artist embraces a relationally attuned, selfless role. Within this practice, the artist monitors attitudes of doer-ship and ownership by becoming true altruistic collaborators. The larger calling of social need beckons the artist to engage directly with communities. This community-based, relational approach to art considers the importance of human need and how art and artist offer back to social causes (Franklin, Rothaus, Schpock, 2005).

Table 8.3. A Formula for Creating Community through Art

1. Loosening defenses, private explorations of honesty	Art, with its capacity to loosen psychological defenses, invites private inner explorations of honesty to fuse with artistic expression.
2. Personal and public vulnerability	Engaging in personal honesty within a group setting fosters personal and public vulnerability.
3. Discerning intimacy: making the private public	Private vulnerability, when appropriately shared with others, results in public intimacy.
4. Witnessing	Shared intimacy when collectively witnessed by all group members flattens hierarchy and results in community. (This view, at first, assumes a critique-like atmosphere of silence. And if/when conversation emerges, skillful speech to do no harm becomes a shared value.)

Gablik (1991) asserted that art is not only about the object of creation but also exists in the act of engagement. This view echoes with the work of Joseph Beuys, whose acrimonious views pried normative beliefs about art apart. He had strong interests in the natural sciences, which later guided his important, radical ecological work (Adams, 1992). During World War II, while serving as a Luftwaffe pilot, Beuys's plane was shot down in Crimea. Careening quickly back toward earth, the sky dropped him, gravity grabbed him, and his broken body needed help. He reported that he was rescued by Tatar tribal people who swaddled his wrecked frame in fat and felt, which later became signature materials in his work. Eventually emerging from his infirmities, he became a type of shamanic, ecologically focused, performance artist who asked important questions about learning, meaning, and the teaching of art (Adams, 1992).

This idea of a contemporary artist performing shamanic acts raises several questions. In her article about artistic acts of last resort, Rosalie Politsky (1995b) observed how offensive artworks challenge the reexamination of complacent social norms. She addresses extreme artists who enact dark ritual performances by taking on societal disorders such as class difference or punishing ethnic or gender bias. Hard to grasp, their work represents solo undertakings of embodying cultural illness and uses the self-sacrifice of their performance art to transmute social poisons. As viewers, we are shocked by the willingness of these performers to self-harm in order to offer cultural healing.

Consider performance artists such as Chris Burden and Gunter Brus, who shamanically take on cultural malaise and regress for us all in the service of the larger, bankrupt social ego and its counterpart collective shadow. Their works, claims Politsky (1995b), serve as confrontive acts of last resort to help jump-start our atrophied guiding myths. When religion becomes arid, void of living numinous symbols, spiritual impoverishment becomes an obvious side effect. Although I struggle with these artists and their work, I am interested to understand their intentions. It is not a stretch to consider how their truly offensive acts are perhaps serving a specific, last-resort social need to wake us up from sanctioned indifference.

As this extreme work demonstrates, there is work in the world that demands the healing attention of the arts. Yet many have been denied this opportunity. Historically, many artists of diverse backgrounds have been refused access to venues such as galleries and museums. For centuries, accomplished women were written out of the history of Western art. More recently, marginalized groups are finally gaining access to showing their work. Advantages of race, gender, class, and financial privilege significantly define institutional art practices in our culture (hooks, 1995). Uniquely through the arts, privileged hierarchies need to be dismantled in support of reclaiming

oppressed art histories. The voices of marginalized groups deserve to be heard. Art studios like ours at Naropa University support democratic ideals as access to an egalitarian setting where the human right of visual free speech can be openly practiced.

There are many community studios across the United States and in other countries. Indeed, art happens in many different places (Cleveland, 2000). A pathway for reclaiming indigenous practices and integrating those retrieved lost histories into contemporary forms of expression is distinctively available through the arts.

Those artists working at the margins, beyond the centralized and homogenized familiar, reflect back societal imbalances. Just as the psyche offers compensatory messages through dreams to attend to one-sided habitual patterns; so, too, does the exceptional artist perform a type of cultural dream work to rebalance uneven social disparities. Part of this work is to remythologize the world by utilizing the arts to locate a living cosmology. Social and spiritual alienation, so prevalent in Western culture, becomes recalibrated through the social adhesive of expressive work. Without apparent guiding myths to steer cultural morality, it is easy to lose a sense of ethical direction (Politsky, 1995a). Socially engaged, community-based artists model how to reconnect with the sacredness of life. Joining artistic action with social responsibility is one way to serve where needed.

In many cases, the socially and culturally engaged artist embraces a social activist role of peacemaker. Those who are oppressed, disenfranchised, or socially exploited deserve to have their voices seen and heard. However, in some settings this is dangerous work. The symbolic coding of visual imagery through either allegory or metaphor can offer needed, yet risky stealth methods for speaking local truth to institutional power. Initially undecipherable, these approaches provide expressive solutions to those working under oppressive circumstances. And for this very reason, power structures have a history of being threatened by the arts.

There are many examples of artists helping to directly transform communities and foster local, regional, and global recovery (Bass & Jacob, 2004; Cleveland, 2000; Lacy, 2005–2006). After the stock market crash of 1929, and for the following ten years, a great financial and emotional depression fell across the United States. As a response to these tragic times, President Franklin Delano Roosevelt launched the New Deal and the government-funded Works Progress Administration, or WPA. The Federal Art(s) Project (FAP) that was part of this New Deal and the WPA, began in 1935 and functioned until 1943. Its purpose was to put unemployed artists, musicians, writers, and actors back to work (Wechsler, 1937). Artists worked as teachers for youth in rural and urban settings as well as researchers cataloguing the material culture of

American design. According to Wechsler, dozens of community studios were in operation around the country in remote areas in the Carolinas, Florida, Oklahoma, Tennessee, Utah, Wyoming, and Virgina. Overall, artists such as Alice Neel, Romare Bearden, Thomas Hart Benton, Mark Rothko, Jackson Pollock, and Louise Nevelson were part of the legions of artists that created thousands of public works. It is important to mention that some of these artists were virtually unknown at the time.

In terms of this book, this information not only marks a tragic time in our history, it also identifies a time when the arts were intelligently utilized to uplift communities. Through newly established local art centers, poverty was addressed and attempts were made to support women and poor children from rural areas such as Mississippi (Swain, 1995).

In Albuquerque New Mexico during the mid-nineteen-nineties, ArtStreet was born. This thriving studio setting addressed homelessness by helping vulnerable people have a place to create, learn artistic skills, and sell their work (Timm-Bottos, 1995). Similar to ArtStreet was the community studio called "Vincent's" in Wellington, New Zealand. This studio was founded on the principle of having a safe place for "psychiatric survivors" to come and work together (Franklin, 1996). More recently, art therapists have been involved with conflict resolution, social violence, and trauma work (Hacoy, 2005; F. Kaplan, 2005). Another example of socially engaged artistic work is the Naropa Community Art Studio (NCAS), a training studio I created in 2001 with the following mission:

> The guiding vision behind the NCAS project is to provide a space for diverse groups to gather and create art together. Equal access for our studio members is stressed, particularly people who are marginalized and unlikely to have access to the humanizing practice of engaging in artistic behavior in community. Respect for cultural, ethnic, gender, and spiritual diversity is a founding principal of the NCAS. Unity in diversity, the birthright to pursue creative expression, and the capacity of visual art to contain and communicate the full range of human experiences comprise the essence of our mission and focus.

Over the years the NCAS has created different venues and served many groups from the Boulder, Colorado community, such as teens needing safe places after school, LGBTQ youth, people without homes, young adults with developmental disabilities, people with mental illness living independently in the community, people who have experienced a head injury or stroke, among others.

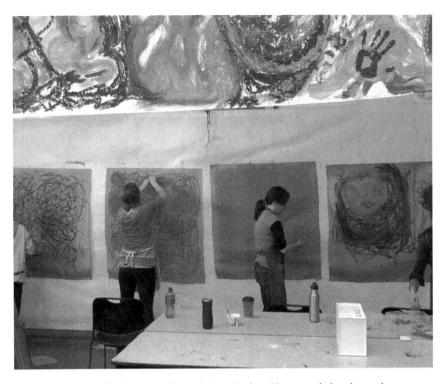

Figure 8.1. Working in Naropa's Art Studio. Photograph by the author.

So often in art schools, anything goes. That is, some artistic expression is about unchecked self-indulgence. As part of the maturing process, egocentric attitudes deserve time to anneal from egocentrism to social engagement. I have often wondered why art schools do not offer courses in twenty-first-century ethics for artists. Free speech for its own sake is a complicated subject. Certainly to be protected, free speech is a sacred right. And, in art as contemplative practice, I am arguing for expanded self-awareness as a core value for creating work. As an artist, I ask myself about personal intentions, what I am trying to say, and if I am achieving my goals. How willing am I to confront myself and examine my motives? How might others perceive the work? Particularly, how might this work serve others? Many of us quickly answer these questions with a resounding YES without taking the time to pause, reflect and defy ourselves to excavate additional layers of truth. For this reason, I created the "Self-Assessment Rubric for Art Assignments" (see Appendix C).

Often related to unexamined personal histories or unconscious blind spots, further investigation of these questions and those found in the rubric are important for deepening artistic awareness. For example, personal culture–bound values inherently influence artwork. Just as bad food will make us sick, unconscious art that malevolently offends can cause harm. Dan Hacoy (2005) argues that dominant, privileged cultural values can blindly influence our actions, including artwork. Therefore, examination of internalized relationship to prevailing power structures is essential in creative work. Unknowingly, personal art can flatter, even reinforce, privileged, dominating social structures that the artist dislikes without even realizing it. This form of self and social betrayal is best addressed through examining these unseen attitudes during critiques or before work is prepared for a gallery showing.

Art and compassion deserve to be linked and studied together in an art-based ethics course. *Ahimsā,* karma yoga, the *pāramitās,* four immeasurables, even Abrahamic ethics are usually not discussed in relationship to visual art. Art can teach us to gently untangle patterns and model a unique form of inner compassion for others and ourselves. Feuerstein (2003) asserted that as stereotypically disengaged artists step out of the studio and directly work for the welfare of others, worldly interconnections are strengthened, resulting in *lokasaṅgraha.* This Sanskrit phrase means "world gathering" or "pulling people together" in ways that transform communities (p. 48). Feuerstein further explained that "our own personal wholeness, founded in self-surrender, actively transforms our social environment, contributing to its wholeness" (p. 48). The question then arises, How can these principles be explored in art settings where the environment, the materials, and the community become its own resource and refuge? The sanctuary of these simultaneous metaphoric spaces within the studio fosters an overall sane environment where personal and collective truths can be explored.

Social activism through art addresses interconnections between oneself and the collective. Ultimately, wherever this approach to art thrives, it humanizes that environment. Addressing social disparity including institutionalized oppression is handled by developing systemic awareness of ecological, social intersections between self and others in the classroom and community at large. Willingness to examine complicity with privileged attitudes imbedded in beliefs about art removes perpetuating veils of individualism. Readiness to decenter egocentric attitudes and open to other perspectives beyond, for example, class-bound values, results in a form of potential existential emptiness. That is, moving beyond personal privilege and opening to other points of view, while at first disorienting, is part of any art process. Considering other ways to think, feel, or create, including shadowed blind spots, "provides a metaphoric space

for other potentialities to emerge" when in or out of the studio (Hacoy, 2005, p. 13). In his words:

> No matter how much therapy we do and how self-enlightened we are, there is no possibility to end psychological suffering until we work on the social disparities that result in intrapsychic trauma, and no matter how much political activism and community service we do, there is no possibility for social justice until we come to terms with the forces of marginalization within our own psyches. (p. 14)

Therefore, we not only critique artwork in classes, we do the same within ourselves including self-assessment of internalized oppressor-oppressed marginalized histories. The awareness that results from this level of self-examination helps to wakefully advance our work with communities.

An exquisite example of socially engaged, participatory focused work is the Mural Arts Program (MAP) of Philadelphia. Developed to uplift and serve community members, this long term extensive effort works with various complex local concerns by igniting social change through art. What I find interesting about this well seated city wide mandate is that it is integrated with public health initiatives like homelessness, addiction, and suicide.

Advocacy programs such as A Place To Call Home worked with high risk youth in Philadelphia dealing with housing insecurity. A goal of the project was to make private suffering not only public, but to also emphasize the magnitude of this civic health concern (Cannuscio, Bugos, Hersh, Asch, & Weiss, 2012). High participation resulted as youth showed up each week to work, for six months, on this long-term transformative endeavor. Forty-eight people, ages fourteen to twenty-three, received job counseling and housing from start to finish.

Another example of how the MAP worked with community needs can be seen in the complex subject of suicide. Mohatt et al. (2013) addressed this public health risk as well as preventive solutions by moving from the individual level of the problem to the larger municipal domain through public art. The Finding Light Within mural project galvanized a multifront response of consciousness raising, harm reduction, community recovery, and social healing. Large public artworks require local initiatives that promote, massage, and support personal and communal healing through verbal and visual storytelling, especially with vulnerable subjects such as suicide and homelessness. The Finding Light Within proposal required a long-term commitment that included mural design and education workshops on both suicide and mural painting. Through the MAP and the "participatory public art" role of Finding Light

Within, "community recovery from suicidal ideation, attempt, or death" was mobilized (p. 198). In this case as with A Place to Call Home, ignored dialogue was brought out from the shadows and openly discussed through extensive verbal and artistic conversations.

Public art of this scale organizes diverse communities to come together, communicate, and problem solve. Participatory public art, as both projects demonstrated, reclaim and revise negative community narratives. The social stigma, shame, and complexity of suicide and homelessness can exist differently for diverse groups within communities. Untying these varied stigmatizing messages by way of the culturally sensitive approaches exemplified by these two mural projects highlights how socially engaged artists can effectively work with contemporary issues.

Public efforts like the MAP combined with an understanding of personal *dharma*, or truthful right action, supports the development of a refined inner compass to serve. Seen through this lens, art becomes a *dharmic* behavior of acting with the integrity of purpose in order to support and sustain personal, regional, or societal needs. Listening to devotion while outwardly acting with moral and ethical behavior begins to define the socially engaged karma yoga artist. We do this work as service, not for ego-driven fame or glory. The work becomes a form of worship as we make ourselves available for what is needed. Within this viewpoint the artist, as much as possible, selflessly shows up and surrenders self-aggrandizing attitudes.

Expressive Pathways to the Self

Emerging out of the vast reservoir of the *Ātman* or Self, art as contemplative practice unfolds from the nondual *spanda* impulse, to subtle states of awareness seeking expression, to intentional efforts, to tangible creations. Participation in this activity of creative movement cultivates nonjudgmental awareness through mindful engagement with materials, processes, cultural connections, and emergent imagery. The resulting endemic states and traits, over time, continue to increase degrees of self-reflection. The following chapter offers personal examples of this charged process by discussing personal stories of practitioner-researcher investigation.

Expressive Pathways to the Self

A Personal Epilogue

During my cancer experience, I made a lot of art—paintings, drawings, pots, and videos. I was particularly attracted to fire-based materials such as clay and charcoal due to their austere simplicity. As burnt wood, charcoal easily transfers to skin, blends, softens and darkens depending on pressure and the type and grade of product. Undoing charcoal is not easy. If not careful with the dust, within seconds the entire page can become a shadow land. I particularly love the place of contact where heavy dark lines meet with lighter edges. Within these interstices, negotiation, collaboration, and apprehension constantly recycle and interact. Researching clay and charcoal became increasingly important to me in order to gather the momentum of process-related insight that constantly emerged.

 I made several pilgrimages to National Parks that had had significant fires over the years. Particularly important were my visits to Yellowstone, Grand

Teton, and Glacier National Parks. I collected samples of charred wood from several sites to use in my drawings. My intention was to include remnants of life from these charnel grounds and place this history into the drawings that I was creating about my own transformation process. I was careful to choose very small pieces and not disturb the land. Massive events had happened in these wilderness areas where entire ecosystems were devastated. What remained was still decomposing and nourishing the new growth that was slowly emerging. In a small way, I had hoped to bring this renewal into my work, but it was difficult to do. I hesitated since the charcoal, as a natural artifact of both destruction and renewal, challenged my sense of the same in my life. For some time, I avoided using what I had found.

Something elemental exists in working with both clay and charcoal, particularly around the ashes from the clay firings or working with burnt wood. *Vibhūti,* which is also called *Bhasma,* is sacred ash collected from Vedic fire ceremonies for application to the body for protection. Clay and charcoal are a form of *Bhasma* to me since they aid me in invoking contemplative space. As I worked I caught glimpses of important phrases central to my process at the time. The mythological phoenix rises, the funeral pyre consumes, and the ashen charnel grounds receive the cremated body. There are trials by fire, fiery personalities, sitting in the fire, the heat of the moment, and global warming. Clay and charcoal situated me in these potent metaphors. Further, charcoal helped me to see experiences of *veil* and *concealment* from the five acts of Lord *Śiva.* Avoidance, distraction, and fear reigned for periods of time. Through practice with charcoal particularly, these layers were dissected and eventually peeled away. Every day in the studio was about directly experiencing the collective wisdom of clay and charcoal as both helped me to unfold my questions, observations, and contemplative inquiry.

One day I made a beautiful pot in the Naropa Commuity Art Studio (NCAS). Sometimes gravity, the viscosity of the clay, my deliberate style of pinching, and the dry atmosphere of Colorado all conspire to produce a certain outcome. As had occurred many times before, unexpected discoveries pointed toward new possibilities with clay. This day, I carefully wrapped the pot in plastic and damp paper towel and placed it on the shelf to evenly dry.

When I returned the following week, I unwrapped the pot and found that it had cracked in several places. The NCAS members were surprised. I, too, was taken aback, not anticipating such severe fault lines in the almost leather-hard clay. Something came over me and I decided to approach the pot with counterintuitive intentions. I amplified the cracks by carving into them, exaggerating their fracture lines. In the past I would have searched for ways to fix the mistakes, especially since I was so fond of the result. As I whittled into the splits, some additional pieces broke off. I watched my thoughts cycle

between attachment to what was and the freedom not to care. Permanence and impermanence became internalized conversation as I embraced the surprises of this counterintuitive thinking.

During this particular time of my cancer experience, no matter how careful I was, unlike any time before, many pots cracked. While disappointing at first, these images of wounding and fracturing were important. I, too, was emotionally cracking up and falling apart. Just when I thought I had the work where it needed to be, another piece would break off and instruct me on fragility and resiliency. I marveled at how attachment can so easily lead to disappointment and, also, unanticipated discovery (see Figs. 9.1–9.3).

The clay and I eventually reached a compromise. The more I listened to it, the more it did not disappoint me. Clay, like hatha yoga, has many flexible positions to observe, study, and understand. If I was consistent with my part of the relationship, then trusting the process became straightforward, even effortless. Eventually, the cracks became welcomed surprises. During this

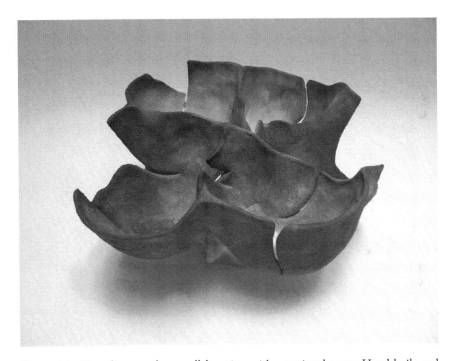

Figure 9.1. First clay pot about collaborating with emotional scars. Hand-built and sawdust-fired by the author.

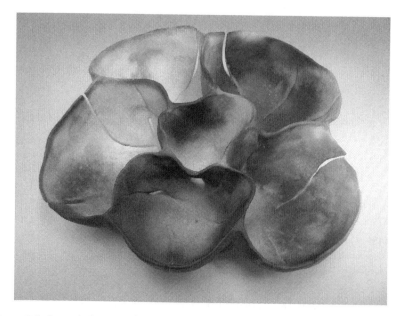

Figure 9.2. Second clay pot about collaborating with emotional scars. Hand-built and sawdust-fired by the author.

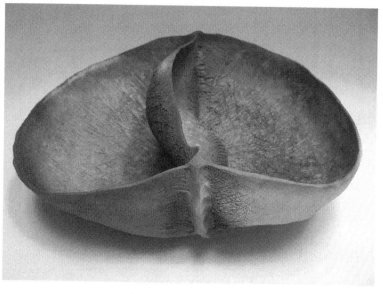

Figure 9.3. Third clay pot about intentionally scarring the clay in order to access hidden emotions. Hand-built and sawdust-fired by the author.

period of hand-building, I never would have done to the clay what it did back to me. Afterward, I remained open to future cracks in subsequent pots, and many more splits and fissures did, in fact, arrive.

As I reflected on what was happening week after week with these cracked pots (pun intended), I became intrigued with the lessons that surfaced. Prostate cancer surgery left a significant mark on my body—from my navel down to my pubic bone. The entire surgery had scarring effects on my emotional life too. Certainly, there was much to celebrate, and there was also much to mourn, such as the fact that I could no longer have children. My emotional scars had now been made visible through the art process with clay. It was not worth hiding from them. The message before me was indelible, like the healing scar on my body; however, I also worked with the clay and the spontaneous process of the fire to accentuate the scars and make the wounds reflect the beauty of entropy, which became an important part of my healing process.

Like being my own surgeon, I attended to these clay welts and wounds with devotion. I incised them, smoothed them, and exaggerated them. Finding what was beautiful and discovering the resiliency within the tragedy became an ongoing theme. Another round of unanticipated surprises soon arrived. While working on another pot in the NCAS, the clay was too wet and therefore

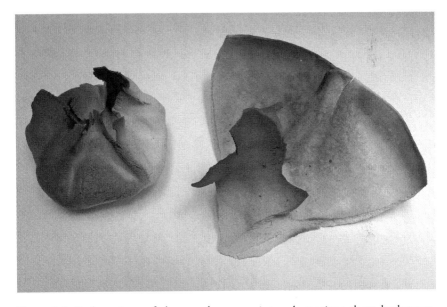

Figure 9.4. Broken pieces of clay pot that access internal emotions about brokenness. Hand-built and sawdust-fired by the author.

unwieldy, behaving like an unleashed dog with a mind of its own. The only way to coexist was to surrender and surf the wave of the clay's unruliness. What followed was an hours-long emotionally exhausting process that art uniquely provides when the veils are made thin between desire and devastation. This pot was not beautiful. In fact it was ugly in its torn-up, pock-marked, broken passages. I stayed in the game, dialoguing back and forth with the clay. By the end of the studio time, I realized that this was my most successful pot, and it took six years to finally complete. It simply held a deep truth that only years later I could finally see, touch, and hold. This pot was an image of the cancer that changed my life (see Fig. 9.5).

Then, there was the firing of the pot. M. C. Richards always referred to pottery as collaboration with fire. I usually fire pots in my home fireplace (see Fig. 9.6) before bed so that the process can unfurl during the quiet hours of the night. While I sleep and dream, it too cooks, simmers, and transforms. In the morning after I fired this particular pot, I hurried over to dig through

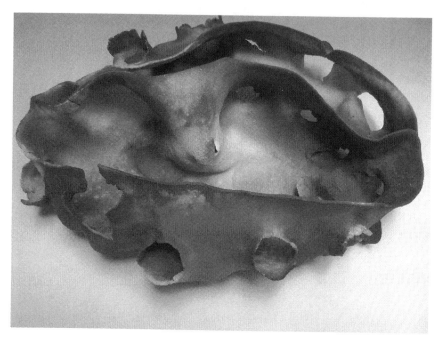

Figure 9.5. Clay pot about seeing my diseased prostate gland. Hand-built and saw-dust-fired by the author. Photograph by the author.

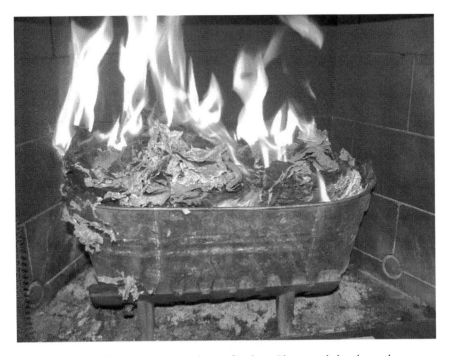

Figure 9.6. Firing clay pots in home fireplace. Photograph by the author.

the ashes. What was waiting for me was truthful unadorned beauty. The austere surface brought me to tears as I received another story of my cancer process, told to me through this pot.

The Symptom Holds the Cure

Prior to the technological breakthroughs of CT scans, MRIs, FMRIs, and PET scans, there was the ability of the arts to see into and catalogue the depths of personal experience. In my opinion, right next to the IMAGING department in modern hospitals there could be the other kind of IMAGING uniquely found in art studios. Sophisticated technologies can see a lot, but not the layered content of imaginal reveries. Using FMRIs to observe real time brain functioning with a supportive art studio next door to reveal the associated stories rendered in paint or clay would be amazing. Studies now have people

drawing or looking at photographs while in the doughnut hole of the scanning device, but this does not exemplify a fully embodied art experience. It is important to image the totality of the psyche if complete healing is to occur. My personal absorption in the challenging subject matter of cancer actually became a source of fortune and meaning. Creativity is a powerful antidote to any illness, especially those that are life threatening. Loss and suffering do not have to win when it is possible to manifest sustaining life-force through art.

All of my art from the time of diagnosis to my current work reveals a set of recurring themes. First, art combined with meditation helped to set up feedback loops that allowed me to become an observer of my thoughts and body during periods of extreme uncertainty. These longitudinal, embodied narratives revealed interesting dual and nondual observations.

Second, the properties of the clay supported opportunities for penetrating observation. The edges of the pots surfaced insights related to limits, fragility, and the search for resilience. Clay, when pinched thin, can only go so far. While I found these thin edges to be beautiful and engaging, I also exposed the walls of each pot, as well as myself, to the possibility of collapse. Sometimes the walls did fail. Words such as *weakness, frailty, tenderness, vulnerability,* and *breakability* were prevalent while working. The clay was my collaborator and it was in my best interest to listen carefully.

Art combined with meditation supported a focused mind, making the management of painful thoughts more tolerable. Ultimately, inspired absorption was deepened through both practices. Beginner's mind became a way to refresh and renew my relationship to my overall engagement with ambiguous events.

Art and meditation slowed everything down, rendering my ruminating thoughts into observable phenomena. While working with clay and charcoal, I was absorbed with body, mind, spirit connections. These noticeable associations then broadened into subsequent projects where the practices of *maitrī* and *tonglen* were applied. I would take in my discomfort, and my hands offered back responses of caring concern to the materials. I savored these tactile moments of firm pressure and light touch.

During this time I read Wendell Berry's (1987) poetry. With unusual clarity, his ecological, contemplative themes helped me to observe connections that I might otherwise have missed. His poem, "Enriching the Earth," conjures images of sowing seeds into the torn-up, plowed ground. The earth's body, inside, is dark and accepting, holding all that she is asked to receive. As with the farmer's plow, my skin was cut into so that renewal could unfold:

> To enrich the earth I have sowed clover and grass
> to grow and die. I have plowed in the seeds

of winter grains and of various legumes,
their growth to be plowed in to enrich the earth.
I have stirred into the ground the offal
and the decay of the growth of past seasons
and so mended the earth and made its yield increase.
All this serves the dark. I am slowly falling
into the fund of things. And yet to serve the earth,
not knowing what I serve, gives a wideness
and a delight to the air, and my days
do not wholly pass. It is the mind's service,
for when the will fails so do the hands
and one lives at the expense of life.
After death, willing or not, the body serves,
entering the earth. And so what was heaviest
and most mute is at last raised up into song. (p. 110)

In many ways, this poem is about working with the dualities that chased me. Several words surfaced as shorthand images that defined this process: *rend, rip, split, slit, sew, scar, heal, renew, plant, grow, resurrect, tear into earth, tearing into skin, surgeon, farmer, surgery, planting, tear to renew, transplant, grow, resurrect, prune.* In order to heal, we must delve into inner images and face what is at first resisted. The symptom, as presented in the unfolding imagery throughout this process, held the wisdom of psychological remedy, even cure as longitudinal effects of my body narrative were engaged. So often, the embedded content in the actual manifested imagery remained out of awareness. The contrails within the art and my body patiently held memory of events while some time later I eventually caught up to the simmering storyline.

Conclusion

I trust that beyond all classifications is pure awareness, the wellspring from which everything originates. Impressively, cognitive scientists, biologists, and physicists have their well-researched, verifiable explanations for how the physical universe works. But still farther behind all empirically validated and replicated studies is additional subtlety. At the back of our many perceptions of self-identity is the omnipresent, untainted, formless forever that we too are. Like any sacred pilgrimage, this core essence is the shrine of spiritual investigation.

We bring ourselves to revered places so that we may become inwardly saturated with devotion. During absorption with materials and processes, the heartfelt inner sanctum of *sat-cit-ānanda* delicately unfolds. Inward listening

to the mindful imagination deepens, revealing new insights of our waiting potential. We are home.

A life is the most sacred of all treasures. The body, acting as sanctuary for the energetic forces of *Śakti,* supports the magnificence of this lifelong gift. Pulsing throughout heart, hands, and limbs, the formless *spanda śakti* seeks to manifest. And like the physical body, the bodies of clay, charcoal, stone, and film gather the *spanda* forces of the imagination and answer Creation back with artistic creation. Art as contemplative practice takes us home to our inherent goodness and the magnificence of the Self.

When actively immersed within these qualities of the creative process, artists can perform subtle acts of worship. Manifesting hidden content requires observant attunement to the refined, granular messages that eventually surface as images. Artists who collaborate with personal images construct visual forms that act as honest containers to hold this contemplative content. For this reason, art is not a frivolous luxury, it is a spiritual necessity! Enjoy the privilege to artistically excavate that which is brilliantly sane within. Consider that beyond our many identities we are embodied infinity—turning awareness inward toward its origins is the creative pilgrimage.

PART III

EXERCISES AND APPENDICES

Appendix A

Imaginal Mindfulness Techniques, Exercises, and Materials

This section highlights methods, techniques, and exercises to support art as your contemplative practice. Read through the brief descriptions and try a few. To get started, select and purchase some basic art materials.

Table A.1. Basic Materials List

Rather than order online, at first it is best to go to an actual art supply store and have the experience of seeing and handling the materials.	
Things to keep in mind: Always consider storage needs; Find a wall you can work on; Try to use a room you can make a mess in; Consider purchasing an easel; Collect some shoeboxes to store your materials; Be near a sink; DO NOT put clay in a sink drain unless it has a professional clay trap. **List of Art Materials:** Journal for writing and notes; One 11×14 and one 16×20 sketchbook—good quality, wet-dry, multiuse paper; Large butcher paper (ask a restaurant for a few large sheets). Or black roofing paper; Acetate pages, 11×14 or larger;	Prismacolor drawing pencils, basic set; Wet-dry Aquarel pencils, basic set; Illustration markers, basic set; Chalk pastels, good quality, basic set (these can get dusty); Old magazines for collage; Oil pastels, good quality, basic set; Assorted, multipurpose, decent quality paintbrushes (take good care of them); Paint—there are many types—experiment with the basics. Water-based include: acrylic, tempera, gouache, watercolor, and water-based oil paint. If using oil-based paints, at first try with canvas paper or board. Purchase gesso too; Clay—simple stoneware to experiment with (likely not to be fired, only explored. Also consider modeling oil-based clay;

continued on next page

Table A.1. Continued.

Glue stick, blue painter's tape, other adhesives, lots of pushpins; Cutting tools (scissors, X-Acto knife + extra blades); Drawing pencils—assorted lead types, one of each: (H, HB, 3B); experiment with others; Peel-off China Markers, three colors; Thin line black Sharpie;	Clay tools, basic set, (make sure there is a wire tool and digging tools); Sculpture materials—experiment with tin foil, soapstone, plaster bandages, found object construction; Camera (phone)—still and video. **(There are more materials to try, but this will get you started.)**

Next are some contemplatively oriented approaches and exercises to consider and practice.

The Practice of Jung's Active Imagination (Chodorow, 1997; Wallace, 2001)

1. Relax, find a quiet place, and start to clear the mind of distractions. Notice emergent thoughts and body sensations. Observe cues of needing to know, explain, reject, or be the clever expert. Try to relax these tendencies, and if possible, release them.

2. Next, let any image that emerges rise, arrive, and unfold. Welcome what surfaces in your field of attention. Strive to not censor the process.

3. Receive the images without holding them in a fixed way. Not too tight, not too loose. Open-mindedly track and follow what emerges. Let the imaginal narrative unfold.

4. Write down what emerged, how it surfaced, and the implicit narrative in present tense language. Simultaneously create artwork about what emerged. Even dance it, sound it; let it dance you, sound you. Help the imagery to materialize any way it needs to come forth.

5. Receive the consequences of the imagery and apply the messages that are conveyed to your worldly, day-to-day, life. This last part is important. Like any potent insight, once applied to daily life, the lessons become realized through action.

Listening to and Engaging with Images

This next set of strategies is helpful when looking at and working with images. First, it can be difficult to realize that image work is a collaborative process. Secondly, when looking at art people tend to freeze up, since they are unsure of what the imagery is communicating. The ideas outlined below will help ease this discomfort.

Begin by noticing the visual elements in any artwork. The more you see, more will be revealed. Practice not only looking at artwork, but also at gardens or interior environments. Use your eyes to trace around ceilings, walls, tables, and chairs.

Table A.2. Design Elements and Principles to Observe in Artwork Events

Design Elements		
Line Texture Scale-proportion-size Silence-noise	Shape/form Balance Temporal elements Contrast	Color-realistic, expressive Symmetry/asymmetry Space-spatial relationships- perspective
Design Principles		
Repetition Directionality-how the eye is invited to move	Pattern-rhythmic configurations Contrast Harmony-discord	Dominating elements- points of emphasis Unity-chaos

Headlines and News

Notice the headlines and news waiting within the image. We are prone to laziness when observing. Because we notice, we think we see. However, to really observe and see something requires effort. A helpful way to fully see images, objects, or living creatures is to consider the relationship between headlines and news. When thumbing through the newspaper, it is easy to read the headline and maybe glance at the first paragraph. If we do not take the time to read the news, we miss the story.

Similarly, when in a museum looking at a painting, we tend to skim over what we see. The title, like the headlines, plus a quick look is all the painting gets. So it goes when observing the sky, landscapes, animals, reflections in glass, or curiously arranged rubbish. When surveying any image in

a dream or a drawing, describe to yourself exactly what you are seeing. The details, textures, relationships, and placement in space equals the patiently waiting poetic news. The Art Materials/Process Awareness Rubric and Imaginal Process Skill Building Rubric in Appendix C can help orient you to this process.

From You to It . . . And It to You

Most observations usually begin with I see this or I see that. You may even project meaning onto the image: *this* looks like a _____. Or this means that.

Now consider the view from the image to you. While I was conducting a workshop this past year, one of my students was confused about this bidirectional perspective. The uncertainty manifested around a dream from the night before. She eventually found clarity when I asked her to report the dream to the group from both points of view. This helped, but she was still bewildered, so I suggested she write a haiku from both perspectives. What she wrote below helped to clarify the subtle differences between each position. She got it!

From her to it	*From it to her*
I am looking now At you, red and blue in this dream Notice confusion	You miss my message Take time to see me flying Hovering above

Slow Down and Simmer

Practice downshifting in order to carefully observe. When engaged in seeing, monitor assumptions and proceed respectfully. Shift your gaze from the point of view of you as viewer to the point of the view of the image, as if it was encountering you. Consider that it is its own ecosystem with interacting parts. During this encounter, always monitor personal projections, that is, your capacity to place meaning on the image before ever fully seeing its uniqueness. Therefore, avoid applying impromptu meaning where it does not belong. Slowing down to see the visual news FIRST begins to reveal content and meaning. Within this approach, the image determines the encounter too, not only the viewer/creator.

Image Work Can Seem Like Interspecies Communication

Interspecies communication occurs mainly in silence. Mammals certainly communicate, but in their own language of contact, gestures, and sounds. It is up to us to carefully observe, learn, and receive their signals. Similarly, a good pediatrician carefully observes a sick newborn in order to move from initial impressions to accurate medical findings and eventual treatment. Images communicate; we just need to learn their language by observing the interconnected parts. This includes its overall contextual atmosphere, feeling tones of emotion spoken through line-shape-color-texture-etc., and spatial sceneries within the painting, sculpture, video, or photograph. What we often believe to be intuitive knowing is closely linked to observational attention, which informs intuition.

Outer World/Inner World and Simultaneity

Seeing the outer world of objects stimulates sensory perception. The inner world of images and imagination stimulates apperception or embodied awareness of subjective knowing.

One final artwork or event, such as a painting, is a simultaneous presentation of multiple compositional parts. Begin looking at the parts of the art event by carefully observing the formal elements of line, shape, color, texture, balance, symmetry, figure/ground, etc. Each single element represents unique visual language. Shift perception back and forth from your point of view to the perspective of the visual elements. Each single yet simultaneous element can be described in terms of its individual connection to context, mood, and scene. *Noticing and writing this information down is key to relating to the imagery.*

Putting It All Together

Start by monitoring personal projections. Bracket them out and place them to the side. I like to imagine a clothesline and hang them there to air out. I even sketch a clothesline with little squares hanging, each filled in with assumptions and projections.

Lastly, while looking at the event before you, imagine that this is like a first date. Remember back to when you were meeting someone you were keen to know. You arrive on time to the restaurant, but the other person is late and spends the entire evening self-promoting narcissistic values. Their chances of getting a second date are unlikely.

Now, like shaking an Etch-A-Sketch, erase that image and reimagine that you are very interested in this person. You both arrive on time, ask respectful questions, and listen intently to each other's responses. Following your questions and the resulting answers, you reverently inquire further and move from the initial headlines to the detailed news that is this person's life in front of you. And lo and behold, you get a second, third, fourth date, and an eventual relationship. Relating to images, in my experience, is similar to this scenario. Arrive with deep curiosity for the image. Listen to its unique language. Do not settle for headlines thinking this is all there is to know. If image centered and focused, it is difficult to exhaust the informational news waiting beyond the first layers of headlines. The more attention we pay to the imagery, the more we see and are rewarded with observational insight.

Specific Imaginal Skills for Working with Images and Unfolding Meaning

Much of the information below is summarized from the work of James Hillman (1978) and his notion of gadgets and Patricia Berry's (1982) work on how to approach dream imagery. You will notice that many of the scenarios offered refer to dreams and not artworks. This is intentional, since dreams are accessible, familiar experiences for most whereas creating art is often unfamiliar. Yet the same methods used to explore dreams are applicable to working with artistic imagery. Finally, some of the passages below reflect a mixture of blended, illustrative examples imagined during classes with students.

Before moving on, review the meaning of image, from chapter 5, which consists of context, mood, and scene.

> **Context:** conditions, circumstances, situations; the core narratives present within the image. *Con* means "together/with" and *text* means "weave." Context is the inherent narrative textures woven together throughout the image.

> **Mood:** feelings or the pervading emotional tone present within the image. Mood can be the specific felt qualities either observed or experienced within the parts or the entirety of the painting or dream.

> **Scene:** is where the event is taking place—a landscape, environment, incident, place, or relationship. The scene is the simultaneous qualities of environments or settings within the painting and dream.

Stay in the Metaphoric Narrative

Image, suggests Berry (1982), is used to know and understand image. Listen to the image—follow the image—relax the need to know what the image means. Suspend doership (view of yourself as primary doer-creator) and ownership of the image and invoke an I-Thou relationship with the event. Since this is a collaborative relationship, you are engaging in a shared exchange with the image—observe, listen, dialogue, and collaborate.

According to Berry (1982), there are benefits and limitations when exploring narratives within dreams or artworks.

1. Verbal descriptions do not fully portray or represent the image since these are reconstructions of what transpired. Fortunately, unlike with dreams, artwork events are tangible, unified singular events. The narrative is waiting; we just need to pay attention.

2. Limitations of discursive language force one to place a story onto the image in order to clarify temporal elements. This can pigeonhole the dream or artwork event into a limiting format. Always search for language that honors the context of the image.

3. The narrative can become a process of explanation rather than a practice of deep listening. When I retell a dream, the very nature of my description restricts the simultaneity of the image. Thus, my multidimensional dream becomes an unavoidable sequence of linear descriptions of events.

Evaluation and Negative Judgment

Avoid evaluating or judging the image since it is an entity in its own right—meet it, engage it in an I-Thou collaborative relationship. Observe repetitions of shapes or colors and other systemic themes in the art event. Notice how patterns of context, mood, and scene, surface as form and content from artwork to artwork.

Texture/Context

The root here is *text*. Closely follow the interlacing weave of metaphor from image to image, part to part, encounter to encounter, dream to dream, artwork to artwork. As in a story, there is a text to listen to and follow. Text, as revealed through story, becomes the texture of the narrative. Dialoguing

with imagery is like taking dictation from the parts or text of the artwork and writing down what emerges. Once written down, take a multicolored pen with blue, red, and green ink. Underline all of the affect words in blue, the adjectives in red, and the nouns or verbs in green. Then only read back the words underlined in each color. This begins to show the weave of the texture from different perspectives.

Simultaneity, Intra-relations, and Specification

SIMULTANEITY

All parts of the artwork are concurrent. Therefore, simultaneity can be defined as more than one theme, object, or image occurring together, at the same time within the same visual space. Langer said something similar about visual art (Julliard & Van Den Heuvel, 1999; Langer, 1951). That is, the parts of an artwork are presented at once, all together. Try to not overemphasize or overvalue one symbolic part over another.

> **Example:** Imagine a fine watch, car, or windmill. All parts of each machine work in relation to each other. If one part malfunctions or breaks, then the whole mechanism loses its ability to function. In the case of the watch, time stops. No part of the watch can function without the other. The watch is a series of interlocking parts that systemically connect and exist together.

- See the entire art event as layers, rather than a linear presentation.

- All parts of the image are noteworthy events.

- Carefully look at the art from side-to-side, top to bottom, background to foreground, and center to edges/edges to center.

INTRA-RELATIONS

Patricia Berry (1982) uses the term "full democracy of the image," a most satisfying phrase (p. 60). The key here is to not value or judge a part of the work over another. If you allow all parts to be in relationship, then the various elements freely exist together.

1. Careful observation and description of the art event respects the presence and autonomy of parts within the imagery.

2. Images arrive with their own context and authority. Approach with a view of egalitarian equality for the parts that constitute the whole.

3. Do not divide images into dualistic splits such as good and bad. Absolutist positions like this miss the point. It is important to avoid negative/positive statements. Therefore, notice opposites as they exist and present in the image. Listen to the image, not your need to know, divide, or project meaning.

SPECIFICATION

Turn a fine-tuned lens on different parts of the image—like looking through a magnifying glass at an insect—and discover the many simultaneous details.

Value and Emotion

What looks "good" is easy to see. However, when you dare to move toward what appears perverse or ugly it is easy to recoil and withdraw. Be counter-intuitive. Look for what is implied—not all parts of the image are necessarily present.

Emotion is a mental state that arises spontaneously rather than through conscious effort and is often accompanied by physiological changes that create a feeling, such as joy, sorrow, reverence, hate, love, etc.

Emotion = feeling with an associated story

Sensation = feeling before there is a story

According to Patricia Berry (1982), emotion is both sensuality and texture that is inseparable from feeling. A dream image likely has a quality of emotion. Dream moments may be expansive, oppressive, empty, menacing, or frenetic. Emotions in dreams/art adhere or inhere to the image. Emotions are crucial for connecting with the images.

> **Example:** I am about to begin a new painting and find myself staring at the colors on my palette; I feel a sense of excitement and trepidation for the unknown that is about to emerge. The color blue has appeal; it even seems to choose me, insisting that I apply it to the canvas. I soak my brush in blue and make a mark. I stand back and look at the isolated blue brush stroke. At this moment, I

feel a peaceful sensation come over me. The mere presence of this liberated blue stroke across the empty canvas has provoked this emotional state. I am not finished, only beginning. Another blue mark is made and now there is a relationship between the two. Emptiness yielded one and then two marks, followed by another. Each action invites another response as layers upon layers emerge.

Practice discernment between sensation and emotion—know the difference. In the example above, the first blue mark instigated calm and satisfaction. My breath slowed down, thoughts settled, I felt at ease and also full of anticipation—all elements of sensation. Then, I could invite emotion to emerge—feelings about the blue marks with their accompanying stories. Many people skip to emotional stories and rarely attend to physiological sensation.

Position/Content/Context

Observe connections; do not force them. A yellow dog in one painting exists in that visual ecosystem; a yellow dog in another painting exists in a different visual ecosystem—similar image, different narrative, context, mood, and scene. And of course, sometimes there are connections to make from artwork to artwork.

Repetition/Reverberation/Reappearance

Repetition is any repeated characteristic of a dream or artwork that draws our attention. Repetitions are reverberating similarities of any sort that ripple throughout a dream or dream/art series such as feeling elated, scared, horrified, or startled. Just remember that what repeats can and will represent different content in different art events.

Repetition involves a recurring theme, or repeating pattern such as loss of control, fear, or joy. In one instance, the imagery may be about nausea or dizziness. In the next scene, the image may convey seasickness. Then a third situation arises in a dream where a person may be trying to run, but the legs will not move. In order to better understand this dream, we must recognize these reappearing, yet varied, body-based themes, and give each room to communicate its context, mood, and scene.

Amplification/Expansion

Amplification, or what Patricia Berry (1982) refers to as essential similarity, is a method of research into the archetypal history of the image. For decades, I

have invited my students to write a symbol amplification research paper about a repeating image from a dream or artwork event. The students consistently report transformative results as seemingly familiar symbols, once amplified, reveal unanticipated insights.

The process of amplification involves expanding a personal image to encompass a broad, cultural context (Berry, 1982). Consider various disciplines (science, anthropology, poetry, mythology, history, art, etc.), and search for similarities that parallel personal understanding/resonance with the image. By making historical and cultural connections, this process gives the personal image broader contextual meaning.

> **Example:** I have a dream where I am playing a drum in a rain forest. To amplify this image of "drum," I research the cultural context of "drum" and discover many cross-cultural sources of information about drums, sound, and rhythm. I look up anthropological research and discover historical origins and related subjects about indigenous drum construction. I visit a drum store and interview the clerk about the many types of drums in the shop. I attend drum concerts. I learn how to build a few drums. The rainforest is another element to research. Ecology, biology, and ecopsychology could also be sources to consult.
>
> Researching specific cultures that use drums in forested landscapes further opens up the imagery. I look up the origin of the word *drum* and find that its Old English and Germanic derivation relates "drum" to "trumpet." If this is significant to the image as it occurred in my dream, I look further into these connections. If it is not, I search in other directions for more relevant meanings. What kind of drum was I playing in this forest? What sound did it make? How was I playing it? What was I wearing? During my visit to the music store I not only play several drums, I rent one and take it to a nearby forest to play it. If I find a drum in the shop similar to the one I was playing in the dream, I find out about that drum. What country is it from? How was it used (was it ceremonial, decorative, utilitarian, symbolic. . . .)? The process of amplification raises many questions about universal, cultural meanings associated with archetypal images, in this case, drums and rainforests.

Elaboration/Embellishment

Without forcing meaning, engage the image through dialogue by elaborating its presence—let it speak and reveal itself. As mentioned, write down and

underline key words using different colored inks and then read this subtext back. We elaborate by noticing our descriptions of a dream or artwork event and then afterward, allowing personal associations to emerge. When making associations (not projections) to a specific word, the dreamer or artist spawns additional associations. Elaboration involves empathically considering embellished attributes of the image/person or object in the dream. These associations are merely larger elaborations of the image. Remember these new, emerging details and also make sure you are not making up meaning—only elaborating on meaning.

> **Example**: Going westward in a dream becomes associated with going toward freedom, not necessarily west. Although a familiar popular culture statement, associations to this phrase within the context of a dream have a particular point.
>
> Another example would be if I saw a certain friend in my dream and only associated the dream's meaning with my actual view of this relationship. It is best not to force meaning onto or into parts of the dream image or artwork.

Synonym Sensitivity

Building synonym vocabularies is essential for skillful image work. As a primary image is revealed, list as many related, associative synonyms as possible. This practice helps to turn the image and look at it from different perspectives, never straying too far from its essential qualities.

Restatement

The goal here is to notice the reversibility of word/noun combinations. For example, *green grass* can be restated as "green in the grass," "green of the grass," "how green is the grass" (dark, light), "grassy green," or "greenish grass." Even the word *green* has further possibilities (greenish, dark or light green, greener, greening (like ripening), etc.

Restatement involves reexamining the image by verbally restating/paraphrasing the unique intrinsic language of context, mood, and scene. This process reveals emphasis and meaning. Often a different tone of voice can be used, placing weight on certain words. One way to restate is to simply say the same words but with different cadence and emphasis.

> **Example:** I report that in my dream "I am running." I could repeat the same words but with emphasis on a particular word,

like "I am **running**!" Emphasizing the word *running* focuses the attention on the action and might lead me to ask myself: "What am I running toward?" "What am I running from?" "What is the scene like where I am running?" "What changes as I am running?" "What am I feeling inside as I am running?" "What am I wearing as I am running?" "Is there anyone else with me?"

Externalizing

Externalizing refers to increasing the volume of the image. One strategy is to take when/then statements and add "ever," so that *when* becomes *whenever*, thus linking two ideas or images together with greater volume. Eternalizing also adds a temporal quality to the image.

> **Example:** I dreamt that I was going to go fishing in a familiar wooden boat and might say: "*When* I go fishing I am reminded of our old wooden boat."
>
> Then, I could restate the sentence as: "*Whenever* I go fishing I am reminded of our old wooden boat."

Changing *when* to *whenever* adds a slightly different angle of volume to the encounter.

Singularizing

Singularizing is similar to eternalizing, except that "only" is placed in front of *when*. This allows for the dream statement to become a unique occurrence (*only when.* . . .). It permits us to focus on that particular instance within the image.

> **Example:** "*When* I forget my cane on the bus, I could fall down and get hurt," can be changed to "*Only when* I forget my cane on the bus, I could fall down and get hurt." This allows us to focus on the particular instance of cane and getting hurt rather than having it become a larger narrative.

Sensuality

Sensuality comes from the word *sensual,* which also means sensory and even gratification of the senses. Images are sensate—sensual—thus awakening sensorial experiences. Fire in a dream can "feel" hot, even burn. Sensuality can be experienced from the point of view of the image, like the implicit sensorial

context of a color, tree, or dog within a dream or painting. While in the dream state, the senses are able to perceive sensory experience.

> **Example**: When a person flies in a dream, the dreamer can feel the experience. Our senses perceive the experience of wind on the body, weightlessness, and speed, as well as the sensation of falling or soaring.

Contrast

Contrast refers to the use of opposite elements together (rough and smooth textures, or warm and cool colors) to provide visual interest or direct the viewer's attention to a focal point. Similarly, Hillman (1978) describes the technique of "contrasting" as a means of opening the imagination to an image by bringing in opposites related to the image's context. We can find meaning by searching relationships within pictorial comparisons.

> **Example:** Upon review of a dream or artwork the artist is asked, "Consider _____ in relationship to _____." Unlike amplification or association, the use of contrasting becomes a tool to explore dream or symbolic imagery by staying within the vocabulary of images. Sometimes we learn more about the qualities of the image by discovering what it is not. For instance, I dream that I am in a skyscraper elevator, ascending faster and faster, not toward the top floor, but the sky. Contrasting ascending with descending, I could explore meanings of sky in this context as well as various speeds of ascension with downward movement. Since up means toward the sky, how far is down and toward what?

Value

Value usually means worth, usefulness, or importance. Some images seem more powerful and attractive than others due to their unusual qualities. For example, consider a monkey driving a car. When an image is presented in a dream in an unusual way, look for where the image turns. A monkey IN a car, while unique, is not as unique as a monkey DRIVING a car. Focus then on driving. Also, some images are more attractive while others are more obtuse. Stay with what is difficult to look at and titrate exposure to this unusual presentation. If we are discussing an artwork event, we could adjust the viewing experience by getting closer or further away from the actual image. Or, use a piece of paper to mask specific sections to block off intrusive parts of the painting.

The Hiatus in the Image

The hiatus in the image is defined as a break, interruption, or turning point. The hiatus in the narrative refers to a fracture of sorts in the image—particularly a break between two parts. Hillman (1978) suggests listening for words like *suddenly, then, until, however, only, nevertheless, later,* and *but* as examples of a hiatus or gap within dream or art imagery (p. 182). When such breaks occur in the middle of reporting dreams/images, the hiatus may be suggesting an unknown detachment (p. 182). Hillman further noted that the importance of the hiatus is difficult to discern—whether the break is created as the dream is reported or whether the break is strictly essential to the image. However, the hiatus may allow the dreamer to get to the root of an implied, yet absent quality. Either way, the hiatus point is worth noticing.

> **Example:** I tell someone about a dream I had concerning a past place of employment. I report that in my dream I am sitting with my coworkers around the table, laughing when *suddenly* I find myself in the middle of a park, alone, safe from the wolves that surround me. The emphasis on *suddenly* is where the hiatus of this image exists. The break in the actual dream reporting is either a result of me trying to put images in order, or it could point toward something important to notice. Either way, the point of hiatus is often very revealing.
>
> The same can happen when describing a video, drawing, or sculpture. As the work is discussed, notice words used like *suddenly, then, until, however, only, nevertheless, later,* or *but.* Pay close attention to these pivotal points in the image, slow them down, and discuss their potency. Or, when looking at an artwork event, there is a transition point where one edge of blue almost touches another edge of black. There is a minute gap between the two sections. Perhaps this small patch of emptiness has meaning waiting to be discovered.

Analyzing Structure

Structure is a tool used to respectfully analyze meaning. Image must be studied in terms of its structural context including obvious sensual qualities such as its surroundings. Structure deals with locating an image in its unique context. Structure is the form, position, and content of an image. Structural relationships exist between multiple images in a dream (or an art event) implying that

images depend on other images for meaning. Look for pairs, triads, or other complex patterns.

Conserving Images

Conserving images means to protect and admire them for their own sake. When first attempting to relate to an image, it can appear dull or even boring. Put it aside for a while and allow the parts to marinate. Even stick figures hold narrative, context, mood, and scene.

> **Example:** Keeping an image is like allowing a bottle of wine to breathe or letting refrigerated fruit warm to room temperature before eating. Let the richness of the image slowly emerge and come into focus. Many images are latent, like when placing an exposed photograph into a tray of developer. Slowly it emerges in its own time. It can't be rushed.

These "gadgets," as Hillman (1978) referred to them, are indispensable contemplative tools. They fine tune intention, attention, and attuned receptivity to images and their meaning.

(See the Imaginal Process Skill Building Rubric)

Core Principles of Art as Contemplative Practice and Accompanying Exercises

(not in rank order)

Note: as with many subjects discussed in this book and this exercise section, further reading and study with a trained teacher is advised.

Sensory Check-In to Pull You into the Moment

Focus attention on the sensorial moment. Take an inventory all of your senses in this very moment—what you are currently seeing, smelling, hearing, touching, and tasting. Pause for a few moments throughout the day, at different times, to practice this exercise as a way to cultivate intentional presence through sensory awareness.

Slow Down & Cultivate Whole Body Awareness

The body is the ultimate feedback resource. Place awareness into any area of the body and simply notice, especially during creative work. Consider that wherever you focus awareness, information is waiting for you.

- Relax the impulse to judge sensation, thought, mood/emotion, or behavior. Trade judging for observing. As you survey any narrative unfolding on the screen of the mind while scanning your body, pretend that you are like a detached, yet engaged viewer in a theater observantly watching this mind-movie.

- Take cues from the body by casting silent observational awareness within. Simply notice emerging phenomena. Even in this moment while reading this sentence, put your awareness in your feet and notice how much information is waiting for you once you become aware of this region of your body.

- Begin with the jaw, teeth, and tongue. Notice when they are tight or relaxed. In a similar way, scan the body for tightness and relaxation. Now clench your teeth and press your tongue against the roof of your mouth. Then, begin with a wide view of the head region and take in the top, sides, eyes, nose, ears, and mouth. Now notice that you are clenching your teeth and that your tongue is pressing against the roof of your mouth. Release and then observe the entire face, neck, and shoulders again as pressure is freed.

- Now look around the room.

- Observe how/what you are seeing, what you might be holding (like a pencil) and how you are holding it, your posture, stance, breath.

- Even though much of the nervous system regulates automatically, it is still important to observantly move with what is moving. The better observer you are of inner and outer information, the more connected you will be to your artwork.

Forms of Observation: Skills 1–5 represent fine-tuned observational strategies for seeing and noticing bidirectional embodied and environmental information (Speeth, 1982).

1. Peripheral/panoramic/aerial observation

2. Pinpoint/focused and detailed observation

3. Oscillating observation between two or more points

4. Observation of systemic connections

5. Holding multiple perspectives of the simultaneous parts

SKILL 1: PERIPHERAL/PANORAMIC/AERIAL OBSERVATION

While sitting in a room in your home, imagine being on the ceiling with a wide-angle lens looking down. What would you see from the vantage point of this peripheral/panoramic perspective in your familiar environment? Next,

fix your gaze on one spot in the room and without moving your head or eyes, take in the entire field of the area including the floor, walls, and ceiling. Practice shifting peripheral perspective.

SKILL 2: PINPOINT/FOCUSED DETAILED OBSERVATION

Select and attend to detail in the room; look at something familiar right in front of you. Notice the subtle, specific detailed qualities. With pinpoint focus, simply observe. Curiously see the unique in the familiar.

SKILL 3: OSCILLATING AWARENESS

Shift awareness from inner to outer, focused to peripheral, aerial to horizontal, sensation to emotion, thought to behavior, emptiness to action, experiencer to observer. Grease the pistons of observation by selecting a dialectic between two positions of observation suggested above. Notice how there are edges and middle spaces between subjects chosen. Try all of the suggestions listed above.

> **Example.** Do a body scan and then switch to a scan of the immediate outer environment. Consider how the environment affects your inner state or how your inner state influences your sense of your surroundings.

SKILL 4: SYSTEMIC CONNECTIONS

Identify interconnected embodied patterns between thoughts, moods/emotions, sensations, and behaviors. Next, consider systemic relationships in the immediate natural or human-made environment. Where did the shirt you are wearing at this moment actually come from?

> **Example.** How many hands were responsible for producing the shirt you are wearing. Think of those who picked the cotton, who made and ran the machines used to spin the fabric, sew the garment, and ship it. What forms of energy were needed for shipping? Practice tracking this sort of systemic interconnection as much as possible as a way to disengage from privileged consumerism and notice interdependent relationships.
>
> Similarly, learn to look at an artwork in a gallery or museum and notice the many simultaneous, interconnected parts of the process and final product from pigments to painting.

SKILL 5: HOLDING MULTIPLE PERSPECTIVES

Notice attachments to personal beliefs, especially related to your art process, and how they influence points of view that cause clinging. Now widen your perception to include additional perspectives. Let them coexist and relax.

Example. (See Exercise: Working with Duality)

Beginning with the Expressive Therapies Continuum, below are supportive art-based contemplative exercises to try.

Expressive Therapies Continuum (ETC)

The Expressive Therapies Continuum (ETC), conceived by art therapists Sandra Kagin and Vija Lusebrink, is general enough to include a wide-angle viewpoint of different forms of expression (Hinz, 2009; Kagin & Lusenbrink, 1978; Lusebrink, 2010). Creativity flows through many filters, including cognition, symbolic communication, perceptual engagement, formation of feeling, somatic experience, and sensory acuity. All levels can be worked with within one art session or over time in one art piece.

The ETC helps to identify creative choice, implementation, and accomplishment when working with various materials and processes. Relationship to the process and product is also addressed. Locating oneself on the ETC can identify habits, strengths, and limitations.

The first three, horizontal levels within the ETC refer to three recognized classifications people use for processing information:

> Kinesthetic/Sensory level (K/S)
> Perceptual/Affective level (P/A)
> Cognitive/Symbolic level (C/S)

The Creative Flow Level (CR) reflects a synthesis of the other levels of the continuum through inclusion, transcendence, and integration of material.

\updownarrow**CR = CR**eative Flow

C (Cognitive) --------------------------↑-------------------------- **S** (Symbolic)
P (Perceptual) --------------------------\updownarrow-------------------------- **A** (Affective)
K (Kinesthetic)--------------------------↓--------------------------**Se** (Sensory)

I have arranged my summaries below in a bottom-up manner. And the formatting can be reversed to show top-down involvement. Either way, it is important to grasp, compare, and contrast top-down and bottom-up art experi-

ences. For an example of an art experience that utilizes all dimensions of the ETC, see Softening the Sore Spot later in this chapter.

Note that the **CReative Flow Level** can traverse all three levels and even integrate all levels in an art experience, which can be quite enjoyable.

The Kinesthetic ↔ Sensory Level relates to preverbal information and non-verbal processing. Work can address rhythmic mark making, tactile engagement with materials, and the delight of sensorial experiencing. Art from this orientation arouses the primal areas of the brain while mindful attention to these experiences offers sensory and kinesthetic information back to the artist. If a person favors the kinesthetic end of the continuum, movement and embodiment is likely very satisfying. Orienting toward the sensory end of the continuum sparks sensual stimulation and gratification.

People new to art who feel intimidated can begin here with spontaneous, tactile mark making. It is possible that preverbal memories will emerge. Consider that defenses can loosen and unexpected material can surface. There is a lot of art to make from this sector of the ETC that celebrates embodiment and sensorial intelligence.

K (Kinesthetic)—Art at this level is about movement as expression and body-based action. Body as feedback resource. Basic motor and sensory engagement with materials and final product results. Fine and gross motor movement.

Se (Sensory)—sensorial exploration of materials and processes. Kinesthetic expression can merge with sensory experience such as finger painting for a child or hand building with clay.

The Perceptual ↔ Affective Level moves from the direct experience of sensory embodiment to deliberately creating a desirable, felt outcome with materials and processes. Intentionality to render emotional material is key. Consider the opportunity to give feelings tangible form.

P (Perceptual)—Art addressing form, defining concrete images, observation without interpretation. Noticing figure/ground relationships. Looking at a still life and rendering what you see.

A (Affective)—emotional expression and processing through art. Feeling *with* a story. Giving feeling artistic form through line, shape, texture, asymmetry.

The Cognitive ↔ Symbolic Level addresses higher levels of cognition that facilitate organization of complex information. Deliberate planning by making studies or maquetts would occur at this level of the continuum. More mindful self-reflection is likely to occur while cognitively problem solving or symbolically representing a subject.

C (Cognitive)—Art that focuses on cognitive functioning and concept development. Memory, narrative, geometric translations of three dimensions

into two dimensions, abstraction, organizing-sequencing, selecting-combining, temporal communication.

S (Symbolic)—Use of art as symbolic speech. Images that stand for and stand in for past-present-future concepts or relationships. Using symbolic imagery to point toward ineffable subjects.

Media Dimension Variables (MDV)

The MDVs address several aspects of using art materials and processes: the *complexity* of the materials; the *structure* of the art-based experience; and the *physical* qualities or *properties* of relationship between materials and processes.

Throughout any art process, consider the relationship between reflective engagement with direct physical actions and personal perceptions of those actions across the ETC. Apply mindfulness to the experience of working with materials and processes.

- **Media Potential**—the many possibilities of using a particular material. Explore as many possibilities as you can. Look at art magazines or books to see what others have done.

- **Boundaries, parameters, or limitations** of different materials such as size of the paper or *quantities* of media being used.

- **Mediated and nonmediated materials**—using tools such as a paintbrush or clay fettling knife to foster degrees of distance and connection between artist and materials. Consider the difference between using your finger to paint and using a brush to paint.

- **Reflective distancing**—stepping back and carefully observing the process and, once finished, the product. Oscillating between experiencer-observer perspectives or other forms of observation mentioned above like peripheral/panoramic/aerial.

Consider the integrative opportunity of physical sensations becoming perceptually organized through art and then finding correlated symbolic meaning in your work. Part of the reflection process incorporates distancing to facilitate the discovery of significance by seeing relationships in your work come alive. Stepping back, observing the artwork, seeing details, and writing about the work helps the reflection process.

MATERIALS

When thinking about art materials, also refer back to the subject of the three *gunas* in the Art as Yoga section. These three dynamic forces are:

- **Tamas** (inertia/stability) represents dormancy, static, concealing

- **Rajas** (fluid/kinetic) represents movement, agility, and stimulation

- **Sattva** (sublime/subtle essence) represents resiliency and illumination.

Simple Materials—not so challenging to work with, such as magazine collage.

Complex/structured Materials—such as photography, which if using film consists of multiple steps including camera operation and dark room procedures like mixing chemistry, etc.

Directive Materials and Processes—such as art-based interventions consisting of specific, supportive exercises or logical steps. Red + blue = purple. Or pinching clay yields very thin edges.

Nondirective Materials and Processes—such as open-ended processes; spontaneous art; long-term open-ended projects with an unknown destination.

WAYS TO THINK ABOUT MATERIALS AND PROCESSES
ON A CONTINUUM

Note: these are not rigid definitions—rather, there is flexibility to mix media and select and combine different materials and processes. Remember, each material holds its own unique vocabulary. Becoming fluent with media takes time.

Fluid to Dry Materials
Fluid---Dry
(wet) (waterless)

Color choices that are wet and can be blended, such as watercolor or oils, and drier materials like markers, pencils, or oil sticks each have different properties to control. Examples of fluid media to blend: types of paint like watercolor, gouache, oil thinning media such as odorless turpenoid, or thickening media such as beeswax.

Pliable to Resistive Solidity-Based Materials
Pliable--Solid
(flexible, additive or subtractive) (rigid to yield)

Clay choices such as stoneware or oil-based clay can be satisfyingly flexible. Stone or metal choices can be stiff and unyielding until their properties are

understood. It is best to avoid thinking stereotypically about materials, too—flexibility can be discovered within rigid materials. Metal, when heated, can become flexible. Examples of restrictive materials: rigid, stiff, unyielding like metal, welding. Examples of tactile materials: fabrics, soft, pliable, connective.

Two-Dimensional to Three-Dimensional

Two-dimensional---Three-dimensional
(flat work) (sculptural materials)

2-D = flat: height + width + geometric skill or bas-relief techniques to imply three dimensions.

3-D = literally, working within the spatial relationships of height + width + depth of three dimensions.

For example, two hands are usually used in three-dimensional work, such as clay, additive and/or subtractive sculpture like stone, while drawing invites the use of one's dominant hand.

Digital Media

Still images--Moving images

Photography selects and captures a moment in time. And, due to the simultaneous parts of one image, a photograph can convey rich narrative content. Video or film moves as time, in time, revealing temporal-narrative relationships. Temporal media where time becomes a material like editing video or film to convey an unfolding event.

Installation Work to Performance Methods

Installations---Performance

Installation work can address rethinking, redesigning, or restructuring environments. Performance work can be part of installations. Consider using oneself as the material to performatively communicate ideas to an audience.

Lastly, all materials contain inherent, implicit healing metaphors. Reflect on the journey of riding the languages of different materials and processes. Use The Imaginal Skill Building Rubric as a tool to explore materials and their inherent metaphors.

Intentions, Witness Writing, and Witnessing

This next section is inspired by The Open Studio Project (OSP) founded by Pat Allen, Dayna Block, and Deborah Gadiel (Allen, 1992, 1995). My summary

below remains faithful to the OSP process while also adding slight modifications that I have have found helpful.

SETTING AN INTENTION

Purpose and Intention: When entering the studio consider the following:

1. The power of intention setting is fundamental to many contemplative practice traditions. Purposefully gathering awareness and vowing to align with resolute action is referred to in yoga as setting a *sankalpa*. Begin by sitting quietly and listening inwardly to inner guiding messages. Practice arriving and settling. Observe developing sensations. Then notice conceptual notions rising into thoughts. Consider what is emerging and where you are being pulled. Write a *sankalpa* or intention based on this emerging purpose or anything else that feels like a truthful premise to follow into your studio work. Locating and articulating alignment with anticipated artistic actions will guide your written intention setting.

2. Then distill two to four key words from your written intention and say them to yourself throughout the studio session as a form of purposeful mantra practice. Someone can randomly ring a mindfulness bell throughout the studio session so everyone present can pause and silently say this short phrase.

3. Now engage in your art process. Every now and then repeat the three or four words you initially wrote down and gently notice the ebb and flow of your intention while working. It might strengthen or perhaps weaken and dissolve. Mindfully notice and follow where you are being authentically pulled.

WITNESS WRITING AND REFLECTIVE DISTANCE

1. Once your art is finished, take reflective distance, observe the work, and based on what you are seeing, write down whatever rises into awareness. Try to not censor what is emerging. Consider taking literal dictation from the imagery. Or practice free writing about whatever emerged from the studio session. Or just describe the lines, shapes and colors to yourself. Refer to the Imaginal Skill Building Rubric (see Appendix C).

2. Lastly, consider finishing with a haiku as a way to distill the events of your studio session. This will help you receive and capture the essence of your experience.

Describing the Witness function in meditation, Swami Anantananda (1996) wrote:

> Witnessing is not suppression, nor is it denial. To witness something, you first have to recognize it is there—and allow it to be. Allowing something to be does not mean indulging in it, however. It means watching it arise and dissolve without either struggling to make it go away, on the one hand, or acting it out on the other. (p. 16)

READING YOUR WITNESS

If inclined, first read your intention aloud and then what you wrote about the art experience. Since this process can involve other people doing the same practice, they will hear you read. Avoid editorializing, making excuses, or criticizing yourself—just simply read exactly what you wrote. People listening are asked to remain silent, avoid congratulating the reader, and not respond for example by running over with tissues if someone is crying. Instead practice receiving, privately resonating, and holding what occurred, that's all. Once finished, wait a few moments, and then the next person can read until all present have had a chance to share their witness. Of course, some will decide to remain silent and not read, which is fine. Reading your witness, while being witnessed by others, becomes a powerful exchange for all present. Overall, mindful or conscious witnessing is about making room for what is unfolding, similar to how a mirror or water holds a reflection.

Exercises

Creating a Space to Work and Practice

Purpose: Set up a place to do artwork and a space to practice sitting or movement meditation. It could be the same place, or two different settings. The main point is to create spaces that inspire inner calm. Even if using the kitchen table, stimulate the senses by placing flowers nearby. Take some essential oils, mix with water, fill a sprayer, and mist the air and table. Always think of honoring the senses with beauty, the manifestation of *ānanda*.

We all have preferences for environmental detail. Consider the specific architectural elements, such as lighting, sound, and furniture, that resonate with your sense of calm. Visit holy sites and places of natural beauty to identify a personal vocabulary of space for your studio and meditation area. Construct an altar, sometimes referred to as a *pūjā*, and adorn it with inspiring objects. The *pūjā* can be portable, kept in a shoebox, and spontaneously set up in any setting. Choose beautiful cloth and place your photos or objects on the fabric. Either set it up in different areas of your home or select a permanent location where you wish to sit in silence.

Surroundings where we work, eat, and sleep deeply affect us. Consider how many modern illnesses are the result of the environments we build for ourselves to live and work in throughout a lifetime. Take charge and make your desired studio and meditation environment. Start small, like adorning a corner of a room. Investigate meditation cushions to either purchase or construct out of household pillows. Just make sure you are comfortable and able to sit upright with an erect spine. Since comfort is important, chairs are fine for sitting meditation too.

Part 1: Recording Prāṇa:[1] Doing, Non-doing; and Part 2: Birth, Death, and Resurrection or Rebirth

PURPOSE

All creative work alternates between doing/manifesting, dismantling/undoing, and moments of recreation. Understand and joyfully participate in these basic rhythms of the creative process.

MATERIALS

Ear plugs. Pushpins. Large paper from a roll of butcher paper, like restaurant paper used to cover tables. Purchase either oil sticks from an art supply store or Cattle Markers from a farm store, which are cheaper. You will need two different colors. If interested, you can also use roofing paper. This comes in a large roll and can be cut to the desired size. Roofing paper is a durable surface—it can be scratched, rubbed, or abraded. Lastly, find inspiring drumming music, such as Baba Olatunji's *Drums of Passion*.

PROCESS

You will need a large wall on which to work. Securely place many tacks all the way around a big 3' × 6' piece of paper, oriented in a vertical plane. Have a chair nearby so you can alternate between sitting and standing.

Next insert the ear plugs so you can hear the magnificent soundtrack of your breath and heartbeat. Place the chair in front of the paper and be still for three to five minutes noticing the potential, empty space before you, while observing the breath. After five minutes, approach the paper with a different color oil sticks in each hand.

For another five to six minutes, make large and small marks corresponding to each inhale and exhale (see Fig. B.1). If you get dizzy, stop, sit, and if inclined, continue to face your work, noting the breath. When ready, stand again and work or sit and work. It is important to coordinate each mark with each inhale and exhale. Do this exercise for 10 to 12 minutes, or longer.

Next, move from stillness to movement by removing the ear plugs, playing the drumming music, and making corresponding marks with each hand for another five to six minutes. It is fine to make marks on top of the previous recorded lines or sweeping shapes. Remember, you are still recording life force (see Figs. 1.1 and 1.2). Practice this part of the process for 8 to 10 minutes, or longer.

Once finished, sit for five minutes in front of the work, still observing the breath, which will be quite rapid at this point. Notice the density of recorded lines (see Fig. 2.9). There is no agenda; only observe the marks, body sensations, and the dense multilayered marks of life force in front of you.

If interested, undoing in part 2 comes next followed by the creation of a new, very different composition.

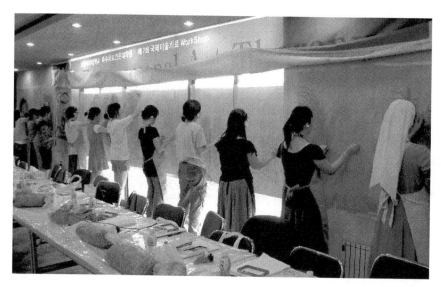

Figure B.1. Recording *prāṇa*/life force. Workshop, Seoul Women's College, Seoul, South Korea. Photograph by the author.

Part 2: Variation: Birth, Death, and Resurrection or Rebirth

(This part can be done in groups)

PURPOSE

As an awareness practice, the goal of Part 2 is twofold. First is to observe the desire for attachment to the outcome of these large drawings. Second is to realize the rhythms birthing/deathing/renewal, as core principles of any transformation process, especially in artistic work. In this project, the art event is created, mindfully dismantled or destroyed, and then reconfigured into new possibilities.

PROCESS

You are likely in a group of people. Or you could be working alone. Next mindfully tear the paper from the previous exercise apart. Twenty or twenty-five (or more) slices of varying sizes should do. Groups of three or four people are formed. The pieces from all five large drawings are then reassembled on the wall, using lots of pushpins. Eventually a large relief sculpture will emerge. Twist and bend the the paper pieces and tack them to the wall in interesting, layered ways (see Fig. B.2). Notice that you have moved from stillness and emptiness, to breath awareness, to movement, to reflection, to attachment,

Figure B.2. Birthing-Deathing-Resurrecting. Photograph by the author.

dismantling, and now to transformational reconfiguration. Since this process can be controversial for some, students are alerted ahead of time about the stages of the project.

There are different ways to do this exercise. In the past, I have tried a few approaches where I have invited students to work on the same piece of paper for the entire semester. Eventually, layers occur, rips appear; change is inevitable. Another approach is to find objects from nature (do not pick living items), choose a few, and focus in tightly on specific details of the organic shapes. Then carefully draw, on a large sheet of paper, these observed details. Once finished, the drawing is mindfully torn into pieces. Note the sensations of resistance, attachment, and grasping. Take the pieces and reconfigure them into a new composition. Repeat for two to three more generations of birthing/deathing/resurrecting new compositions.

Textures of Silence

PURPOSE

Become curious about your relationship to silence. Does it annoy you, stimulate you, put you at ease, or cause anxiety? This exercise makes the visual language of silence seen, known, and internally anchored.

MATERIALS

Any materials from the Basic Materials List will do.

PROCESS

Start a word list of synonyms for silence (*quiet, stillness, peace,* etc.). Make the list as long as possible. Then play with the list by making word combinations like quiet stillness or peacefully calm. Take your sketchbook, make a series of small hand drawn squares (3 × 3 inches) for thumbnail sketches. Or, look through magazines for images that convey this emerging visual vocabulary of silence. Notice the emerging color palette, forms, and memories stimulated. For example, green would show up a lot if choosing outdoor scenes from the magazines. Write your thoughts down as they surface. Next, using any drawing material, spontaneously sketch lines/shapes in the thumbnail boxes to visually represent each word-pair. Lastly, refer to the thumbnail sketches as guides to be made larger with additional materials (drawing, paint, pastels, even clay). Use the thumbnail studies to compose larger drawings, paintings, or sculptures. See the textures of silence, hold them, look closely at them, and consider them

internally as touchstone references. Perhaps place them on your altar. It can be exciting to to use the thumbnails as a departure point for larger work, which I encourage.

Ugliness and Mindfulness

PURPOSE

One of my art therapy professors, Edith Kramer, used to say we have to teach children to work and adults to play. For some adults, play is difficult for one simple reason. Grown-ups consistently judge their actions and consequently seize up inside and become rigid. I learned long ago not to talk people out of their inner judgment. In fact, the opposite is true. It is possible to amplify and externalize, through art processes, self-deprecating thoughts. A simple way to enliven critical thoughts for observation is to do a mixed-media piece that is intentionally ugly. All efforts are devoted to making unsightly, unpleasant color combinations and imagery. Avoid and observe the urge to organize the offensive into something perfect.

Keep a journal nearby to write down the thought-voices related to: Judgment/Criticism; Shame/Embarrassment; Fear/Anger, and how others will see you and this work. Try not to censor these voices or compare yourself to others. Rather, give them freedom to speak, be observed, and be written down.

Judgment/Criticism	Shame/ Embarrassment	Fear/Anger	Comparisons with Others
Post Journaling Section: include comments of inner friendship/kindness			

MATERIALS

Be prepared to make a mess, which is part of playing as an adult. Already, after reading this one sentence some are becoming rigid and avoidant to get their hands messy. Many of us have been shamed and criticized for behaving creatively. In many cases, this is an intergenerational problem. Replication of the same concern, from another generation, is passed down to the next generation like artistic trauma.

Wear an apron. Mixed media is best. Choose many items from the Basic Materials List. Select a sturdy surface to work on, such as roofing paper, cardboard, or anything else that can take some hard activity. Best to experiment working on a table or standing so you can come in close and also stand back. Since this work will likely drip, begin flat on a table. Arrange paints, inks, glues, magazine images, tools for gouging and scratching.

PROCESS

Start out slow by adding different media to the surface. Move it around while trying to make it messy and chaotic. In fact, intentionally set out to make visual chaos. If inclined, stop and jot down thoughts as they arise. Once you are into it, scratch the surface, mix in other materials—anything, really. Try not to give up—stay steady and move forward in the process.

It is quite likely that the uglier it gets, the more you will try to make it look nice. Keep in mind that you may even like the result, feeling liberated by your accidents and explorations. Remember, while making visual chaos, you were also containing it and stockpiling new knowledge for future projects of how art materials behave.

This process is best explored over many sittings like working on the same piece of paper for an entire semester. Over time, the surface becomes abraded. Areas develop worn and fragile layers as wet media cakes and dries while also being excised with sharp tools.

After each sitting, journal your thoughts, especially those related to Judgment/Criticism, Shame/Embarrassment, and Fear/Anger. See how they have been defined, internalized, or perhaps liberated. Be gentle with yourself. This can be a powerful exercise lasting weeks or months. Over time, differing felt voices surface from embarrassment to excitement for unanticipated discoveries. Inner friendship even emerges as the work becomes less about accomplishing a product and more about experimental eurekas.

Noticing and Reclaiming Projections

PURPOSE

We tend to see in others what we disown in ourselves. Projection is mostly an unconscious, relational survival tool. Rather than prejudge and recklessly project onto people, landscapes, animals, or artworks, become aware of this tendency to spontaneously place meaning on others. Meditation increases the gap space between the impulse to project and actual projection, which is one reason why we practice the practice.

MATERIALS

Any materials from the Basic Materials List will do.

PROCESS

Thumb through a magazine and look at pictures of people on several pages. Make up stories about them and write them down. Consider that some of these anecdotes actually relate to your own style of seeing people and constructing meaning about them. Observe the process; avoid shaming yourself, just become curious about the automatic tendency to engage in projective behavior. Observe how automatic this impulse can be. Next, take a fresh image, do the same process; however, this time, observe yourself making up the story. Practice reclaiming what is so easily cast out onto others. Use your journal to write down insights and awareness about the experience.

Sensory Collages

PURPOSE

Develop personal methods for connecting with your senses. Consider that each sense has a corresponding art form:

- hearing—music
- sight—visual art
- kinesthetic/tactile—dance
- taste—food
- smell—space awareness

MATERIALS

Cell phone, journal or sketchbook, and any materials from the Basic Materials List.

PROCESS

Develop a sensory diary. Set your phone for random alarms throughout the day. When it rings, pause, bring awareness to each sense, and notice the present moment through each sense. After moving through the cycle, become still for five minutes and observe how present you are. Then write down corresponding thoughts related to your emerging observations. Next take your sketchbook and make a series of 3 × 3 thumbnail sketches. Using lines, shapes, colors, and textures, draw a corresponding cell for each sensory experience. Use these studies as reference points for larger artworks. Consider working both two-dimensionally and three-dimensionally. You may even create a corresponding song for sound or dance for kinesthetic/tactile emergent knowledge.

Multiple Perspectives and Visual Haikus

PURPOSE

Explore flexible seeing, noticing thoughts and corresponding outer events from different perspectives. This exercise develops empathic sight for difference, uniqueness, and sameness.

MATERIALS

Camera (still, video, or both).

PROCESS

Without a goal or agenda, walk about in a familiar or new place. Find a reference point in this place that you are drawn to. Once noticed, take a picture. Then move to a different location, and photograph the same reference point from each changing perspective. Stop at times to write a haiku (three sentences—the first is five syllables, the second is seven, and the third sentence is again five syllables). If you go over, which is fine, you are writing what I call a buku (French: beaucoup, great amount).

Continue the same process, even taking pictures of this same spot from above, below, throughout the day, nighttime, and sunrise. Notice that you are focusing on the same place, but seeing it from numerous perspectives.

Reflect afterward on how this sort of flexible seeing is similar to building agile qualities of mind to hold multiple perspectives. Rather than staying stuck in one point of view, allow curiosity to lead you into numerous points of view, especially when looking at the art created by others. Move beyond yourself and back to yourself by noticing experiencer and observer roles.

Decisively, choose three final photographs and hang them next to each other in succession. Each picture will represent a line from a final haiku. Consider the poetic associations between the visual and verbal images.

Acetate Collage

PURPOSE

This exercise develops awareness of inner spatial and temporal relationships like past-present-future thinking or memories, including experiences of emotions that occupy foreground, middle ground, and background mind-space.

MATERIALS

Journal, three to four clear acetate pages, peel-off grease markers in red, black, white (sometimes called China markers), and blue painters tape.

PROCESS

Reflect on a memory or current event in your life that has emotional charge. Journal thoughts related to past, present, and future relationships with this memory. Next observe how this topic occupies inner foreground—like always on your mind, middle ground—there but not hounding you, background—out of awareness—mind-space. Drawing on one piece of acetate at a time with different color china markers, represent how these foreground, middle ground, and background references link to this emotion or memory.

Since acetate is clear, consider how each page can show see-through dimensional relationships simultaneously, not unlike old encyclopedia anatomy pages where the circulatory system can be laid on top of the skeletal system, on top of the nervous system. Use tape to block out areas that you want to mask off. Consider how you are constructing a layered view of experience that occupies temporal and spatial prominence. Notice how your mind layers experience (see Fig. B.3).

Figure B.3. Acetate Collage. Photograph by the author.

Visual Vocabulary

(Connected to the next exercise, "Working with Duality")

PURPOSE

To create your own unique visual vocabulary of specific content areas, especially as they relate to corresponding thoughts of duality.

MATERIALS

Sketch pad paper and prismacolor pencils or illustration markers.

PROCESS

Construct a list of at least fifteen dual word pairs such as endings/beginnings, birth/death, happy/sad, and so on. Place your paper vertically and write down each word pair like this:

Birth----------------------------------**Death**

Leave room under each word for drawing a quick, spontaneous shape like the example below.

Birth----------------------------------**Death**

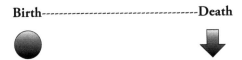

Spontaneously choose a color and make a small, quick corresponding sketch underneath each word that specifically represents that word. It is important not to labor or judge these quick drawings. Just let it pour out and make each drawing small.

Working with Duality

(Connected to the previous exercise "Visual Vocabulary")

PURPOSE

We naturally think and perceive inner and outer events in terms of dualistic relationships. This exercise exposes the rich relationships between duality and coexistence, while also highlighting nondual perception.

MATERIALS

16 × 20 paper, chalk pastels, or prismacolor pencils, or illustration markers, or clay.

PROCESS

Refer to and complete the visual vocabulary exercise and choose one word pair. Use the small thumbnail sketches as a departure point for making larger drawings. Begin with the 8 × 10 paper and create expanded, enlarged studies

of each sketch. Do a few of them in order to become familiar with the subtle-
ties of each image. When ready, go to larger paper and make three drawings.
Look at your chosen pair and completed studies. Your first drawing becomes
a further expanded elaboration of one word informed by the studies, the sec-
ond picture elaborates on the other, and the third is of the first two literally
coexisting together on one page. This last drawing is the most interesting—you
will need to consider how both duality words and images coexist together.
Take your time with this last picture. Repeat the process with other word
pairs. And, also try this with clay, making three separate sculptures, one of
each word and then a third of the two connectively coexisting. Note that this
example focuses more on the duality theme, omitting the third sculpture for
the sake of illustration (see Fig. B.4).

Buddha Family Masks

PURPOSE

The Buddha families represent different aspects of enlightened awareness. And,
conversely, they can also show corresponding neurotic, confused states. In either
enlightened or neurotic form, they are energies alive within us to observe
and learn from. Often depicted as a *maṇḍala,* each family is represented in a

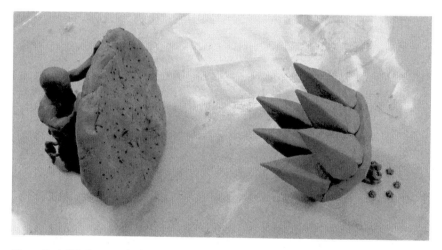

Figure B.4. Working with duality through clay. Workshop, SASANA, Bogota Colombia.
Photograph by the author.

different section of the circle. At the center is Lord Vairocana (Vairochana),[2] characterized as white, and the wisdom of wide-open, empty space.

Explore the Buddha families by creating masks for each one and for personal ritual use. The Buddha families represent interiorized energies coursing through us as primordial intelligence (Trungpa, 2005). These forces are found throughout nature and serve as personality markers. The Buddha families are: *Buddha, Ratna, Padma, Karma, Vajra.*

Buddha: Represented by a wheel and the color white, exudes spaciousness, peacefulness, and sustaining wisdom. To embody and reflect Buddha understanding results in contentment with simply being as well as selfless service. In its confused state, Buddha can be stuck and inert, exposing dullness, sluggishness, and doubt. Yet this family embodies the Buddha's "spaciousness rather than selfishness" (Trungpa, 2005, p. 170).

Ratna: Ratna is symbolized by a jewel and is associated with earth, peaceful solidity, and openness (Trungpa, 2005). Ratna qualities, including the color yellow, generate equipoise, contentment, and creativity. This family is generous and accepting of indulgences rather than rejecting, that is, until paired with ignorance. Then ratna becomes prideful self-indulgence. The illusion of needy security emerges, more is desired, and the confused aspects of ratna emerge. In this state people display egotistical qualities such as dependency and pretentious overconfidence.

Padma: Represented by a lotus and the color red, padma is linked to the element of fire. When manifesting in its neurotic state, padma seductively confuses inherent unification with striving for unification (Trungpa, 2005). Grasping to hold onto pleasure is another dimension of padma. Transmuting these tendencies renders striving pointless. Union becomes obtainable through "precise seeing" as "discriminating awareness" of awakened, compassionate perception (Trungpa, 2005, p. 171). Intuition becomes refined and heartfelt, empathic speech surfaces.

Karma: Karma is represented by a sword and symbolized by the active wind element and the color green. Aggression and effort can reside in this family. It can feel as if there is always more to do as we greedily compare ourselves to others and envy their accomplishments (Trungpa, 2005). In its transmuted form, like the wind element, karma is free of attachment and therefore actions are constituted for the benefit of others. One moves about with elegant detachment, clearing away obstacles.

Vajra: Vajra is associated with blue and the impartial, mirror-like clarity of the water element. Water gently conforms to the shape of its container, or it moves with flowing grace. People manifesting vajra qualities exude intelligent precision and the capacity to hold multiple perspectives. The confused

qualities of vajra are anger and aggression resulting from emotional distancing, resistance, and opinionated critiques. Further, vajra misunderstanding manifests as overconfidence and authoritative perfectionism. In its clarified state, vajra is clear, "mirror-like" wise perception (Trungpa, 2005, p. 172).

MATERIALS

Oil-based modeling clay, clay tools, especially a wire tool, plaster bandages, scissors, petroleum jelly, bowls for clean water, a tray, acrylic paint, brushes, newspaper. You will use this same clay over and over.

PROCESS

Read up on this subject before beginning. Understand the living forces that are characteristic of each family. Begin with journaling and free-associate your personal views of the healthy and neurotic qualities of each Buddha family. Once you have a sense of how these qualities live within you, move to oil-based modeling clay and sculpt a mold for each sane and neurotic aspect of each Buddha family (there will be two masks for each Buddha family so this will take a while).

The clay can be stiff, so set it in a *tray* on a windowsill and let the sun soften it up for about an hour (do not put clay in the microwave or a hot oven). Once softened, begin by fashioning the clay into a sphere the size of a very large grapefruit. Take a wire tool and cut the sphere in half as a starting place for each mask. Since clay offers both additive and subtractive qualities, dig into it to remove unnecessary clay or add to it to build up sections. Take your time pushing, pulling, squeezing, and modeling the clay to represent each aspect of the Buddha family. *Since the layered plaster bandages cover over details, make sure to exaggerate all features. Also be careful to avoid complex hollow areas. Overall attend to detail, but make simple surfaces.*

When finished with the mold, you are now ready to apply the plaster bandages. Place some newspaper down and then smear some petroleum jelly all over the clay. Since it is oil-based, this will not hurt the clay. Next, take the roll of dry plaster bandages and cut them into various-sized strips—nothing too small. For example, measure a few strips that can reach all the way around the outermost edge. You will have to work quickly, putting three total layers on the mold.

One at a time, dip each bandage into the water once and then place it on the mold. Work from the outermost parts toward the middle. Run your fingers around each applied strip to smooth out the plaster.

Once finished, let it dry (note, plaster becomes warm as it dries). When fully dry, turn it over, take a clay gouging tool, and begin to dig the clay out by the edges. The plaster edges may become a little flimsy—don't worry; this can be trimmed with scissors once the plaster is free from the clay. Gently take an edge and pry the plaster off. In some cases, it may not want to release. If this happens, you will have to dig more clay out.

Next, apply a few coats of gesso to the mask. You can take a fine grit sandpaper and smooth out the surfaces after each application. Once dry, paint the inside and outside of the mask. Consider how the inside represents your inner relationship to this Buddha family quality and the outer represents how you show this family aspect to the outside world. Repeat the process for each mask.

Storm Drawings with Sensory Studies

PURPOSE

To work large while acknowledging the interconnected forces of nature. Arnheim (1969) suggested that art is a way to think with the senses. Therefore, engaging the senses and noticing how they inform direct experience is part of this exercise.

MATERIALS

Camera, 11 × 14 and 16 × 20 paper, pencil, chalk, charcoal, (perhaps chalk pastels), larger paper from a roll of butcher paper or restaurant paper used to cover tables.

PROCESS

Begin by looking at YouTube videos of inclement weather and storms. In pencil, make a series of thumbnail sensory sketches of weather related processes. Ask questions such as:

- What would lightning smell like, sound like, or feel like if I were to touch it?
- What would the inside of a cloud smell like, sound like as weather inside builds, or feel like if I were to touch it?
- Where does a raindrop originate?
- How does water feel or sound as it falls as rain?

Make many small corresponding thumbnail sketches as a way to build a visual vocabulary of natural forces and processes. Next, cut out the many thumbnails and collage them together on the floor. Move them around into many different configurations. Make a photo of each. Finally, settle on one collage and make a photo of it.

Next, work with charcoal, chalk, and gradations of gray by mixing the two materials together on either 16 × 20 or larger butcher paper. Begin by copying parts of interest from the final collage onto the larger paper. Outline large and small areas and then fill them in with blacks, whites, and grays. Take your time, as these can be stunning drawings.

In terms of content, this drawing can become a metaphor for forming and externalizing ranges of affect from calmness to turbulence to power to destruction to regeneration. Consider phrases like the calm before the storm. Look at news footage of the aftermath of floods, hurricanes or tornados as well as documentation of regeneration.

Why charcoal and chalk? Sometimes intense affect, especially when we are working large with potent forces, needs to be mollified. Black, white, and values of each soften the charge of too much color. Charcoal and chalk are inexpensive—a little goes a long way, especially when working with a meager budget. Also, too many colors can become muddied—we can show intense affect without color, at least to start with.

Next, consider a painted version either with a monochromatic palette or choosing two colors only, plus black and white. Use black sparingly and also be cautious if using complementary colors as they will mix together in shades of gray.

Rhythm Portraits and Modality Translations

PURPOSE

Life force moves in tempos of rhythm. Consider identifying your personal rhythms from the perspective of the guṇas: tamas (fixed, sedentary, inactivity), rajas (activity, movement, transformation), and sattva (balanced harmony). Or consider rhythmic words like stillness/silence/tranquility, receptive/alert/responsive, active/lively/vital, oscillate/vacillate, pressure/force, quake/tremor, shiver/tremble, surge/gush/swell, throb/vibrate/pulsate, undulate/surge/rise-fall. This exercise connects to these forces living and moving within us and in nature.

MATERIALS

Any materials from the Basic Materials List can work. I prefer clay.

PROCESS

Begin by reflecting on the rhythmic patterns that are unique to you. Like the Visual Vocabulary exercise, make some sketches of each, only this time with clay. Next, translate these sketches into sound equivalents. Then translate them to written poetic equivalents and eventually to movement equivalents. Each translation from visual, to actual movement and sound takes you deeper into the embodied feeling of each rhythm. If interested, combine all parts into a private performance where you sculpt, sing, dance, and make poetry about each rhythm. Note—there is no order to the sequence of translations. You can start anywhere.

Variation on the Previous Exercise: Contemplative Portraits and Modality Translations of The Four Immeasurables and Body-Speech-Mind

PURPOSE

Many contemplative concepts and topics tend to be examined from conceptual points of view, basically from the neck up. Direct experience of these subjects through the arts can awaken deeper connection and insight.

The four immeasurables, also known as the four divine states or abodes, are: loving kindness/*metta*; compassion/*karuṇā*; joy/*muditā*; and equipoise/*upekkha*. Understanding the four immeasurables or divine states supports the discovery of personal happiness, mindful relationship to suffering, cultivation of joy for others, and seeing with equanimity.

With an attentive ear and eye, we listen and look for hints of each in body, speech, mind, and corresponding artworks. Tenderly relating to these subjects through modality translations awakens the discovery of compassion for self and other, inner friendship, and soft interior spaces of equipoise. Contemplative approaches to creative work orient artistic practitioners to promote and internalize these awakened qualities of body, speech, and mind. We strive to bring the loving kindness of *ahimsā* to our work through compassionate seeing of self and other.

MATERIALS

In order to see your thoughts on this subject, use any art materials and mix them together. Experiment.

PROCESS

Create felt, abstract portraits using lines shapes and colors of each divine state. Perhaps start with collage. Once finished, engage in modality translations. Try again with other materials. Use a camera to take self-portraits of how your face expressively registers each abode.

Split Screen *Tonglen*

PURPOSE

Tonglen is a practice of connecting with suffering and, therefore, reciprocally with compassion. We coordinate inhales with receiving or taking in discomfort and exhales with sending out hopefulness. Usually, this is done quietly in meditation. Split Screen *Tonglen* is a visual way to practice. I devised this approach using the idea of a split screen metaphor to coordinate inward observation with *seeing* our sending and receiving process. In sports broadcasting, the screen often becomes split, one side playing what just happened in the game and the other side showing real time footage of what is occurring. This visual template reinforces the synergy of observing the mind while simultaneously seeing the memory contrails of those thoughts.

MATERIALS

16 × 20 paper, pencil, markers, prismacolor pencils, oil pastels.

PROCESS

First, seek out instruction from a qualified teacher. Additionally, read supportive books to help clarify questions. When reasonably oriented, practice *tonglen* for five to ten minutes for a few days. Choose a topic that is not too potent. After each session, journal and make spontaneous sketches of the feeling tones that represent what was sent and received. Become familiar with this personal subject through practice, journaling, and sketching.

Later, use 16 × 20 paper and draw a line down the middle. The left side would represent the space of the in-breath and the right side the out-breath. Choose two colors from your set of oil pastels and/or prismacolors, hold one in each hand, and on the left make corresponding lines to represent what you are taking in or receiving. On the right, make corresponding lines to represent what you are releasing or sending. This can either be a warmup for the next part, or serve as a complete experience.

If interested, next, take a fresh piece of paper, draw a line down the middle, and use your previous sketches as references to make a more developed picture on each side. At this point, you are not coordinating mark making with the breath as in the first part. Instead, you are working at an easel or on a wall or table. What you have come to know about sending and receiving content through the in and out-breath from your sketches will be further developed into full bloom images using the prisma color pencils or oil pastels to render lines, shapes, colors, and textures that visually represent what you have observed and realized. Lastly, once finished, sit before the work and, like a scribe, take dictation from the imagery.

Next, practice by looking at the art. Beginning with the receiving side, inhale and take in the visual imagery of this side while silently saying to yourself what you are receiving. On the exhale switch to the other side and observe this imagery, and quietly phrase to yourself your comments of compassion. Repeat for several more rounds by coordinating breath with the imagery and phrases while alternating back and forth. Notice how the visual split screen display supports visualizing received and sent content.

Softening the Sore Spot

PURPOSE

According to Trungpa Rinpoche, there is a hidden inner sore spot within each of us that calls to be softened (Midal, 2001, p. 131). Often armored from feeling bruised and hurt, this place holds profound vulnerability. Mindfully and artistically noticing this space facilitates the opening of our compassionate hearts. Trungpa taught that to love and know our own broken, opening heart allows us to know the same in others. Practicing this view unlocks a portal to the innate compassionate wisdom of *bodhicitta* (awakened heart-mind) for oneself and others.

MATERIALS

Larger paper from a roll of butcher paper (3' × 6') or restaurant paper used to cover tables, pushpins, two bowls for two different paint colors, two cotton rags, clay, and a wall for working on a large painting.

PROCESS

First, do not choose your most vulnerable bruise. Remember, when someone asks for a drink of water, do not give the person a fire hose. Similarly, there

is no need to go directly toward our greatest pain. Instead, practice titration and healthy risk taking. Like a bruised piece of fruit, it is still whole and good to eat; it just has a soft spot that needs attention. Therefore, choose something that is real for you, yet manageable, and begin by naming this vulnerability.

Once named (not defined), begin journaling feelings related to the personal textures of this designated vulnerability. Attempt to contact stories closely related to emotional and autobiographical connections by freely writing.

Next, read the journaling back to yourself and underline the words that represent affect/emotion. Then only read these underlined words and notice this emotional subtext. Take each word and write synonyms for its context, mood, and scene.

If interested, based on your journaling, write a haiku about this material in order to distill it down even further to essence points.

As you recount these narratives, you may need to practice touch and go. That is, mindfully touch the emotional presence of soft, felt bruises, and then let them go (Trungpa, 2005). Try not to touch and grab or touch and run as you sit in the tenderness of your inner truth (Wegela, 2010). Too much space becomes a form of inner abandonment, while too much contraction and grabbing becomes somatically restrictive, even claustrophobic.

Afterward, for a day or two, practice *tonglen* with these felt narratives. Then select two colors, perhaps one each from the warm and cool sides of the palette. Begin with a large, vertical sheet of paper taped or tacked to the wall. Think of atmosphere, fog, or diffuse space where the soft spot exists—nothing solid; rather, atmospheric. Place two paint colors in a dish along with a rag in each hand for each color and charge them up with those paint colors. Next, wipe the paint on the paper with broad applications. Cover the entire page with two colors only, more will create muddy results. Feel free to incorporate white and black to modify each color.

Take another plain white rag (not paper towel) and blend the wet color together in order to mute the diaphanous qualities.

Next, working with clay, consider the shape, texture, scale, and overall visual language of the soft, sore spot and make some sculpted studies. Notice the emerging variations and eventually take the honest qualities from the studies and compose a final representation of this place of sore vulnerability. Try to hone it down to an actual wounded spot.

Once finished, place a stool in front of the atmospheric painting. Put one or both of the colored rags used on top of the chair, and then place the clay soft spot on top of the colored rag(s) (see Figs. A.5 and A.6). These rags become like prayer rugs to receive and hold the soft spot.

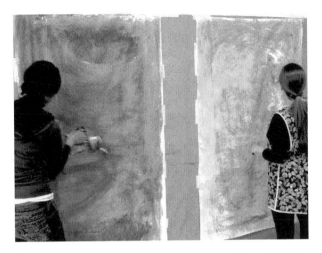

Figure B.5. Softening the Sore Spot, rag wiping two colors. Workshop, SASANA, Bogota Colombia. Photograph by the author.

Figure B.6. Softening the Sore Spot—display. Workshop, SASANA, Bogota Colombia. Photograph by the author.

Befriending Inner Diversity: Mapping The Layers of Our Interiorized Communities

PURPOSE

The important subject of diversity is addressed here with a focus on our inte-riorized communities of ancestry, body image, and social identities such as professional and spiritual beliefs. Cultivating awareness of these subjects facili-tates attention to our privileges, blind spots, and, importantly, to outer cultural similarities and differences with others. Using art materials and processes, we can materialize the layered relationships between these inner/outer embodied stories.

MATERIALS

Personal journal, clay and clay tools, large roll of butcher paper for maps and body tracings, two-dimensional materials (pencil, eraser, paint, rags, oil pastels), yarn, glue, tape, and pushpins. The full armamentarium of the Basic Materials List. Participants need to prepare ahead of time by bringing photos, preferably Xeroxed copies, of race, class, gender, and community themes from their personal life. It is best to choose significant theme-related images from now, childhood, and across the personal and ancestral developmental spectrum.

PROCESS

Whether working individually or in a group for this project, explore the mean-ings and definitions of inner and outer diversity, focusing on race, class, gender, community, and more. This process will facilitate surfacing and naming the complications inherent in this inner/outer subject as well as insights gleaned from this process. Vulnerability is innevitable.

Next, studio methods for visually creating a body-map of personal inner diversity follow. Tape a life-sized piece of butcher paper to the wall. If working in a group with an unknown partner, clarify for yourself how you feel about someone touching the outline of your body. If this is too uncomfortable, either find a trusted friend or sit this one out. Next, have someone *lightly* trace around you in pencil. When outlining the inside of the legs, be careful to stop well below the knee. The reason for this is to not violate the personal space of the genital area. When finished, step away from the paper and use your pencil and eraser to make adjustments to the tracing and complete the inner thigh area. This will not be an exact likeness, only an approximate contour, so be prepared if body image is a challenging subject for you. Next consider how inner diversity lives within you. Collage, write, and construct inside the tracing, first, your embodied diversity, including shadowed, unacceptable parts, as well

as acceptable self-structure portions. Move about the process with intention as you visually map the architecture of personal interiorized diversity.

Once the inside drawing is complete, use clay to sculpt shorthand representations of ancestry, body image, and social identities such as professional and spiritual beliefs. When these figurines are finished, bring a small table nearby, place the clay objects on the surface, and connect yarn from the sculpture to the place in the body where this theme lives. In essence, you are making your inner diversity unflatten while connecting it to your embodied experience.

Figure B.7 A & B. Befriending Inner Diversity: Mapping the Layers of Our Interiorized Communities. Workshop, SASANA, Bogota Colombia. Photograph by the author.

Practicing Dying

(This process can be linked to the Softening the Sore Spot exercise by repeating similar steps.)(Check with a health care professional before trying this exercise.)

PURPOSE

Teenagers rightly feel the youthfulness of the body as a reflection of life's abundance. For me, this naiveté was challenged by my father's decade-long illness and eventual death. The overall experience resulted in intense curiosity, at a young age, about the human soul and its disembodied journey after death. Introductions to yoga, meditation, and art became chosen subjects for investigating the questions of my adolescent circumstances.

My interests were further aroused by George Harrison's album *All Things Must Pass*. Of the many songs on this seminal recording, it was "The Art of Dying" that stayed with me. If death is a certainty, then as my contemplative roots have since taught me, best to practice for this moment by rehearsing for the instant when we release our last breath. Years later during my meditation sessions, with curiosity I began to exhale and wait as long as I could before inhaling. The more I did this, my restless mind eventually softened and, over time, slowly relaxed. As I prepared for my cancer surgery, I shared this process with Reb Zalman since he was intensely interested in transformative spiritual practices from all traditions. Years later, while working on his *December Project*, Reb Zalman practiced a similar process minus the art part and reported finding it very helpful.

For years in certain workshops I have been offering art-based processes to imaginally and meditatively rehearse the last breath. This exercise, likely provocative for some, invites us to encounter the abrasive agitation of no breath. When practiced regularly, the result is less fear, increased awareness, and attentive presence around our mortality and final exhale.

MATERIALS

16x24 paper, larger paper from a roll of butcher paper or restaurant paper used to cover tables, pushpins, two bowls for two different acrylic paint colors, two bowls for clean water, two cotton rags, clay, and a wall for working on a large painting.

PROCESS

As noted in chapter 6, between the two points of our first in-breath as infants and our very last exhale are numerous inhales and exhales, or many small

deaths. Regularly sit for meditation and focus awareness on the delicate, thin gap between your inhales and exhales.

After ten to fifteen minutes of meditation and observing your normal breathing rhythms, when arriving at your last exhale, gently breathe out all air. Slowly empty your lungs all the way and observe what emerges. Hesitate, as long as possible without hurting yourself, before taking your next in-breath. Observe body sensations and the harsh panic that can emerge. At this point, notice these sensations for as long as it is reasonably comfortable. Detect figure/thought and ground/body impressions. Tightening and holding will naturally occur. Bring observant intention to relax several seconds into this panicky anxiety. When ready, **gently** inhale without gulping air and observe the sensations of moving from no oxygen to having full lungs. Continue to regulate your rapid breathing patterns at this point, and when ready, bring attention to the celebratory return of life force.

Continue to sit in meditation for another five minutes. DO NOT repeat this process again; it should only be done once during each sitting. Be gentle with yourself when practicing this exercise and all exercises in this section. Experiment, remain curious, and continue to claim art as an expression of inner necessity.

Next, use the 16 × 20 paper to imagine the gap space between breaths. Dip each rag into one color and the water as needed for thinning the paint. Gently blend washes of color as a way to articulate the atmospheric space between breaths. Do several versions on five separate sheets, and while working, make sure to mindfully observe your breath.

Next, work on the large paper pinned or taped to the wall. Utilize the previous studies on the 16 × 20 pages as reference points for enlarging this subtle space. Cover the entire paper. Place a seat in front of the painting, sit back, and look carefully at the subtle, likely formless blended atmospheres. Spend time here, do not rush this part of the process.

Lastly, take the clay and imagine the direct experience of this last breath. What shape was it? What textures covered its surfaces? Sculpt your candid, envisioned experience from your meditation. When finished, put the color-soaked rags on the chair or stool, move it as close as possible to the painting, and place your sculpture on top. Assume additional reflective distance, sit back, and take dictation from the imagery, from it to you and also from you to it, and fill a few pages in your journal.

Appendix C

Rubrics

Table C.1. Imaginal Process Skill Building Rubric

Imaginal Process Skill Building Rubric Compiled by Michael Franklin, PhD, ATR-BC© Informed by: P. Berry, 1982; J. Hillman, 1978	
1. Start by looking at the entire event (artwork), receiving the narrative, and then take dictation from the imagery by writing write down whatever emerges. Look for: • **Context:** surrounding conditions, circumstances, situation, the setting of an event, the core parts. • **Mood:** feeling present in the image, humor, ambiance, pervading tone of the image. • **Scene:** where the event is taking place—a landscape, environment, incident, place, or site. Context, mood, and scene constitute the narrative alive within the image. • **Simultaneity and Intra-Relations:** Address the "full democracy of the image" (P. Berry, 1982, p. 60), use the grammar of the image, not your projection or interpretation. Fully see the work before any interpretation.	
2. List the lines, shapes, and colors in each quadrant: Write down any obvious recognizable objects as well. But do not take reckless liberty to call a something a something like frivolously ascribing gender. It is best to describe the formal elements of shape, color, line etc. to inform your understanding of content.	
Left side:	**Right side:**
Upper part:	**Lower part:**
Foreground:	**Middle and background:**

continued on next page

Table C.1. Continued.

Center:	Edges:
Absent/implied content:	**Present/obvious content:**

3. Repetition: Observed, repeated patterns (color, line, shape, arrangement):

4. Specification: Select a specific section of the visual simultaneity & write down observational descriptions:

5. Singularizing (only)/Externalizing (whenever): Change **when** statements to **"only."** (only when I. . . .) **When** statements to **"whenever,"** (Whenever I. . . .)

6. Contrasting: Address contrasts like warm/cool or black/white colors or themes like happy/sad, beginning/ending temporal events in artwork:

7. The Hiatus in the Image: notice pauses when being told about the art or actual breaks or spaces in places of contact in the image:

8. Restatement: always restate/paraphrase within the metaphoric language of the image:

9. Text/Texture: Look back at what you first wrote in #1, take 3 different color pens, and first underline the words that imply affect/emotion like *sad, happy, rejected, alone, excited, angry, confident, amazed, curious, upset, shy, fear, humiliated, alienated, grief, celebration.* Then, with another color, underline words that imply movement. Then underline words that imply _____; you decide on the category and use a third color. Read these underlined words back to yourself and notice the different subtexts/textures within the larger narrative.

10. Use adverbs (*slowly* moving), particularized nouns (*tree-bird*), noun combinations (*green eyes*), reversibility (*tree bird* or *bird tree*) when discussing images.

11. If looking at someone else's work, list your personal projections, bracket them out, and place them to the side. If not intrusive, invite the artist to speak about the work both during the art process & afterwards. Understand that days or weeks after the first review of the work, information can continue to surface.

12. Working w/color (or form): red, redness, light/dark red, soft/heavy red, bluish-red, painful red, amorous red, what is red saying in this part of the picture, poetic associations to red . . .

13. Make specific notes here about your core, primary observations of the image:

Table C.2. Self-Assessment Rubric for Art Assignments

Self-Assessment Rubric for Art Assignments Michael Franklin PhD, ATR-BC©
Course:_____ **Date:**_____ **Project** _____
Name:_____ **Final Grade:**_____ **/100**
Rate each question w/concise written comments, on a separate sheet of paper, on a 1–10 scale (it is OK to use 1/2 or 1/4 points like 9.5 or 8.75). Consult the grading chart at the very bottom, ex: a 93% would be 9.3/10 for that category. Final grades are based on 100 total possible points). Perfect scores or consistent 10's in any category is a rare event—**please be objective. Guiding question:** What am I trying to do & am I doing it with high standards? If so, why? If not, why? Articulately speak to these questions.

Pre Self-Reflection Questions (not part of the total 100 points): 1. Am I willing to be balanced in my self-assessment? (include comments beyond yes/no for all 4) 2. How do I work with self-deprecation, mistakes, and/or my 'inner critic'? 3. Am I prone to over-inflate the evaluation of my artwork? 4. Am I capable of being a skillful, critical inner observer of my art process and final product?	
****From here, evaluate each question, 1–10, on a 10-point scale.**	
1. Exploration & integration of materials, planning & construction. Openness to materials, incorporating new materials, working outside of comfort range, refining old and new skills, assessment of planning strategies.	
2. Involvement with process, particularly mistakes & failures. Reflect on mistakes/failures & how they led to unanticipated opportunities. Consider failure as a necessary part of the creative process. How did the process begin (divergent/convergent thinking)? Reflect on the stages of the process (preparation, incubation, verification, elaboration). How did you refine your intentions throughout the process? Relational awareness between the process and product?	
3. Project resolution/final presentation. Resolving construction problems, integrity of craftspersonship & compositional themes. Assessment of final presentation (framing, hanging work, artist statement, installation, video documentation of visual data trails). ***Responses to completed work/product.*** Resistance to your work. How is the work confronting you? Appreciation of efforts & failures-appropriately critical. Sustained engagement with content over time. Mindfully working with resistance. Define relationships between expressive efforts & artistic quality?	
4. Body awareness. Consider body-based insight, eye-hand coordination, how the content inhabits your body, rhythm variations of kinesthetic activity, shifting breathing patterns, somatic responses to color, symbols, mark-making, closeness & distance from the work.	

continued on next page

Table C.2. Continued.

5. Development of themes/ideas contained in your expressive work. Search for authentic imagery/content. Did you cultivate and maintain authentic involvement with your work process, especially your imagery? Development/ elaboration/integration of unique, original ideas that convey healthy risk-taking. Truthful critique and engagement with the product and nourishing risk-taking.	
6. Did you make cultural connections? Connections to cultural themes such as power, privilege, gender, class bound values, social roles, ethnicity, appropriation, identity formation, ancestry, internalized oppression? Concerning these topics, what blind spots were revealed and addressed in your work?	
7. Imaginal Dialogue & engagement with images. Expressive content such as personification, listening to images & most important following them? What has shifted over time with your process? Did you make use of the active imagination process or distinctions between image personification and imaginal dialogue? How? When? Results?	
8. How might others experience this work? Adequate or strong craftspersonship? Conceptually rich but poorly executed? Successfully communicating significant elements of your original intentions? What impact might your work have on different audiences? Hopefully you are thinking about the viewer; if so, how does this influence your evaluation?	
9. Did you glean wisdom & insight? Leaving space for the unknown? Specific learning from inner listening, authentic spontaneity, engaging somatic cues, honoring intuition by moving instinctual ideas into concrete solutions, biographical insight, mindful relationship to failures & ambiguity? Insight related to process-product relationships.	
10. Fill in with comments: Open-minded critical observations: areas for improvement & development: A) Improvement of formal elements. B) Improvement of content themes—deepening the narrative. C) Improvement of process—planning, time management, sustained effort, accepting & working with confusion, transforming problems into solutions. D) Methods of critiquing & evaluating your work.	
Total Points (– Add them all up):	
Post Self Reflection Questions (not part of the total 100): write out comments. No yes/no responses. 1. Have I been balanced & appropriately self-critical in my final self-assessment? 2. Have I been overly self-critical throughout phases of the art & self-grading process? 3. Have I over-inflated my final grade (10's)? 4. Overall, what was I trying to do & did I accomplish it with high standards? If so why? If not why?	

Final Grade Chart:	A+ = 97–100	B+ = 87–89.75	C+ = 77–79.75	
Example—93% (A–) for	A = 94–96.75	B = 84–86.75	C = 74–76.75	
one category becomes 9.3	A– = 90–93.75	B– = 80–83.75	C– = 70–73.75	
			D 69.75 & below	

Table C.3. Art Materials/Process Awareness Rubric

Art Materials/Process Awareness Rubric
Compiled by Michael A. Franklin Ph.D., ATR-BC ©
Sensation = body-based feeling awareness before a story emerges **Emotion** = feeling, including sensation, with a story
I. Notice what surfaces for you when you first encounter/see the material(s) (first thoughts):
A. Curiosity? Desire to touch & handle the materials: Fear? Memory of a past encounter? Do you feel intimidated? <u>Observe, then describe, and then explain:</u> • Initial Observation— • Experiential Description— • Reflective Explanation—
II. Initial engagement with the material:
A. Sensation/sensory awareness without a story (the felt sense without an "I" or "me" based story attached): • Bring awareness to the contact boundaries/extremities of your body: hands, fingers, arms, changing body orientations towards the materials. Notice sensations:
B. Notice sensations of pleasure/desire (the felt sense without an "I" or "me" based story attached):
• Attraction:
• Disgust:
• Smell:
• Touch:

continued on next page

Table C.3. Continued.

• Sound:
• Temperature:
• Contact once removed (brush to paper, camera lens to subject):
III. Flexibility of the material: focus on observations—what can it do, how does it behave:
• Wet media (paint):
• Dry media (pencil, colored, graphite):
• Blending media (pastel, charcoal):
• Digital media (computer, video, photography):
• 3-D media (clay, stone, wood):
• Collage material (found objects, magazines):
IV. Concerning any material that you are using:
• Confusion/uncertainty—how does it work:
• Control—easy to difficult:
• Results of sustained exploration:
• List of new awareness's for the next time you use this material:
• Ideas for combing materials: (paint with collage, clay with found objects, handmade paper with embossed objects):
• What will you try/do next:

V. Emotional responses to the material. Now notice the stories attached to your process:
• Spontaneity/playfulness:
• Rigidity/discomfort:
• Fear:
• Imaginal threads (context/mood/scene narratives):
Color: • Attraction: • Beauty: • Emotional access: • Communication possibilities: • Frustrations: • Insights:
VI. Cognitive responses:
• Selecting and combining:
• Ordering and sequencing:
• Working with perspective—translating three-dimensions into two-dimensions:

continued on next page

Table C.3. Continued.

• Blending:
• Mixing:
VII. What have you learned about yourself by working with this material:
• Managing frustrations:
• Tolerating ambiguity:
• Emotional regulation:
• Re-authoring past narratives:
• New possibilities learned from this exercise for future work:
VIII. How would you teach someone to use this material:
• Introduction to the material:
• Motivation to use the material:
• Demonstrating basic properties of the material:
• Supporting the process of working with this material:
• Engaging the body in the use of this material:
• Looking at and working with the final product:
IX. Clean Up Needs: access to a sink, toxic materials, soap, hand cleaner, lotion
X. Storage Needs: wet work, 3-D work, taking work home/or not, safe storage

Table C.4. Working with Antonym Opposites: Creating Visual Vocabularies Rubric

Working with Antonym Opposites: Creating Visual Vocabularies Rubric Michael A. Franklin Ph.D., ATR-BC ©			
Name/write down the two parts of the antonym opposites: 1. _____ 2. _____			
Define in descriptive prose the context narrative of the antonym relationships:			
Name one side of the opposite:		**Name the other side of the opposite:**	
List synonyms	Sketch analogous image	List synonyms	Sketch analogous image
1.	1.	1.	1.
2.	2.	2.	2.
3.	3.	3.	3.
4.	4.	4.	4.
5.	5.	5.	5.
6.	6.	6.	6.
7.	7.	7.	7.
8.	8.	8.	8.
9.	9.	9.	9.
10.	10.	10.	10.
Use the visual vocabularies from this exercise to help bloom more articulate images, sculptures, videos, or written narratives.			

Notes

Introduction

1. Embodied subtle energy/creative power (*śakti*), metaphorically coiled like a pot (*kuṇḍa*) at the base of the spine.

2. A "seeming movement," the "vibrational impulse" of Lord *Siva*'s engagement in the play of the Divine, in the Kashmir Shaivism Tantra tradition. Throughout the book, *Spanda* is sometimes capitalized to represent the subtle effulgence of the Self throbbing towards manifestation.

3. *Rasa* is the emotive aesthetic dimension of Tantra vital to the arts. 9 rasas.

4. Act of sacred "seeing"; linking to the sacred dimension of "viewing" or connecting to Divine Reality through a deity, guru, or any activity. Receiving Grace.

Chapter 1. Art as Contemplative Practice: Beginnings

1. "To sit close to"/The Upanishads are vital source teachings in Vedanta on the nature of Reality/Self. Composed as dialogues by various sages, approximately 800–300 BC.

2. *Sarasvati* (She who flows towards the Self) Vedic river goddess, the goddess of knowledge, wisdom, music and the arts. Holds an Indian lute (*veena*).

3. Publications by this author are spelled as Lakshman Joo or Lakshman Jee. Joo is an honorific Kashmiri name that means beloved. Therefore, Lakshmanjoo means Beloved Lakshman whereas Jee is Hindi for Joo. Lakshman Jee was used when early publications of *Kashmir Shaivism, The Secret Supreme*, came out in the nineteen eighties. Technically, Jee is incorrect as it is short for Ji, which is used to infer respect, whereas Joo is a reverential title of honor. Yet for this publication I will be using Lakshman Jee since this is how his name is spelled in the reference used for this project.

Chapter 2. Art as Contemplative Practice: Foundations

1. Oldest revered oral (and later written) transmissions of ecstatic poetic hymns to the Vedic deities/archetypal metaphysical forces, 2500 BC or earlier.

2. *Sāṅkhya* is a *darsana* or one of the ancient six Hindu wisdom traditions. A dualistic cosmology of twenty-four categories of existence (*tattvas*). The *Sāṅkhya* system has been widely adapted and expanded in the Yoga, Vedanta, and Tantra traditions.

3. In *Sāṅkhya*, the three *guṇas* are "strands" in the tapestry of existence. Fundamental principles/components of *Prakṛti* (Universal manifesting power) that also make up human temperaments. In Yoga, liberation theology includes transcending the power of the *guṇas*.

4. *Prakṛti* in the *Sāṅkhya* tradition represents the manifesting power of Consciousness (*Puruṣa*) in all its forms, names, and levels.

5. "Song of God." Famous Vedanta text of dialogues on the nature of the Self and paths of yoga.

6. Hindu deity of universal preservation/maintenance energy.

7. *Rudra*—a wrathful, fearsome Vedic deity of blustering windy storm energy (dissolution energy), who was later assimilated into the Shiva Tantra tradition.

Chapter 3. Snapshots of Western History and Lineage in Art as Contemplative Practice

1. In Tantra, the *bindu* or central dot in a sacred geometrical space represents the contraction of Divine Consciousness of *Śiva-Śakti* in unity.

2. In Tantra, a *yantra* is the sacred geometry specifically representing the "cosmic" body or most subtle body/form with embedded categories of existence (*tattvas*).

Chapter 4. Tasting and Seeing the Divine

1. Theory/structure/discipline of dance.

2. A *mūrti* represents a sanctified icon/image/statue of a deity that is honored as the living embodiment of the archetypal deity principle while it is being worshiped.

Chapter 5. Imaginal Intelligence and Contemplative Practice

1. *Ṛta,* from ancient Vedic times, represents the moral/ cosmic order of the Universe, or the inherently conscious orderly arrangement of universal function and form.

2. Famous seventh-century philosopher/thinker/exponent of nondual Vedanta.

3. Mantra: that which liberates/protects through the mental body. In Tantra, a sanctified mantra represents the subtle-level sonic body of a deity.

4. Techniques and strategies for working with images can be found in Appendix A, and an Imaginal Process Skill Building Rubric for working with images can be found in Appendix C.

Chapter 6. Art as Yoga

1. Goddess of abundance/preservation energy/archetypal Divine mother principle.

2. See the Self-Assessment Rubric for Art Assignments in Appendix C.

3. Distinction/difference/particularity. One of the six Hindu wisdom traditions that elaborates on seven systems of peculiarities of existence.

4. *Pāda* ("foot") here represents a basis/fundamental/grounded teaching.

5. *Kaivalya*: in Patanjali's classical yoga is the liberation of *Puruṣa* from *Prakṛti*, freed from the bondage of the three *guṇas*. The yogi's Spirit is now in eternal freedom.

6. Body-based postural yoga system from India. The key proponent of modern haṭha yoga is considered to be Sri Krishnamacharya from South India.

7. In Patanjali's classical yoga, *dhāraṇa* ("to hold/to ground") is the meditative concentration of the mind on an object, with focus, clarity, and effort.

8. In Patanjali's classical yoga system, *dhyāna* (absorption/reflection/abstraction) is the contemplative flow of awareness continuously and effortlessly toward the object of contemplation. *Dhāraṇa* leads to *dhyāna* and then to *samādhi*.

9. *Trika* of Kashmir Shaivism also represents the three *Śaktis*/female deity principles of *Parā*, *Aparā*, and *Parāparā*. (transcendental level *Śakti*, immanent level *Śakti*, and the intermediate *Śakti* of both-transcendental-and-immanent levels) (Wallis 2012).

10. Eleventh-century-philospher/author in the Kashmir Shaivism Self-Recognition school lineage.

11. An eleventh-century short text and commentary in the Kashmir Shaivism school of Self-Recognition, written by Kṣemarāja.

12. The Five Divine Acts of *Śiva*: creation, preservation, dissolution, dormancy (concealment), and revelation/Grace.

13. *Vāk* (Vak): Goddess of sacred speech from the Vedas, also linked to Goddess *Sarasvatī*. In Tantra, the four levels of *vāk* as expressed through the manifestation of sacred letter-sounds (*mātṛkā śakti*) are of vital importance in the contemplative path of self-awareness through symbolic sound/image/word.

14. A *tantrika* is a practitioner of the Tantric tradition, the *Śiva* or *Śakti* path.

15. The *Yoga Vāsiṣṭha* (Yoga Vashishta) is a profound set of teachings on the nature of the Self (Atman) and Reality, offering tools for our psychological liberation. Famous eleventh- to fourteenth-century dialogue style teachings on the nature of Reality, the Self, and means of liberation. Influenced by both Vedanta and *Shaivite Trika* traditions.

16. "Song of God." Most universally revered text and teaching in India in the Vedantic/*Viṣṇu*/*Kṛṣṇa* traditions. The three paths of yoga (*bhakti*, *jñāna*, and *karma*) are taught, in addition to the emphasis on *dhyāna* yoga (meditation).

17. A noble king in the *Mahābhārata* era; an *avatāra* or divine embodiment of Lord Vishnu.

18. In the Vedic medical system of healing called *āyurveda*, the three *doṣas* are three health-related constitutional principles based on the three *guṇas* in *Sāṅkhya*.

Chapter 8. Karma Yoga, *Ahimsā*, and the Socially Engaged Artist

1. This chapter contains excerpts from: Franklin, M. (2010). Global Recovery and the Culturally/Socially Engaged Artist. In Peoples, D. (Ed.), *Buddhism and Ethics*, 309–320. Ayuthaya, Thailand: Mahachulalongkornrajavidyalaya University.

2. *Yajña* from Vedic civilization represents the sacrifice of various offerings made during a sacred fire ritual while chanting Vedic mantras and hymns to the deities. In yoga, the inner fire of *tapas* (heat) of purifying practices represents *yajña,* in which the bondage of *Puruṣa* to *Prakṛti* is sacrificed. In selfless service, ego is sacrificed.

Appendix B. Core Principles on Contemplative Practice with Art and Exercises

1. *Prāṇa*: breath/life force/subtle energy. In yoga, there are five kinds of *prāṇa*. At the universal level, *prāṇa* is also the creative/generative/maintaining/dissolution aspects of Universal manifesting power of Consciousness, or *prāṇa-śakti*.

2. Embodiment of the Sun, Moon, and Fire principles in Tantra.

References

Adams, D. (1992). Joseph Beuys: Pioneer of radical ecology. *Art Journal, 51*(2), 26–34. http://dx.doi.org/10.1080/00043249.1992.10791563.

Ajaya, S. (1976). *Psychology East and West.* Honesdale, PA: Himalayan International Institute of Yoga Science and Philosophy.

Allen, P. B. (1992). Artist in residence: An alternative to "clinification" for art therapists. *Art Therapy: Journal of the American Art Therapy Association, 9*(1), 22–29. http://dx.doi.org/10.1080/07421656.1992.10758933.

Allen, P. B. (1995). *Art is a way of knowing.* Boston, MA: Shambhala.

Anantananda, S. (1996). *What's on my mind?* South Fallsburg, NY: SYDA Foundation.

Arieti, S. (1976). *Creativity the magic synthesis.* New York, NY: Basic Books.

Armstrong, K. (1993). *A history of God: The 4,000 year quest of Judaism, Christianity and Islam.* New York, NY: Gramercy Books.

Arnheim, R. (1966). *Toward a psychology of art: Collected essays.* Berkeley, CA: University of California Press.

Arnheim, R. (1969). *Visual thinking.* Berkeley, CA: University of California Press.

Arnheim, R. (1981). Art as therapy. *The Arts in Psychotherapy, 7*(4), 247–251.

Aurobindo. (2001). *The essential Aurobindo: Writings of Sri Aurobindo* (R. A. McDermott, Ed.). Great Barrington, MA: Lindisfarne Books.

Aurobindo. (2004). *Letters on poetry and art.* In *The complete works of Sri Aurobindo* (Vol. 27). Pondicherry, India: Sri Aurobindo Ashram Press.

Ayto, J. (1990). *Dictionary of word origins.* New York, NY: Arcade.

Baer, R. A., Smith, G. T., Hopkins, J., Krietemeyer, J., & Toney, L. (2006). Using self-report assessment methods to explore facets of mindfulness. *Assessment, 13*(1), 27–45. http://dx.doi.org/10.1177/1073191105283504.

Bass, J., & Jacob, M. J. (2004). *Buddha mind in contemporary art.* Berkeley, CA: University of California Press.

Batchelor, S. (1999). Foundations of mindfulness. In J. Smith (Ed.), *Radiant mind: Essential Buddhist teachings and texts* (pp. 133–136). New York, NY: Riverhead Books.

Bäumer, B. (2008). The Lord of the heart: Abhinavagupta's Aesthetics and Kashmir Śaivim. *Religion and the Arts, 12,* 214–229. http://dx.doi.org/10.1163/1568 52908X271033.

Benson, H. (1975). *The relaxation response.* New York, NY: Avon Books.

Benson, H., Beary, J., & Carol, M. (1974). The relaxation response. *Psychiatry, 37,* 37–46.

Berry, P. (1982). *Echo's subtle body: Contributions to an archetypal psychology.* Dallas, TX: Spring.

Berry, W. (1987). *Collected poems, 1957–1982.* New York, NY: North Point Press.

Betensky, M. (1977). The phenomenological approach to art expression and art therapy. *Art Psychotherapy, 4,* 173–179.

Blandy, D., & Franklin, M. (2012). Following the siren's song: Scott Harrison and the carousel of happiness. In A. Wexler (Ed.), *Art education beyond the classroom: Pondering the outsider and other sites of learning* (pp. 117–134). New York, NY: Palgrave Macmillan.

Bolin, P. E., & Blandy, D. (2003). Beyond visual culture: Seven statements of support for material culture studies in art education. *Studies in Art Education, 44*(3), 246–263.

Bollas, C. (1987). *The shadow of the object: Psychoanalysis of the unthought known.* New York, NY: Columbia University Press.

Boorstein, S. (1996). *Transpersonal psychotherapy.* Albany, NY: State University of New York Press.

Borchardt-Hume, A. (2008). *Rothko: The late series.* London, England: Tate.

Bowlby, J. (1980). *Attachment and loss: Volume 3: Loss.* New York, NY: Basic Books.

Brooks, D. R., Durgananda, S., Muller-Ortega, P. E., Mahony, W. K., Rhodes-Bailly, C., & Sabharathnam, S. P. (1997). *Meditation revolution: A history and theology of the Siddha yoga lineage.* South Fallsburg, NY: Agama Press.

Buber, M. (1970). *I and thou* (W. Kaufmann, Trans.). New York, NY: Scribner's. (Original work published 1923)

Bucke, R. M. (1923). *Cosmic consciousness: A study in the evolution of the human mind.* New York, NY: Dutton.

Bühnemann, G. (2003). *Mandalas and yantras in the Hindu traditions.* Leiden, The Netherlands: Koninklijke Brill NV.

Burnham, J. (1968). Beyond modern sculpture: The effects of science and technology on the sculpture of this century. New York, NY: George Braziller.

Cabanne, P. (1971). *Dialogues with Marcel Duchamp* (R. Padgett, Trans.). New York, NY: Viking Press. (Original work published 1967)

Cahn, B. R., & Polich, J. (2006). Meditation states and traits: EEG, ERP, and neuroimaging studies. *Psychological Bulletin, 132*(2), 180–211. http://dx.doi.org/10.1037/0033-2909.132.2.180.

Campbell, J. (with Moyers, B.). (1988). *The power of myth.* New York, NY: Doubleday.

Cane, F. (1951). *The artist in each of us.* New York, NY: Pantheon Books.

Cannuscio, C., Bugos, E., Hersh, S., Asch, D. A., & Weiss, E.E. (2012). Using art to amplify youth voices on housing insecurity. *American Journal of Public Health 102*(1), 10–12.

Caplan, M., Hartelius, G., & Rardin, M. (2003). Contemporary viewpoints on transpersonal psychology. *Journal of Transpersonal Psychology, 35*(2), 143–162.

Capra, F. (1975). *The Tao of physics.* Boulder, CO: Shambhala.

Capra, F. (1996). *The web of life: A new understanding of living systems.* New York, NY: Anchor Books.

Castillo, R. J. (1985). The transpersonal psychology of Pantanjali's Yoga-sutra (Book I: Samadhi): A translation and interpretation. *Journal of Mind and Behaviour, 6*(3), 391–417.

Chapple, C. (1984). Introduction. In Venkatesananda, *The concise yoga Vāsistha* (pp. ix–xv). Albany, NY: State University of New York Press.

Chapple, C. (1986). *Karma and creativity.* Albany, NY: State University of New York Press.

Chapple, C., & Viraj, Y. A. (1990). *The yoga sutras of Patanjali.* Delhi, India: Sri Satguru.

Chaudhuri, H. (1975). Yoga psychology. In C. T. Tart (Ed.), *Transpersonal psychologies* (pp. 231–280). New York, NY: Harper.

Chaudhury, P. J. (1965). The theory of rasa. *Journal of Aesthetics and Art Criticism, 24*(1), 145–149. http://dx.doi.org/10.2307/428204.

Chidvilasananda, S. (1997). *Enthusiasm.* South Fallsburg, NY: SYDA Foundation.

Chipp, H. B. (1968) *Theories of modern art.* Berkeley, CA: University of California Press.

Chittick, W. C. (1989). *Ibn al-Arabi's metaphysics of imagination: The Sufi path of knowledge.* Albany, NY: State University of New York Press.

Chodorow, J. (1997). *Jung on active imagination.* Princeton, NJ: Princeton University Press.

Chodron, P. (1997). *When things fall apart.* Boston, MA: Shambhala.

Chodron, P. (2001). *Tonglen: The path of transformation.* Halifax, Nova Scotia: Vajradhutu.

Cleveland, W. (2000). *Art in other places: Artists at work in America's Community and social institutions.* Amherst, MA: Arts Extension Service Press.

Cohen, G. D. (2006). Research on creativity and aging: The positive impact of the arts on health and illness. *Generations, 30*(1), 7–15.

Cohen, M. (2008). Spiritual Improvisations: Ramakrishna, Aurobindo, and the freedom of tradition. *Religion and the Arts, 12,* 277–293. http://dx.doi.org/10.1163/156852908X271079.

Coomaraswamy, A. K. (1917). Introduction. In Nandikeśvara, *The mirror of gesture: Being the Abhinaya Darpana of Nandikeśvara* (A. K. Coomaraswamy & G. K. Duggirala, Trans.) (pp. 1–10). London, England: Oxford University Press.

Coomaraswamy, A. K. (1934). *The transformation of nature in art.* New York, NY: Dover.

Coomaraswamy, A. K. (1957). *The dance of Shiva.* New York, NY: Noonday Press.

Cooper, A. (1998). The man who found flow. *Shambhala Sun, 9,* 5–63.

Corbin, H. (1969). *Creative imagination in the Sufism of Ibn 'Arabi* (R. Manheim, Trans.). Princeton, NJ: Princeton University Press. (Original work published 1958)

Cortright, B. (1997). *Psychotherapy and spirit: Theory and practice in transpersonal psychotherapy.* Albany, NY: State University of New York Press.

Coward, H. (1985). *Jung and eastern thought.* Albany, NY: State University of New York Press.

Coward, H. (2002). Yoga and psychology: Language, memory, and mysticism. Albany, NY: State University of New York Press.

Coward, H. G. (1983). Psychology and karma. *Philosophy East and West, 33*(1), 49–60. http://dx.doi.org/10.2307/1398665v.

Craven, R. C. (1976). *Indian art: A concise history.* London, England: Thames.

Csikszentmihalyi, M. (1997). *Finding flow: The psychology of engagement with everyday life.* New York, NY: Basic Books.

Daumal, R. (1982). *Rasa, or knowledge of the self* (L. Landes, Trans.). New York, NY: New Directions Books. (Original work published 1970–72).

Davis, D. M., & Hayes, J. A. (2011). What are the benefits of mindfulness? A practice review of psychotherapy-related research. *Psychotherapy, 48*(2), 198–208.

Detre, K. C., Frank, T., Kniazzeh, C. R., Robinson, M. C., Rubin, J. A., & Ulman, E. (1983). Roots of art therapy: Margaret Naumburg (1890–1983) and Florence Cane (1882–1952): A family portrait. *American Journal of Art Therapy, 22*(4), 111–123.

Deutsch, D. (1969). *Advaita Vedanta: A philosophical construction.* Honolulu, HI: University of Hawaii Press.

Diamond, D. (2013). *Yoga: The art of transformation.* Washington, DC: Freer Gallery of Art / Arthur M. Sackler Gallery Smithsonian Institution.

Dissanayake, E. (1992). Art for life's sake. *Art Therapy: Journal of the American Art Therapy Association, 9*(4), 169–177. http://dx.doi.org/10.1080/07421656.1992. 10758958.

Dyczkowski, M. S. G. (1987). *The doctrine of vibration: An analysis of the doctrines and practices of Kashmir Shaivism.* Albany, NY: State University of New York Press.

Ebony, D. (2009). Marina Abramović: An interview by David Ebony. *Art in America*, 112–121.

Eck, D. L. (1998). *Darsan: Seeing the divine image in India.* New York, NY: Columbia University Press.

Emerson, R. W. (1934). *The essays of Ralph Waldo Emerson.* New York, NY: Heritage Press.

Epstein, M. (2004). Sip my ocean. In J. Bass & M. J. Jacob (Eds.), *Buddha mind in contemporary art* (pp. 29–35). Berkeley, CA: University of California Press.

Erikson, J. M. (1979). The arts and healing. *American Journal of Art Therapy, 18*(3), 75–80.

Fant, Å. (1986). The case of the artist Hilma af Klint. In M. Tuchman (Ed.), *The spiritual in art: Abstract painting 1890–1985* (pp. 219–237). New York, NY: Abbeville Press.

Feuerstein, G. (1998). *Tantra: The path of ecstasy.* Boston, MA: Shambhala.

Feuerstein, G. (2001). *The yoga tradition: Its history, literature, philosophy and practice.* Prescott, AZ: Hohm Press.

Feuerstein, G. (2003). *The deeper dimension of yoga: Theory and practice.* Boston, MA: Shambhala.

Feuerstein, G. (Ed. & Trans.). (1989). *The yoga-sutra of Patanjali: A new translation and commentary.* Rochester, VT: Inner Traditions International.

Frankl, V. E. (1984). *Man's search for meaning: An introduction to logotherapy.* New York, NY: Touchstone.

Franklin, M. (1991). Art therapy and self esteem. *Art Therapy: Journal of the American Art Therapy Association, 9*(2), 78–84. http://dx.doi.org/10.1080/07421656.1992.10758941.

Franklin, M. (1996). A place to stand: Maori culture-tradition in a contemporary art studio. *Art Therapy: Journal of the American Art Therapy Association 13*(2), 126–130. http://dx.doi.org/10.1080/07421656.1996.10759208.

Franklin, M. (2010). Global recovery and the culturally/socially engaged artist. In D. Peoples (Ed.), *Buddhism and ethics* (pp. 309–320). Ayuthaya, Thailand: Mahachulalongkornrajavidyalaya University.

Franklin, M. A. (2012). Know thyself: Awakening self-referential awareness through art-based research [Special Issue: *Art-based research: Opportunities & challenges*]. *Journal of Applied Arts and Health, 3*(1), 87–96. http://dx.doi.org/10.1386/jaah.3.1.87_1.

Franklin, M. A. (2016a). Contemplative approaches to art therapy: Incorporating Hindu-Yoga-Tantra and Buddhist wisdom traditions in clinical and studio practice. In Rubin, J. A. (Ed.). *Approaches to Art Therapy* (pp. 308–329). New York: Routledge.

Franklin, M. A. (2016b). Essence, art, and therapy: A transpersonal view. In D. Gussak & M. Rosal (Eds.), *The Wiley-Blackwell handbook of art therapy.* New York, NY: Wiley.

Franklin M. A. (2016c). Imaginal mindfulness-imaginal intelligence: Musings on the languages of shadow and light in art, meditation, and clinical practice. In F. J. Kaklauskas, C. J. Clements, D. Hocoy, & L. Hoffman (Eds.), *Shadows & Light: Theory, research, and practice in transpersonal psychology (Vol. 1: Principles & Practices*; pp. 101–121). Colorado Springs, CO: University Professors Press.

Franklin, M., Rothaus, M., & Schpock, K. (2005). Unity in diversity: Communal pluralism in the art studio and the classroom. In F. Kaplan (Ed.), *Art therapy and social action: Treating the world's wounds* (pp. 213–230). Philadelphia, PA: Kingsley.

Frawley, D. (1994). *Tantric yoga and the wisdom goddesses.* Twin Lakes, WI: Lotus Press.

Freud, A. (1978). *The ego and the mechanisms of defense* (C. Baines, Trans.). New York, NY: International Universities Press. (Original work published 1937)

Freud, S. (2010). *Sigmund Freud: The interpretation of dreams* (J. Strachey, Trans.). New York, NY: Basic Books. (Original work published 1900)

Gablik, S. (1991). *The reenchantment of art.* New York, NY: Thames.

Gennaro, R. J. (2007). Consciousness and concepts: An introductory essay. *Journal of Consciousness Studies, 14*(9–10), 1–19.

Germer, G. K, Siegel, R. D., & Fulton, R. F. (2005). *Mindfulness and psychotherapy.* New York, NY: Guilford Press.

Godbole, V. S. V. (1993). Namaskar: The ancient tradition of salutation. *Darshan: In the Company of Saints, 79,* 20–21.

Golding, J. (2000). *Paths to the absolute: Mondrian, Malevich, Kandinsky, Pollock, Newman, Rothko, Still.* Princeton, NJ: Princeton University Press.

Greene, A. B. (1940). *The philosophy of silence.* New York, NY: Smith.

Greene, T. M. (1964). Paul Tillich and our secular culture. In C. W. Kegley & R. W. Bretal (Eds.), *The theology of Paul Tillich* (pp. 50–66). New York, NY: Macmillan.

Grof, S., & Grof, C. (1989). *Spiritual emergency.* Los Angeles, CA: Tarcher.

Hacoy, D. (2005). Art therapy and social action: A transpersonal framework. *Art Therapy: Journal of the American Art Therapy Association, 22*(1), 7–16. http://dx.doi.org/10.1080/07421656.2005.10129466.

Hamilton, N. G. (1989). A critical review of object relations theory. *American Journal of Psychiatry, 146*(12), 1552–1560.

Harding, M. E. (1961). What makes the symbol effective as a healing agent? In G. Adler (Ed.), *Current trends in analytical psychology* (pp. 1–18). London, England: Tavistock.

Hari Dass, B. (1999). *The yoga sutras of Patanjali: A study guide for book I: Samadhi pada.* Santa Cruz, CA: Sri Rama.

Hartranft, C. (2003). *The yoga-sutra of Patanjali.* Boston, MA: Shambhala.

Hegel, G. W. F. (1966). *The phenomenology of mind* (J. B. Baillie, Trans.) (Rev. 2nd ed.). London, England: Allen. (Original work published 1807)

Henderson, L. D. (1981). Italian futurism and "the fourth dimension." *Art Journal, (41)*4, 317–323. http://dx.doi.org/10.1080/00043249.1981.10792495.

Henderson, L. D. (1986). Mysticism, romanticism, and the fourth dimension. In *The spiritual in art: Abstract painting 1890–1985* (pp. 219–237). New York, NY: Abbeville Press.

Henepola, G. (1999). Vipassana meditation. In J. Smith (Ed.), *Radiant mind: Essential Buddhist teachings and texts* (pp. 151–157). New York, NY: Riverhead Books.

Hewitt, J. (1977). *The complete yoga book.* New York, NY: Schocken Books.

Higgins, K. M. (2007). An alchemy of emotion: "Rasa" and aesthetic breakthroughs. *Journal of Aesthetics and Art Criticism, 65*(1), 43–54. http://dx.doi.org/10.1111/j.1540-594X.2007.00236.

Hillman, J. (1978). Further notes on images. *Spring, 45,* 152–182.

Hillman, J. (1983). *Healing fiction.* New York, NY: Station Hill Press.

Hillman, J. (1999). *The force of character: And the lasting life.* New York, NY: Ballantine Books.

Hinz, L. D. (2009). *Expressive therapies continuum: A framework for using art in therapy.* New York, NY: Routledge.

Hodin, J. P. (1972). *Edvard Munch.* New York, NY: Oxford University Press.

hooks, b. (1995). *Art on my mind: Visual politics.* New York, NY: New Press.

Jahoda, G. (2005). Theodore Lipps and the shift from "sympathy" to "empathy." *Journal of the History of the Behavioral Sciences, 41*(2), 151–163. http://dx.doi.org/10.1002/jhbs.20080.

James, W. (2002). *The varieties of religious experience: A study in human nature.* New York, NY: Modern Library.

Jee, S. L. (1988). *Kashmir Shaivism: The secret supreme.* Delhi, India: Sri Satguru.

Johari, H. (1986). *Tools for Tantra.* Rochester, VT: Destiny Books.

Jones, K. (1989). *The social face of Buddhism.* London, England: Wisdom.

Julliard, K. N., & Van Den Heuvel, G. (1999). Susanne K. Langer and the foundations of art therapy. *Art Therapy: Journal of the American Art Therapy Association, 16*(3), 112–120. http://dx.doi.org/10.1080/07421656.1999.10129656.

Jung, C. G. (1989). *Memories, dreams, reflections* (A. Jaffe, Ed.) (R. Winston & C. Winston, Trans.) (Rev. ed.). New York, NY: Vintage Books. (Original work published 1961)

Jung, C. G. (1998). Foreword: Sri Ramana and his message to modern man. In R. Maharshi, *The spiritual teachings of Ramana Maharshi* (pp. ix–xii). Boston, MA: Shambhala.

Jung, C. G. (2009). *The red book: Liber novus* (S. Shamdasani, Ed.) (S. Shamdasani, M. Kyburz, & J. Peck, Trans.). New York, NY: Norton.

Kabat-Zinn, J. (1990). *Full catastrophe living: Using the wisdom of your body and mind to face stress, pain, and illness*. New York, NY: Delacorte.

Kabat-Zinn, J. (1994). *Wherever you go, there you are: Mindfulness meditation in everyday life*. New York, NY: Hyperion.

Kagin, S. L., & Lusenbrink, V. B. (1978). The expressive therapies continuum. *The Arts in Psychotherapy, 5*(4), 171–180. http://dx.doi.org/10.1016/0090-9092(78)90031-5.

Kandinsky, W. (1977). *Concerning the spiritual in art* (M. T. H. Sadler, Trans.) (pp. xiii–xxi). New York, NY: Dover. (Original work published 1911)

Kaplan, A. (1985). *Jewish meditation: A practical guide*. New York, NY: Schocken Books.

Kaplan, F. (2005). *Art therapy and social action: Treating the world's wounds*. Philadelphia, PA: Kingsley.

Karunamayi, S. (1999). *Sri Karunamayi: A biography*. New York, NY: Sri MatruDevi Viswashanti Ashram Trust.

Kearns, M. (1976). *Käthe Kollwitz: Woman and artist*. New York, NY: Feminist Press at The City University of New York.

Kegley, C. W., & Bretall, R. W. (1964). *The theology of Paul Tillich*. New York, NY: Macmillan.

Kellogg, J. (2002). *Mandala: Path of beauty* (3rd ed.). Belleair, FL: Association of Teachers of Mandala Assessment.

Khanna, M. (1979). *Yantra: The tantric symbol of cosmic unity*. New York, NY: Thames.

King, S. B. (2005). *Being benevolence: The social ethics of engaged Buddhism*. Honolulu, HI: University of Hawaii Press.

Knafo, D. (2002). Revisiting Ernst Kris's concept of regression in the service of the ego in art. *Psychoanalytic Psychology 19*(1), 24–49. http://dx.doi.org/10.1037/0736-9735.19.1.24.

Knight, J. A. (1987). The spiritual as a creative force in the person. *Journal of the American Academy of Psychoanalysis, 15*(3), 365–382.

Kortan, E. (1991). *Turkish architecture and urbanism through the eyes of Le Corbusier*. Ankara, Turkey: Middle East Technical University.

Kraft, K. (1999). *The wheel of engaged Buddhism: A new map of the path*. New York, NY: Weatherhill.

Kramer, E. (1971). *Art as therapy with children*. New York, NY: Schocken Books.

Kramer, E. (1979). *Childhood and art therapy*. New York, NY: Schocken Books.

Kripananda, S. (1989). *Jnaneshwar's Gita*. Albany, NY: State University of New York Press.

Kris, E. (1952). *Psychoanalytic explorations in art*. New York, NY: International Universities Press.

Kuspit, D. (2003). Reconsidering the spiritual in art. *Blackbird Archive, 2*(1). Retrieved from http://www.blackbird.vcu.edu/v2n1/gallery/kuspit_d/reconsidering_text.htm.

Lacy, S. (2005–06). Buddha mind in contemporary art. *Urthona, 22,* 19–23.

Langer, S. K. (1951). *Philosophy in a new key: A study in the symbolism of reason, rite, and art*. New York, NY: New American Library.

Langer, S. K. (1953). *Feeling and form*. New York, NY: Scribner's.

Leadbeater, C. W. (1971). *Man visible and invisible*. Wheaton, IL: Quest.

Lee, V. & Anstruther-Thomson (1912). *Beauty and ugliness and other studies in psychological aesthetics*. London, England: Lane.

Leidy, D. P., & Thurman, R. A. F. (1998). *Mandala: The architecture of enlightenment*. New York, NY: Asia Society Galleries.

Levine, S. K., & Levine, E. G. (1999). *Foundations of expressive arts therapy: Theoretical and clinical perspectives*. London, England: Kingsley.

Liddell, H. G., & Scott, R. (1996). *A Greek-English lexicon*. Oxford, England: Clarendon Press.

Lucie-Smith, E. (1986). *Lives of the great twentieth century artists*. New York, NY: Rizzoli.

Lusebrink, V. B. (2010). Assessment and therapeutic application of the expressive therapies continuum: Implications for brain structures and functions. *Art Therapy: Journal of the American Art Therapy Association, 27*(4), 168–177. http://dx.doi.org/10.1080/07421656.2010.10129380.

Mahony, W. K. (1998a). *The artful universe: An introduction to the Vedic imagination*. Albany, NY: State University of New York Press.

Mahony, W. K. (1998b). The artist as yogi, the yogi as artist. *Darshan: In the Company of Saints, 138,* 56–62.

Mallapragada, M. (2010). Desktop deities: Hindu temples, online cultures, and the politics of remediation. *South Asian Popular Culture, 8*(2), 109–121. http://dx.doi.org/10.1080/14746681003797955.

Mallgrave, H. F., & Ikonomou, E. (1994). Introduction. In H. F. Mallgrave & E. Ikonomou (Eds.), *Empathy, form, and space* (pp. 1–85). Santa Monica, CA: The Getty Center for the History of Art and the Humanities.

Marlan, S. (Ed.). (2012). *Archetypal psychologies: Reflections in honor of James Hillman*. New Orleans, LA: Spring Journal Books.

Marini, G. (2014). Aristotelic learning through the arts. *Studies in Philosophy and Education, 33,* 171–184. http://dx.doi.org/10.1007/s11217-013-9371-6.

McNiff, S. (1992). *Art as medicine*. Boston, MA: Shambhala.

Mehta, K. K. (2008). *Milk, honey, and grapes: Simple Hinduism concepts for everyone*. Atlanta, GA: Puja.

Michael, P. (2014). Karma in the Bhagavad Gita: Way for all to self realization. *Asia Journal of Theology, 28*(2), 203–227.

Midal, F. (2001). *Chogyam Trungpa: His life and vision*. Boston, MA: Shambhala.

Mitchell, S. (2000). *Bhagavad Gita*. New York, NY: Three Rivers Press.

Mohatt, N.V., Singer, J.B., Evans Jr., A.C., Matlin, S.L., Golden, J., Harris, C., Burns, J., & Tebes, J.K. (2013). A community's response to suicide through public art: Stakeholder perspectives from the Finding Light Within project. *American Journal of Community Psychology 52*, 197–209. http://dx.doi.org/10.1007/s10464-013-9581-7.

Mookerjee, A., & Khanna, M. (1977). *The tantric way: Art, science, ritual*. London, England: Thames.

Muktananda, S. (1979). *Introduction to Kashmir Shaivism*. South Fallsburg, NY: SYDA Foundation.

Muktananda, S. (1989). *From the finite to the infinite: Volume II*. South Fallsburg, NY: SYDA Foundation.

Muller-Ortega, P. E. (1989). *The triadic heart of Śiva: Kaula Tantricism of Abhinavagupta in the non-dual Śhaivism of Kashmir*. Albany, NY: State University of New York Press.

Nandikeśvara. (1917). *The mirror of gesture: Being the Abhinaya Darpana of Nandikeśvara* (A. K. Coomaraswamy & G. K. Duggirala, Trans.). London, England: Oxford University Press.

Naumburg, M. (1987). *Dynamically oriented art therapy: Its principals and practice*. Chicago IL: Magnolia Street.

Neihardt, J. G. (1959). *Black Elk speaks*. New York, NY: Pocket Books.

Nhat Hanh, T. (1987). *Interbeing: Fourteen guidelines for engaged Buddhism*. Berkeley, CA: Parallax Press.

O'Flaherty, W. D. (1983). *Karma and rebirth in classical Indian traditions*. Delhi, Varanasi, Patna, India: Motilal Banarsidass.

Partsch, S. (2006). *Franz Marc*. Cologne, Germany: Taschen.

Pintchman, T. (2001). *Seeking MahaDevi: Constructing the identities of the Hindu great goddess*. Albany, NY: State University of New York Press.

Plazy, G. (1990). *Cezanne*. New York, NY: Crescent Books.

Politsky, R. (1995a.). Penetrating our personal symbols: Discovering our guiding myths. *The Arts in Psychotherapy, 22*(1), 9–20. http://dx.doi.org/10.1016/0197-4556(94)00070-8.

Politsky, R. (1995b.). Acts of last resort: The analysis of offensive and controversial art in an age of cultural transformation. *The Arts in Psychotherapy, 22*(2), 111–118. http://dx.doi.org/10.1016/0197-4556(95)00013-U.

Preston, E., & Humphreys, C. (1966). H. P. Blavatsky: A brief biography. In E. Preston & C. Humphrey (Eds.), *An abridgement of the secret doctrine* (pp. xiii–xvii). London, England: Theosophical.

Queen, C., Prebish, C., & Keown, D. (Eds.). (2003). *Action dharma: New studies in engaged Buddhism*. London, England: Routledge Curzon.

Rabten, G. (1999). The heart sutra. In J. Smith (Ed.), *Radiant mind: Essential Buddhist teachings and texts* (pp. 181–191). New York, NY: Riverhead Books.

Rachlin, N. (2013). Giving a Swedish pioneer of abstraction her due. Retrieved from http://www.nytimes.com/2013/04/30/arts/artsspecial/Giving-a-Swedish-Pioneer-of-Abstract-Art-Her-Due.html.

Rappaport, L. (2013). *Mindfulness and the arts therapies: Theory and practice.* London, England: Kingsley.

Rhyne, J. (1998). Special feature: Janie Rhyne's dissertation drawings as personal constructs: A study in visual dynamics. *American Journal of Art Therapy, 36*(4), 115–124.

Richards, M. C. (1964). *Centering in pottery, poetry, and the person.* Middletown, CT: Wesleyan University Press.

Richards, M. C. (1973). *The crossing point: Selected talks and writings.* Middleton, CT: Wesleyan University Press.

Rogers, C. R. (1951). *Client-centered therapy.* Boston, MA: Houghton.

Rubin, J. A. (1984). *The art of art therapy.* New York, NY: Brunner/Mazel.

Sadler, M. T. H. (1977). Translator's introduction. In W. Kandinsky, *Concerning the spiritual in art* (M. T. H. Sadler, Trans.) (pp. xiii–xxi). New York, NY: Dover.

Schore, A. N. (2003). *Affect regulation and the repair of the self.* New York, NY: Norton.

Schore, J. R., & Schore, A. N. (2008). Modern attachment theory: The central role of affect regulation in development and treatment. *Clinical Social Work, 36*(1), 9–20. http://dx.doi.org/10.1007/s10615-007-0111-7.

Schwartz, S. L. (2004). *Rasa: Performing the divine in India.* New York, NY: Columbia University Press.

Sewall, L. (1995). The skill of ecological perception. In T. Roszak, M. E. Gomes, & A. D. Kanner (Eds.), *Ecopsychology: Restoring the earth, healing the mind* (pp. 201–215). Berkeley, CA: Sierra Club Books.

Shantananda, S. (2003). *The splendor of recognition.* South Fallsburg, NY: SYDA Foundation.

Siegel, D. J. (2010). *The mindful therapist.* New York, NY: Norton.

Silburn, L. (1988). *Kundalini: Energy of the depths.* Albany, NY: State University of New York Press.

Singh, J. (1992). *The yoga of vibration and Divine pulsation: A translation of the Spanda Karikas with Ksemaraja's commentary, the Spanda Nirnaya.* Albany, NY: State University of New York Press.

Singh, J. (1998). *Pratyabhijñāhṛdayam: The secret of self-recognition.* Delhi, India: Banarsidass.

Singh, R. & Rawat, S. S. (2013). Rabindranath Tagore's contribution to education. *VSRD International Journal of Technical & Non-Technical Research, 4*(8), 201–208.

Sivaraksa, S. (2005). *Conflict, culture, change: Engaged Buddhism in a globalizing world.* Boston, MA: Wisdom.

Slegelis, M. H. (1987). A study of Jung's mandala and its relationship to art psychotherapy. *The Arts in Psychotherapy, 14,* 301–311. http://dx.doi.org/10.1016/0197-45 56(87)90018-9.

Smith, J. (1999). *Radiant mind: Essential Buddhist teachings and texts.* New York, NY: Riverhead Books.

Sogyal Rinpoche. (1993). *The Tibetan book of living and dying.* New York, NY: HarperCollins.

Speeth, K. R. (1982). On psychotherapeutic attention. *Journal of Transpersonal Psychology, 14*(2), 141–160.

Stein, M. (2012). How to read the Redbook and why. *Journal of Analytical Psychology,* *57,* 280–298.

Steiner, R. (1964). *The arts and their mission.* New York, NY: Anthroposophic Press.

Steiner, R. (2001). *The fourth dimension: Sacred geometry, alchemy, and mathematics.* Great Barrington, MA: Anthroposophic Press.

Stone, L. (2012). Revising attitudes to physical reality: Quantum physics and visual art. *International Journal of Arts and Sciences, 5*(6), 59–72.

Storr, A. (1988). *Solitude: A return to the self.* New York, NY: Ballantine Books.

Suzuki, D. T. (1959). *Zen and Japanese culture.* New York, NY: Princeton University Press.

Suzuki, S. (1999). Mahayana/Zen practice. In J. Smith (Ed.), *Radiant mind: Essential Buddhist teachings and texts* (pp. 52–53). New York, NY: Riverhead Books.

Swain, M. H. (1995). *Ellen S. Woodward: New Deal advocate for women.* Jackson, MS: University Press of Mississippi.

Thayer, J. A. (1994). An interview with Joan Kellogg. *Art Therapy: Journal of the American Art Therapy Association, 11*(3), 200–205. http://dx.doi.org/10.1080/0 7421656.1994.10759085.

Tillich, P. (1980). *The courage to be.* New Haven, CT: Yale University Press.

Timm-Bottos, J. (1995). ArtStreet: Joining community through art. *Art Therapy: Journal of the American Art Therapy Association, 12*(3), 184–187. http://dx.doi.org/10.10 80/07421656.1995.10759157.

Titchener, E. B. (1909). *Lectures on the experimental psychology of thought processes.* New York, NY: Macmillan.

Tomkins, C. (1996). *Duchamp: A biography.* New York, NY: Holt.

Trungpa, C. (1976). *The myth of freedom and the way of meditation.* Berkeley, CA: Shambhala.

Trungpa, C. (1996). *Dharma art.* Boston, MA: Shambhala.

Trungpa, C. (2005). *The sanity we are born with: A Buddhist approach to psychology.* Boston, MA: Shambhala.

Tuchman, M. (1986). Hidden meanings in abstract art. In M. Tuchman (Ed.), *The spiritual in art: Abstract paintings 1890–1985* (pp. 17–61). New York, NY: Abbeville Press.

Ulman, E. (1975). Art therapy: problems of definition. In E. Ulman & P. Dachinger (Eds.), *Art therapy in theory and practice.* New York, NY: Schocken Books.

Venkatesananda, S. (1984). *The concise Yoga Vasistha.* Albany, NY: State University of New York Press.

Vivekananda, S. (2012). *Karma-yoga.* Mansfield Centre, CT: Martino.

Wallace, E. (2001). Healing through the visual arts. In J. A. Rubin (Ed.), *Approaches to art therapy* (pp. 95–108). Philadelphia, PA: Brunner-Routledge.

Wallis, C. D. (2012). *Tantra illuminated: The philosophy, history, and practice of a timeless tradition.* The Woodlands, TX: Anusara Press.

Walsh, R., & Shapiro, S. L. (2006). The meeting of meditative disciplines and Western psychology. *American Psychologist, 61*(3), 227–239. http://dx.doi.org/10.1037/ 0003-066X.61.3.227.

Walsh, R., & Vaughan, F. (1993). Meditation: The royal road to the transpersonal [Introduction]. In R. Walsh & F. Vaughan (Eds.), *Paths beyond ego: The transpersonal vision* (pp. 46–55). New York, NY: Tarcher-Putnam.

Watkins, M. (1984). *Waking dreams.* Dallas, TX: Spring.

Wechsler, J. (1937, December 25). Record of the boondogglers. *The Nation, 145,* pp. 715–716.

Wegela, K. K. (2009). *The courage to be present: Buddhism, psychotherapy, and the awakening of natural wisdom.* Boston, MA: Shambhala.

Weisberg, J. (2011). Introduction. *Journal of Consciousness Studies, 18*(1), 7–20.

Welsh, R. P. (1987). Introduction. In K. J. Regier (Ed.), *The spiritual image in modern art* (pp. 1–11). Wheaton, IL: Theosophical.

Winner, E. (1982). *Invented worlds: The psychology of the arts.* Cambridge, MA: Harvard University Press.

Winnicott, D. W. (1965). The capacity to be alone. In *The maturational processes and the facilitating environment* (pp. 29-36). London, England: Hogarth/Institute of Psycho-Analysis.

Yogananda, P. (2003). *Autobiography of a yogi.* Los Angeles, CA: Self Realization Fellowship.

Zimmer, H. (1946). *Myths and symbols in Indian art and civilization* (J. Campbell, Ed.). Princeton, NJ: Princeton University Press.

Illustration Permissions

Figure 2.1

Three Aspects of the Absolute, page 1 from a manuscript of the Nath Charit, 1823, by Bulaki. India. Opaque watercolor, gold, and tin alloy on paper.
Permission granted from the Mehrangarh Museum Trust, Jodhpur, Pajasthan, India, and His Highness Maharaja Gaj Singh of Jodhpur.

Figure 3.1

Kandinsky, Wassily (1866–1944) © ARS, New York.
Panel for Edwin R. Campbell No. 4. 1914. Oil on canvas, 64¼ × 48¼" (163 × 122.5 cm). Nelson A. Rockefeller Fund (by exchange). ©Artists Rights Society (ARS), New York / ADAGP, Paris.
Location: The Museum of Modern Art, New York.
Photo Credit: Digital Image ©The Museum of Modern Art/Licensed by SCALA /Art Resource, New York.
CREDIT: ©2015 Artists Rights Society (ARS), New York.
Wassily Kandinsky, "Panel for Edwin R. Campbell No. 4."

Figure 3.2

Brancusi, Constantin (1876–1957) ©ARS, New York.
Bird in Space. 1928. Bronze, 54 × 8½ × 6½" (137.2 × 21.6 × 16.5 cm).
Given anonymously.
Location: The Museum of Modern Art, New York.
Photo Credit: Digital Image ©The Museum of Modern Art/Licensed by SCALA / Art Resource, New York.
CREDIT: © 2015 Artists Rights Society (ARS), New York / ADAGP, Paris.
Constantin Brancusi, "Bird in Space."

Figure 3.3

Marc, Franz (1880–1916).

The World Cow. 1913. Oil on canvas, 27⅞ × 55⅝" (70.7 × 141.3 cm). Gift of Mr. and Mrs. Morton D. May, and Mr. and Mrs. Arnold H. Maremont (both by exchange).

Location: The Museum of Modern Art, New York.

Photo Credit: Digital Image © The Museum of Modern Art/Licensed by SCALA / Art Resource, New York.

Figure 3.4

Malevich, Kazimir (1878–1935).

Suprematist Composition: White on White. 1918. Oil on canvas, 31¼ × 31¼" (79.4 × 79.4 cm). 1935 Acquisition confirmed in 1999 by agreement with the Estate of Kazimir Malevich and made possible with funds from the Mrs. John Hay Whitney Bequest (by exchange).

Location: The Museum of Modern Art, New York.

Photo Credit: Digital Image ©The Museum of Modern Art/Licensed by SCALA / Art Resource, NewYork.

Figure 3.5

Duchamp, Marcel (1887–1968) ©ARS, New York.

Bicycle Wheel. New York, 1951 (third version, after lost original of 1913).

Metal wheel mounted on painted wood stool, 51 × 25 × 16½" (129.5 × 63.5 × 41.9 cm). The Sidney and Harriet Janis Collection.

Location: The Museum of Modern Art, New York.

Photo Credit: Digital Image ©The Museum of Modern Art/Licensed by SCALA / Art Resource, New York.

CREDIT: © Succession Marcel Duchamp / ADAGP, Paris / Artists Rights Society (ARS), New York 2015.

Marcel Duchamp, "Bicycle Wheel"

Figure 6.5

Rothko, Mark (1903–1970) ©ARS, New York.

Untitled. (1968). Synthetic polymer paint on paper, 17⅞ × 23⅞" (45.4 × 60.8 cm). Gift of The Mark Rothko Foundation, Inc. ©Kate Rothko Prizel & Christopher Rothko / Artists Rights Society (ARS), New York.

Location: The Museum of Modern Art, New York.

Photo Credit: Digital Image ©The Museum of Modern Art/Licensed by SCALA / Art Resource, New York.
CREDIT: ©1998 Kate Rothko Prizel & Christopher Rothko / Artists Rights Society (ARS), New York.
Mark Rothko, "Untitled."

Figure 7.4

Morandi, Giorgio (1890–1964) C ARS, New York.
Still Life. 1949. Oil on canvas, 14¼ × 17¼" (36 × 43.7 cm). James Thrall Soby Bequest.
Location: The Museum of Modern Art, New York.
Photo Credit: Digital Image ©The Museum of Modern Art/Licensed by SCALA / Art Resource, New York.
CREDIT: ©2015 Artists Rights Society (ARS), New York / SIAE, Rome.
Giorgio Morandi, "Still Life."

Index

Blake, William, 54
Blandy, Douglas, 85
Blaue Reiter, Der (The Blue Rider), 58
Blavatsky, Helena P., 55–58
Block, Dayna, 228
bodhicitta, 170–71, 249
body, art and the, 19–20
body-speech-mind, 247–48
Bolin, Paul, 85
Bollas, Christopher, 138
boredom, 7
Bowling Green State University, art therapy program at, xxvii
Brahma, 50, 104
Brahma granthi, 50
Brahman, 14
Brancusi, Constantin, 59
Bird in Space, 61–62, 62f
Braque, Georges, 58–59
breath, 123–24
as an art material, 123–25
Brus, Gunter, 186
Buber, Martin, 87
Bucke, Richard, 23–24
Buddha, 243
Buddha (Siddhartha Gautama), 182
Buddha Families, five, 243
Buddha Family Masks (exercise), 242–45
Buddhism, engaged, 182–84
art-based connections, 185
Bühnemann, Gudrun, 145
Burden, Chris, 186

Cage, John, 67–68
Campbell, Joseph, 86, 109
cancer, xxiii–xxvi. *See also* Franklin, Michael A.: prostate cancer
Cane, Florence, 112, 118
Carroll, Mary Ellen, 68

causality and cause-effect relationships, 148
Cézanne, Paul, 168–69
Chapple, Christopher Key, 120, 147–48
Chidvilasananda, Swami, 50
Chinnamastā Yantra (Franklin), 142f
Chittick, William, 8
Chodorow, Joan, 89–90
Chödrön, Pema, 170, 171
circle shape/circle design, 143–45
cit, 109, 110
City of Philadelphia Mural Arts Program (MAP), 191–92
clay, 113t, 227. *See also specific topics*
discovering *prakṛti* through, 114
transformation and, 114, 115
working with, 31–34, 94, 114, 115f, 144, 193–200, 242f, 244
clay maṇḍalas, 143f
clay pots, 94t, 95, 145f, 162f, 168f, 195f–198f
firing, 199f
clay workshop, 33f
client-centered therapy, 97
Coburn, Thomas, 75–76
Cognitive/Symbolic (C/S) level of the Expressive Therapies Continuum, 224–26
Cohen, Gene, 160–61
collages
Acetate Collage (exercise), 239, 240f
sensory, 237–38
color fields, 58
communication, interspecies, 39, 209
community, 185
a formula for creating community through art, 185t
community studios, 187, 188

Made in the USA
Middletown, DE
05 May 2021